Edgar Wind

CULTURAL MEMORIES

VOL. 20

SERIES EDITOR

Dr Katia Pizzi
Institute of Languages, Cultures and Societies,
School of Advanced Study,
University of London

PETER LANG
Oxford - Berlin - Bruxelles - Chennai - Lausanne - New York

Edgar Wind

Art and Embodiment

Jaynie Anderson, Bernardino Branca and
Fabio Tononi (eds)

PETER LANG
Oxford - Berlin - Bruxelles - Chennai - Lausanne - New York

Bibliographic information published by the Deutsche Nationalbibliothek. The German National Library lists this publication in the German National Bibliography; detailed bibliographic data is available on the Internet at http://dnb.d-nb.de.

A catalogue record for this book is available from the British Library.

Library of Congress Cataloging-in-Publication Data

Names: Anderson, Jaynie, editor. | Branca, Bernardino, editor. | Tononi, Fabio, 1985– editor.
Title: Edgar Wind : art and embodiment / Jaynie Anderson, Bernardino Branca, Fabio Tononi.
Other titles: Edgar Wind (Peter Lang Publishing)
Description: Oxford ; New York : Peter Lang Publishing, [2024] | Series: Cultural memories, 2235-2325 ; volume no. 20 | Includes bibliographical references and index.
Identifiers: LCCN 2023042935 (print) | LCCN 2023042936 (ebook) | ISBN 9781800799523 (paperback) | ISBN 9781800799530 (ebook) | ISBN 9781800799547 (epub)
Subjects: LCSH: Wind, Edgar, 1900-1971—Knowledge and learning.
Classification: LCC N7483.W514 E336 2024 (print) | LCC N7483.W514 (ebook) | DDC 709.2—dc23/eng/20231017
LC record available at https://lccn.loc.gov/2023042935
LC ebook record available at https://lccn.loc.gov/2023042936

In collaboration with The Edgar Wind Journal.

Cover image: Michelangelo Buonarroti, *Delphic Sibyl*: detail from Sistine Chapel ceiling, 1508–12, fresco. Vatican Museums, Rome. Image in the public domain.
Cover design by Peter Lang Group AG

ISSN 2235-2325
ISBN 978-1-80079-952-3 (print)
ISBN 978-1-80079-953-0 (ePDF)
ISBN 978-1-80079-954-7 (ePub)
DOI 10.3726/b19978

© 2024 Peter Lang Group AG, Lausanne
Published by Peter Lang Ltd, Oxford, United Kingdom
info@peterlang.com - www.peterlang.com

Jaynie Anderson, Bernardino Branca and Fabio Tononi have asserted their right under the Copyright, Designs and Patents Act, 1988, to be identified as Editors of this work.

This publication has been peer reviewed.

Contents

Figures

Fabio Tononi, 'Aby Warburg and Edgar Wind on the Biology of Images: Empathy, Collective Memory and the Engram'

Giovanna Targia, 'On Details and Different Ways of Viewing Raphael: Edgar Wind and Heinrich Wölfflin'

Franz Engel, ' "Chaos Reduced to Cosmos": Reconstructing Edgar Wind's Interpretation of Dürer's *Melencolia I*'

Bernhard Buschendorf, 'Symbol, Polarity and Embodiment:
The Composite Portrait in Aby Warburg and Edgar Wind'

Bernardino Branca, 'Edgar Wind: Metaphysics Embodied in Michelangelo's Sistine Chapel Ceiling'

C. Oliver O'Donnell, 'A Crucial Experiment: An Historical Interpretation of Edgar Wind's "Hume and the Heroic Portrait" '

Ianick Takaes de Oliveira, ' "That Magnificent Sense of Disproportion with the Absolute": On Edgar Wind's Critique of (Humourless) Modern Art'

Oswyn Murray, 'Edgar Wind and the Saving of the Warburg Institute'

Elizabeth Sears, 'Edgar Wind and the "Encyclopaedic Imagination"'

Jaynie Anderson, 'Understanding Excessive Brevity: The
Critical Reception of Edgar Wind's *Art and Anarchy*'

Acknowledgements

We would like to thank Jonathan Blower for translating the chapter by Pablo Schneider; Derek Clements-Croome for his invaluable advice; Henry Hardy for his advice on Isaiah Berlin's papers; Colin Harrison and Ben Thomas, Literary Executors of the Estate of Edgar Wind, for permission to quote from Wind's published and unpublished materials held at the Edgar Wind Archive; Martin Kauffmann, Head of Early and Rare Collections and Tolkien Curator of Medieval Manuscripts, Bodleian Libraries, for his inestimable advice concerning the Edgar Wind Archive; Katia Pizzi, Director of the Italian Cultural Institute of London, for hosting the conference 'Edgar Wind: Art and Embodiment' at the Italian Cultural Institute, where some of the texts included in this book were first presented; Ben Thomas again for his role in co-organizing that conference; Paul Taylor, Curator of the Photographic Collection of the Warburg Institute, for his help with some of the illustrations; Claudia Wedepohl, Archivist of the Warburg Archive at the Warburg Institute, for assistance with some aspects of the works of Aby Warburg; Belinda Nemec for her work as copyeditor of this book; and finally Laurel Plapp, Senior Acquisitions Editor at Peter Lang, for her constant guidance.

We are grateful for the comments on earlier versions of this volume from the anonymous referees. Of course, we take full responsibility for the final book.

Jaynie Anderson, Bernardino Branca, Fabio Tononi

Archival Sources Cited and Abbreviations Used

Bodleian Libraries, University of Oxford	Bodleian
Bodleian Libraries, University of Oxford, Edgar Wind Papers	Bodleian, EWP
Bodleian Libraries, University of Oxford, Archive of the Society for the Protection of Science and Learning	Bodleian, SPSL
Frick Collection/Frick Art Reference Library Archives, New York	Frick
Getty Research Institute, Special Collections, Los Angeles	
Kulturwissenschaftliche Bibliothek Warburg	KBW
Staatsarchiv Hamburg	
Universitätsbibliothek Basel	UB BS
University of London's Vice-Chancellor's Archive	
Warburg Institute Archive, University of London	WIA
Warburg Institute Archive, University of London, General Correspondence	WIA, GC

FABIO TONONI, JAYNIE ANDERSON AND
BERNARDINO BRANCA

Introduction

This volume[1] presents a collection of studies on the pioneering art historian and philosopher Edgar Wind (1900–71) (Figure 0.1), who is also remembered as the first professor of art history at the University of Oxford.[2] Since the death of his widow, Margaret Wind, at the age of 91 in 2006, the Edgar Wind Archive has been accessible at the Bodleian Libraries at the University of Oxford. All authors have consulted it. The archive has contributed to a revival of interest in Wind's work and to an understanding of his importance to art historiography. Our volume is the first collection of studies on this extraordinary art historian and philosopher to take full advantage of this resource.

To understand the work of an art historian, is it important to know the story of their life? In the case of Wind, the answer is a resounding *yes*. The aims of this book are to clarify Wind's contribution to the theory of cultural memory (a concept introduced by Aby Warburg),[3] to analyse his notion of embodiment, to reconsider his published and unpublished works on art history and aesthetic theory, and to explore his life's trajectory.

In 1983, Jaynie Anderson edited and published the first posthumous volume of Wind's collected essays, *The Eloquence of Symbols: Studies in*

1 All quotations from the published and unpublished writings of Edgar Wind are made by kind permission of the Literary Executors of the Estate of Edgar Wind.

2 For more on Wind's intellectual biography, see Ben Thomas, 'Edgar Wind: A Short Biography', *Stanrzeczy* 1/8 (2015), 117–37; and Creighton Gilbert, 'Edgar Wind as Man and Thinker', *New Criterion Reader* 3 (1984), 36–41.

3 For more on Warburg's intellectual biography, see Ernst Gombrich, *Aby Warburg: An Intellectual Biography, with a Memoir of the Library by F. Saxl* (London: Warburg Institute, 1970).

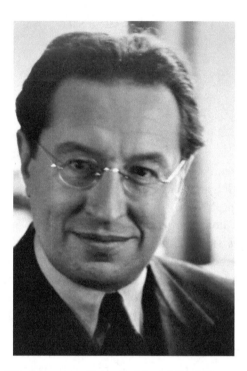

Figure 0.1: Edgar Wind, c. 1937–9. Photograph by Adelheid Heimann. Courtesy of the
Warburg Institute, London.

Humanist Art, reintroducing Wind to the scholarly world.[4] The volume
contains the first biographical memoir of Wind and the translations of his
principal works, which cover topics from the Renaissance to the twentieth
century. This book was reprinted three times in English, and was translated
into Italian, Spanish and Japanese.[5] The Italian translation (*L'eloquenza*

4 Edgar Wind, *The Eloquence of Symbols: Studies in Humanist Art*, ed. Jaynie
 Anderson, with a biographical memoir by Hugh Lloyd-Jones (Oxford: Clarendon
 Press, 1983; repr. 1985, rev. edn 1993).
5 For the Italian translation of *The Eloquence of Symbols* (with the addition of sev-
 eral essays), see Edgar Wind, *L'eloquenza dei simboli (e) La Tempesta: Commento
 sulle allegorie poetiche di Giorgione*, ed. Jaynie Anderson, trans. Enrico Colli
 (Milan: Adelphi, 1992). For the Spanish translation, see Edgar Wind, *La elocuencia
 de los simbolos: Estudios sobre arte humanista*, ed. Jaynie Anderson, trans. Luis
 Millán (Madrid: Allianza, 1993). For the Japanese translation, see Edgar Wind,
 Shinboru no shūjigaku, trans. Fuminori Akiba, Tetsuhiro Katō and Momoe
 Kanazawa (Tokyo: Shōbunsha, 2007).

dei simboli) sold thousands of copies and is still in print. Additionally, the publication of Italian translations of some of Wind's lesser-known works initiated a revival of scholarly interest in his work in Italy.[6] During his lifetime, Wind collaborated with Roberto Calasso, an Italian publisher who created the publishing house Adelphi in Milan. Calasso had an affinity with Wind, so much so that he could be considered Wind's pupil.[7] In France, philosopher Pierre Hadot appreciated the philosophical relevance of Wind's work, as demonstrated in Hadot's essay 'Métaphysique et images: Entretien avec Pierre Hadot'.[8]

In 1986, Anderson edited and published a second volume of Wind's collected essays, on English art of the eighteenth century: *Hume and the Heroic Portrait: Studies in Eighteenth-Century Imagery*.[9] At the core of the volume is Wind's first art-historical study, 'Humanitätsidee und heroisiertes Porträt in der englischen Kultur des 18. Jahrhunderts', first published in 1933 in *England und die Antike*.[10] Wind wrote it while arguing for the Warburg Library to be relocated from Hamburg to London, his objective being to emphasize the importance of the Warburgian methodology for the study of English art. The first translation of this lengthy essay is titled 'Hume and the Heroic Portrait', and it continues to have a considerable influence on the study of English art.[11]

Edgar and Margaret Wind documented their lives meticulously. After her husband's death, Margaret put substantial effort into organizing their

6 See, for example, Edgar Wind, *Humanitas e ritratto eroico: Studi sul linguaggio figurativo del Settecento inglese*, ed. Jaynie Anderson and Colin Harrison, trans. Piero Bertolucci (Milan: Adelphi, 2000).

7 See Jaynie Anderson, '"Posthumous Reputations": Edgar Wind's Rejected Review of Ernst Gombrich's Biography of Warburg', *The Edgar Wind Journal* 3 (2022), 14–35.

8 Pierre Hadot, 'Métaphysique et images: Entretien avec Pierre Hadot', *Préfaces: Les idées et les sciences de l'édition européenne* 0 (June 1992), 33–7.

9 Edgar Wind, *Hume and the Heroic Portrait: Studies in Eighteenth-Century Imagery*, ed. Jaynie Anderson (Oxford: Clarendon Press, 1986).

10 Edgar Wind, 'Humanitätsidee und heroisiertes Porträt in der englischen Kultur des 18. Jahrhunderts', in Fritz Saxl, ed., *England und die Antike: Vorträge der Bibliothek Warburg: 1930–1931* (Leipzig: Teubner, 1932), 156–229.

11 Edgar Wind, 'Hume and the Heroic Portrait', in Wind, *Hume and the Heroic Portrait*, 1–52.

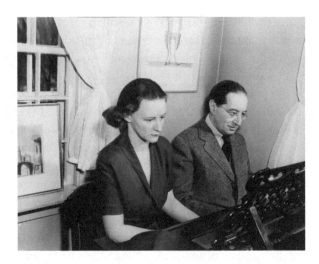

Figure 0.2: Margaret and Edgar Wind playing the piano at Smith College,
Northampton, 1948. Bodleian Libraries, University of Oxford.

archive. There is only one photograph of Edgar and Margaret Wind to-
gether; it depicts them at the piano in Northampton (Figure 0.2) and it
is interesting psychologically. They had an extraordinary relationship that
endured beyond death. The archive is the result of that relationship. One
day, Margaret told Jaynie Anderson that she and Edgar were not able to
have children, and so the archive was her child.

During the editing of *The Eloquence of Symbols*, Anderson became
aware of this considerable resource and was shown parts of it; however, she
was not granted access to personal materials. Later, Christa and Bernhard
Buschendorf, Pascal Griener, Colin Harrison, Elizabeth Sears and Ben
Thomas obtained access to documents related to works that they were
editing. Margaret Wind was dedicated to creating a comprehensive archive;
she realized that her husband was able to express his motivations and ideas
more clearly in his private correspondence than in his formal publica-
tions. This new understanding helps to explain the recent rise in interest
in Wind's scholarship.

From 22 to 24 February 1996 at the Einstein Forum in Potsdam, Horst
Bredekamp convened a conference on Edgar Wind, as part of his project

on German art historians who had been forced to emigrate during the Nazi period. Margaret Wind supported many of the scholars and supplied them with archival materials. Some papers from that conference were collected into a volume that was published two years later, in 1998.[12] It contains research by international scholars, including Elizabeth Sears, whose contribution on Michelangelo's painting of the Sistine Chapel ceiling is an earlier version of her introductory essay to the book *The Religious Symbolism of Michelangelo: The Sistine Ceiling* (2000).[13] Margaret sponsored the posthumous publication of some of her husband's unfinished works, such as those contained in Sears' volume just mentioned.

Nevertheless, it was not until after Margaret Wind's death that anyone was able to view the full range of archival materials. The first scholar to do so was Rebecca Zorach. Jon Whiteley, literary executor of the Wind estate, granted Zorach access when the archival materials were still in the Winds' flat at 27 Belsyre Court in Oxford (Figure 0.3).[14] Some of the archival materials were made available to scholars after they had arrived at the Bodleian Libraries in 2006, long before the cataloguing of the papers was undertaken in 2014 and 2015.

In 2009, Image, Act and Embodiment, a research group led by Bredekamp and John Michael Krois, was given access to the Oxford archive. This culminated in Franz Engel's contribution to Bredekamp's *Festschrift*, published in 2012.[15] When the Edgar Wind Archive was opened to the

12 See Horst Bredekamp, Bernhard Buschendorf, Freia Hartung and John Krois, eds, *Edgar Wind: Kunsthistoriker und Philosoph* (Berlin: Akademie, 1998).

13 Edgar Wind, *The Religious Symbolism of Michelangelo: The Sistine Ceiling*, ed. Elizabeth Sears, with essays by John O'Malley and Elizabeth Sears (Oxford: Oxford University Press, 2000).

14 Zorach's research resulted in the article 'Love, Truth, Orthodoxy, Reticence; or, What Edgar Wind Didn't See in Botticelli's *Primavera*', *Critical Inquiry* 34 (2007), 190–224.

15 See Franz Engel, '"In einem sehr geläuterten Sinne sind Sie doch eigentlich ein Empirist!": Ernst Cassirer und Edgar Wind im Streit um die Verkörperung von Symbolen', in Ulrike Feist and Markus Rath, eds, *Et in imagine ego: Facetten von Bildakt und Verkörperung (Festgabe für Horst Bredekamp)* (Berlin: Akademie, 2012), 369–92.

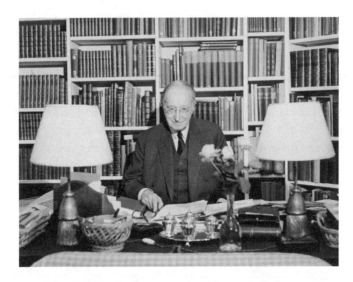

Figure 0.3. Edgar Wind in his flat at 27 Belsyre Court, Oxford, 1970. Photograph
by Michael Dudley. Bodleian Libraries, University of Oxford, courtesy of Jonathon
Dudley.

public in 2015, younger scholars who had never met Wind benefited from
these important sources, enabling research by Ianick Takaes de Oliveira,
Pablo Schneider and others.[16]

The most recent books on Wind are Ben Thomas's *Edgar Wind and
Modern Art: In Defence of Marginal Anarchy* (2020), which focuses on
Wind's writings on modern art,[17] and Bernardino Branca's *Edgar Wind's
Raphael Papers* (2020), which includes Wind's full manuscript from 1950 on

16 See, for example, Ianick Takaes de Oliveira, 'Arte e transgressão em Edgar Wind: Um
 estudo sobre a armadura conceitual e a recepção de *Art and Anarchy* (1963)', Master's
 thesis, Universidade Estadual de Campinas, 2017; and Matthew Rampley,
 'Introduction', in Edgar Wind, *Experiment and Metaphysics: Towards a Resolution
 of the Cosmological Antinomies*, trans. Cyril W. Edwards (Abingdon: Routledge,
 2017), xiii–xxviii.
17 Ben Thomas, *Edgar Wind and Modern Art: In Defence of Marginal Anarchy*
 (London: Bloomsbury, 2021).

Raphael's *School of Athens.*[18] Branca also wrote the only biography of Wind to date, *Edgar Wind, filosofo delle immagini: La biografia intellettuale di un discepolo di Aby Warburg* (2019).[19] In German, books on Wind include *Die allgemeine Kunstwissenschaft (1906–1943): Max Dessoir, Emil Utitz, August Schmarsow, Richard Hamann, Edgar Wind: Grundlagentexte* (2021), edited by Bernadette Collenberg-Plotnikov,[20] and *Edgar Wind: Kunsthistoriker und Philosoph* (1998), edited by Bredekamp, Buschendorf, Freia Hartung and Krois.[21]

Until very recently, scholarly publications on Wind's works have been sporadic.[22] This contrasts with the consistent scholarship on Wind's contemporaries with similar cultural backgrounds, including Aby Warburg, Alois Riegl, Erwin Panofsky and Ernst Gombrich. There are various reasons for the sporadic nature of scholarly interest in Wind. Margaret Wind was a meticulous and protective custodian of her husband's reputation and was slow to approve the re-publication of his works. Indeed, in some cases, such as *The Feast of the Gods*, she did not allow it at all. Also, she was often apprehensive about publishing her husband's unpublished works, and generally approved such projects only after lengthy consultations with numerous scholars. Wind's reputation was also problematic. Although he was recognized as a brilliant scholar, he had often quarrelled with the Warburg Institute, which he had always hoped to direct. In addition to Oswyn Murray's account of Wind's Oxford years, this volume includes the memorandum that Wind wrote to the vice-chancellor of the University of

18 Bernardino Branca, ed., *Edgar Wind's Raphael Papers: The School of Athens* (Wroclaw: Amazon KDP, 2020).

19 Bernardino Branca, *Edgar Wind, filosofo delle immagini: La biografia intellettuale di un discepolo di Aby Warburg* (Milan: Mimesis, 2019).

20 Bernadette Collenberg-Plotnikov, ed., *Die allgemeine Kunstwissenschaft (1906–1943): Max Dessoir, Emil Utitz, August Schmarsow, Richard Hamann, Edgar Wind: Grundlagentexte* (Hamburg: Felix Meiner, 2021).

21 Bredekamp et al., eds, *Edgar Wind: Kunsthistoriker und Philosoph*.

22 For more on the bibliography of works by and on Wind, see Ada Naval Garcia, ed., 'Edgar Wind: A Bibliography of the Works and Secondary Literature', *La rivista di engramma* 184 (updated September 2021), 97–137.

London in 1933, thus settling any doubts about the importance of Wind's role in bringing the Warburg Library to London.

Some of the writings in this volume were first presented at the conference 'Edgar Wind: Art and Embodiment', organized by Ben Thomas and Bernardino Branca, and held at the Italian Cultural Institute of London on 28 and 29 October 2021. In connection with that conference, Bernardino Branca and Fabio Tononi founded *The Edgar Wind Journal*, a twice-yearly open-access publication on Wind's life, published and unpublished works, and research interests.[23] It has now published four issues and is well established.

Wind belongs to the tradition of scholars who contributed to the study of cultural memory. Many chapters of this book look at the role of cultural memory in both the making and the perception of art. Building on the pioneering research of his mentor, Warburg, Wind developed the notion of 'memory function', which refers to the 'traces' that the representations of bodily movements and physical and facial expressions leave on the collective memory of a specific culture.[24] Warburg's notion of the 'survival of antiquity' in Renaissance imagery and culture is a constant theme in Wind's research. Several authors in the present volume mention Warburg's last great project, his never-completed *Bilderatlas* (picture atlas) *Mnemosyne* (the Greek goddess of memory), to which Wind contributed during his time at the KBW and which continues to inspire art historians today.[25] Wind's study of the 'embodiment' of metaphysical ideas in the

23 See website of *The Edgar Wind Journal*, <https://www.edgarwindjournal.eu>. See also Fabio Tononi and Bernardino Branca, 'Introduction: Edgar Wind and a New Journal', *The Edgar Wind Journal* 1 (2021), 1–11.

24 For more on the intellectual relationship between Warburg and Wind, see Fabio Tononi, 'Aby Warburg, Edgar Wind, and the Concept of *Kulturwissenschaft*: Reflections on Imagery, Symbols, and Expression', *The Edgar Wind Journal* 2 (2022), 38–74.

25 Warburg's presentation of his *Bilderatlas* in Rome has been recently analysed by Elizabeth Sears in 'Aby Warburg's Hertziana Lecture, 1929', *The Burlington Magazine* 165 (August 2023), 852–73. See also Bernardino Branca, 'The Giordano Bruno Problem: Edgar Wind's 1938 Letter to Frances Yates', *The Edgar Wind Journal* 1 (2021), 12–38 (12–14).

images and cultures of different epochs, ranging from classical antiquity to modern art, is also connected to the notion of the 'survival of antiquity'.[26]

Wind summarized the aim of his research in a letter sent in 1952 to the Guggenheim Foundation in New York:

> For some twenty years my chief interest has been to explore the boundaries between the histories of art and of philosophy. My aim has been to demonstrate that in the production of some of the greatest works of art the intellect has not thwarted but aided the imagination; and I have tried to develop a method of interpreting pictures which shows how ideas are translated into images, and images sustained by ideas.[27]

Wind has often been regarded as a disciple of Warburg. This book shows that Wind was a scholar in his own right, who not only developed Warburg's ideas, but also opened new avenues of research and formulated new theories on the history of cultures, the history of imagery, and the philosophy of science.

This volume brings together three groups of scholars: the few who knew Wind personally (Oswyn Murray and Jaynie Anderson), those who worked closely with his wife and literary executrix Margaret Wind as she was organizing and cataloguing the Edgar Wind Archive (including Jaynie Anderson, Bernhard Buschendorf, Elizabeth Sears and Ben Thomas), and other scholars who are fascinated by many aspects of Wind's works and ideas (including Bernardino Branca, Franz Engel, C. Oliver O'Donnell, Pablo Schneider, Ianick Takaes de Oliveira, Giovanna Targia, Fabio Tononi and Tullio Viola). Contributors consider Wind's ideas relevant to contemporary and emerging research paradigms in the visual arts. Merging this multifaceted perspective with the unpublished sources in the Edgar Wind Archive is an ambitious task and a stimulating research model.

The chapters are organized thematically into three parts. Part I covers Wind's early intellectual career – that is, the years from his doctoral thesis to his travels to the United States – which includes his

26 For more on Wind's notion of embodiment, see Fabio Tononi and Bernardino Branca, 'Edgar Wind: Art and Embodiment', *The Edgar Wind Journal* 2 (2022), 1–8.
27 Edgar Wind to Guggenheim Foundation, 15 April 1952, Bodleian, EWP, MS. Wind 216, folder 1.

dialogues with contemporaries such as Aby Warburg, Heinrich Wölfflin and Ernst Cassirer. Part II discusses Wind's approach to the analysis of artworks, from Renaissance to modern art. Part III focuses on Wind's career as émigré scholar and public intellectual, including his commitment to transferring the Warburg Library from Hamburg to London. The common thread that runs through all the chapters is cultural memory, a concept introduced by Warburg and largely applied by Wind in his studies.

Part I comprises contributions by Pablo Schneider, Fabio Tononi, Giovanna Targia and Tullio Viola, who analyse Wind's early intellectual career. Schneider's study focuses on Wind's doctoral thesis, which he completed in 1922 and titled 'Ästhetischer und kunstwissenschaftlicher Gegenstand: Ein Beitrag zur Methodologie der Kunstgeschichte' [The Object of Aesthetics and the Science of Art: A Contribution to the Methodology of Art History]. Wind published only a short summary of his thesis, in 1924. Schneider's contribution is the first English-language study on this subject. It analyses Wind's evolving goal of establishing art history as an exact science. Schneider also considers Wind's fruitful collaborations with his supervisor, Erwin Panofsky, and with the broader group surrounding the Kulturwissenschaftliche Bibliothek Warburg (KBW). This setting was conducive to Wind's research in the fields of art history and philosophy, which he considered to be closely linked. Schneider's chapter concludes with an examination of the years Wind spent in Hamburg before his forced emigration in 1933.

Tononi takes an experimental aesthetic perspective to analyse Wind's interpretation of Warburg's theory of images, focusing on the concepts of *Einfühlung* [empathy], collective memory, and the engram. He stresses the role that Warburg and Wind played in the study of the biology of images. In this way, Tononi explores the biological implications of images by discussing recent neuroscientific research on the universality of the expression of emotions and movements, empathy, collective memory, and the engram, in relation to Warburg's and Wind's insights. Tononi also discusses the disagreement between Wind and Gombrich over the correct interpretation of Warburg's research and its significance. Finally, Tononi's chapter regards Warburg's and Wind's research as forming a foundation for a theory of aesthetic response.

Drawing on both archival and published sources, Targia's contribution compares Wind's and Wölfflin's perspectives on Raphael's Vatican fresco *The School of Athens*. In his *Die klassische Kunst* (1899),[28] Wölfflin provided a detailed formal description of Raphael's *School of Athens*, separating the concept of form from that of meaning. From a completely different perspective, Wind engaged in a polemic on Wölfflin's interpretation, and discussed questions of perception and formal analysis.

Viola analyses Wind's perspective on the genesis of symbolic faculties, which he derived from Ewald Hering's understanding of memory. Viola also discusses Cassirer's rejection of Hering's argument that memory is made possible by habit acquisition and the repetition of stimulus–reaction cycles. Cassirer argued that memory is not the mere product of habit acquisition, but rather is the result of a synthesis of time as a transcendental form. Moreover, Viola argues that the disagreement between Hering and Cassirer, and therefore that between Cassirer and Wind, may shed some light on the ultimate foundation of a philosophy of culture, which can be either transcendental or naturalistic.

Part II examines Wind's approach to the study of images. It includes the chapters of Franz Engel, Bernhard Buschendorf, Bernardino Branca, C. Oliver O'Donnell and Ianick Takaes de Oliveira. Engel's chapter reconstructs Wind's perspective on Albrecht Dürer's *Melencolia I* by referring to unpublished material in the Edgar Wind Archive and contextualizing Wind's contribution to the iconography and iconology of chaos. Engel's primary sources are correspondence between Wind, Fritz Saxl, Panofsky and Raymond Klibansky. In this way, Engel is able to reconstruct parts of Wind's argument, which Panofsky's summary explains as the idea of 'chaos reduced to cosmos'.

Buschendorf discusses the close intellectual connection between Warburg and Wind, and analyses Wind's contribution to the conceptual basis of Warburg's approach to cultural studies. Buschendorf argues that Wind applied to Warburg's theory a series of major methodological maxims taken from the pragmatist philosophy of Charles Peirce. To explicate this,

28 Heinrich Wölfflin, *Die klassische Kunst: Eine Einführung in die italienische Renaissance* (Munich: Bruckmann, 1899).

Buschendorf compares Warburg's essay 'Francesco Sassetti's Last Injunctions to His Sons' (1907) with Wind's article 'Albrecht von Brandenburg as St. Erasmus' (1937). According to Buschendorf, the two studies employ the same methodology and share a thematic focus on the 'afterlife of antiquity'. To further highlight the similarity of their implicit methodologies, Buschendorf also draws on Wind's early theoretical articles.

Branca analyses the role of the concepts of embodiment and symbolic function in Wind's lifelong studies of Michelangelo's painting of the Sistine Chapel ceiling. According to Branca, these notions are essential for understanding the connections that Wind drew between the spiritual world of the age of Pope Julius II and the imagery on the chapel ceiling. For this purpose, Branca assesses Wind's study of the prophets and sibyls on the ceiling. By marshalling evidence from Wind's several published papers and unpublished drafts on Michelangelo, Branca explains Wind's interpretation of the ceiling's imagery as the embodiment of the 'mystical' metaphysics of the time. In Branca's reading, Wind's study of the prophets and sibyls displays the full range of Wind's incorporation and modulation of Warburg's ideas on the 'afterlife of antiquity'.

O'Donnell's historical study of Wind's growing familiarity with Hume's philosophy during his serial visits to England in 1930 and 1931 serves as a foundation for an analysis of Wind's study of Enlightenment-era thinking. O'Donnell focuses on Wind's article 'Humanitätsidee und heroisiertes Porträt in der englischen Kultur des 18. Jahrhunderts', in which Wind uses Hume's works to consider, both philosophically and historically, the production of portraits by Joshua Reynolds and Thomas Gainsborough.

Wind was notable (but not unique) among European scholars of Renaissance art for his deep interest in modern and contemporary art. In this context, Ianick Takaes de Oliveira analyses Wind's critique of modern art in connection with the notion of humour. Takaes de Oliveira challenges the common view that Wind possessed an irascible and difficult personality, by highlighting his sense of humour. In fact, Wind considered comicality an important aspect of both artistic and scholarly production. In his writings on modern art, Wind regarded twentieth-century artistic production as humourless. Focusing on *Art and Anarchy* (1963), Takaes de Oliveira shows how this aspect of Wind's persona is reflected in his works.

Part III of the book deals with Wind's years as émigré scholar and public intellectual. It comprises the contributions of Oswyn Murray, Elizabeth Sears, Ben Thomas and Jaynie Anderson. The point of departure for Murray's chapter is Wind's life in Nazi Germany. Murray reconstructs Wind's and Raymond Klibansky's efforts in 1933 to save the KBW in Hamburg from the Nazis, and their attempt to relocate it to London and rename it the Warburg Institute. Sears reconstructs Wind's developing interest in the 'encyclopaedic imagination', covering his early days as a librarian at the KBW in the 1930s, his time teaching at the University of Chicago in 1943, and beyond. In 1943, while briefly at the University of Chicago and embroiled in debates on pedagogy, Wind proposed publishing a monograph series titled 'Encyclopaedic Studies'. Speaking of the 'deadening effect' of departmentalism on the 'encyclopaedic ideal', he advocated for training the mind to reawaken an imagination that can connect a wide range of apparently disparate subjects, such as the histories of art, science, superstition, literature and religion.

Thomas's contribution is a document-based account of Wind's years in Chicago (1942–4). As Thomas argues, Wind's brief time at the University of Chicago ended due to difficulties related to his health and relationships with colleagues. In his discussion Thomas draws on Wind's correspondence with Saxl and other unpublished material from the Edgar Wind Archive.

Finally, Anderson considers the complex reactions to *Art and Anarchy*, ranging from the view that it is a book by a historian of Renaissance art who had made the blunder of thinking he understood modern art, to the interpretation that the book is a sophisticated overview of Wind's philosophy of art.

Reactions, both positive and negative, to Wind before and after 1971 can now be properly historicized, and doing so will raise many thought-provoking points that will be highly relevant to contemporary discussions on art history, aesthetics and artistic practice. This volume seeks to clarify and enrich the study of Wind's distinctive approach as a scholar and writer, while also examining his legacy as a major intellectual figure of his time. As one of the leading refugee scholars who taught in Europe and the United States, Wind was known internationally at the time of his death. Wind was a refugee in several senses. He was born in 1900 as a stateless person in Berlin to an Argentinian father of Russian

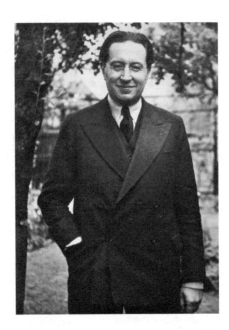

Figure 0.4. Edgar Wind, c. 1937–9. Photograph by Adelheid Heimann. Courtesy of
the Warburg Institute, London.

origin. According to German law, Wind had to take his father's nationality,
whereas Argentinian law recognized only the nationality of his birthplace.
Wind could not resolve the problem of his nationality until he was 30 years
old, during the Nazi period. Then, in 1933, Wind lost his university position
due to the Nazi regime, and became a displaced person when he moved the
KBW to London (Figure 0.4).[29]

Wind was a brilliant thinker in several fields, original in many aspects
of his published work, and a captivating lecturer for all kinds of audiences
(evident for instance in his Reith Lectures of 1960).[30] The debates explored

29 For an analysis of Wind's reflections on his loss of freedom when he left Germany,
 see Ben Thomas, 'Freedom and Exile: Edgar Wind and the Congress for Cultural
 Freedom', *The Edgar Wind Journal* 1 (2021), 74–94. See also Anderson, 'Edgar
 Wind and Giovanni Bellini's "Feast of the Gods": An Iconographic "Enfant
 Terrible"', *The Edgar Wind Journal* 2 (2022), 9–37.
30 First published as Edgar Wind, *Art and Anarchy: The Reith Lectures, 1960, Revised
 and Enlarged* (London: Faber & Faber, 1963).

in the present volume raise questions that are of significance in the humanities. The close connections that Wind identified between Renaissance art and ancient philosophy, theology and imagery, as well as the broader connections between art and humanism, remain crucial matters of scholarly interest in both art history and the wider field of intellectual history. Moreover, this volume cements Wind's status not just as an art historian but also more broadly as a public intellectual – the latter demonstrated by the BBC's invitation to deliver the Reith lectures in 1960.

This volume is both a summation of previous interest in Wind and a new departure. The departure derives in part from the opportunity to use previously unpublished archival sources; it also comes from the fresh intellectual perspectives of several of the contributors. For example, while many existing studies have focused on Wind's research on the Italian Renaissance and humanist thinking, this volume goes further to include his interests in pedagogy and new interdisciplinary approaches, and his engagement with and lecturing on modern art.

Wind's work takes a unique approach, yet parallels that of other well-known figures, most notably Panofsky and Gombrich, who too were closely connected with – and partly formed by – the famous library and centre of scholarly research established by Aby Warburg. There is another dimension to Wind's scholarly contributions that is discussed in depth in this volume: the intellectual clarity and conceptual acuity he brought to his work by virtue of his background as a philosopher.

PART I

Intellectual Formation

PABLO SCHNEIDER

1 Edgar Wind: A Mind Naturalized in Antiquity

Prelude[1]

Edgar Wind's career as art historian and, in equal measure, philosopher, began with a highly ambitious undertaking. The dissertation he completed in 1922 set out to define the basic parameters of what would henceforth be understood as *Kunstwissenschaft*, or the science of art. Given the tumultuous historical context in which he wrote it, it would be perfectly reasonable to expect something polemical. And yet Wind submitted an inquiry that was sophisticated in its structure and intelligently witty in its argumentation. Like so many of his works, it would remain unpublished for years – and yet it still made its mark. For in his dissertation Wind not only worked through questions that prepared the way for some genuinely profound trains of thought; in the manner of a somnambulist he exposed points of contact that would have an almost explosive effect just a few years later. As Aby Warburg asked, 'Wann kommt Wind?' [When is Wind coming?].[2]

 Wind did not regard works of art – and in this respect his thinking was very close to Warburg's – as representations, much less illustrations, of

1 This chapter was translated from the German by Jonathan Blower.
2 Aby Warburg, entry in the diary ('Tagebuch') of the Kunstwissenschaftliche Bibliothek Warburg, 20 January 1928, as reproduced in Aby Warburg, Gertrud Bing and Fritz Saxl, *Tagebuch der Kulturwissenschaftlichen Bibliothek Warburg*, ed. Karen Michels and Charlotte Schoell-Glass, Aby Warburg, Gesammelte Schriften, vol. VII (Berlin: Akademie, 2001) [hereafter *Tagebuch*], 184.

ideas or concepts. Images and their representations for him were objects capable of polarizing action. This observation established the connection to Warburg but at the same time set Wind up in opposition to art-historical scholarship, not just in the 1920s but also in the iconographical phase after the Second World War. Wind's thinking did not sit well with a world view primarily concerned with systems, a world view that is currently starting to impinge on future-oriented political interpretations once again. This contemporaneity on the part of Wind the art historian is exemplified in his reflections on Giorgione.[3] Here he found visual and philosophical ideas that could not be shoe-horned into a hierarchical structure of before and after; instead they existed in a state of creative tension that would never conform to some harmonized stylistic position.

The dust jacket of Wind's volume on Giorgone features the artist's *Self-Portrait as David* in the 1650 engraving by Wenceslaus Hollar (Figure 1.1). This hybrid figure of David and Giorgione looks out in the direction of the beholder with a melancholic, almost mournful, expression. Self-doubt as symbolic form could hardly be presented in a more apt and fertile manner. For this is not an expression of uncertainty, but an anti-authoritarian turn that conceives the image as a space of dialogue, not a place for putative ultimate truths.

Thus it was virtually impossible to grasp the interdependence of the idea, the image and the beholder in exclusively historical terms; that always had some effect on the present temporal context. The science of the image was also the science of an anthropological way of seeing and, for Wind, was inseparable from a humanistic understanding of the world. The conception of the image implicit in this approach found itself on a scientific path all of its own. For Wind did not adhere to the sort of iconographical interpretations that became increasingly popular after the Second World War. He was never particularly convinced by them. Instead he concentrated his thinking on constellations, and on the meeting of motifs in constellations. These allowed for situations that promoted interaction and mutual comment, situations that were always open, never closed. Internal

3 Edgar Wind, *Giorgione's Tempesta: With Comments on Giorgione's Poetic Allegories* (Oxford: Clarendon Press, 1969).

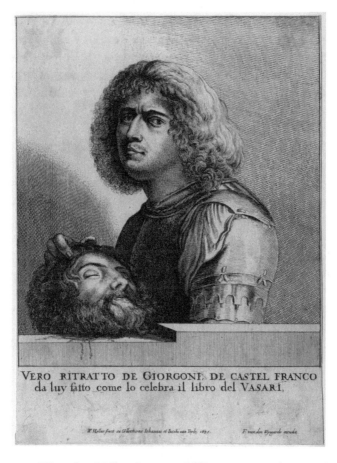

Figure 1.1: Wenceslaus Hollar, *Giorgione: Self-Portrait as David*, 1650, etching, 25.6 × 18.6 cm. British Museum, London.

iconographical structures never came to the fore with Wind and would always remain suspect to him. He focused on forms of a subversive survival that were perfectly capable of detaching themselves from the motif. Exemplary of this is the drawing by Joshua Reynolds in which a female figure stands at the foot of the Cross with her arms thrown up in the air.[4]

4 On the migration of motifs, see Edgar Wind, 'The Mænad Under the Cross: Comments on an Observation by Reynolds', *Journal of the Warburg*

This expression of emotional distress and physical pain can be seen as a visual embodiment of extreme anguish. Indeed, the anguish is so great that it has taken possession of the mourner's body. But this power is also evident in the bodies of classical bacchantes and maenads. It is these oscillating, energy-laden transfers of emotive power that concern Wind. For these gestural attitudes express positive and negative forms of ecstasy whose effects are suprahistorical. And yet contemplating them is no intellectual game. A rigorous methodical apparatus is needed to generate the requisite mental space.[5] The motifs subvert their temporal allegiances and become active again once these have been reactivated by historical and social circumstances. This was how R. B. Kitaj, who studied with Wind at Oxford, created his picture *Warburg as Maenad* in 1961–2. Here the energies that have seized the body are clearly delineated, presented as their direct effect on the personification of Warburg.[6] To identify the source of this sequence with some iconographic line would be to deny the potential of its visual after-effects. Wind elaborated the methodological parameters within which works of art could maintain their autonomy.[7] The goal was to create a mental space that would put deep historical analysis on the agenda, but without being beholden to it.

 Institute 1 (1937), 70–1, and Edgar Wind, 'Dürer's *Männerbad*: A Dionysian Mystery', *Journal of the Warburg Institute* 3 (1939), 269–71.

5 See also Bernardino Branca, *Edgar Wind, filosofo delle immagini: La biografia intellettuale di un discepolo di Aby Warburg* (Milan: Mimesis, 2019).

6 On this, see Martin Roman Deppner, 'Bilder als Kommentare: R. B. Kitaj und Aby Warburg', in Horst Bredekamp, Michael Diers and Charlotte Schoell-Glass, eds, *Aby Warburg: Akten des internationalen Symposions Hamburg 1990* (Weinheim: VCH, 1991), 235–60, and 245–7 for the significance of Wind for Kitaj; Edward Chaney, 'Ein echter Warburgianer: R. B. Kitaj, Edgar Wind, Ernst Gombrich und das Warburg Institute', in Hubertus Gassner, Eckhart Gillen and Cilly Kugelmann, eds, *R. B. Kitaj 1932–2007: Die Retrospektive* (Bielefeld: Kerber, 2012), 97–103.

7 This is evident in Wind's *Art and Anarchy: The Reith Lectures 1960, Revised and Enlarged* (London: Faber & Faber, 1963). See also Ben Thomas, *Edgar Wind and Modern Art: In Defence of Marginal Anarchy* (London: Bloomsbury, 2020).

Wind's dissertation: A statement without images

Edgar Wind began his studies at the Friedrich-Wilhelms-Universität in Berlin, the city of his birth, in early 1918 (Figure 1.2). He enrolled in two subjects: art history and philosophy. Among the lectures and seminars he attended were those of philosopher Ernst Cassirer and those of theologian and cultural philosopher Ernst Troeltsch. The art-history lectures he attended were given by Adolph Goldschmidt. The year 1918 was marked by the gradual collapse of the German armed forces on the various fronts of the First World War, which ground to a halt when the Armistice of Compiègne officially brought an end to hostilities on 11 November. By this point it had been apparent for several months that most soldiers and sailors in the German army and navy were no longer willing to fight. With the Kiel mutiny of 3 November and the subsequent abdication of Kaiser Wilhelm II, it became evident that the political situation in the German Empire was also changing fundamentally. This was articulated on 9 November 1918 when social democratic politician Philipp Scheidemann declared the republic from a balcony of the Reichstag in Berlin.

Wind experienced this period of upheaval first hand. He not only commenced his studies in Berlin but also embarked on his chosen career – against the wishes of his family. It is noteworthy that the dissertation he submitted just a few years later would focus on two aspects that seem to respond to that period: first, he set out to describe methodological foundations that would be capable of producing reliable propositions; and second, he dealt with *Stilgeschichte* [the history of styles] in art historiography and sought to demonstrate its inherent limitations. The end of the authoritarian empire and the beginning of the democratic reorganization of society seem to have been written in the same key, albeit not in perfect harmony with Wind's preoccupations. Yet there are parallels, particularly in the underlying thought patterns.

In the summer semester of 1918 there was no teaching at the university in Berlin on account of the social, political and military situation. But in the winter semester Adolph Goldschmidt offered his lecture course on Netherlandish painting of the fifteenth and sixteenth centuries. Through

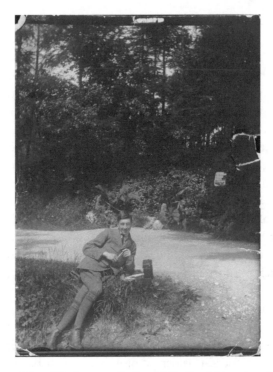

Figure 1.2: Edgar Wind in 1918. Bodleian Libraries, University of Oxford.

this connection Wind was brought to the attention of people who would
later be important for him, since Goldschmidt was a close friend of Aby
Warburg and supervisor of the dissertation that Erwin Panofsky submitted
in 1920. In his research on medieval ivories, Goldschmidt had emphasized
the importance of description as a central part of art-historical work, and
this was extremely important for Wind's dissertation.[8] Goldschmidt was of
the view that 'dasjenige Werk der Kunstgeschichte in erster Reihe stehen

8 For these themes, see Kai Kappel, Claudia Rückert and Stefan Trinks, eds, *Atlanten
 des Wissens: Adolph Goldschmidts Corpuswerke 1914 bis heute* (Berlin: Deutscher
 Kunstverlag, 2016).

[wird], das neben seinem bestimmten Standpunkt doch Kenntnis der übrigen Anschauungsweisen bezeugt und ihre wertvollen Resultate sich zu eigen gemacht hat' [first-rank works of art history are those which, alongside their own specific viewpoints, show an awareness of all other perspectives and incorporate any valuable results they might have produced].[9] This point makes it clear that artworks are not to be interpreted as singular objects, but have their own intrinsic perspectives, be they political, social or aesthetic. These forms of incorporation would later be important for the description of the workings of cultural memory. Similarly, in Goldschmidt we discern the desire to make of art history a scientific discipline, a discipline that would no longer be content with results derived from the history of styles. Wind was part of this emerging circle.

Efforts to establish art history as a *Kunstwissenschaft* or science of art with firm methodological foundations attracted a great deal of attention after 1900, particularly in the German-speaking countries. Essentially this was about the effects of visual perception and what visual perception could effect in relation to works of art. Hans Kahn, for example, identified the two sides of the debate in his review of Ernst Heidrich's essays on the history and methods of the science of art, published at Basel in 1917. Having pointed out the importance of the philosophy of Georg Wilhelm Friedrich Hegel for art history, Kahn went on to explain that 'Anschauungen werden zu Begriffen stabilisiert. Doch die gedankliche Konstruktion überwiegt die sinnliche Anschauung, das Gefühl, vor einem interessanten Problem zu stehen, läßt nicht die volle Stärke des künstlerischen Eindrucks aufkommen' [visual perceptions stabilize into concepts, but the conceptual construction outweighs sensory perception; the sense that one is standing before an interesting problem detracts from the full force of the artistic impression].[10] The unease felt by so many of Kahn's contemporaries is clearly delineated

9　Adolph Goldschmidt, 'Kunstgeschichte', in Gustav Abb, ed., *Aus fünfzig Jahren deutscher Wissenschaft: Die Entwicklung ihrer Fachgebiete* (Berlin: De Gruyter, 1930), 192–205, esp. 197; Kathryn Brush, *The Shaping of Art History: Wilhelm Vöge, Adolph Goldschmidt and the Study of Medieval Art* (Cambridge: Cambridge University Press, 1996).

10　Hans Kahn, 'Rezension von Ernst Heidrich, *Beiträge zur Geschichte und Methode der Kunstwissenschaft*', *Monatshefte für Kunstwissenschaft* 11 (1918), 107–8.

here. The manifest intention is a mental process with a sound conceptual basis, yet this process ought not to obscure the artistic impression or visual experience, however that might be defined. This means that analysis is ultimately presented as a kind of antagonist or counterpart to visual perception. This polarization is even more pronounced in Max J. Friedländer: 'Man nimmt eine Uhr auseinander, um den Mechanismus kennenzulernen. Die Uhr geht dann aber nicht mehr. Die Analyse ist lebensgefährlich wie für die Uhr so für die Seele des Kunstwerks.' [One takes a watch apart in order to study the mechanism. The watch no longer works. Analysis is fatal for the watch and for the soul of the artwork.][11] But what does analysis mean in this context, and why is it regarded as a threat? At first glance, art-historical connoisseurship and stylistic categorization are simple approaches based on a corpus of objects which they record and place in order. The problem lies in the organization. Histories of style are ultimately based on expert knowledge that is virtually incomprehensible to the layperson. The value of scientific analysis lies in the transparency of its methods and the presentation of its results. From this crucial point Wind proceeded to develop the approach that he would contribute to his field with his dissertation.[12]

The context of contemplation and conceptual concentration was another central problem for Wind. Its importance is evident in his elaborate scientific substantiation, firstly of what the process of visual perception was capable of effecting and secondly of the conclusions that could be reached through it. This is also reflected in the title of the dissertation: *Ästhetischer und kunstwissenschaftlicher Gegenstand* [The object of aesthetics and the science of art], while the subtitle stated the aim: 'Ein Beitrag zur Methodologie der Kunstgeschichte' [A contribution to the methodology of art history].[13]

11 Max J. Friedländer, *Der Kunstkenner* (Berlin: Cassirer, 1919), 23. Friedländer, *On Art and Connoisseurship*, trans. Tancred Borenius (4th edn, Oxford: Cassirer, 1946), translates a far longer manuscript.

12 For the tendency to establish methodological foundations for art-historical research, see Charlotte Klonk and Michael Hatt, *Art History: A Critical Introduction to Its Methods* (Manchester: Manchester University Press, 2006), 65–94.

13 Edgar Wind, *Ästhetischer und kunstwissenschaftlicher Gegenstand: Ein Beitrag zur Methodologie der Kunstgeschichte*, ed. Pablo Schneider (Hamburg: Philo Fine Arts, 2011).

Wind's analysis homes in on the efficacy of conceptualizations in order to elaborate on significant aspects of the formation of style and the finding of forms. Seeing and description are supposed to release the artistic object from a reception oriented exclusively towards aesthetic factors. Wind regards this aestheticizing constellation of seeing, which is very close in substance to Aby Warburg's position, as unfreedom on the part of the beholder. But he doesn't reject the history of styles entirely. Instead, significant details, such as the multivalence of visual reception, were to be set on scientific foundations. Wind starts by elaborating and conceptualizing his problem in opposing terms: artwork versus aesthetic enjoyment, and artistic understanding versus *Kunstwissenschaft*. Within this constellation he saw a fundamental problematic that would be important for later analyses and would open up a path to Warburg's thinking. He was critical of the fact that art scholarship seemed to draw no clear distinction between aesthetic and theoretical analysis. A concrete science of art had no place for the vague similarities of the history of styles. Sound judgement could be based only on quantifiable numbers of artistic objects. At this point the method of iconography propounded by Wind's doctoral supervisor Erwin Panofsky makes an appearance, revealing the innovative orientation of his dissertation. Grouping together large numbers of works according to specific characteristics is a necessary and desirable step, because it places them in a logical context from which insights can be derived. Thus Wind's dissertation identified the object as the starting point for all subsequent reflection. The concrete science of art was to be understood as a description of the framework within which it deals with a defined quantity and prepares it for analysis by conceptual formulation of the material and its visual phenomena. As presented in Wind's dissertation, this conceptual framework is fundamental, because it combines two areas, the immediately visible and the temporal-historical, and reveals the insights that these have to offer. The relationship of objects to inference is not just described in the course of the work but actually grasped through this reciprocal relationship of the visible and the historical. The sequence is important from the methodological point of view, because the scope of art scholarship and thus the object of art-historical analysis is defined as the plenitude of visible phenomena. This not only encompasses a vast number of artefacts, but may also

produce insights of a more general nature. Interleaved with this problem
is the question of whether artworks can be regarded as embodiments of
regularities, a question that would take on greater significance when Wind
came to deal with Warburg's cultural-scientific concept of the symbol.[14]

If the dissertation that Wind submitted in 1922 was driven by a critique
of the history of styles, it nowhere slips into a general repudiation. Its aim –
and herein lies its value – is to establish the foundations of art-historical
knowledge. Wind doesn't exclude the history of styles from this under-
taking, though he does impose limits on the validity of its results. Wind
expresses this with absolute clarity when he says: 'Auf wissenschaftlichem
Wege muß sich dasselbe Urteil noch einmal gewinnen lassen, das vorher
auf ästhetischem Wege gewonnen wurde.' [That same judgement which
has previously been arrived at aesthetically must now be obtainable again,
this time scientifically.][15] Hence the visual experience is the initial trigger,
as the word *vorher* [previously] here suggests. Even at this stage, beholders
are already able to arrive at judgements or insights that occur immediately
in the act of visual perception. But such occurrences have to concur with
rational scientific knowledge in order to stand as valid art-historical con-
clusions. This train of thought establishes a compelling connection be-
tween the act of seeing and the analysis of the seen, ultimately leading to
a hermeneutics of contemplation. The impact of the image or the various
visual phenomena is left undiminished. This energy, which is based on
the act of visual perception, is fundamental for Wind, and links his ob-
servations to Warburg's thinking.[16] In this respect his *Ästhetischer und
kunstwissenschaftlicher Gegenstand: Ein Beitrag zur Methodologie der
Kunstgeschichte* remains relevant because the artworks, rather than being
proofs of some scientific argument, are the independent objects that stood

14 For the concept of embodiment in Wind's work, see the foundational contribu-
 tion of John M. Krois, 'Kunst und Wissenschaft in Edgar Winds Philosophie der
 Verkörperung', in Horst Bredekamp, Bernhard Buschendorf, Freia Hartung and
 John Krois, eds, *Edgar Wind: Kunsthistoriker und Philosoph* (Berlin: Akademie,
 1998), 181–205.
15 Wind, *Ästhetischer und kunstwissenschaftlicher Gegenstand*, 152.
16 For these themes, see Horst Bredekamp, *Image Acts: A Systematic Approach to
 Visual Agency* (Berlin: De Gruyter, 2018).

at the very beginning of the investigation. In this respect Wind was elaborating on the positions that started the discussion.

Attempts to theorize *Kunstwissenschaft* after 1900 were marked by endeavours to distinguish the science of art both from the history of styles and from art-historical connoisseurship. Panofsky's articles for the *Zeitschrift für Ästhetik und Allgemeine Kunstwissenschaft* were innovative approaches that would also be fundamental for Wind's dissertation and would underpin the relevance of his reflections.[17] Wind's own approach evidenced a theoretical understanding that was shaped by an engagement with the image.[18] Here he had weighed the process of direct visual perception against that of historical contextualization, though without regarding either as secondary. The result of this engagement was a methodological constellation that recognized seeing and the artistic objects as independent analytical tools, specifically without allocating them minor subordinate roles in the formation of judgements. This idea is reinforced by the fact that the scientific analysis of art can dramatically increase the returns of contemplation.[19]

It is a methodical approach that has produced a lasting enrichment of seeing, an aspect decidedly opposed to those who regarded scientific analysis of the artwork as an inherently inferior way of seeing. But it is precisely these various levels of information that reveal to the beholder the many

17 The articles by Panofsky were 'Das Problem des Stils in der bildenden Kunst' (1915) and 'Der Begriff des Kunstwollens' (1920). He subsequently published an article 'Über das Verhältnis der Kunstgeschichte zur Kunsttheorie: Ein Beitrag zu der Erörterung über die Möglichkeit kunstwissenschaftlicher Grundbegriffe' (1925), which explicitly cited Wind's dissertation. On these articles, see Karlheinz Lüdeking, 'Panofskys Umweg zur Ikonographie', *Zeitschrift für Ästhetik und allgemeine Kunstwissenschaft*, Special Issue 8 (2007), 201–24.

18 See also Bernadette Collenberg-Plotnikov, 'Forschung als Verkörperung: Zur Parallelisierung von Kunst und Wissenschaft bei Edgar Wind', in Judith Siegmund, ed., *Wie verändert sich Kunst, wenn man sie als Forschung versteht?* (Bielefeld: Transcript, 2016), 65–86, esp. 67–71.

19 For these themes, see Martina Sauer, 'Ästhetik versus Kunstgeschichte? Ernst Cassirer als Vermittler in einer bis heute offenen Kontroverse zur Relevanz der Kunst für das Leben', in Thiemo Breyer and Stefan Niklas, eds, *Ernst Cassirer in systematischen Beziehungen: Zur kritisch-kommunikativen Bedeutung seiner Kulturphilosophie* (Berlin: De Gruyter, 2018), 239–60.

facets of the object. Wind would return to these observations time and again. In the published version of the Reith Lectures of 1960 he revisited them under the heading 'Fear of Knowledge': 'There is one – and only one – test for the artistic relevance of an interpretation: it must heighten our perception of the object and thereby increase our aesthetic delight.'[20]

Wind's attempt in his dissertation to establish methodological foundations for the science of art were continued in conversations with Warburg, particularly in the late 1920s, that considered and confirmed the autonomy of the work of art. This was a position that Wind had developed very early on.[21] The elaboration of an art-historical method also implied total transparency as to the scientific methods employed. The political implications of this observation can also be seen in his appraisal of one specialist publication. Wind described the *Kritische Berichte zur kunstgeschichtlichen Literatur* in the following terms:

> Criticism is as necessary to-day as ever; a strictly scientific attitude is *more* necessary than ever before. This calls for unity of action, co-operation between all those who have the will and capacity for accurate art historical work. More important than the triumph of a certain art historical school is to-day the defence of the scientific position as such. [...] Free from compromise and completely independent, the *Kritische Berichte* aims at serving scientific study. It will discuss fairly any scientific opinion, and will attack only unscientific opinions. Those who realize the value of free research will approve the policy and work of the *Berichte*.[22]

From this description of a specialist journal it is clear that Wind's goal of establishing scientific foundations for art-historical scholarship should

20 Wind, *Art and Anarchy*, 66.
21 On this, see Bernadette Collenberg-Plotnikov, ' "Das Auge liest anders, wenn der Gedanke es lenkt": Zur Bestimmung des Verhältnisses von Sehen und Wissen bei Edgar Wind', in Nikolaj Plotnikov, ed., *Kunst als Sprache – Sprache der Kunst: Russische Ästhetik und Kunsttheorie der 1920er Jahre in der europäischen Diskussion* (Hamburg: Meiner, 2014), 92–110.
22 Edgar Wind, notes on *Kritische Berichte zur kunstgeschichtlichen Literatur*, Bodleian Libraries, University of Oxford, Edgar Wind Papers (hereafter Bodleian, EWP), box 273. When I consulted the Edgar Wind Papers, latest in the year 2013, they had not yet been arranged and listed according to the current system. For this reason my citations do not reflect the latest finding aid to the collection.

by no means be understood as a concern that could be confined to the margins of the discipline, for his approach describes a mindset essentially based on transparency. In this much it draws its impetus from the European Enlightenment and is just as profoundly democratic.

Wind does not reduce the image to its significance as a single artefact in a chain of evidence, be it stylistic or iconographic. Rather, the image is the object that triggers analysis and guides reflection. This, says Wind, in a crucial part of his dissertation,

> ist darin begründet, dass der Kunstwissenschaftler seinem Objekt nicht so 'frei' gegenübersteht wie etwa der Naturwissenschaftler oder auch der naturgenießende Mensch einem Naturgegenstand: das Kunstwerk stellt seinem Wesen nach den *autonomen Anspruch*, in einem ganz bestimmten Sinne betrachtet zu werden (die ästhetische Synthesis ist ihm gegenüber als eine 'gebundene' oder 'rekonstitutive'), sodass die Aufgabe der Kunstwissenschaft darin besteht, diesen seinen Anspruch auf theoretischem Wege zu erfüllen, d. h. die *Individualität* und den aus der Verwirklichung einer bestimmten Gesetzlichkeit entspringenden *Wert* der verschiedenen Kunsterscheinungen begrifflich aufzuweisen.[23]

> [is because the scientist of art is not so 'free' in relation to his object as is, for instance, the natural scientist or even the nature lover in relation to their natural objects: the artwork by its very nature makes an *autonomous claim* to be regarded in a very specific sense (relative to this the aesthetic synthesis is 'casebound' or 'reconstitutive'), so that the task of the science of art consists in answering this claim theoretically, i.e. by conceptually demonstrating the *individuality* of the various artistic phenomena and their *value* as manifestations of specific laws.]

Here Wind introduces ideas that not only defined the topic of his dissertation but would also prove fundamental to his later art-historical and philosophical analyses. Similarly, these lines of inquiry enriched his discussions with Warburg on the meaning of the symbol and its potential for the operation of memory. Wind emphasizes the theoretical nature of his work from the early 1920s, in that his dissertation deals with works of art not as concrete objects but as abstract proxies. His reflections thematize Rembrandt in a general sense, for instance. Visual particulars are characterized more closely only where they might lead to the identification

23 Wind, *Ästhetischer und kunstwissenschaftlicher Gegenstand*, 188.

of artworks. The steps of abstraction that Wind integrates into the art-historical analysis are important here. They link imagery to a symbolic interpretive approach, particularly in the dissertation. Crucially, the symbolic is not understood as a sign that merely translates or transfers content to a different system of signs. The specific energies of the image cannot be negated. As a consequence, 'der Kunstwissenschaftler steht seinem Objekt nicht so "frei" gegenüber' [the scientist of art is not so 'free' in relation to his object]. Wind's final lecture at the University of Hamburg was entitled 'Grundbegriffe der Geschichte der Kulturphilosophie' [Basic Concepts in the History of the Philosophy of Culture]. His notes from November 1932 to February 1933 contain reflections on the potentiality of symbols.[24] With a characteristic reference to star signs, Wind writes:

> Hier das Problem: diese Symbolik (Sternbilder z. B.) hat Mehrdeutigkeit, Vibration. In der Methode der Distanz entwickelt sich das, was man in der Wissenschaft Isolierung nennt. Dadurch Symbolcharakter zerstört: es wird nur mit Zeichen gerechnet. Naturwissenschaft hat also ihr Wesentliches darin, dass sie Gegenstände sondert, Affektbetonung der Symbole auflöst und mit Zeichen rechnet.[25]

> [Here's the problem: this symbolism (e.g. star signs) has ambiguity, vibration. The method of distance produces what scientists call isolation. This destroys symbolic character; it reckons only with signs. So the essence of the natural sciences lies in isolating things, depriving symbols of their emotional emphasis and reckoning with signs.]

Of central importance here are the terms *vibration* and *distance*, which are bound up with the understanding of symbols. These terms bring out the aspect of energy and the notion of actively seeking distance. The vibrations bridge the gap between work and beholder and make self-determination difficult for the beholder. Thus distance is an

24 Edgar Wind, notes for the lecture 'Grundbegriffe der Geschichte der Kulturphilosophie', November 1932 – February 1933, Bodleian, EWP, box I, 2.

25 Edgar Wind, cited in Bernhard Buschendorf, 'Zur Begründung der Kulturwissenschaft: Der Symbolbegriff bei Friedrich Theodor Fischer, Aby Warburg und Edgar Wind', in Horst Bredekamp, Bernhard Buschendorf, Freia Hartung and John Krois, eds, *Edgar Wind: Kunsthistoriker und Philosoph* (Berlin: Akademie, 1998), 227–48, esp. 241.

essential means of creating space for scientific analysis. These ideas are already present in Wind's central moment of unfreedom and are allied to Warburg's *Denkraum der Besonnenheit* [mental space for self-reflection]. It is this observation in particular, namely that the beholder is not *free* in relation to the work of art, that opens up further lines of inquiry. Objects make claims that are more than just historical, and prevent what the dissertation calls 'natural enjoyment', whereas concepts are the indispensable tools that allow the beholder to achieve a certain degree of receptive freedom in relation to the effects of the work. This methodological motif is very close to Warburg's thinking and recurs in Wind's later thoughts on interactions with symbols and the polarities that drive them.[26] This tendency is evident where Wind analyses Michelangelo's cycle of frescos for the Sistine Chapel, which he interprets as the implementation of a structure based on reciprocities.[27]

In his dissertation at the beginning of the 1920s, Wind set out to provide a solid methodological basis for judgements in art-historical scholarship. In doing so it was important to be clear about the applicability of the inferences drawn. His criticisms of insights derived from the history of styles, for instance, were only superficial. He was far more concerned with defining what a scientific result might mean in the field of art-historical research. As with any scientific experiment, results had to be reproducible and notionally repeatable.[28] Remarkably, Wind attached no significance to any knowledge associated with the authoritative aspects of connoisseurship. It is noteworthy that this line of thought already reflects an implicit and fundamental rejection of radical political

26 Bernhard Buschendorf, 'Enthusiasmus und Erinnerung in der Kunsttheorie Edgar Winds', in Aleida Assmann and Dietrich Harth, eds, *Mnemosyne: Formen und Funktionen der kulturellen Erinnerung* (Frankfurt: Suhrkamp, 1991), 319–34.

27 Edgar Wind, *Die Bildsprache Michelangelos*, ed. Pablo Schneider (Berlin: De Gruyter, 2017).

28 For the context of these reflections, see Franz Engel, ' "In einem sehr geläuterten Sinne sind Sie doch eigentlich ein Empirist!" Ernst Cassirer und Edgar Wind im Streit um die Verkörperung von Symbolen', in Ulrike Feist and Markus Rath, eds, *Et in imagine ego: Facetten von Bildakt und Verkörperung* (Berlin: Akademie, 2012), 369–92.

tendencies, fatal tendencies that Wind experienced first hand and which had lasting consequences for his career.[29] In this respect his method, which was based squarely on the principle of transparency, can be regarded as profoundly democratic.

In his dissertation and the associated articles, Wind sought to transform the history of art into a science of art. He not only demarcated the scope of artistic judgement, but also showed that the process of determining that scope had to be understood as part of the method. This crystalline definition of the object included important aspects of Wind's conception of the symbol. The symbol was understood as more than just a visual artefact. For Wind it was important that the image retained a degree of independence and resistance, and he characterized this in terms of vibration, for instance. The fact that this could be countered only by intellectual distancing underscores the significance of the symbol. With these reflections Wind found himself in the immediate proximity of Aby Warburg, with whom he collaborated intensively from 1927. Fritz Saxl summarized the emergence of this collaboration and its salient points when he reported to Lord Lee of Fareham in 1933:

> Dr. Wind is much younger, but none the less manysided. He began with an essay on the method of art history [...]. With him it is the interest in symbolic representation and expression by symbols, which made him appreciate Warburg's historical method and made him stay with the Library.[30]

The elements that brought Wind and Warburg together are evident once again here: methodology, the concept of the symbol, and the expressive values of the visual – the vibrations.

29 Wind's application for reparations was approved on 19 March 1959. The reparations were based on the assumption that he would have been a full professor at Hamburg University by April 1938. On this see the file on Wind in the Staatsarchiv Hamburg, 361–6 IV 1191.

30 Fritz Saxl to Lord Lee of Fareham, 1933, Bodleian, EWP, box I, 3.

Vibrations – mental spaces – Mnemosyne

The collaboration between Wind and Warburg intensified in the years 1928 and 1929. This was accompanied by some degree of turbulence, for the same period saw the emergence of a constellation that also included Fritz Saxl, Gertrud Bing, Ernst Cassirer and Erwin Panofsky. Warburg regarded this constellation as his inner circle.[31] On 28 December 1928 he wrote to Wind from Rome:

> Ich will das Jahr 1928 nicht in den Aktenschrank der Ewigkeit gelegt wissen, ohne Ihnen und ihrer lieben Frau zu sagen, dass ich Ihren Eintritt in den engeren Kreis derer, für die die K. B. W. ein wirkliches Lebenselement bedeutet, zu den wirklich guten Gaben eines Schicksals rechne, das es mit mir ernst meint.[32]

> [I don't want to let 1928 pass into the filing cabinet of eternity without telling you and your dear wife that I regard your admission to the inner circle of those who see the KBW as a really vital force as a really good gift and a sign that fortune is favouring me.]

Wind and his first wife, Ruth Hatch Wind, were counted as part of the inner circle of the Kulturwissenschaftliche Bibliothek Warburg. A shared interest in material such as the work of poet and philosopher Giordano Bruno and in explicitly methodological questions tended to promote a common mindset.[33] On 11 October 1929 Warburg added the following

31 Lucas Burkart, '"Die Träumereien einiger kunstliebender Klosterbrüder ..." Zur Situation der Kulturwissenschaftlichen Bibliothek Warburg zwischen 1929 und 1933', *Zeitschrift für Kunstgeschichte* 1 (2000), 89–119.

32 Correspondence between Warburg and Wind, Bodleian, EWP I, 3, copy from the Warburg Institute, London.

33 Aby Warburg (in Rome) to Edgar Wind, 3 December 1928, Warburg Institute Archive, London (hereafter WIA), GC/22069, Bodleian, EWP I, 3. 'Ist Ihnen eigentlich Giordano Bruno etwas [...] Ich würde Sie bitten, seine Werke in deutscher Uebersetzung von Kuhlenbeck noch ein zweites Mal für die B.W. anzuschaffen, und den spaccio della bestia trionfante zu lesen. Zunächst ein dorniges Unternehmen, über das Sie aber als Schwerarbeiter hinwegkommen werden, wobei ich auch auf die Hilfe Ihrer verehrten Frau rechne, es lohnt sich. Ich denke in einiger Zeit der K.B.W., (d. h. den "Köpfen" der B.W.) ein kurzes Exposé nach dieser Richtung zu übersenden.' [Is Giordano Bruno anything to you [...] I would ask you to acquire

remark to the diary of the KBW: 'Edgar Wind die "Grundlegenden Bruchstücke" gegeben, die er liest; es eröffnen sich ungeahnte Perspektiven der Gemeinsamkeit der "Methode" zwischen meinem Gestammel vor 40–30 Jahren und der heutigen Erkenntnistheorie.' [Gave Edgar Wind my 'Fundamental Fragments', which he is reading; unexpected vistas reveal commonalities of 'method' between contemporary epistemology and my stuttering work from forty to thirty years ago.] After a few reports on the day-to-day business of the KBW, Warburg returned to the theme again that same day. He underscored the particular significance of having handed over his 'Grundlegende Bruchstücke', and records this as a noteworthy occurrence: 'Gab Winds die *Grundlegenden Bruchstücke* mit einer Karte der K.B.W.: "Denkraumschöpfung als Kulturfunktion. Versuch einer Psychologie der menschlichen Orientierung auf universell bildgeschichtlicher Grundlage".' [Gave the Winds my 'Fundamental Fragments' with a card from the KBW: 'Creation of mental space as a function of culture: Attempt at a psychology of human orientation on the basis of a universal history of the image.']³⁴

The material given – and perhaps the gesture of giving it – seem to have had the desired effect. The diary entry for the following day, 12 October, notes that Wind had been reading Warburg's fragments until four in the morning.³⁵ Wind had mentioned some interesting observations from the field of animal psychology, which in turn led Warburg to end the entry on this striking remark: 'In der Entfernung zwischen greifender Hand, Auge und Mund – der Denkraum in statu nascendi' [In the distance between grasping hand, eye and mouth – mental space *in statu nascendi*].³⁶ It is these

his works in the German translation by Kuhlenbeck for the KBW again, and to read the spaccio della bestia trionfante. A tricky undertaking at first, but as a hard labourer I'm sure you'll cope, and I'm also counting on help from your dear wife. It'll be worth the effort. I'm thinking of sending the KBW (i.e. the "heads" of the KBW) a short exposé along these lines.] Besides mentioning Giordano Bruno, this passage again shows how important it was to Warburg to make Wind part of the inner circle of the KBW.

34 Aby Warburg, 11 October 1929, *Tagebuch*, 547.
35 Aby Warburg, 12 October 1929, *Tagebuch*, 548.
36 Warburg, 12 October 1929, *Tagebuch*.

fundamental parameters – hand to grasp, eye to apprehend, mouth to in-
corporate – that create the moment with the greatest charge of energy – the
nascent state – where mental space emerges.[37]

Denkraum [mental space] appears even earlier in Warburg's work,
albeit as part of a differently stacked problematic. And yet the following
detail demonstrates the extent to which Wind had entered into Warburg's
mind and cosmos and was now thinking with him. On 13 March 1929 he
wrote to Warburg, on KBW stationery:

> Meine Frau bittet mich, Sie und Fräulein Dr. Bing vielmals und herzlich zu grüßen.
> Sie arbeitet kräftig an der Übersetzung des 'Luther' und hat für viele Stellen, die
> der englischen Sprache zu spotten schienen, ein sehr schönes Äquivalent gefunden.
> 'Denkraum der Besonnenheit' bleibt allerdings noch immer ein durchaus ungelöstes
> Problem.[38]

> [My wife asks me to send many warm greetings to you and Dr Bing. She's working
> hard on her translation of your 'Luther' and has already found some fine equivalents
> for several passages that seemed to confound the English language. 'Denkraum der
> Besonnenheit', though, remains an entirely unsolved problem.]

The meaning of *Denkraum der Besonnenheit*, which, having read the
Grundlegende Bruchstücke, one could describe as a vibrating state of emer-
gence, gives an account of a profound engagement. Warburg's reflections
turned on the aspects of movement and gesture, which also concerned the
active accomplishment of the beholder who manages to distance himself
from the motif. The position of the object in this group of ideas was at once
real and theoretical. Warburg's understanding of artworks and images rested
squarely on the notion of mental space, but its inestimable quality – and
Wind went even further with this idea – lay in its temporality and its ener-
getic charge. This was more than audacious in the context of art scholarship

37 For a broader perspective on this, see also Claudia Wedepohl, 'Pathos – Polarität –
 Distanz – Denkraum: Eine archivarische Spurensuche', in Martin Treml, Sabine
 Flach and Pablo Schneider, eds, *Warburgs Denkraum: Formen, Motive, Materialien*
 (Munich: Fink, 2014), 17–49, esp. 47–9.

38 Edgar Wind to Aby Warburg, 13 March 1929, WIA GC/22041. For this collabor-
 ation, see in particular Bernhard Buschendorf, '"War ein tüchtiges gegenseitiges
 Fördern": Edgar Wind und Aby Warburg', *Idea* 4 (1985), 165–209.

in the 1920s, for this *Denkraum der Besonnenheit* essentially identified the temporal bounds and the ultimate fragility of all scientific knowledge.[39] Wind's dissertation provided some important impulses here. After all, his analysis was a tentative attempt at describing the parameters of scientific judgement without defining them hierarchically.[40] The careful consideration of polarity and distance embedded within it would assume greater significance in his later work. In *Pagan Mysteries in the Renaissance* of 1958, for instance, the details of the paintings are not just identified iconographically. Instead Wind describes the ebb and flow of their meaningful content. The temporary result lies in a state that the beholder is able to enter into. Thus Wind cites Joshua Reynolds in the context of his reflections on Titian's landscape paintings; in respect of Nicolas Poussin's arcadian landscapes, Reynolds in turn had spoken of *a mind naturalized in antiquity*. It is an attitude that is *naturalized* in the images, not just depicted there. Warburg sought to approximate this notion via visual argument on panel 55 of the third documented version of the *Bilderatlas Mnemosyne* (Figure 1.3), where he traced the survival of antiquity up to Eduard Manet's *Déjeuner sur l'herbe*. But the notion of the naturalized mind also finds striking form in his treatment of Rembrandt's *Conspiracy of Claudius Civilis*. Here, the conspiratorial scene not only appropriates the motif of the Last Supper. What's more important is that it incorporates the very *idea* of the Last Supper (Figure 1.4).[41]

The viewing dynamic of the panels from the Mnemosyne Atlas can be illuminated with reference to a brief but important note from the

39 It is possible that this was one motivation for Warburg contacting Albert Einstein; see Horst Bredekamp and Claudia Wedepohl, *Warburg, Cassirer und Einstein im Gespräch: Kepler als Schlüssel der Moderne* (Berlin: Wagenbach, 2015).

40 For this material, see Ulrich Pfisterer, 'Der "kleine Antennerich" – Kunstpsychologie als Selbsterkundung als Kunstpsychologie', in Ulrich Pfisterer and Hans Christian Hönes, eds, *Aby Warburg: Fragmente zur Ausdruckskunde* (Berlin: De Gruyter, 2015), 321–51. Pfisterer also mentions Wind's attempts to prepare the *Grundlegende Bruchstücke* for publication.

41 Pablo Schneider, 'Die Zivilisation vorantreiben: Bilder, Motivwanderungen und Humanitätsidee im Denken Aby Warburgs', in Pablo Schneider, ed., *Nachhall der Antike: Aby Warburg – Zwei Untersuchungen* (Berlin: Diaphanes, 2012), 103–30.

Figure 1.3: Aby Warburg, *Bilderatlas Mnemosyne*, panel 55, reconstruction.
Roberto Ohrt and Axel Heil, *Aby Warburg: Bilderatlas Mnemosyne – The Original*
(Berlin: Hatje Cantz, 2020), 117.

Figure 1.4: Aby Warburg, *Bilderatlas Mnemosyne*, panel 72, reconstruction.
Roberto Ohrt and Axel Heil, *Aby Warburg: Bilderatlas Mnemosyne – The Original*
(Berlin: Hatje Cantz, 2020), 135.

diary of the KBW. On 9 October 1929 Warburg writes: 'Nachmittag 5–7 trotz leichter Müdigkeit Winds Botticelli im Wunschraum zwischen burgundischer trachtenrealistischer Gegenwart und ovidianischer pantheistischer Totentanz-Romantik gezeigt. Pollajuolo placiert und die Arazzi. War ein sehr tüchtiges gegenseitiges Fördern.'[42] [Afternoon, five to seven, despite slight fatigue showed the Wind's Botticelli in the wish-space between realistic Burgundian period-dress present and pantheistic Ovidian danse macabre romanticism. Placed Pollaiuolo and the Arazzi. A very productive instance of mutual encouragement.]

The themes sketched out here also provide the context for panels 39, 34 and 37. But Warburg's diary entry records yet another detail: for two hours in the late afternoon, Warburg used his panels to present his thoughts on Botticelli, and this was not to be understood as a lecture so much as a visual argument, and a discussion in particular. This much is implicit in the reference to mutual encouragement. Work on the panels took the form of discussions that led to insights. The purpose of these gatherings was not the presentation of fixed results so much as interaction between equals.[43] Even if this approach tended to impede the path to publications, it ultimately corresponded to a conception of created images as active objects. The observation of natural-ized meaning – *a mind naturalized in antiquity* – also highlights the hugely important role of motifs for the functioning of memory.[44]

After Warburg's death in 1929, the inner circle of colleagues at the KBW – Fritz Saxl, Gertrud Bing and Edgar Wind – began an intensive period of engagement with the work of the founder of the library. The aim was to make the ideas of the KBW accessible to a broader circle. In a supple-ment to the *Zeitschrift für Ästhetik und allgemeine Kunstwissenschaft*, Wind published an essay, 'Warburgs Begriff der Kulturwissenschaften und seine

42 Aby Warburg, 9 October 1929, *Tagebuch*, 551.
43 See also Pablo Schneider, 'From Hamburg to London: Edgar Wind, Images and Ideas', in Uwe Fleckner and Peter Mack, eds, *The Afterlife of the Kulturwissenschaftliche Bibliothek Warburg: The Emigration and the Early Years of the Warburg Institute in London* (Berlin: De Gruyter, 2015), 117–30, 228–32.
44 On this see also Buschendorf, 'Enthusiasmus und Erinnerung', 319–34.

Bedeutung für die Ästhetik' ['Warburg's Concept of *Kulturwissenschaft* and its Meaning for Aesthetics'].[45] Here, in his description of Warburg's ideas and in tracing their subsequent development, Wind argued against a conception of art that propagated an ahistorical experience of the work. Harking back once again to the ideas in his dissertation, he asserted the following: 'Wer aber die Funktion des Sehens verstehen will, der darf es nicht aus dem Zusammenhang mit den übrigen Kulturfunktionen völlig herauslösen.' [However, to understand this function […] one should not dissociate it from its connection with the functions of other elements of that culture.][46] This is how the context for the contemplation of works is initially defined. But scholarship for Wind is not confined to a purportedly historical perspective. With the mnemosyne in mind, he argues that this is to be understood

> als Aufforderung an den Forscher, sich darauf zu besinnen, daß er, indem er Werke der Vergangenheit deutet, Erbgutverwalter der in ihnen niedergelegten Erfahrungen ist – zugleich aber als Hinweis auf diese Erfahrungen selbst als einen *Gegenstand* der Forschung, d. h. als Aufforderung, die Funktionsweisen des sozialen Gedächtnisses an Hand des historischen Materials zu untersuchen.[47]

> [as a reminder to the scholar that in interpreting the works of the past he is acting as trustee of a repository of human experience, but at the same time as a reminder that this experience is itself an object of research, that it requires us to use historical material to investigate the way in which 'social memory' functions.]

45 Edgar Wind, 'Warburgs Begriff der Kulturwissenschaften und seine Bedeutung für die Ästhetik', in *Vierter Kongress für Aesthetik und allgemeine Kunstwissenschaft*, supplement to the *Zeitschrift für Ästhetik und Allgemeine Kunstwissenschaft* 25 (1931), 163–79, reprinted in Ekkehard Kaemmerling, ed., *Ikonographie und Ikonologie: Bildende Kunst als Zeichensystem* (Cologne: Du Mont, 1979), 165–84. For the English translation, see Edgar Wind, 'Warburg's Concept of *Kulturwissenschaft* and Its Meaning for Aesthetics', in Edgar Wind, *The Eloquence of Symbols: Studies in Humanist Art*, ed. Jaynie Anderson, with a biographical memoir by Hugh Lloyd-Jones (Oxford: Clarendon Press, 1983), 21–35.

46 Wind, 'Warburgs Begriff', 170 [Wind, 'Warburg's Concept', 25].

47 Wind, 'Warburgs Begriff', 171 [Wind, 'Warburg's Concept', 26]. Tullio Viola, 'Edgar Wind on Symbols and Memory', *Visual History* 6 (2020), 99–118.

Memory – both individual and collective – thus becomes an act that entails a degree of responsibility, the administration of heritage. But since the operations of memory address both individual and collective forms of experience, the echoes of motifs also resonate; for these (or their survivals, which become evident especially in the symbolic forms and their interpretations), tell us that content of some kind has been transported. The conveyors of images are charged with layers of ideas and interpretations that dynamically changed them without them ever losing all of their energy. Wind pursues these ideas once again with a direct reference to Warburg: 'Jede Entdeckung am Gegenstand seiner Forschung war zugleich ein Akt der Selbstbesinnung. Jede Erschütterung, die er an sich selbst erfuhr und durch Besinnung überwand, wurde zum Organ seiner historischen Erkenntnis.' [Each discovery regarding the object of his research was at the same time an act of self-discovery. Correspondingly, each shattering experience, which he overcame through self-reflection, became a means of enriching his historical insight.][48] What Wind is describing here with reference to Warburg is a profound understanding of the survival of memory. The shattering experience is the impact of the artwork and preparation for work in the mental space of self-reflection. Though Wind did no more than describe these psychological factors, he continued to elaborate on their significance in his reflections. Memory is a conveyor of images that transports levels of understanding. So the posture of the maenads is an expression of extreme exertion that can be transformed into the forms of ecstasy and mourning. What's left is the physical energy in the act of recollection. So the latter is not to be interpreted as a hermetically sealed historical phenomenon; it always reaches out to the time of the beholder. And so the motif of the maenads is also to be understood as a symbolic form with which antiquity related to specific social processes and could call them up repeatedly. When the art of the Renaissance made reference to this, there were two interwoven viewpoints. On the one hand it revitalized a motif that was capable of visualizing the physical power of mourning. On the other hand, and this is by far the more significant aspect, the force of the mental state – mourning or ecstasy – was brought to life in visual memory. Here Wind

48 Wind, 'Warburgs Begriff', 171 [Wind, 'Warburg's Concept', 26].

sees a connection to symbolic forms because these can be interpreted as attempts to bring resolution in critical situations: 'Gerade in diesen Krisen aber muß sich die gestaltende Macht der Erinnerung bewähren, die durch Ergreifung und Belebung überkommener Symbole zur Besinnung aufruft oder zur Handlung treibt und so die Umkehr periodisch auslöst.' [(But in crises such as these) Memory must assert its constructive power. Memory which revives and re-interprets traditional symbols calls for reflection or instigates action and thus effects periodic reversions.][49] Memory is a connecting act that grasps and perpetuates the energy of motifs and symbols. Historical, reconstructive contemplation is inevitably bound up with the temporal circumstances of the beholder. Memory as Wind understood it always looks to the past and the future in equal measure.

Conclusion

With his dissertation of 1922, Wind made a major contribution to the methodological development of art-historical research in the German-speaking countries. It was unfortunate – and largely due to historical circumstances – that the text was not published at the time. Still, it became influential in the form of shorter publications.[50] Of central importance for its methodological approach was the recognition that visual perception as a process is directly interwoven with other forms of knowledge acquisition. Information that is meaningful in the context of a depiction

49 Edgar Wind, 'Einleitung', in Bibliothek Warburg, *Kulturwissenschaftliche Bibliographie zum Nachleben der Antike. Erste Band: Die Erscheinungen des Jahres 1931*, ed. Hans Meier, Richard Newald and Edgar Wind (Leipzig: Teubner, 1934), v–xxvi, esp. x. [Edgar Wind, 'Introduction', in Warburg Institute, *A Bibliography on the Survival of the Classics. First Volume: The Publications of 1931*, ed. Hans Meier, Richard Newald and Edgar Wind (London: Cassell, 1934), v–xii, esp. vii, original emphasis].

50 Edgar Wind, 'Zur Systematik der künstlerischen Probleme', *Zeitschrift für Ästhetik und Allgemeine Kunstwissenschaft* 18 (1925), 438–86.

permanently enriches its reception. But it also points to the responsibility of the viewer, who not only has to integrate various levels of meaning but also has to estimate their historical effects. The knowing eye no longer just sees; it now has to find connections between various multifaceted interpretations. Wind's methodological analysis brought him to an interpretation of the image as an active object. With its motival diversity the image is conceived as something with a capacity for action. To encounter the image is to liberate oneself by way of concepts from the unfreedom of passive enjoyment, in order to obtain knowledge and insight – 'The eye focuses differently when it is intellectually guided.'[51] The early ideas that Wind presented in his dissertation not only led to collaboration with Erwin Panofsky. The triad of his dynamic understanding of visual perception, the aspect of layered information, and the path to scientific knowledge also coincided with Aby Warburg's understanding of art and the image. Wind's conception of the symbol was not just inspired by Warburg; he was able to work through it with him. And this succeeded because the two men shared similar interpretations of visual perception and the effects of symbols. Their ideas came together in their interpretations of the workings of memory and survival – ideas that Wind would elaborate in his own later work.

51 Wind, *Art and Anarchy*, 63.

FABIO TONONI

2 Aby Warburg and Edgar Wind on the Biology of Images: Empathy, Collective Memory and the Engram

Introduction

This study explores Edgar Wind's interpretation of Aby Warburg's central ideas about the biology of images, offering a fresh perspective on both scholars in light of recent research on neurophysiology and experimental aesthetics. In the Warburgian historiography, Wind's perspective stands in contrast to that of Ernst Gombrich. Through its focus on the universality of the expression of emotions and movements, the concept of *Einfühlung* [empathy], the phenomenon of collective memory, and the engram, this paper supports Wind's interpretation by updating his and Warburg's views in response to recent scientific achievements. This work substantiates Warburg's and Wind's insights on the biological implications of images for both artist and viewer. In this way, this research positions Warburg's and Wind's works as the foundation for a theory of aesthetic response.

Between the anthropology of memory and the biology of images

In a series of texts, Edgar Wind and Ernst Gombrich investigated, from different points of view, the biological roots of Aby Warburg's

theory of images.[1] Warburg's theory consists of several notions, some created by Warburg himself – such as the concept of *Pathosformel* (the expression of motion and emotion through animated accessories such as garments) – and some borrowed from other scholars – such as the concepts of collective (or social) memory, dynamogram, engram, and *Einfühlung*.

An important step towards Warburg's understanding of the role that biology plays in the creation, transmission and perception of images was his American journey in 1895–6 when he visited the land of the Hopi.[2] This experience allowed him to observe first hand the mechanisms underlying 'the coining and transmission of symbols', as Fritz Saxl stated.[3] During his journey, Warburg focused on the so-called Hopi lightning-snake, that is, the representation of lightning and snakes in

1 For Wind's interpretation of Warburg's research, see Edgar Wind, 'Introduction', in Hans Meier, Richard Newald and Edgar Wind, eds, *A Bibliography on the Survival of the Classics. First Volume: The Publications of 1931* (London: Cassel and the Warburg Institute, 1934), v–xii; Edgar Wind, 'Warburg's Concept of *Kulturwissenschaft* and Its Meaning for Aesthetics', in Edgar Wind, *The Eloquence of Symbols: Studies in Humanist Art*, ed. Jaynie Anderson, with a biographical memoir by Hugh Lloyd-Jones (Oxford: Clarendon Press, 1983), 21–35; and Edgar Wind, 'On a Recent Biography of Warburg', in Wind, *The Eloquence of Symbols*, 106–13. For Gombrich's interpretation of Warburg's intellectual career, see Ernst Gombrich, *Aby Warburg: An Intellectual Biography, with a Memoir of the Library by F. Saxl* (London: Warburg Institute, 1970); and Ernst Gombrich, 'Aby Warburg: His Aims and Methods: An Anniversary Lecture', *Journal of the Warburg Institute* 62 (1999), 268–82. For a first study on the differences between Wind's and Gombrich's interpretations of Warburg's thought, see Fabio Tononi, 'Aby Warburg, Edgar Wind, and the Concept of *Kulturwissenschaft*: Reflections on Imagery, Symbols, and Expression', *The Edgar Wind Journal* 2 (2022), 38–74. For a biological interpretation of Warburg's central ideas, see Vittorio Gallese, 'Aby Warburg and the Dialogue Among Aesthetics, Biology and Physiology', *Ph* 2 (2012), 48–62.

2 For Warburg's American journey, see Carlo Severi, *The Chimera Principle: An Anthropology of Memory and Imagination*, trans. Janet Lloyd (Chicago: HAU Books, 2015), 25–87; Gombrich, *Aby Warburg*, 88–92; and Fritz Saxl, 'Warburg's Visit to New Mexico', in Fritz Saxl, *Lectures*, 2 vols (London: Warburg Institute, University of London, 1957), vol. I, 325–30.

3 Saxl, 'Warburg's Visit to New Mexico', 326.

Figure 2.1: Serpent as lightning (snakes and clouds). Reproduction of an altar floor, kiva ornamentation. In Aby Warburg, 'A Lecture on Serpent Ritual', trans. W. F. Mainland, *The Journal of the Warburg Institute* 2/4 (1939), 277–92 (table 44). Photograph in the public domain.

Hopi culture, which assumes the same morphology in different cultural contexts (Figure 2.1).

Due to his interest in this phenomenon, Warburg asked himself a series of questions: Why are lightning and snakes represented in the same way in Hopi culture? With what intensity does the image of the snake survive once it has taken shape?[4] Regarding the first question, Warburg realized that, for the American Indians, lightning images have the same flickering shape as fleeing snakes. Furthermore, lightning signifies a mortal threat, just as snakes do. In this way, 'a symbol serves to circumscribe a shapeless

4 See Saxl, 'Warburg's Visit to New Mexico', 327.

Figure 2.2: Hopi schoolboy's drawing of a house in a storm with lightning (Howato's drawing), 1896. In Aby Warburg, 'A Lecture on Serpent Ritual', trans. W. F. Mainland, *The Journal of the Warburg Institute* 2/4 (1939), 277–92 (table 44). Photograph in the public domain.

terror'.[5] To answer his second question, Warburg asked an English-speaking teacher to tell his Hopi schoolchildren a story involving a thunderstorm while they drew it. Warburg was amazed to see that two out of fourteen children drew, as their ancestors had, a snake-like shape crossing the sky (Figure 2.2), suggesting either a biological inheritance or direct contact with that image.[6]

Warburg's findings also confirmed anthropologist Franz Boas' idea that there are two different ways of representing space.[7] One depicts reality as it appears to the eye, while the other represents objects according to the

5 Saxl, 'Warburg's Visit to New Mexico', 327.
6 See Saxl, 'Warburg's Visit to New Mexico', 327.
7 See Franz Boas, *Primitive Art* (Oslo: Aschehoug, 1927).

mind. Clearly, the Hopi children employed the second manner of representation. Philosopher Robert Vischer's research on the role of imagination in perception further illuminated Warburg's discovery: imagination is what transforms a stylized snake in the sky into an image of lightning, charging the image with a particular intensity.[8]

With the aim of deepening his understanding of this iconographic motive and its recurrence, Warburg began to study Hopi pottery. Alexander Stephen's catalogue, titled *Hopi Pottery Symbols*, was instrumental in Warburg's research.[9] Warburg identified what he called the 'heraldic skeleton' of the form, which is at the base of the cultural transmission of images, stating: 'It is typical of the drawing on such vessels that a kind of heraldic skeleton of natural forms is represented.'[10] Warburg noticed that the scheme adopted by the Hopi children to represent lightning in the form of a snake matched the practices of Hopi artists, who produced pottery in which 'a bird is dissected into its essential component parts so that it appears as a heraldic abstraction. It becomes a hieroglyph, not meant simply as a picture to look at but rather as something to be read.' Similarly, according to Warburg, the 'Hopi lightning-snake' represents 'an intermediary stage between image and sign, between realistic representation and script'.[11] It is in this common practice of image-making within the same culture that the role of biology comes into play, suggesting a biological inheritance of images charged with a particular meaning.

Thus, this process of image-making illustrates the mechanism underlying the transmission of symbols in the memory of a society, and the role that biology may play in this process. Warburg investigated this

8 See Robert Vischer, 'On the Optical Sense of Form: A Contribution to Aesthetics' [1873], in Harry Francis Mallgrave and Eleftherios Ikonomou, eds, *Empathy, Form and Space: Problems in German Aesthetics 1873–1893* (Los Angeles: University of Chicago Press, 1994), 89–123.

9 See Alex Patterson, *Hopi Pottery Symbols*, illustr. Alexander M. Stephen, William Henry Holmes and Alex Patterson, based on *The Pottery of Tusayan* (Boulder: Johnson, 1994). See also Severi, *The Chimera Principle*, 35 n. 5.

10 Aby Warburg, 'A Lecture on Serpent Ritual', trans. W. F. Mainland, *The Journal of the Warburg Institute* 2/4 (1939), 277–92 (279).

11 Warburg, 'A Lecture on Serpent Ritual', 279.

phenomenon by developing Robert Vischer's concept of *Einfühlung* and applying a biological approach to the study of images. Warburg wrote: 'I had acquired an honest disgust of aestheticising art history. The formal approach to the image – devoid of understanding of its biological necessity as a product between religion and art – [...] appeared to me to lead merely to barren word-mongering.'[12]

Accordingly, a specific nineteenth-century anthropological tradition known as the biology of images or the biology of ornaments became instrumental in Warburg's research.[13] This tradition was well established at the American Anthropological Society, where Warburg became acquainted with ethnology. From this approach to the study of images, Warburg developed a number of concepts, such as *Nachleben der Antike* (the fortune of certain ancient iconographic themes in subsequent epochs) and *Pathosformeln*. In this way, by applying the psychology of expression to the study of images, Warburg conceptualized a model of the iconographic tradition.

On the universality of the expression of emotions and movements

In the introduction to *A Bibliography on the Survival of the Classics*, Wind stated that Warburg regarded the 'survival in the rudimentary forms of magic and lore' and the 'revival as an aesthetic or intellectual ideal' as unified concepts in the study of European civilization. In another passage, Wind wrote that 'these two opposing but interconnected forms of transmitting the classical inheritance provide a feature which is characteristic of the transmission of symbols in general'. For both Warburg and Wind, it was important to define the concept of 'historical memory' and

12 Aby Warburg, quoted in Gombrich, *Aby Warburg*, 88–9.
13 See Severi, *The Chimera Principle*, 41.

investigate how it functions. Furthermore, they discussed the 'survival of the classics', which they regarded as crucial for understanding European history.[14]

According to Warburg and Wind, 'The word "survival" [...] is a biological metaphor.' Wind stated: 'When we speak of "survival of the classics", we mean that the symbols created by the ancients continued to assert their power upon subsequent generations.' In reflecting on the link between Warburg's approach to the study of civilizations and the research carried out in England, Wind stated: 'His theory of symbols, dependent though it is upon one of the most striking essays of Friedrich Theodor Vischer, owes a great debt to both Darwin and Carlyle.'[15]

Starting in his 1891 doctoral dissertation, Warburg identified the visual and written sources used by Renaissance artists for representing the expression of motions and emotions in ancient cultures. In his examination of Botticelli's *Birth of Venus* (Figure 2.3), for example, Warburg stated that 'the dress and hair of the goddess who stands on the shore are flying in the wind, as are Venus's own hair and the mantle that is to cover her.'[16] In late December 1927, in his semi-official statement concerning the aims of his private library and research institute, Warburg remarked on the goal of his research, starting from his doctoral dissertation:

> [B]y the end of my Italian semester (during the first assay of an art-historical institute, led by Schmarsow with seven German students), I understood that the movement in the details of figures – such as their hair and garments – which had been carefully discounted as the artist's decorative fancies, must originate in antiquity. I discovered that the pursuit of Zephyr and Flora in Botticelli's *Primavera* must certainly be a direct imitation of Ovid's *Fasti* (which I realized by virtue of the way such images were translated in a German advertisement). Accordingly,

14 Wind, 'Introduction', vi–viii.
15 Wind, 'Introduction', viii–ix.
16 Aby Warburg, 'Sandro Botticelli's *Birth of Venus* and *Spring*: An Examination of Concepts of Antiquity in the Italian Early Renaissance', in Aby Warburg, *The Renewal of Pagan Antiquity: Contributions to the Cultural History of the European Renaissance*, introduction by K. W. Forster, trans. David Britt (Los Angeles: Getty Research Institute, 1999), 89–156 (95).

Figure 2.3: Sandro Botticelli, *The Birth of Venus*, 1484–6, tempera on canvas,
172.5 × 278.9 cm. Gallerie degli Uffizi, Florence. © Gallerie degli Uffizi.

I chose the theme of intensified outward movement as it was derived from
antiquity for my doctoral thesis.[17]

In another passage, he stated, 'In the year 1897, from a completely
different perspective, I took on the task of understanding artistic imagery
as the stylistic product of an interrelation, in the broadest sense, with the
dynamism of life.' In this respect, Warburg was interested in exploring
human physiology to understand 'how the dynamic elements reflected in
the artwork functioned as essential and internal human processes.'[18]

17 Aby Warburg, Christopher D. Johnson and Claudia Wedepohl, 'From the Arsenal
 to the Laboratory', *West 86th* 19 (2012), 106–24 (114). See also Matthew Rampley,
 'From Symbol to Allegory: Aby Warburg's Theory of Art', *The Art Bulletin* 79/1
 (1997), 41–55.
18 Warburg, Johnson and Wedepohl, 'From the Arsenal to the Laboratory', 115.

Together with the representation of movement, the depiction of the human expression of emotions was another important theme in Warburg's research:

> For some time I had been developing the idea of how to grasp human expression in the artwork, as a minted work of practical, animated life – whether it be religious ritual, the drama of courtly festival, or theater. In this I was inspired by two books I read in Florence in 1888, which I read independently of each other and without any inkling that they would have an impact on my art-historical endeavors: Darwin's *On the Expression of Mind* and Piderit's *Mimicry and Physiognomy*. The primary theme of Darwin's tract is that general facial expressions are reflexive and repetitive externalizations of intellectual stimuli that are triggered akin to the remembrance of sensory stimuli. For example, if you dislike someone, you move your mouth as if tasting something sour.[19]

In relation to bodily expressions, Wind discussed 'the phenomenon of metaphor':

> All expression through movement of muscles is metaphorical, and subject to the polarity of the symbol. The stronger and more intense the psychological excitation released in the expression, the nearer the symbolic movement comes to the physical one. (In cases of extreme psychological revulsion we are also physically sick). The weaker and milder the excitation, the more restrained is the mimetic movement, the limit being when the momentary mimetic expression vanishes in the normal expression of the features.[20]

Therefore, Charles Darwin's works on the universality of the expression of emotions played an important role in Warburg's (and Wind's) research:

> The Darwinian theory of the memory of sensory stimuli had thus to be grasped as a polar, and not a simple, process. In this sense, stylistic transformation had to be understood not as a simple dynamic reaction, but as a counter-reaction to some tension.[21]

19 Warburg, Johnson and Wedepohl, 'From the Arsenal to the Laboratory', 116.
20 Wind, 'Warburg's Concept of *Kulturwissenschaft*', 31.
21 Warburg, Johnson and Wedepohl, 'From the Arsenal to the Laboratory', 116.

In *The Expression of the Emotions in Man and Animals* (1872), Darwin distinguished between innate or inherited actions and learned or imitated actions, underlining the universality of the expression of emotions:

> That the chief expressive actions, exhibited by man and by the lower animals, are now innate or inherited – that is, have not been learnt by the individual – is admitted by every one. So little has learning or imitation to do with several of them that they are from the earliest days and throughout life quite beyond our control; for instance, the relaxation of the arteries of the skin in blushing, and the increased action of the heart in anger. We may see children, only two or three years old, and even those born blind, blushing from shame; and the naked scalp of a very young infant reddens from passion. Infants scream from pain directly after birth, and all their features then assume the same form as during subsequent years. These facts alone suffice to show that many of our most important expressions have not been learnt; but it is remarkable that some, which are certainly innate, require practice in the individual, before they are performed in a full and perfect manner; for instance, weeping and laughing. The inheritance of most of our expressive actions explains the fact that those born blind display them, as I hear from the Rev. R. H. Blair, equally well with those gifted with eyesight. We can thus also understand the fact that the young and the old of widely different races, both with man and animals, express the same state of mind by the same movements.[22]

In these lines, Warburg found a scientific reference for the phenomenon he had observed in the visual arts, that is, the cultural memory inherent in the representation of actions, gestures and expressions, which are often innate and share similar characteristics worldwide. In 1888, referring to Darwin's *Expression of the Emotions in Man and Animals*, Warburg wrote, 'finally a book that helps me' [*endlich ein Buch, das mir hilft*].[23] Thus, Warburg based his studies on theories of evolution and perception. Claudia Wedepohl, archivist of the Warburg Archive and one of the leading scholars of Warburg's intellectual career, stated: 'These theories were particularly

22 Charles Darwin, *The Expression of the Emotions in Man and Animals* [1872], ed. Paul Ekman (London: Harper Perennial, 2009), 348.

23 See Claudia Wedepohl, 'Why Botticelli? Aby Warburg's Search for a New Approach to Quattrocento Italian Art', in Ana Debenedetti and Caroline Elam, eds, *Botticelli Past and Present* (London: UCL Press, 2019), 183–202 (193).

crucial to him as they offered a scientific explanation for the reappearance of expressive formulas throughout the history of visual culture.'[24]

According to Darwin, 'Actions, which were at first voluntary, soon became habitual, and at last hereditary.'[25] Darwin explained the reason behind the universal in the following terms:

> I have endeavoured to show in considerable detail that all the chief expressions exhibited by man are the same throughout the world. This fact is interesting, as it affords a new argument in favour of the several races being descended from a single parent-stock, which must have been almost completely human in structure, and to a large extent in mind, before the period at which the races diverged from each other. No doubt similar structures, adapted for the same purpose, have often been independently acquired through variation and natural selection by distinct species.[26]

According to Darwin, this is why a specific emotion, such as fear, is expressed or manifested by similar features throughout the world. He continued:

> We may likewise infer that fear was expressed from an extremely remote period, in almost the same manner as it now is by man; namely, by trembling, the erection of the hair, cold perspiration, pallor, widely opened eyes, the relaxation of most of the muscles, and by the whole body cowering downwards or held motionless.[27]

Robert Vischer, whose main ideas informed Warburg's research, also suggested that gestures can be universal: 'To suggest something unfurled or magnificent, for instance, we open our arms wide; to indicate greatness and majesty, we raise them high; to show something contemplated, doubtful, or untrue, we shake our head and hands.'[28]

More recently, Paul Ekman updated the study of the expression of emotions in humans from a psychological perspective, and came to the same conclusions as Darwin, Robert Vischer and Warburg, that is, that there are a number of emotions that have universal expressions and that are

24 Wedepohl, 'Why Botticelli?', 184–5.
25 Darwin, *The Expression of the Emotions*, 352.
26 Darwin, *The Expression of the Emotions*, 355.
27 Darwin, *The Expression of the Emotions*, 356.
28 Robert Vischer, 'On the Optical Sense of Form', 115.

therefore transmissible. To confirm Darwin's research and propositions, Ekman conducted a series of studies. For example, in 1967, Ekman visited Papua New Guinea to study the South Fore culture.[29] The people he met were unfamiliar with the visual representations of other cultures, due to their physical isolation. Ekman summarized the results of this study as follows: 'These stone-age people, who could not have learned expressions from the media, chose the same expressions for each emotion as had the people in the 21 literate cultures.'[30] This and other studies conducted by Ekman and his colleagues supported Darwin's statement about the universality of the expression of emotions.[31]

In the 1996 afterword to Darwin's *Expression of the Emotions in Man and Animals*, Ekman stated: 'It is never a question only of nature or only of nurture. We are biosocial creatures, our minds are embodied, reflecting our lives and the lives of our ancestors.'[32] Therefore, to say that there are universal expressions of emotions does not imply that expressions are universal in every aspect. As Ekman argued, 'Our evidence, and that of others, shows only that when people are experiencing certain strong emotions, and are not making any attempt to mask their expressions (display rules), the expression will be the same regardless of age, race, culture, sex, or education.'[33] These passages condense and update the Darwinian notion of universality, which greatly inspired Warburg's research not only on emotion and movement, but also on empathy and collective memory.

29 See Paul Ekman, 'Afterword: Universality of Emotional Expression? A Personal History of the Dispute', in Darwin, *The Expression of the Emotions*, 363–93 (377).
30 Ekman, 'Afterword', 379.
31 See, for example, Paul Ekman, *Emotions Revealed: Recognizing Faces and Feelings to Improve Communication and Emotional Life* (London: Weidenfeld and Nicolson, 2003); Paul Ekman and Karl G. Heider, 'The Universality of a Contempt Expression: A Replication', *Motivation and Emotion* 12 (1988), 303–8; Paul Ekman et al., 'Universals and Cultural Differences in the Judgments of Facial Expressions of Emotion', *Journal of Personality and Social Psychology* 53 (1987), 712–17; Paul Ekman, *Emotion in the Human Face* (Cambridge: Cambridge University Press, 1982); and Paul Ekman, *Darwin and Facial Expression: A Century of Research in Review* (New York: Academic Press, 1973).
32 Ekman, 'Afterword', 393.
33 Ekman, 'Afterword', 391.

From Robert Vischer's concept of *Einfühlung* to the neuroscience of empathy

In 1971, Wind wrote a harsh review challenging Gombrich's interpretation of Warburg's thought, in *Aby Warburg: An Intellectual Biography* (1970). One of the main points of contention was the role that Robert Vischer's theory of *Einfühlung* played in Warburg's theory of imagery. According to Wind, Gombrich did not take into account 'Vischer's work or [...] the reference to it in Warburg's dissertation'.[34] Wind connected Warburg's interest in miming and the role he assigned to it in art with Robert Vischer's theory of *Einfühlung* outlined in Robert Vischer's 1873 doctoral thesis, 'On the Optical Sense of Form: A Contribution to Aesthetics'. Wind explained that Warburg, in his dissertation on Botticelli, considered Robert Vischer's thesis as an important source for developing his method. According to Wind, Warburg wanted to demonstrate how empathy was turned into a force to create a style. Warburg did so by analysing Botticelli's way of representing animating figures that borrowed from the depiction of ancient Bacchantes (Figure 2.4).[35]

As Wind observed, Warburg mentioned the term *Einfühlung* frequently in his works. Furthermore, Wind stated that:

> in Warburg's concern with empathy and its operation lies the key to his later and more famous researches into magic and demonology, which led, for example, to his epochal discovery of oriental star-demons in the frescoes of the Palazzo Schifanoia in Ferrara, or of traces of pagan augury in Luther's anti-papal policy of advertising animal monstrosities as authentic portents, illustrated in broadsheets. Indeed, some perhaps over-refined distinctions introduced by Vischer into the study of empathy – 'Einfühlung, Anfühlung, Zufühlung' – recur in one of Warburg's earliest attempts to distinguish between various kinds of magical appropriation ('Einverleibung, Anverleibung, Zuverleibung').[36]

34 Wind, 'On a Recent Biography of Warburg', 108.
35 See Wind, 'On a Recent Biography of Warburg', 108.
36 Wind, 'On a Recent Biography of Warburg', 109.

Figure 2.4: After Callimachus, relief of a dancing maenad, neo-Attic copy after a classical Greek original, c. 406–405 BC, Pentelic marble, 143 × 109 cm. Palazzo dei Conservatori, Musei Capitolini, Rome. Photograph in the public domain.

According to Wind, Gombrich did not provide an explanation of Warburg's debt to Robert Vischer's work 'and of the constructive ideas that grew out of it'.[37] Wedepohl recently concurred with Wind's point, stating:

37 Wind, 'On a Recent Biography of Warburg', 108.

For Warburg's attempt to offer a psychological explanation for the problem of the formation of style, Vischer's thesis was surely crucial. While Vischer was thinking of Signorelli, however, Warburg drew attention to Agostino di Duccio, the Florentine sculptor whose principal work, dating from the 1450s, can be found in the *Tempio Malatestiano* in Rimini and in San Bernardino in Perugia.[38]

Wind also contested Gombrich's position, according to which 'Warburg's psychological concepts make no allowance for the creative imagination and are therefore of little use for an understanding of artistic traditions.'[39] Moreover, according to Wind, Gombrich

> repeatedly asserts that Warburg based his conception of the human mind on an outmoded mechanistic psychology that only 'talked in terms of sense impressions and the association of ideas' – the very doctrine against which Vischer had written *Über das optische Formgefühl.*[40]

Another point of contrast between Wind and Gombrich concerned Warburg's idea that it is essential to have an exact neuroscientific account of the working of empathy:

> One phase of Warburg's psychological thinking embarrasses Professor Gombrich particularly: like Vischer, Warburg believed that the physiology of the brain would one day offer the means of giving a scientifically exact account of the workings of empathy and its ramifications.[41]

Wind accused Gombrich of failing to mention Warburg's notes pertaining to these reflections. Wind added, 'It is to be hoped that this interesting phase of Warburg's thought will eventually be studied by a historian who has mastered the physiological psychology of that period.'[42] In fact, Warburg's ideas on the biological basis of empathy find confirmation in recent neuroscientific investigation. In this sense, the physiological basis

38 Wedepohl, 'Why Botticelli?', 190–1.
39 Wind, 'On a Recent Biography of Warburg', 108.
40 Wind, 'On a Recent Biography of Warburg', 108.
41 Wind, 'On a Recent Biography of Warburg', 108.
42 Wind, 'On a Recent Biography of Warburg', 109.

of empathy supports Warburg's and Wind's claims, according to which an exact neuroscientific account of the functioning of empathy may shed light on both the formation of style and the recurrence in history of certain artistic patterns.

As Wind stated, Warburg's concern regarding the biological foundation of empathy was shared by Robert Vischer, who, in his doctoral thesis, explained empathy as a body–brain response to objects and subjects. He developed this concept in the following statement:

> My principal concern in developing these concepts now became to explain mental stimulation in every case precisely through and together with bodily stimulation. Although the physiological knowledge at my disposal is inadequate for this task, it seems to me that the manner of its application is valid in itself and not unworthy of being carried forward and completed by the sure hand of a specialist in this field. We stand here before a 'mystery that has to be explained by physiology in conjunction with psychology'.[43]

Significantly, recent neuroscientific advances have identified the brain–body system underlying the phenomenon of empathy, thus confirming Robert Vischer's, Warburg's and Wind's claims about the biological basis of empathy. In this respect, one of the most important scientific discoveries concerns mirror neurons, a class of neurons that enable people to understand the motions and emotions of both the self and others.[44] Mirror neurons are responsible for an individual's (inner) imitation of the expression of emotions and the goal-oriented movements of others. In this way, people usually empathize with what they see.[45] Reflecting on

43 Robert Vischer, 'On the Optical Sense of Form', 92.

44 For more on mirror neurons, see Giacomo Rizzolatti and Corrado Sinigaglia, 'The Mirror Mechanism: A Basic Principle of Brain Function', *Nature Reviews Neuroscience* 17/12 (2016), 757–65; and Luigi Cattaneo and Giacomo Rizzolatti, 'The Mirror Neuron System', *Archives of Neurology* 66/5 (2009), 557–60.

45 For other neuroscientific studies on empathy, see Jean Decety and Kalina J. Michalska, 'A Developmental Neuroscience Perspective on Empathy', in John Rubenstein, Pasko Rakic and Helen Tager-Flusberg, eds, *Neural Circuit and Cognitive Development: Comprehensive Developmental Neuroscience* (Amsterdam: Academic Press, 2020), 485–503; Jean Decety and Ariel Knafo-Noam, 'Empathy', *Brain Mapping: An Encyclopedic Reference* 3 (2015), 191–4; Jean Decety, ed., *Empathy: From Bench to Bedside* (Cambridge, MA: MIT Press, 2011);

this understanding of brain activity, Vittorio Gallese speaks of embodied simulation, that is, the tendency of our brain–body system to simulate in our inner self the gestures, movements and expressions of others, both in real life and in the visual arts.[46]

This provides scientific support (and an experimental aesthetic interpretation) for Warburg's research, which was largely based on the relationship between motion and emotion in the depiction of figures in the European Renaissance. In fact, in the 'prolegomena' of Gottfried Semper's work on style (1860),[47] Warburg recorded the statement that 'empirical aesthetics' would naturally have to follow 'speculative aesthetics.'[48] In this respect, neuroscience offers a biological explanation for Warburg's theory of imagery, which combines two distinct approaches: one that studies how

Jean Decety, 'Dissecting the Neural Mechanisms Mediating Empathy', *Emotion Review* 3/1 (2011), 92–108; Jean Decety, 'Neuroscience of Empathic Responding', in Stephanie L. Brown, R. Michael Brown and Louis A. Penner, eds, *Moving Beyond Self-Interest: Perspectives from Evolutionary Biology, Neuroscience, and the Social Sciences* (New York: Oxford University Press, 2011), 109–32; Jean Decety and Andrew N. Meltzoff, 'Empathy, Imitation, and the Social Brain', in Amy Coplan and Peter Goldie, eds, *Empathy: Philosophical and Psychological Perspectives* (New York: Oxford University Press, 2011), 58–81; and Antonio Damasio, *Descartes' Error: Emotion, Reason, and the Human Brain* (London: Vintage Books, 2006).

46　For more on Gallese's embodied simulation theory, see Vittorio Gallese, 'A Bodily Take on Aesthetics: Performativity and Embodied Simulation', in Antonino Pennisi and Alessandra Falzone, eds, *The Extended Theory of Cognitive Creativity: Interdisciplinary Approaches to Performativity* (Cham: Springer, 2020), 135–49; Vittorio Gallese, 'Embodied Simulation: Its Bearing on Aesthetic Experience and the Dialogue between Neuroscience and the Humanities', *Gestalt Theory* 41/2 (2019), 113–28; and Vittorio Gallese, 'Visions of the Body: Embodied Simulation and Aesthetic Experience', *Aisthesis: Pratiche, linguaggi e saperi dell'estetico* 10/1 (2017), 41–50.

47　See Gottfried Semper, *Der Stil in den technischen und tektonischen Künsten, oder Praktische Aesthetik: Ein Handbuch für Techniker, Künstler und Kunstfreunde* (Frankfurt: Verlag für Kunst und Wissenschaft, 1860). For the English translation, see Gottfried Semper, *Style in the Technical and Tectonic Arts; or, Practical Aesthetics*, trans. Harry Francis Mallgrave and Michael Robinson (Los Angeles: Getty Research Institute, 2004).

48　See Wedepohl, 'Why Botticelli?', 193, 201 n. 48.

artists select and copy certain models, and another that investigates the biological mechanism that triggers a predetermined response to external forces.

The theory of collective memory and the question of the engram: A neurophysiological analysis

In 'Warburg's Concept of *Kulturwissenschaft* and Its Meaning for Aesthetics', Wind introduced an important topic: the biological functioning of memory:

> We need only consider the way the human body functions. What we find is that the stimulus in question is converted into various different muscular movements and that each fulfils a particular function, strengthening its capacity to fulfil it every time it does so. It was in connection with such phenomena as the strengthening of muscles through their exercise that Hering spoke of the memory as a 'general function of organised matter'.[49]

Here, Wind was referring to 'Über das Gedächtnis als allgemeine Funktion der organisierten Materie' ['Memory as a General Function of Organised Matter'], a lecture that the German neurophysiologist Ewald Hering published in 1870.[50] As Gombrich stated: 'There is a fleeting allusion to Hering's ideas in Warburg's fragment on the "Nympha" – "The memory of Antiquity as a function of organized matter".'[51] Gombrich continued:

> Hering proposed to reduce the two characteristics of living matter – memory and heredity – to one. Heredity is nothing but racial memory. Hering also touched upon

49 Wind, 'Warburg's Concept of *Kulturwissenschaft*', 31. See also Claudia Wedepohl, 'Mnemonics, Mneme and Mnemosyne: Aby Warburg's Theory of Memory', *Bruniana & Campanelliana* 20/2 (2014), 385–402.

50 Ewald Hering, 'Memory as a General Function of Organised Matter', in Ewald Hering, *Memory: Lectures on the Specific Energies of the Nervous System* (Chicago: Open Court, 1913), 1–24.

51 Gombrich, *Aby Warburg*, 241.

the role of cultural traditions, of language and symbolism, in the 'memory' of mankind, but surmised that there must be some inherited dispositions which account for the force of certain traditions.[52]

In his endorsement of Hering's ideas, Gombrich observed, Warburg regarded expressive movements 'as due to impulses reaching the artist from the past. He [Warburg] speaks of unconscious inherited dispositions and regards art as an "organ of social memory".'[53]

Hereditary (or genetic) memory has recently become a promising subject in the field of cognitive neuroscience. For instance, Gisella Vetere's lab found that the 'presentation of an odor (acetophenone) that corresponded to the targeted olfactory glomerulus (and, importantly, not another odor) induced natural memory recall'.[54] In other words, the researchers discovered that 'memory formation occurred in the absence of any sensory experience'.[55] Therefore, Vetere's study suggests that the brain–body system can bypass experience and rely on hereditary memory. A previous study, directed by Brian Dias and Kerry Ressler, drew similar conclusions. Using olfactory molecular specificity, they investigated the inheritance of parental traumatic exposure. They 'subjected F0 mice to odor fear conditioning before conception and found that subsequently conceived F1 and F2 generations had an increased behavioral sensitivity to the F0-conditioned odor, but not to other odors'. In this way, the scientists found that 'these transgenerational effects are inherited via parental gametes'.[56] Therefore, their 'findings provide a framework for addressing how environmental information may be inherited transgenerationally at behavioral, neuroanatomical and epigenetic levels',[57] thus confirming, at least in part, Darwin's, Hering's and Warburg's ideas about hereditary memory.

52 Gombrich, *Aby Warburg*, 241.
53 Gombrich, *Aby Warburg*, 241.
54 Gisella Vetere et al., 'Memory Formation in the Absence of Experience', *Nature Neuroscience* 22 (2019), 933–40 (933).
55 Vetere et al., 'Memory Formation', 936.
56 Brian G. Dias and Kerry J. Ressler, 'Parental Olfactory Experience Influences Behavior and Neural Structure in Subsequent Generations', *Nature Neuroscience* 17/ 1 (2014), 89–96 (89).
57 Dias and Ressler, 'Parental Olfactory Experience', 89.

In his introduction to the Mnemosyne Atlas, titled 'The Absorption of the Expressive Values of the Past', Warburg explained that the imagery that constitutes the collective memory of a culture 'encompasses the entire range of emotional gesture, from helpless melancholy to murderous cannibalism.'[58] As he stated, this is the purpose of the Mnemosyne Atlas: 'Through its images the Mnemosyne Atlas intends to illustrate this process, which one could define as the attempt to absorb pre-coined expressive values by means of the representation of life in motion.'[59]

Warburg linked the expression of motion and emotion to memory, emphasizing the necessity of studying the psychological functioning of collective memory. He explained: 'In order to grasp the sense of these expressive values preserved in the memory', the Mnemosyne Atlas undertakes a 'penetrating examination of social psychology.'[60] To accomplish this goal, Warburg assigned an important role to 'artistic empathy'.[61] As he stated, 'Only then does one reach the mint that coins the expressive values of pagan emotion stemming from primal orgiastic experience: thiasotic tragedy.'[62] Therefore, according to Warburg, movement, emotions, (collective) memory, and empathy are connected and contribute to the formation of an artistic style.

Whereas collective memory has long been studied in the humanities, this topic has only recently been explored in psychology. Until recently, psychological studies of collective memory have focused on three main topics: (i) the social representations of history, including the differences and similarities between one generation and another; (ii) the cognitive processes of the formation of collective memories from either a top-down or bottom-up approach; and (iii) the way people transmit personal memories of historical importance across

58 Aby Warburg, 'The Absorption of the Expressive Values of the Past', trans. Matthew Rampley, *Art in Translation* 1 (2009), 273–83 (277). See also Aby Warburg, *Der Bilderatlas Mnemosyne*, ed. Martin Warnke and Claudia Brink (Berlin: Akademie, 2003).

59 Warburg, 'The Absorption of the Expressive Values', 277.

60 Warburg, 'The Absorption of the Expressive Values', 278.

61 Warburg, 'The Absorption of the Expressive Values', 279.

62 Warburg, 'The Absorption of the Expressive Values', 279.

generations.[63] This promising line of research testifies to the pioneering level of Warburg's research interests as well as to his visionary approach.

The phenomenon of collective memory is linked to that of the engram. As Gombrich stated, 'The symbol, in Warburg's reading, was the counterpart, in the collective mind, of the "engram" in the nervous system of the individual.'[64] Warburg introduced the engram in the following way:

> It is in the zone of orgiastic mass-seizures that we must look for the mint which stamps upon the memory the expressive movements of the extreme transports of emotion, as far as they can be translated into gesture language, with such intensity that these engrams of the experience of suffering passion survive as a heritage stored in the memory. They become the exemplars, determining the outline traced by the artist's hand as soon as maximal values of expressive movement desire to come to light in the artist's creative handiwork.[65]

Warburg borrowed the term 'engram' from the German zoologist and evolutionary biologist Richard Semon, who coined the term in 1904 to describe the neural substrate responsible for storing and recalling memories.[66] Semon defined the engram as 'the enduring though primarily latent modification in the irritable substance produced by a stimulus'.[67] In other words, an engram (that is, a memory trace) describes the lasting physical changes in the brain that take place in response to an event or experience. Once formed, an engram becomes dormant until it is awakened in a process that Semon named 'ecphory' (a memory retrieval).

Similarly, according to Warburg, the energy contained in an engram may be reactivated and discharged.[68] Warburg's research surrounding

63 See William Hirst, Jeremy K. Yamashiro and Alin Coman, 'Collective Memory from a Psychological Perspective', *Trends in Cognitive Sciences* 22/5 (2018), 438–51.
64 Gombrich, *Aby Warburg*, 260–1.
65 Gombrich, *Aby Warburg*, 245.
66 See Richard Semon, *The Mneme* (London: Allen & Unwin and Macmillan, 1921).
67 Semon, *The Mneme*, 12.
68 See Gombrich, *Aby Warburg*, 242.

engrams led him to hypothesize another means of image absorption: that of re-interpretation.[69] As Gombrich put it:

> The artist who uses the dangerous 'superlatives' of thiasotic origin may draw on the full energy of these symbols without at the same time giving rein to their archaic mentality. He can use them in a different context, 'invert' their original savage meaning, and yet benefit from their value as expressive formulae. In this way Bertoldo di Giovanni had used the model of a pagan maenad to give expression to the passionate grief of the Magdalen under the cross, and Donatello, in Warburg's view, used a relief on the cover of a sarcophagus, in which Pentheus is torn to pieces by maenads, for a composition of his own in the Santo in Padua. Where pagan frenzy had represented a leg torn off by insensate women, the Christian artist 'inverted' the scheme to glorify the healing of a broken leg.[70]

Therefore, as Gombrich stated, 'Whether by heritage or by contact, the artist who comes into touch with these symbols once more experiences the "mnemic energies" with which they were charged.'[71] Warburg called the coinages of ancient images 'dynamograms'.

Significantly, the study of the engram is now prominent in neuro-psychology.[72] For example, Karl Lashley's research demonstrates that an engram is not localized in a specific cortical region but is stored in the brain as a distributed network.[73] Donald Hebb was one of the first to provide evidence of how an engram (or cell assembly) is formed.[74] In the 1960s, James McConnell's studies concluded that the engram is encoded in RNA

69 See Gombrich, *Aby Warburg*, 247.

70 Gombrich, *Aby Warburg*, 247.

71 Gombrich, *Aby Warburg*, 244.

72 See, for example, Bryan D. Devan and Robert J. McDonald, 'Editorial: The Emergent Engram: Multilevel Memory Trace Components and the Broader Interactions', *Frontiers in Behavioral Neuroscience* 16 (2022), 1–3; and Felipe De Brigard, 'The Nature of Memory Traces', *Philosophy Compass* 9/6 (2014), 402–14. See also Yadin Dudai, 'In Search of the Cultural Engram', *Neuron* 108 (2020), 600–3.

73 See Sheena A. Josselyn, Stefan Köhler and Paul W. Frankland, 'Heroes of the Engram', *The Journal of Neuroscience* 37/18 (2017), 4647–57. See also Eric R. Kandel, 'The Biology of Memory: A Forty-Year Perspective', *The Journal of Neuroscience* 29/41 (2009), 12748–56.

74 See Josselyn, Köhler and Frankland, 'Heroes of the Engram'.

and could be transmitted genetically.[75] In the same period, Brenda Milner discovered that certain forms of memory are stored in the hippocampus and the medial temporal lobe.[76]

Furthermore, a substantial amount of empirical evidence based on recently developed techniques suggests that memory is encoded in the brain by distributed neurons, the so-called engram cells.[77] These neurons are activated during learning, and represent the substrate for the storage of a memory engram.[78] Dae Hee Han and his colleagues stated:

> On a regional scale, lesion and pharmacological inhibition studies supported the idea that each memory resides in a specific cortical structure (localization theory) such that a lesion or inhibition of the hippocampus, for example, disrupts contextual fear memory, with the added twist that the locus of a memory may change over time.[79]

They further stated: 'On a cellular scale, immunohistochemical data, utilising immediate early genes (IEG) as a marker of neuronal activity, established that a substantial subset of neurons in a region involved in storing a particular memory is activated to encode that memory.'[80]

Other studies have identified the correlation between engram cells and fear memory in various cortical regions, including the CA1 area and dentate gyrus in the hippocampus, the medial prefrontal cortex, and the retrosplenial cortex, confirming that engram cells for a certain memory are distributed throughout the brain.[81] Moreover, as Han's group explained, 'the

75 See Josselyn, Köhler and Frankland, 'Heroes of the Engram'.

76 See, for example, Brenda Milner, 'Les troubles de la mémoire accompagnant des lésions hippocampiques bilaterales', in P. Passouant, ed., *Physiologie de l'hippocampe* (Paris: Centre National de la Recherche Scientifique (CNRS), 1962), 257–72.

77 See Priyanka Rao-Ruiz et al., 'A Synaptic Framework for the Persistence of Memory Engrams', *Frontiers in Synaptic Neuroscience* 13 (2021), 1–15.

78 See Sheena A. Josselyn and Susumu Tonegawa, 'Memory Engrams: Recalling the Past and Imagining the Future', *Science* 367/6473 (2020), <https://www.science. org/doi/10.1126/science.aaw4325>, accessed 13 October 2022.

79 Dae Hee Han et al., 'The Essence of the Engram: Cellular or Synaptic?', *Seminars in Cell and Developmental Biology* 125 (2022), 122–35 (122–3).

80 Han et al., 'The Essence of the Engram', 123.

81 See Mariana R. Matos et al., 'Memory Strength Gates the Involvement of a CREB-Dependent Cortical Fear Engram in Remote Memory', *Nature Communications* 10

study of engrams has involved the investigation of conceptually different types of memories, such as social memory and reward memory, suggesting that engrams are involved in multiple forms of memory.'[82] Finally, synaptic plasticity has been regarded as evidence of the existence of engram cells.[83] For instance, Tim Bliss and Terje Lømo's research has provided an empirical basis for the synaptic plasticity and memory hypothesis, which states that the pattern's modification of synaptic connections mediated by synaptic plasticity explain how the brain stores memory.[84]

Thus, these empirical studies provide a solid basis for Semon's and Warburg's claims about the existence and function of the engram and its role in a culture. In this sense, recent research has continued the work of Warburg by providing updated insights on the biology of empathy and memory, which may be applied to the study of visual imagery. As this study has demonstrated, Warburg's research path was highly promising for promoting a deeper understanding of the biology of images.

Conclusion: A foundation for a theory of aesthetic response

To conclude, Warburg's research on the 'afterlife of antiquity' [*Nachleben der Antike*] and Wind's interpretation of his works suggest the existence of a biological basis for the creation, transmission and perception of images and artworks in different epochs and cultures. In pursuing

(2019), 1–11; Sungmo Park et al., 'Neuronal Allocation to a Hippocampal Engram', *Neuropsychopharmacology* 41 (2016), 2987–93; Tomás J. Ryan et al., 'Engram Cells Retain Memory under Retrograde Amnesia', *Science* 348 (2015), 1007–13; and Kiriana K. Cowansage et al., 'Direct Reactivation of a Coherent Neocortical Memory of Context', *Neuron* 84 (2014), 432–41.

82 Han et al., 'The Essence of the Engram', 123.

83 See Han et al., 'The Essence of the Engram', 128.

84 See Tim Bliss and Terje Lømo, 'Long-Lasting Potentiation of Synaptic Transmission in the Dentate Area of the Anaesthetized Rabbit Following Stimulation of the Perforant Path', *The Journal of Physiology* 232 (1973), 331–56.

his objectives, Warburg mainly focused on the concepts of universality, *Einfühlung* [empathy], collective memory, and the engram. Therefore, it is important to evaluate the validity of Warburg's ideas in light of recent scientific advances. Today, much more is known about the physiology of the brain and the biological functioning of empathy and memory. It is, therefore, possible to confirm the majority of Warburg's conclusions and suggest that the path Warburg and Wind established for a theory of images can also provide a foundation for a theory of aesthetic response.[85]

85 See, for example, Fabio Tononi, 'Life After the Warburg: Fabio Tononi', interview by Gemma Cornetti, in *Mnemosyne: The Warburg Institute Blog*, 26 September 2022, <https://warburg.sas.ac.uk/blog/life-after-warburg-fabio-tononi>, accessed 18 October 2022; Fabio Tononi, 'Worringer, Dewey, Goodman, and the Concept of Aesthetic Experience: A Biological Perspective', *ITINERA: Rivista di filosofia e teoria delle arti* 23 (2022), 303–28; Fabio Tononi, 'The *Night* of Michelangelo: Animism, Empathy, and Imagination', *Journal of Comparative Literature and Aesthetics* 45/4 (2022), 178–92; Fabio Tononi, 'The Aesthetics of Freud: Movement, Embodiment and Imagination', *Reti, saperi, linguaggi: Italian Journal of Cognitive Sciences* 8/1 (2021), 125–54; Fabio Tononi, 'Intermediality and Immersion in Gaudenzio Ferrari's *Adoration of the Magi* in Chapel V of the Sacred Mountain of Varallo', *PsicoArt: Rivista di arte e psicologia* 10 (2020), 1–18; Fabio Tononi, 'Andrea Mantegna and the Iconography of Mourners: Aby Warburg's Notion of *Pathosformeln* and the Theory of Aesthetic Response', *IKON: Journal of Iconographic Studies* 13 (2020), 79–94; Fabio Tononi, 'Aesthetic Response to the Unfinished: Empathy, Imagination and Imitation Learning', *Aisthesis: Pratiche, linguaggi e saperi dell'estetico* 13/1 (2020), 135–53; David Freedberg and Antonio Pennisi, 'The Body in the Picture: The Lesson of Phantom Limbs and the Origins of the BIID', *Reti, saperi, linguaggi: Italian Journal of Cognitive Sciences* 7/1 (2020), 5–50; David Freedberg, 'From Absorption to Judgment: Empathy in Aesthetic Response', in Vanessa Lux and Sigrid Weigel, eds, *Empathy: Epistemic Problems and Cultural-Historical Perspectives of a Cross-Disciplinary Concept* (New York: Palgrave Macmillan, 2017), 139–80; David Freedberg, 'Feelings on Faces: From Physiognomics to Neuroscience', in Rüdiger Campe and Julia Weber, eds, *Rethinking Emotion: Interiority and Exteriority in Premodern, Modern, and Contemporary Thought* (Berlin: De Gruyter, 2014), 289–324; David Freedberg, 'Memory in Art: History and the Neuroscience of Response', in Suzanne Nalbantian, Paul M. Matthews and James L. McClelland, eds, *The Memory Process: Neuroscientific and Humanistic Perspectives* (Cambridge, MA: MIT Press, 2011), 337–58; David Freedberg, 'Empathy, Motion and Emotion',

Finally, the results of the present research provide evidence that the creation, transmission and response to images have both cultural and biological implications.

GIOVANNA TARGIA

3 On Details and Different Ways of Viewing Raphael: Edgar Wind and Heinrich Wölfflin

Wind's and Wölfflin's eye

'Even Wölfflin's eye sometimes failed him.' With these words, in one of the numerous endnotes added to the 1963 published version of his 1960 Reith Lectures, *Art and Anarchy*,[1] Edgar Wind refers to what he presents as a revealing mistake in the interpretation of Raphael's Vatican fresco *The School of Athens* in one of Heinrich Wölfflin's most widely read books, *Die klassische Kunst*.[2] Wind had differently understood the composition of the group in the left foreground of the fresco (Figure 3.1), his interpretation diverging from both formalist readings, including that put forward by Wölfflin, and the iconographic identifications of individual figures then prevailing in international historiography. According to Wind, Raphael *did* depict the philosopher and mathematician Pythagoras, but he was not the man in profile who sits writing, surrounded by his disciples, including a youth at his feet who holds a small panel – an identification then believed by the majority of scholars and still accepted by

1 Edgar Wind, *Art and Anarchy: The Reith Lectures 1960, Revised and Enlarged* (London: Faber & Faber, 1963), 159 n. 114.
2 Heinrich Wölfflin, *Die klassische Kunst: Eine Einführung in die italienische Renaissance* (Munich: Bruckmann, 1899). The book was steadily reprinted, arriving at six editions in fifteen years.

most today;[3] rather, Pythagoras was the figure seated in the typical pose of the pensive melancholic, resting his head on his hand, self-absorbed, withdrawn, and not interacting with others.[4] In Wind's view, identifying the melancholic thinker with Pythagoras would appropriately, though unexpectedly, link this figure to the man standing at his side and thus to the group at the left of the fresco – this despite the fact that, owing to his isolating bodily posture, he seems to be simply an extrinsic addition, thus belonging to no group or philosophical school. It is with reference to this detail that Wind challenged Wölfflin's interpretation, saying:

> in *Die klassische Kunst* pp. 94 f. a detail from the *School of Athens* is interpreted as a symmetrical group (a philosopher standing between two seated scribes) whereas the argument defines these figures as part of a series progressing in a crescendo from right to left. It is clear from the cut of Wölfflin's illustration (p. 95) that, misled by an arbitrary choice of focus, his eye seized on a subordinate clause as principal.[5]

3 The first to put forward this identification was Giovan Pietro Bellori, correcting Giorgio Vasari, who described it as the Evangelist Matthew copying from the slate held for him by an angel: Giorgio Vasari, *Le vite de' più eccellenti pittori, scultori e architettori: Nelle redazioni del 1550 e 1568*, ed. Rosanna Bettarini and Paola Barocchi, vol. 4 (Florence: Sansoni, 1976), 167, and Giovan Pietro Bellori, *Descrizzione delle imagini dipinte da Rafaelle d'Urbino nelle camera del Palazzo Apostolico Vaticano* (Rome: Gio. Giacomo Komarek Boemo, 1695), 30. See most recently David Ekserdjian, 'La Stanza della Segnatura: Dal disegno al dipinto', *Accademia Raffaello: Atti e Studi* 1/2 (2019), 9–34 (25); Christoph Luitpold Frommel, *Raffael: Die Stanzen im Vatikan* (Vatican City: Musei Vaticani, Libreria editrice vaticana, 2017), 22–3; Giovanni Reale, *La "Scuola di Atene" di Raffaello: Una interpretazione storico-ermeneutica* (Milan: Bompiani, 2005), 41–3; Glenn W. Most, *Raffael: Die Schule von Athen; Über das Lesen der Bilder* (Frankfurt: Fischer, 1999), 22–3. For the most authoritative readings during Wind's lifetime, see the bibliography in Luitpold Dussler, *Raphael: A Critical Catalogue of His Pictures, Wall-Paintings and Tapestries* (London: Phaidon, 1971), 73–4.

4 This figure is currently identified as Heraclitus, and his features are usually said to resemble Michelangelo's. Following a tradition handed down by Diogenes Laertius and Theophrastus, among others, Heraclitus is associated with melancholy, and is often nicknamed 'the weeping philosopher' (Diogenes Laertius, *Lives and Opinions of the Eminent Philosophers*, IX, 6).

5 Wind, *Art and Anarchy*, 159 n. 114. He probably refers to the sixth edition of Wölfflin's book, from 1914 (an unchanged reprint of the fourth edition, of 1908), which was in his possession (a copy of this edition is listed in the register of his

Figure 3.1: Raphael, *The School of Athens*, c. 1509–11, fresco. Detail of the group in the left foreground. Stanza della Segnatura, Apostolic Palace, Vatican Museums, Rome. © Foto Scala, Florence.

In this passage, Wind refers to an illustration added only from the fourth edition (1908) of Wölfflin's book, but always included thereafter (Figure 3.2). In the stratified history of its reprints and new editions, the original set of illustrations of Wölfflin's text was progressively expanded. Notwithstanding the prominent role assigned to Raphael in the overall structure of *Die klassische Kunst*, the first three editions did not include any reproduction of Raphael's *School of Athens*, neither of the whole fresco

personal collection: 'The Wind Library', catalogued by T. J. Kirtley, J. Stemp and A. Yorke (Oxford, 1998), available at Bodleian Libraries, University of Oxford, 'Subject and Research Guides. Art and Architecture: Library Collections; Edgar Wind's Personal Library Collection', <https://libguides.bodleian.ox.ac.uk/art-architecture/edgar-wind-library-collections>). Therefore, all citations from *Die klassische Kunst* in what follows are taken from this edition.

nor of any details. It was probably in relation to his continuing reflection
on the use of photographic reproductions that Wölfflin decided to fur-
ther exemplify his method, while buttressing his interpretation, by adding
an explicit visual reference to this particular detail of Raphael's painting.[6]
Indeed, by analysing Wölfflin's and Wind's divergent views on this detail,
we have a means to better assess some of their theoretical strategies, since
it may be demonstrated that *The School of Athens* assumed an almost para-
digmatic role for both authors.

Wind's polemic against Wölfflin's theoretical stance is well known.
It dates back to the very beginnings of the intellectual path of the much
younger scholar, writing in the wake of the lively discussion sparked by the
first publication of the *Kunstgeschichtliche Grundbegriffe* in 1915.[7] Decades
later, Wind's remark on this macroscopic detail in *The School of Athens*, even

6 Wölfflin's concern for photographic reproduction has been emphasized in recent
 scholarship, with particular reference to the reproduction of sculpture, in relation
 to his famous article, published in three parts: 'Wie man Skulpturen aufnehmen
 soll', *Zeitschrift für bildende Kunst* 7 (1896), 224–8; 8 (1897), 294–7; 25 (1915),
 237–44. On the reproduction of paintings and drawings, see most recently Monika
 Wagner, 'Farbe in kunstgeschichtlicher Theorie und Publikationspraxis: Semper,
 Riegl, Wölfflin', in Joseph Imorde and Andreas Zeising, eds, *In Farbe: Reproduktion
 von Kunst im 19. und 20. Jahrhundert; Praktiken und Funktionen* (Ilmtal-
 Weinstrasse: VDG, 2022), 27–44.

7 For an overview of both the immediate debates and the *longue durée* of the global re-
 ception of Wölfflin's *Grundbegriffe*, see Tristan Weddigen and Evonne Levy, eds, *The
 Global Reception of Heinrich Wölfflin's Principles of Art History* (New Haven: Yale
 University Press, 2020). For Wind's early contributions to these discussions, see
 Edgar Wind, *Ästhetischer und kunstwissenschaftlicher Gegenstand: Ein Beitrag zur
 Methodologie der Kunstgeschichte* [1922], ed. Pablo Schneider (Hamburg: Philo Fine
 Arts, 2011), 279–87; Edgar Wind, 'Zur Systematik der künstlerischen Probleme',
 Zeitschrift für Ästhetik und allgemeine Kunstwissenschaft 18/4 (1925), 438–86; Edgar
 Wind, 'Warburgs Begriff der Kulturwissenschaft und seine Bedeutung für die
 Aesthetik', in *Vierter Kongress für Ästhetik und allgemeine Kunstwissenschaft*, supple-
 ment to the *Zeitschrift für Ästhetik und allgemeine Kunstwissenschaft* 25 (1931), 163–79
 (163–8); Edgar Wind, 'Einleitung', in Bibliothek Warburg, *Kulturwissenschaftliche
 Bibliographie zum Nachleben der Antike. Erster Band: Die Erscheinungen des Jahres
 1931*, ed. Hans Meier, Richard Newald and Edgar Wind (Leipzig-Berlin: Teubner,
 1934), v–xvii (vii).

Figure 3.2: Heinrich Wölfflin, *Die klassische Kunst: Eine Einführung in die italienische Renaissance* (sixth edn, with 126 explanatory illustrations, Munich: Bruckmann, 1914), 94–5.

if confined to an endnote in *Art and Anarchy*, usefully raises a broader set of questions. To what extent can optical perception be led by a guiding principle, be it formal analysis or iconographical interpretation? Can an allegedly purely formal analysis really do away with subject matter? Is it valid to regard a pictorial composition as a text, to be interpreted through conceptual instruments such as readability or syntactic coherence (in Wind's own words: 'his eye seized on a subordinate clause as principal')? And how does the selective verbal description honed by an art historian relate to, combine with and convey both a perceptual experience and an erudite investigation into many (textual and visual) sources?

In what follows, I would like to reconsider the schematic opposition often drawn between Wölfflin and Wind, most commonly framed as the alternative between formalism and iconology, and rarely examined

analytically. In particular, I will argue that, notwithstanding his broader focus on the topic of cultural memory, examined from both a philosophical and an iconological point of view, Wind did not refrain from polemicizing on Wölfflin's very ground: that of perception and formal analysis.

The group of 'Pythagoras' according to Wölfflin

The treatment of Raphael in Wölfflin's *Klassische Kunst* against which Wind directed his polemic remark is explicit about the method adopted. Wölfflin saw in the papal commission of the Stanza della Segnatura a task particularly suited to Raphael's already developed talents: 'inventiveness in simple gesture and sensitivity in grouping'.[8] In his own words:

> Raphael had a feeling for that which is agreeable to the eye which none of his predecessors possessed. Historical learning is not essential for the understanding of these frescoes, which deal with familiar subjects, and it is quite wrong to attempt interpretations of the *School of Athens* as an esoteric treatise in historical and philosophical ideas, or of the *Disputà* as a synopsis of church history.[9]

It may seem at first that Wölfflin wished only to warn his readers against over-interpretation, since some historical learning is presupposed even in his own statements. Indeed, he drew an opposition between the attitude of art historians of his time and that of Raphael's contemporaries,

8 Wölfflin, *Die klassische Kunst*, 86; Engl. trans. by Peter and Linda Murray: Heinrich Wölfflin, *Classic Art: An Introduction to the Italian Renaissance* (London: Phaidon, 1952), 87.

9 Wölfflin, *Die klassische Kunst*, 86–7; Engl. trans., 88, with a telling reference to 'the illuminating essay by Wickhoff', who suggested taking Paolo Giovio's account seriously and considering the Stanza della Segnatura decorated 'ad praescriptum Julii Pontificis'. Julius II, Wickhoff remarked, 'war kein Gelehrter und kein Dichter und was er auftrug, kann nur etwas Einfaches gewesen sein'. Franz Wickhoff, 'Die Bibliothek Julius' II', *Jahrbuch der Königlich Preussischen Kunstsammlungen* 14 (1893), 49–64 (49).

thus evoking practices of vision allegedly predominant at the time when the frescoes were produced.[10] He wrote:

> When Raphael wanted to make his meaning unmistakable, he employed inscriptions, but this happens only rarely and there are even important figures, protagonists of the compositions, for which no explanations are given, since Raphael's own contemporaries did not feel the need for them. The all-important thing was the artistic motive which expressed a physical and spiritual state, and the name of the person was a matter of indifference: no one asked what the figures *meant*, but concentrated on what they *are*.[11]

Such an emphasis on the difference between meaning and being of the painted figures might even sound to us in hindsight like a warning against iconology in its codified Panofskian form. More properly, however, this passage refers to a line of study that had dominated throughout the later decades of the nineteenth century, when scholars – from Johann David Passavant to W. W. Lloyd, the philosopher Adolf Trendelenburg, J. A. Crowe, G. B. Cavalcaselle and Eugène Müntz – had attempted to identify every figure in *The School of Athens*. This practice probably reached the highest degree of specificity in Anton Springer's essay published in 1883 on the 400th anniversary of the painter's birth (Figure 3.3).[12]

In contrast, in the chapter of his *Klassische Kunst* dedicated to Raphael's fresco, Wölfflin indicates only very few names of the philosophers who

10 Although Wölfflin's comparison here arguably still relies on late nineteenth-century empathy theories, it would have been developed in a different perspective in later scholarship. As is well known, this is a point on which Michael Baxandall would have built one of his major studies dealing with the 'period eye': Michael Baxandall, *Painting and Experience in Fifteenth Century Italy: A Primer in the Social History of Pictorial Style* (Oxford: Clarendon Press, 1972). Indeed, in a retrospective account Baxandall remembered that his first idea for a research topic as a student – 'a very broad approach to "Restraint" in Renaissance behavior' – was 'partly prompted by the last part of Heinrich Wölfflin's Classic Art'. Michael Baxandall, *Episodes: A Memory Book* (London: Lincoln, 2010), 118.

11 Wölfflin, *Die klassische Kunst*, 87; Engl. trans., 88.

12 Anton Springer, 'Raphael's *Schule von Athen*', *Die Graphischen Künste* 5 (1883), 53–106 (87). See in particular his overview of all the names proposed by previous interpreters for the figures appearing in Raphael's fresco.

Figure 3.3: Overview of all the names proposed by previous interpreters for the figures
appearing in Raphael's fresco *The School of Athens*. Anton Springer, 'Raphael's Schule
von Athen', *Die graphischen Künste* 5 (1883), 87.

could be identified without long explanations: besides the central figures
of Plato and Aristotle, he names only Socrates, Diogenes, the astronomers
Ptolemy and Zoroaster, and Euclid the geometer. Then, more cautiously or
rather elusively, he adds: 'An elderly man, who may be Pythagoras, writes
something down, while a tablet inscribed with the harmonic scale is held
out in front of him.'[13] Wölfflin concentrates instead on the difficulties pre-
sented by the composition and the formal solutions devised by Raphael
for the arrangement of groups and single figures. He discusses the great
variety in the treatment of the subject, drawing a contrast to the *Disputa*,
and the increasing effectiveness of 'the motives expressing mental states

13 Wölfflin, *Die klassische Kunst*, 92; Engl. trans., 93.

by physical actions',[14] briefly making single comparisons and pointing to possible prototypes or borrowings from other artists – from Luca della Robbia to Leonardo and Donatello, as well as Michelangelo.[15] As to the group in the left foreground of the fresco, Wölfflin writes:

> The group around Pythagoras is still more interesting (fig. 3.1). A man in profile sits writing on a low seat, with one foot on a stool; and behind him are other figures pressing forward and leaning over him – a whole garland of curves. A second man also sits writing, but he is seen from the front and his limbs are arranged in a more complex pattern; between these two there is a standing figure supporting an open book against his thigh, apparently citing a passage in it.[16]

It is this description of the composition, postures and gestures of the figures that Wind saw as an inadequate, oversimplifying account, based on an apparent formal symmetry in an arbitrarily chosen portion of the fresco. The emphasis placed on the standing figure between two seated scribes is, in Wind's view, revealing of such an arbitrary choice, since no other element of the overall assemblage depicted by Raphael seems to characterize that figure as a protagonist; it is made to seem so, he argues, through the mere 'cut' of the illustration. Wind's rather ironic comment on Wölfflin's keen eye alludes to a frequent trope: the Swiss art historian was famed for his sense of the visual accents of works of art that 'lead' the eye of the beholder.[17] And even if it is true, on the one hand, that Wölfflin hinted at a more complex compositional feature when he described 'a whole garland of curves', or when he stressed that the 'analysis of the fresco should not stop short at single figures', on the other hand, statements such as the following one were unequivocal: 'There is no need to puzzle one's head over the meaning of this figure, for in the intellectual sense of this group he has none, and he exists solely as a physical motive, for formal reasons.'[18]

14 Wölfflin, *Die klassische Kunst*, 93; Engl. trans., 93.

15 Wölfflin, *Die klassische Kunst*, 93–4; Engl. trans., 94–5. It should be noted, how-ever, that neither of these comparisons is carried out analytically: only a brief men-tion here and in a footnote, for instance, fleetingly hints at the role of Donatello.

16 Wölfflin, *Die klassische Kunst*, 94; Engl. trans., 94.

17 See for instance Wölfflin, *Die klassische Kunst*, 103, 116; Engl. trans, 103, 118.

18 Wölfflin, *Die klassische Kunst*, 94; Engl. trans, 94.

One might read Wölfflin's insistence merely as a reaction against nineteenth-century *Quellenforschung* [the study of sources] and the tendency towards erudite explanation of works of art. Such a reductive reading, however, will not take us far in the assessment of the critical remarks of either Wölfflin or Wind. In fact, for both authors the crucial task was defining the specific achievement of the artist, and determining what distinguishes artistic quality and separates it from mere illustration. It is in the different answers to this question that their positions diverge so drastically.

Against the background of Wölfflin's argumentation, the paedagogical aspect of *Sehenlehren* and *Sehenlernen*,[19] of teaching and learning to see, to which he constantly refers throughout his work, is thrown into relief. Attentive since his student years to the role of drawing as an epistemic tool,[20] and having himself assiduously practised the craft,[21] Wölfflin repeatedly claimed that 'only the artist can talk to artists about art'.[22] In his lively

19 Wölfflin, *Die klassische Kunst*, ix; Engl. trans., xii. As it has been noted, in particular, the term *Sehenlernen* derives from an expression used frequently by the contemporary painter Hans von Marées, who was admired by Wölfflin: 'sehen lernen ist Alles'. See Konrad Fiedler, *Schriften zur Kunst* (Munich: Fink, 1991), vol. I, 369–462.

20 Especially important for Wölfflin had been, in this respect, the teaching of one of his first mentors, the archaeologist Heinrich Brunn; see in particular Heinrich Brunn, *Archäologie und Anschauung: Rede an die Studierenden beim Antritte des Rektorates der Ludwig-Maximilians-Universität, gehalten am 21. November 1885* (Munich: Wolf, 1885).

21 See, among the first explicit testimonies, Wölfflin's letter to his family from Rome, dated December 1886, preserved among his papers at the Universitätsbibliothek Basel (hereafter UB BS), Nachlass 95, III A 153: 'Meine Arbeiten gedeihen leidlich. Es geht wenigstens etwas vorwärts, und die Hauptsache: ich lerne sehen! Hier unterstützt mich der große Vorzug, das ich zeichne. Den ganzen letzten Monat bin ich auf die Akademie gegangen, abends 5–7 Uhr, um nach dem lebenden Modell zu studieren. Das hat mich sehr gefördert'. Several sketchbooks filled with drawings and descriptions of monuments and architectural elements are also preserved in UB BS, Nachlass 95, Nachtrag 1973, II 1b.

22 Heinrich Wölfflin to his parents, 5 May 1899 (UB BS, Nachlass 95, III A 430). On Wölfflin's teaching praxis, see Elizabeth Sears, 'Eye Training: Goldschmidt/ Wölfflin', in Gunnar Brands and Heinrich Dilly, eds, *Adolph Goldschmidt (1863– 1944): Normal Art History im 20. Jahrhundert* (Weimar: VDG, 2007), 275–94.

descriptions, perception seems mediated also by a sort of re-enactment of the design process itself, as he explains the difficulties confronting the artists under examination. In addition to this focus on *Produktionsästhetik*, in both his monographs and his occasional writings, Wölfflin expresses a sharpened sensibility to the trends and attitudes of the audience for art in his day. As a sort of precondition of any 'correct' way of seeing, he seeks to give pre-eminence to the tasks [*Aufgaben*] undertaken by those who produced works of art in order to define and emphasize the 'artistic content, which follows its own inner laws'.[23] During the book's gestation, as confirmed by many diary pages and still only partially published letters, Wölfflin's exchange with architects, painters, sculptors and musicians was crucial for his intellectual progress.[24] Thus, for instance, his observations in a notebook entirely dedicated to Raphael are focused almost exclusively on compositional problems the artist had to solve.[25] And even more generally, it can be noted that, while he gradually revised and partially reformulated his theory of 'fundamental principles of art history' over the course of his career, Wölfflin's way of looking at Raphael remained essentially unaltered in his later years, favouring an analysis of his compositional strategies and 'artistic intentions' over extrinsic factors.[26]

23 Wölfflin, *Die klassische Kunst*, viii; Engl. trans., xi. For the use of the term 'richtig' ('right, correct') in relation to his assessment of photographic reproduction, see also Geraldine Johnson, ' "(Un)richtige Aufnahme": Renaissance Sculpture and the Visual Historiography of Art History', *Art History* 36/1 (2013), 12–51.

24 A selection of such testimonies can be found in Heinrich Wölfflin, *Autobiographie, Tagebücher und Briefe*, ed. Joseph Gantner ([1982], Basel: Schwabe, 1984).

25 UB BS, Nachlass 95, Nachtrag 1973, I, 1a, Notizheft 32. *Die klassische Kunst* was in fact originally planned as a monograph on Raphael, and it was vividly discussed with Wölfflin's mentor, Jacob Burckhardt, but eventually took its final form: a combined analysis of 'components of individual artists' works with concepts of general stylistic development'. On the genesis of the book, see Joan Hart, 'Heinrich Wölfflin: An Intellectual Biography', dissertation, University of California, Berkeley, 1981, 212–13; Meinhold Lurz, *Heinrich Wölfflin: Biographie einer Kunsttheorie* (Worms: Werner, 1981), 124–57.

26 See for example Wölfflin's essays 'Die Schönheit des Klassischen' and 'Das Problem der Umkehrung in Raffaels Teppichkartons', in Heinrich Wölfflin, *Gedanken zur Kunstgeschichte* (Basel: Schwabe, 1941), 28–48 and 90–6.

Some coordinates of Wind's reading: Visual symmetries and visual dissonances

In the early 1960s, several decades after the first publication of Wölfflin's *Klassische Kunst*, Wind turned again to the roots of the formalist approach. Unfolding at the height of the Cold War, scientific and societal discourse in the art scene was marked by different versions of formalism combined with the modernist narrative and a growing theorization of abstraction. In this context, Wind resumed the anti-Wölfflinian polemic of his younger years, although striking a different note. He, too, had become increasingly concerned about the problems that artists – including contemporary artists – had to solve.[27] His comment on what he saw as a 'visual error' committed by Wölfflin appears in the fourth of his Reith Lectures, tellingly titled 'The Fear of Knowledge'.[28] While tackling the problem of 'the Romantic revolt against reason', he argues that 'the assumption that rational discourse and art are *incompatible* is as false as to suppose that they are *identical*, and that one should strive for an aesthetics capable of explaining such anomalous cases as Lucretius' or Dante's didactic, yet artistically powerful, poems.[29] It is to again exemplify the possibility of unifying imagination and learning, or, in his own words, 'intellectual precision and pictorial fantasy', that Wind refers to the prominent example of Raphael's *School of Athens*.[30] Again, with a touch of irony (though this time rather self-ironically), Wind views it as a sort of extreme case, where both the artist's imagination and the complexity of the doctrine expressed reach the highest degree. 'The theory is abstruse, perhaps even absurd, and

27 On Wind's critical engagement with modern art, see Ben Thomas, *Edgar Wind on Modern Art: In Defense of Marginal Anarchy* (London: Bloomsbury, 2020).

28 Wind, *Art and Anarchy*, 52–67. For a reconstruction of the genesis of these lectures, see Ianick Takaes, 'A Tract for the Times: Edgar Wind's 1960 Reith Lectures', *Journal of Art Historiography* 21 (December 2019), 1–23.

29 Wind, *Art and Anarchy*, 52–6, 59.

30 Wind, *Art and Anarchy*, 62.

I may say, from personal acquaintance, that it is a rarefied form of mental torture to study it in Renaissance texts', and he then adds in a footnote:

> For some years I have been preparing a book on the philosophical sources of the *School of Athens*. As I have often said in lectures, the painting represents a particular doctrine, the *Concordia Platonis et Aristotelis* (cf. Pico della Mirandola, *Opera*, 1557, pp. 83, 241, 249, 326, etc.), which supplies the key to the entire cycle of frescoes in the Stanza della Segnatura.[31]

With typical understatement, Wind was alluding to the quite complex study he had undertaken, one leading him through a labyrinth of sources discovered in libraries and archives, involving consultation with other scholars. Concomitantly he was working on the analysis of the theological sources of the Sistine ceiling and thus on the 'religious symbolism of Michelangelo'. He used a sabbatical year at Smith College and a Guggenheim Fellowship to travel to Italy between 1949 and the early

31 Wind, *Art and Anarchy*, 158 n. 112. Wind's book on *The School of Athens*, which remained unfinished, is attested by an annotated typescript of 157 folios dated 'c. 1950' as well as by a large number of notes, photographs and preparatory and parallel versions that are preserved in the author's manuscript bequest at Bodleian Libraries, University of Oxford, Edgar Wind Papers (hereafter Bodleian, EWP), MS. Wind 216–31. Aspects of the genesis of this work have been reconstructed in Pascal Griener, 'Edgar Wind und das Problem der Schule von Athen' and Elizabeth Sears, 'Die Bildersprache Michelangelos: Edgar Winds Auslegung der Sixtinischen Decke', in Horst Bredekamp, Bernhard Buschendorf, Freia Hartung and John Michael Krois, eds, *Edgar Wind: Kunsthistoriker und Philosoph* (Berlin: Akademie, 1998), 77–103 and 49–75; Elizabeth Sears, 'Edgar Wind on Michelangelo', in Edgar Wind, *The Religious Symbolism of Michelangelo: The Sistine Ceiling*, ed. Elizabeth Sears, with essays by John O'Malley and Elizabeth Sears (Oxford: Oxford University Press, 2000), xvii–xl; Pablo Schneider, 'Nachwort', in Edgar Wind, *Die Bildsprache Michelangelos*, ed. Pablo Schneider (Berlin: De Gruyter, 2017), 115–26. Since a critical edition of Wind's text (hereafter abbreviated as Wind, 'School of Athens') is still in preparation, in what follows I will refer to the archival source (Bodleian, EWP, MS. Wind 216, folder 4). I am grateful to Colin Harrison, Martin Kauffmann and the staff of the Manuscript Room at the Bodleian Libraries, where I was able to study these papers.

1950s.[32] His surviving correspondence testifies to both his onsite observations and his search for documents, as he travelled to Rome and throughout central Italy – from Florence to Bologna, from Mantua to Ferrara, Rimini, Urbino – filling 'three note-books full of details', which unfortunately seem not to have survived.[33]

Between 1937 and 1938 Wind published some of his results in two contributions that have since almost always been referred to in the literature on Raphael: a short note entitled 'Platonic Justice, Designed by Raphael' in the first issue of the *Journal of the Warburg Institute*,[34] and a longer article, 'The Four Elements in Raphael's Stanza della Segnatura', which appeared in the same journal the following year.[35] Presented for the first time in three lectures given at the Warburg Institute in March 1939,[36]

32 As Wind himself registered in his application for a Guggenheim Fellowship, submitted for the first time for the academic year 1950–1, his plans for a book on Raphael's *School of Athens* went back to the year 1938 (Bodleian, EWP, MS. Wind 216, folder 1). During his research fellowship in Italy he repeatedly exchanged ideas with Italian colleagues – among them, the historian Delio Cantimori: see Giovanna Targia, 'Détails et hypothèses: Edgar Wind, Aby Warburg et *L'École d'Athènes* de Raphaël', *Revue Germanique Internationale* 28 (2018), 87–105 (98–9).

33 Wind, *The Religious Symbolism of Michalengelo*, xxvii. For an account of the loss of books, papers and photographs during the transfer from London to Northampton, see Wind's correspondence with Rudolf Wittkower, Hugo Buchthal and Gertrud Bing between February 1947 and August 1948: Bodleian, EWP, MS. Wind 7, folder 4.

34 Edgar Wind, 'Platonic Justice, Designed by Raphael', *Journal of the Warburg Institute* 1 (1937), 69–70.

35 Wind, 'The Four Elements in Raphael's "Stanza della Segnatura"', *Journal of the Warburg Institute* 2/1 (1938), 75–9.

36 The overall title was 'The Renaissance Encyclopaedia in Raphael's Frescoes'; see Bodleian, EWP, MS. Wind 6, folder 3: 'Lectures by Members of the Warburg Institute' for the months February–July 1939. Wind would repeatedly remember these lectures, also after the publication of Frances Yates' book *The French Academies of the Sixteenth Century*, as Wind complained that she had been adopting his interpretation of the Stanza della Segnatura without mentioning him as a source. See Wind's correspondence with Saxl, Wittkower and Yates, February–March 1948, starting with Wind's letter to Saxl dated 15 February 1948 ('I may say that Miss Yates repeats practically *verbatim* what I explained in my lectures at the Warburg Institute in 1939; and I am not aware that anyone observed these matters before.

this research was also the topic of several seminars, lectures and courses, delivered in Princeton and New York in 1940,[37] in Chicago in 1943, at Brown University (the Colver Lectures, 1948),[38] and at All Soul's College, Oxford (the Chichele Lectures, 1954, which dealt with the broader theme of 'Art and Scholarship under Julius II').[39] He also used the materials for these lectures in some of his classes offered at Oxford in the 1960s, and partially in his publications.[40] When his book *Pagan Mysteries in the Renaissance* came out in 1958, Wind introduced certain insights from his research on Raphael, but no autonomous essay. Invited to give the Rede Lectures in Cambridge at the end of 1959, Wind chose as his topic 'On Classicism'

Please assure her – and be yourself assured – that this does not detract in the least from my admiration of this excellent book'), and Yates' apologetic letter to Wind, 28 February 1948. Bodleian, EWP, MS. Wind 7, folder 3.

37 On Wind's lecture at Princeton, see also Erwin Panofsky to Fiske Kimball, 22 January 1940: 'Dear Kimball, this is only to tell you that Wind's lecture (on Raphael's School of Athens) will take place on Monday, February 19, at 5 o'clock in McCormick Hall.' Erwin Panofsky, *Korrespondenz 1910 bis 1968: Eine kommentierte Auswahl in fünf Bänden*, ed. Dieter Wuttke (Wiesbaden: Harrassowitz, 2001–14), vol. 2: *Korrespondenz 1937 bis 1949* (Wiesbaden: Harrassowitz, 2003), 239–40, no. 786. For an account of Wind's relationship with Panofsky, see C. Oliver O'Donnell, 'Two Modes of Midcentury Iconology', *History of Humanities* 3/1 (2018), 113–36. Wind's lectures in New York, which took place in April 1940, were recorded by the German émigré art historian Jakob Rosenberg in typewritten notes which are preserved at Los Angeles, Getty Research Institute, Special Collections, Jakob Rosenberg Research Papers, 1917–61, box 2, folder 5.

38 For notes and correspondence relating to the Colver Lectures, see Bodleian, EWP, MS. Wind 216, folder 2.

39 Lecture lists and notes are preserved in Bodleian, EWP, MS. Wind 216, folder 3.

40 For a list of Oxford lectures and classes delivered by Wind from 1954 to 1967, see Bodleian, EWP, MS. Wind 12, folder 3. See also Edgar Wind, 'A Source for Reynold's Parody of *The School of Athens*', *Harvard Library Bulletin* 3 (1949), 294–729, reprinted in Edgar Wind, *Hume and the Heroic Portrait: Studies in Eighteenth-Century Imagery*, ed. Jaynie Anderson (Oxford: Clarendon Press, 1986), 77–80, where the editor publishes also an additional note (78 n. 7) from Wind's Raphael papers, on the 'Pythagorean' tablet in *The School of Athens*.

and reshaped one of the chapters of his more comprehensive study on Raphael's *School of Athens*.[41]

This text, which he was still working on when he died,[42] is founded on at least two basic assumptions that guide both his method and its exposition: firstly, the hypothesis – widely shared in contemporary historiography – that the interpretation of Raphael's fresco should be inserted into that of the Stanza della Segnatura considered as a whole,[43] and secondly, that *The School of Athens* was designed for 'speculative' observers, much in the same way as Michelangelo's frescoes in the Sistine Chapel were 'designed to arouse meditation', as Wind wrote in his parallel book project on Michelangelo.[44]

41 See the critical edition and German translation of this text, with an interpretive essay by Franz Engel and Bernhard Buschendorf, 'Edgar Winds Cambridger Rede Lecture "On Classicism" von 1960', *Pegasus: Berliner Beiträge zum Nachleben der Antike* 18/19 (2018), 195–277.

42 See Edgar Wind to Anthony Bertram, 22 September 1968 'I am sorry to say that this book, on which I have worked for so long, is still in preparation, but I hope to bring it out in a year or two.' See also Margaret Wind to John Van Doren (executive editor of 'The Great Ideas of Today', Chicago), 30 June 1972: 'The delay in the publication of his Raphael studies worried us both. At the time of his death he was deeply engaged in his book on the Theological Sources of Michelangelo. In fact, he was working so fast one could hardly keep up with him. After the completion of that volume he intended to turn again to Raphael. The School of Athens exists in an early manuscript of which he no longer approved. He was always busy refining his texts to make them as lucid, simple and evocative as possible, yet at the same time he was very exacting in his scholarship, never wishing his interpretations to be published without precise documentation. This now poses many problems which we hope to sort out with time. He died too soon.' Both in Bodleian, EWP, MS. Wind 216, folder 2.

43 Crucial for this hypothesis was establishing the function of the Stanza. In his notes, Wind takes into account the suggestion, put forward by Franz Wickhoff among others, that the Stanza della Segnatura was the personal library of Pope Julius II (Wickhoff, 'Die Bibliothek Julius' II'). This idea was later supported by John Shearman in his fundamental essay, 'The Vatican Stanze: Functions and Decoration', *Proceedings of the British Academy* 57 (1971), 369–424. The theory is widely accepted, although there is no absolute consensus.

44 Wind, *The Religious Symbolism of Michelangelo*, 56.

At the start of his study on *The School of Athens*, Wind highlights some 'incidental features which the artist has introduced as external signs', discussing in particular what appears to him as an anomaly: the words *Timeo* and *Etica* 'written on the books held by Plato and Aristotle'.[45] According to Wind's understanding of the reception history of Plato and Aristotle, this choice was far from self-evident. In the early cinquecento, on the one hand, the imitators of Petrarch would not have felt enchanted by an old-fashioned Plato holding a *Timaeus* and appearing as a scholastic 'teacher of an abstruse cosmology, the master of that sect of occult dialecticians which culminated in Proclus',[46] and, on the other hand, Aristotle was not depicted as the *auctoritas* on syllogisms, on physics and biology, but rather as an elegant Cortegiano.[47] Wind's rather reductive account of a complex line of transmission might seem problematic: we may ask whether he is manipulating the history of tradition in order to provocatively stress a schematic opposition. Such a dualistic scheme, however, finds a counterpart on the ceiling above *The School of Athens*, where the allegory of Philosophy holds two books, inscribed *moralis* and *naturalis* respectively, thus pointing out the standard division of philosophy at the beginning of the sixteenth century which, as Wind notes, determined the visual organization of Raphael's fresco – 'the staging of *The School of Athens*'.[48]

Evoking a whole context of accessibility, circulation and organization of knowledge, and referring to the history of editions and university teaching at the time the iconographic program was designed, Wind singles out a first coordinate of interpretation that is not so far removed from the ones proposed by previous scholarship. At least since the late nineteenth century, classic studies by Anton Springer[49] and Julius von Schlosser[50]

45 Wind, 'School of Athens', fol. [1].
46 Wind, 'School of Athens', fol. [2], discarded text passage.
47 Wind, 'School of Athens', fols [2–3], with reference to a passage on Aristotle in Baldassarre Castiglione's *Il libro del cortegiano*, book IV, chapter 47.
48 Wind, 'School of Athens', fol. [4].
49 Springer, 'Raphael's *Schule von Athen*'.
50 Julius von Schlosser, 'Giusto's Fresken in Padua und die Vorläufer der Stanza della Segnatura', *Jahrbuch der kunsthistorischen Sammlungen des Allerhöchsten Kaiserhauses* 17 (1896), 13–100.

interpreted Raphael's *School of Athens* and the decoration on the vault of the Stanza as directly derived from the medieval tradition of allegorical representations of Philosophy and the seven liberal arts. Sources could be traced back at least to Martianus Capella's fifth-century *De nuptiis Philologiae et Mercurii*,[51] and these could be seen as informing programs executed only a few years before, including Perugino's frescoes in the Collegio del Cambio and Pinturicchio's allegories in the Appartamento Borgia, one floor below the Stanze in the Apostolic Palace.

Wind was able to challenge this classificatory, symmetrical model, however, which neither accounted for the more comprehensive, holistic view of philosophy conveyed through the organic program of the Stanza della Segnatura, nor explained the frequent alterations of visual symmetry, or the 'visual dissonances' that, as Wind stresses, Raphael introduced in *The School of Athens* in particular.[52]

In order to account for such deviations from symmetry, Wind introduces a further coordinate into his interpretation, which might be defined as 'relational'. He aims not so much to find a criterion for the division and classification of sciences, but rather to reflect on the problem of the foundations both of the single disciplines and of their reciprocal relations. Wind finds this line of research emblematically summarized in a quotation from the *Oratio sive Encomium artium liberalium* of the Ferrarese humanist Celio Calcagnini: 'Ex quo illud vere dictum intelligitur, nullam esse disciplinam, quae sua probet principia. Ex proxima enim & cognata subsidium petit, & alienis radijs illustrari postulat.'[53] This is a characteristic

51 As pointed out by Most, *Raffael: Die Schule von Athen*, 30.

52 See Wind, 'School of Athens', fol. [40], where he notes that Raphael had also introduced notes of 'discord which would deepen the harmony of the rest of the composition'.

53 Celio Calcagnini, 'Oratio sive Encomion artium liberalium', in Celio Calcagnini, *Opera aliquot* (Basel: Froben, 1544), 552–5 (553). In Wind's own English translation: 'no science probes its own principles, because it seeks aid from the one next to it and nearest in kind, and demands to be enlightened by extraneous rays': Wind, 'School of Athens', fols [5] and [99]. On Calcagnini in general, see Quirinus Breen, 'Celio Calcagnini (1479–1541)', *Church History* 21/3 (September 1952), 225–38, as well as the corresponding entry in the *Dizionario biografico degli italiani* 16 (1973), 492–8.

formulation of Renaissance debates on the nature of 'encyclopaedia' and, Wind writes, 'might serve as a motto for *The School of Athens*':[54] it substitutes linear and discrete taxonomies with an ideal of learning as an organic body, whose scope is not to be exhaustive, but rather to be functional and organized as a living being.

The group of 'Pythagoras' according to Wind

Turning from a consideration of the overall composition to the analysis of single groups of figures, Wind starts from the right-hand section (Figure 3.4) and identifies in the foreground the 'philosophers of nature on the side of Minerva':[55] first comes the group of the 'geometers' surrounding the figure that Wind, along with the majority of scholars, interprets as Euclid; then two representatives of cosmological theories, their attributes being the terrestrial and celestial globes; and finally the two portraits on the far right, the self-portrait of Raphael himself and, next to him, a figure that Wind interprets as his humanist adviser. Only on this last point does Wind deviate from the more common opinion, according to which the figure portrayed next to Raphael is a painter – Perugino or

54 Wind, 'School of Athens', fol. [99]. This idea of a unitary foundation of the sciences conceived as members of a living body is also what legitimized Calcagnini's forays into territories outside disciplinary specializations, despite critics who called him vagrant and desultory, as the Ferrarese humanist wrote in a letter to his nephew Tommaso (see Calcagnini, *Opera*, 22–3). On the parallel between the organization of the Kulturwissenschaftliche Bibliothek Warburg – as it was described for instance by Ernst Cassirer in the dedicatory letter of his *Individuum und Kosmos in der Philosophie der Renaissance* (Leipzig: Teubner, 1927), v – and Wind's understanding of the encyclopaedic character of the *School of Athens*, see in particular Griener, 'Edgar Wind und das Problem der Schule von Athen'. More broadly, on Wind's insistence on the topic of the 'encyclopaedic imagination', see Elizabeth Sears' article in the present volume.

55 Wind, 'School of Athens', fol. [6].

Sodoma (as Giovanni Morelli proposed) – although even today, there is
no scholarly consensus on his identity.[56]

Rather than indulge in riddle-solving for its own sake, Wind identifies
specific figures only as the result of his close readings of single details. So,
for instance, his identification of the central character in the group of the
'geometers' as Euclid starts from the analysis of the theorem illustrated on
his blackboard, intimately connected to the Platonic doctrine of the five
regular solids as expounded in the *Timaeus*, and which stimulated, more
broadly, the mathematical imagination of the Renaissance. By demon-
strating that Euclid's *Elements* was 'treasured as a code-book of Platonic
cosmology', and adding that the doctrine of the five solids 'enjoyed its
greatest vogue' when *The School of Athens* was painted,[57] Wind is able to
discard an alternative identification of the figure as Archimedes.

Another identification resulting from deeper research into a detail is
that of the more mysterious seated figure in the left-hand group, discussed
earlier, nowadays identified by the majority of interpreters as Heraclitus;
it was added by Raphael at a later point, as shown by its absence from the
preparatory cartoon in the Pinacoteca Ambrosiana (Figure 3.5).[58] In this

56 See Giovanni Morelli, *Die Werke italienischer Meister in den Galerien von
 München, Dresden und Berlin* (Leipzig: Seemann, 1880), 472. For recent discus-
 sions, see Matthias Winner, 'Progetti ed esecuzione nella Stanza della Segnatura',
 in Guido Cornini, Christiane Denker Nesselrath and Anna Maria De Strobel, eds,
 Raffaello nell'appartamento di Giulio II e Leone X (Milan: Electa, 1993), 247–91
 (264) ('un compagno sconosciuto'); Frommel, *Raffael: Die Stanzen im Vatikan*, 22
 ('vermutlich Giuliano da Sangallo').

57 Wind, 'School of Athens', fols [9–10]. Plato, *Timaeus*, 53c–57d; see also Francis
 Macdonald Cornford, *Plato's Cosmology: The Timaeus of Plato Translated with a
 Running Commentary* (New York: Liberal Arts Press, 1937). Among recent explor-
 ations of Raphael's knowledge of mathematicians at the time he painted his *School
 of Athens*, see Ingrid Alexander-Skipnes, 'Mathematical Imagination in Raphael's
 School of Athens', in Ingrid Alexander-Skipnes, ed., *Visual Culture and Mathematics
 in the Early Modern Period* (New York: Routledge, 2017), 150–76.

58 Wind refers to Luca Beltrami, *Il cartone di Raffaello Sanzio per la Scuola d'Atene
 in Vaticano* (Milan: Alfieri & Lacroix, 1920). See also Konrad Oberhuber and
 Lamberto Vitali, *Raffaello: Il cartone per la Scuola di Atene* (Milan: Silvana,
 1972); Alberto Rocca, *Il Raffaello dell'Ambrosiana: In principio era il cartone*
 (Milan: Electa, 2019).

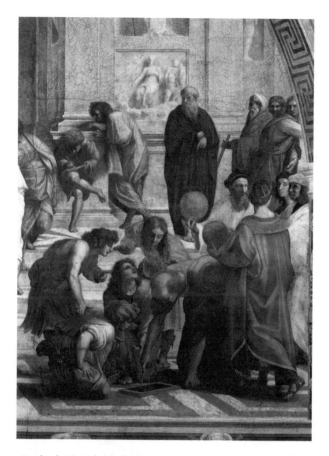

Figure 3.4: Raphael, *The School of Athens*, c. 1509–11, fresco. Detail of the group in the right foreground. Stanza della Segnatura, Apostolic Palace, Vatican Museums, Rome. © Foto Scala, Florence.

effort too, Wind's reading might seem problematic or at least arbitrary. While the symmetrical disposition of the groups of figures confirmed by the Ambrosiana cartoon might indeed support an identification of the older man in profile who sits writing, surrounded by his disciples, the pendant figure to Euclid, as Pythagoras, Wind suggests another possibility. Drawing on his argument as to the 'relational' – and not only symmetrical – character of the iconographic program of the Stanza della

Figure 3.5: Raphael, preliminary cartoon for *The School of Athens*, 1509, charcoal, black chalk, and white highlights, 285 × 804 cm. Biblioteca Ambrosiana, inv. 126, Milan. © Foto Scala, Florence, courtesy Ministero Beni e Attività Culturali e del Turismo.

Segnatura, he identifies the added figure, the 'melancholic', as Pythagoras. He puts forward this idea in a chapter titled 'The Harmony of Numbers', adducing a number of sources pivoting on Giovanni Pico's doctrine of the *Concordia Platonis et Aristotelis*.[59]

The difficult matching of textual and visual evidence enhances, in this case, the attention to details, even though it leads to a rather counter-intuitive conclusion. The new identification enables Wind to draw an extended parallel between the Pythagorean and the Euclidean groups, which he interprets as 'a crescendo from right to left' of the fresco.[60] This also implies that, for Wind, the figure in profile most commonly interpreted as Pythagoras must be reidentified, and he suggests that this is Boethius.[61] His demonstration revolves around the diagram on the tablet held by a

59 Wind, 'School of Athens', fol. [19], with reference to Pico's *Heptaplus* (in Giovanni Pico della Mirandola, *De hominis dignitate. Heptaplus. De ente et uno. E scritti vari*, ed. Eugenio Garin (Florence: Vallecchi, 1942), 169–383 (172), in which Pythagoras is characterized as 'silentii magister').

60 Wind, *Art and Anarchy*, 159 n. 114. The opposite thesis, arguing for Raphael's tendency to work from left to right, has been expressed for instance by Most, *Raffael: Die Schule von Athen*, 50.

61 Wind, 'School of Athens', fols [21–5].

youth in front of this figure – one of the most studied details of the fresco.[62] According to Wind, this diagram is derived from the illustration to a particular proposition in Boethius' *Institutio arithmetica*, the theorem of the *maxima harmonia*, based on the definition of four different musical intervals in mathematical terms, in the same way as they are defined in Plato's *Timaeus*.[63] For this figurative equivalent of an antonomasia, Wind seeks to adduce sources that must have been known to the painter, in which the discovery of the theorem was attributed to Boethius.[64]

Having detected 'a strictly symmetrical argument' in the groups in the proscenium, from right to left, Wind remarks that, after the addition of the figure of Pythagoras, 'in the visual distribution of the figures there is an overwhelming preponderance on the side of the Pythagoreans'.[65] He goes so far as to write that 'to imagine *The School of Athens* without Pythagoras is intellectually less difficult than visually',[66] and analyses the individual visual articulations of the various groups as altered in consequence of the addition of this last figure.

Here, as well as in other passages of his text, Wind is seen grappling with a dilemma similar to that of squaring the circle:[67] he does not want

62 Among the numerous contributions see Emil Naumann, 'Erklärung der Musiktafel in Raffaels "Schule von Athen"', *Zeitschrift für bildende Kunst* 14 (1879), 1–14; Hermann Hettner, *Italienische Studien: Zur Geschichte der Renaissannce* (Braunschweig: Vieweg, 1879), 190–212; Rudolf Wittkower, *Architectural Principles in the Age of Humanism* (London: Warburg Institute, 1949), 109–10. See also Konrad Oberhuber, *Polarität und Synthese in Raphaels "Schule von Athen"* (Stuttgart: Urachhaus, 1983), 60, 121–3; Matthias Winner, 'The Mathematical Sciences in Raphael's School of Athens', in Wolfgang Lefèvre, Jürgen Renn and Urs Schoepflin, eds, *The Power of Images in Early Modern Science* (Basel: Birkhäuser, 2003), 269–308; Alexander-Skipnet, 'Mathematical Imagination in Raphael's *School of Athens*', 164, 174 n. 56, emphasizing that in the Ambrosiana cartoon there is no diagram on the tablet.

63 Wind, 'School of Athens', fol. [22].

64 Wind, 'School of Athens', fols [23–6].

65 Wind, 'School of Athens', fol. [39].

66 Wind, 'School of Athens', where he also notes: 'However startling and strange, this observation is confirmed by the inherent evidence of the painting.'

67 Wind, 'School of Athens', fol. [10].

to dismiss any of the elements involved, and not only does he try to integrate 'extrinsic' factors with 'the inherent evidence of the painting',[68] but also he postulates that Raphael effectively transposed a philosophical argument into a pictorial composition through a persuasive visual rhetoric. Wind's holistic understanding of Raphael's fresco constitutes one of the most detailed exemplifications of the method he often advocated in more theoretical interventions, from his early writings on the 'systematics of artistic problems'[69] and on the concept of *Kulturwissenschaft* as proposed by Warburg,[70] through to his Reith Lectures of the early 1960s.

Wind and art-historical formalism: 'How vision operates'

While in his early years Wind argued against art-historical formalism largely by emphasizing conceptual antitheses, his polemical strategy in his later interventions seems to have gradually become more complicated and nuanced as he explored different versions of formalism, and sometimes made his opponents' arguments his own. In the 1920s, for instance, while intervening in the continuing debate on the foundations of *Kunstwissenschaft*, he operated through binary alternatives in order to define the field of objects pertaining to a scientific study of art in contrast to philosophical aesthetics. He not only distinguished between 'pre-artistic tasks' and 'artistic problems',[71] but he also proceeded from a clear-cut distinction between the respective roles of intellect and imagination

68 Wind, 'School of Athens', fol. [39].
69 Wind, 'Zur Systematik der künstlerischen Probleme'; English translation by Fiona Elliott, 'On the Systematics of Artistic Problems', *Art in Translation* 1/2 (2009), 211–57.
70 Wind, 'Warburgs Begriff der Kulturwissenschaft'.
71 Wind 'Zur Systematik der künstlerischen Probleme', 439–41; Engl. trans., 213–15. See also on this point Andrea Pinotti, 'Wind, Warburg et la Kunstwissenschaft comme Kulturwissenschaft', *Zeitschrift für Ästhetik und Allgemeine Kunstwissenschaft* 61/2 (2016), 267–79.

in posing and solving artistic problems.[72] As to his contribution to the problem of the 'fundamental principles' or *Grundbegriffe* of artistic figuration, he discussed the table of binary 'categories' put forward by Wölfflin, pointing out what he saw as its inadequacies. Further, in order to redefine Wölfflin's antithetical oppositions, which he considered inexact and indeterminate, he extended these beyond the sphere of formal or 'qualitative appearance' into that of the subject matter and the emotional content of works of art (the spheres of the 'appearing thing' and of 'self-manifesting life', as he put it).[73] In so doing, Wind constructed a scheme still based on binary concepts, though conceived as polarities rather than simple antitheses.

In his fundamental lecture 'Warburg's Concept of *Kulturwissenschaft* and its Meaning for Aesthetics', delivered in October 1930 and published one year later, Wind further elaborated on his anti-formalist polemic, as a sort of counterpoint to his more extensive reflections on symbols and the functioning of cultural memory.[74] This time he drew a closer association between the positions of Wölfflin and Alois Riegl as representatives of what, in his opinion, was an improper dualistic distinction between contents and means of expression.[75] In this text, however, despite his rejection of a purely psychological theory of vision, Wind did not completely dismiss the possibility of focusing on perceptual conditions in order to appreciate

72　Wind, *Ästhetischer und kunstwissenschaftlicher Gegenstand*, 232–3. See Franz Engel, 'Though This Be Madness: Edgar Wind and the Warburg Tradition', in Sabine Marienberg and Jürgen Trabant, eds, *Bildakt at the Warburg Institute* (Berlin: De Gruyter, 2014), 87–115 (91).

73　Wind, 'Zur Systematik der künstlerischen Probleme', 462–72; Engl. trans., 232–40.

74　Wind, 'Warburgs Begriff der Kulturwissenschaft', 163–9. For an analysis of the philosophical sources of these reflections on symbols and memory, see Tullio Viola, 'Edgar Wind on Symbols and Memory: Pragmatist Traces on a Warburgian Path', *Visual History* 6 (2020), 99–118.

75　Wind, 'Warburgs Begriff der Kulturwissenschaft', 163–5, 168. More articulated reflections were annotated in the working manuscript for this lecture, where Wind adds, among other things, quotations and closer remarks on Riegl's anti-Semperian polemic. Bodleian, EWP, MS. Wind 58, folder 5, fols [8a–9a]. I am grateful to Professor Bernhard Buschendorf for pointing out to me the importance of this manuscript.

and interpret works of art, which was one of the basic concerns of formalist approaches. He rather integrated it into the broad anthropological framework investigated by Warburg.[76]

In later interventions, he would eventually propose to redefine, more generally, the role of perception. So in his inaugural lecture at the University of Oxford, 'The Fallacy of Pure Art', given in 1957, he summarized at some length the arguments of formalist theories but, instead of simply pointing out their one-sidedness from the standpoint of the historian of cultural memory, he concluded that 'a belief in art as pure vision rests on a mistaken theory of how vision operates'.[77] A one-sided contextualism, he seems to imply, cannot effectively counter the fundamental theoretical flaws of a one-sided formalism. It is with reference to this methodological question that here, as well as in his Reith Lectures, Wind introduces inferences drawn from his longstanding work on Raphael's *School of Athens* to 'how vision operates'. He argues for an intimate complementarity between extrinsic factors and formal appreciation, employing precisely the aesthetic experience (that is, his opponents' main argument) to assess the validity of a potentially vague and ineffective iconographic interpretation.[78] Clearly, there is an inherent risk of a vicious circularity in this way of proceeding, as Wind himself was prepared to acknowledge.[79] And in fact, his identification

76 Wind, 'Warburgs Begriff der Kulturwissenschaft', 174–7.

77 Quoted after Thomas, *Edgar Wind and Modern Art*, 164. See also Bernhard Buschendorf, 'Das Prinzip der inneren Grenzsetzung und seine methodologische Bedeutung für die Kulturwissenschaften', in Edgar Wind, *Das Experiment und die Metaphysik: Zur Auflösung der kosmologischen Antinomien* (Tübingen: Mohr, 1934); new edition by Bernhard Buschendorf, with a foreword by Brigitte Falkenburg and an afterword by Bernhard Buschendorf (Frankfurt: Suhrkamp, 2001), 301–26.

78 See the well-known passage in Wind, *Art and Anarchy*, 62.

79 See Wind, *Pagan Mysteries in the Renaissance* (Oxford: Oxford University Press, 1958), 16 n. 47, and Wind, 'School of Athens', fol. [11]. See also Wind's earlier reflections on the 'hermeneutical circle' in Edgar Wind, 'Some Points of Contact between History and Natural Science', in Raymond Klibansky and Herbert James Paton, eds, *Philosophy and History: Essays Presented to Ernst Cassirer* (Oxford: Clarendon Press, 1936), 255–64. For a critique based on a specific case of circular interpretation, see Carlo Ginzburg, 'Da A. Warburg a E. H. Gombrich: Note su un problema di metodo' [1966], in Carlo Ginzburg, *Miti emblem spie: Morfologia e storia* (Turin: Einaudi, 2000), 29–106 (50–1).

of Pythagoras in Raphael's fresco cannot be considered as thoroughly and convincingly demonstrated – leaving, among others, the question of the successive changes in the iconographical program still open. Nevertheless, it may help the interpreter to explore a 'border region' that would probably otherwise remain overlooked.[80]

And even if Wölfflin's way of looking at Raphael may appear more solid in the light of such considerations, his straightforward description of an endlessly rich variation of physical and psychological postures as the only focal point of interpretation still leaves several questions unanswered. The very style of his verbal description accentuates a divide between perception and erudition: he insists on the psychological response to the painting conceived as an impressive 'decorative' accomplishment – using the term 'decorative' in the technical sense borrowed from contemporary artists.[81] Internal, optical elements, however, assume a clear pre-eminence over external factors only inasmuch as they simply elude the latter's existence. By contrast, it is by polemicizing on his adversary's very same ground – that of perception and its verbalization – that Wind seeks to expose the inadequacies of Wölfflin's position, questioning the hierarchy of the internal and external conditions underlying Raphael's painting.

80 Wind, 'School of Athens', fol. [11].
81 Wölfflin, *Die klassische Kunst*, 86–7 and n. 1, with reference to Arnold Böcklin's expression 'das Gross-Dekorative in den Bildern'.

TULLIO VIOLA

4 Philosophy of Culture: Naturalistic or Transcendental? A Dialogue between Edgar Wind and Ernst Cassirer

Introduction: A Hamburg debate on the nature of symbols

This essay seeks to reconstruct an indirect dialogue that occurred in the early 1930s between Edgar Wind and his former mentor, Ernst Cassirer. At the centre of this dialogue is the Fourth Congress of Aesthetics and *Kunstwissenschaft*, held in Hamburg in October 1930.[1] Cassirer served as the chair of the organizing committee, and the members of the Warburg Library played a significant role in planning the event. Wind and Cassirer each delivered a lecture, yet they expressed contrasting views on the scope and purport of a philosophical investigation of culture. The full significance of their differing views becomes clear once we consider their

1 For information on the conference's program, as well as a short account of its history, see the original proceedings (where Wind's and Cassirer's lectures were first printed): Hermann Noack, ed., *Vierter Kongress für Ästhetik und allgemeine Kunstwissenschaft. Hamburg, 7.–9. Oktober 1930*, supplement to the *Zeitschrift für Ästhetik und allgemeine Kunstwissenschaft* 25 (Stuttgart: Ferdinand Enke, 1931). See also Elizabeth Sears, 'Walter Riezler on the Unity of the Arts: Unsiloing Art and Music in the Weimar Era', in Bryan Parkhurst and Jeffrey Swinkin, eds, *Perspectives on Contemporary Music Theory: Essays in Honor of Kevin Korsyn* (London: Routledge, 2023).

lectures in relation to other texts written in the years just before and after the event.[2]

We may take as the focal point of the dialogue between Wind and Cassirer a relatively circumscribed problem, namely the link between memory and symbols, a link that both authors considered crucial in understanding the dynamics of cultural phenomena. On what basis should we account for the human faculty of representing the past as past in the present? And what is the relationship between this basic human faculty and the ability to use symbols to refer to objects that are not immediately available in our environment? As I will explain in greater detail below, Wind leaned towards a naturalistic answer to these questions. That is, he stressed how both the mnemonic and the symbolic faculties of human beings emerge out of basic physiological processes. This was consistent with his attempt to elaborate a philosophical conception of culture strongly influenced by a variety of pragmatist experimentalism. In contrast, Cassirer adhered to a transcendental perspective rooted in his neo-Kantian background. In his view, a philosophical account of memory and symbols should be concerned less with human physiology than with an inquiry into the *a priori* conditions of our representation of time.

Towards the end of the present chapter, however, I will show that the naturalist and the transcendental approaches to memory, symbols and culture need not be viewed as entirely opposed to one another.[3] This is all the

2 On the philosophical relation between Wind and Cassirer, see Franz Engel, '"In einem sehr geläuterten Sinne sind Sie doch eigentlich ein Empirist!"': Ernst Cassirer und Edgar Wind im Streit um die Verkörperung von Symbolen', in Markus Rath and Ulrike Feist, eds, *Et in imagine ego: Facetten von Bildakt und Verkörperung* (Berlin: Akademie, 2012), 369–92; Bernhard Buschendorf, '"War ein sehr tüchtiges gegenseitiges Fördern"': Edgar Wind und Aby Warburg', *Idea* 4 (1985), 165–209; John Michael Krois, 'Kunst und Wissenschaft in Edgar Winds Philosophie der Verkörperung', in Horst Bredekamp, Bernhard Buschendorf, Freia Hartung and John Michael Krois, eds, *Edgar Wind: Kunsthistoriker und Philosoph* (Berlin: Akademie, 1998), 181–205.

3 A good entry point to the vast literature on naturalism and transcendental philosophy is Joel Smith and Peter Sullivan, eds, *Transcendental Philosophy and Naturalism* (Oxford: Oxford University Press, 2011). For more specific references, see below.

more evident as both Wind and Cassirer show a shared concern in revising some of the assumptions traditionally associated with these philosophical outlooks. Still, it remains essential to acknowledge the distinctions between their views. As we shall see, these differences encompass not only questions about time, memory and symbols, but also ethical considerations about freedom and autonomy, as well as methodological issues pertaining to the study of the cultural sciences.

Wind's lecture on Warburg: Time, memory and symbols

Let me start with Edgar Wind's lecture 'Warburg's Concept of *Kulturwissenschaft* and its Meaning for Aesthetics',[4] delivered at the end of the second day of the Hamburg congress. The lecture took place after a guided tour of the Warburg Library led by the library's director, Fritz Saxl. It had at least three related objectives. First, Wind sought to introduce his audience to the research methodology of the Warburg Library. Second, he wished to pay homage to the library's founder, who was initially supposed to give a lecture himself, had he not died the year before. Third, he aimed to advance an interpretation of Warburg's work through filters that would bring out its full philosophical purport.[5]

4 Edgar Wind, 'Warburgs Begriff der Kulturwissenschaft und seine Bedeutung für die Ästhetik' (1931), in John Michael Krois and Roberto Ohrt, eds, *Heilige Furcht und andere Schriften zum Verhältnis von Kunst und Philosophie* (Hamburg: Philo Fine Arts, 2009), 83–111. Engl. trans: 'Warburg's Concept of *Kulturwissenschaft* and its Meaning for Aesthetics', in Edgar Wind, *The Eloquence of Symbols: Studies in Humanist Art*, ed. Jaynie Anderson, with a biographical memoir by Hugh Lloyd-Jones (rev. edn, Oxford: Clarendon Press, 1993), 21–36.

5 On Wind's relation to Warburg, see for example Andrea Pinotti, 'Wind, Warburg et la "Kunstwissenschaft" comme "Kulturwissenschaft"', *Zeitschrift für Ästhetik und allgemeine Kunstwissenschaft* 61/2 (2016), 267–79. I have analysed the role of pragmatism in Wind's interpretation of Warburg in Tullio Viola, 'Edgar Wind on Symbols and Memory: Pragmatist Traces on a Warburgian Path', *Visual History* 6 (2020), 99–118.

One of the problems that Wind discussed in his lecture is Warburg's understanding of artistic expression and its relation to other, non-artistic, forms of symbolization, such as ordinary language, bodily gestures, and the expressive use of artefacts. He approached this problem by asking a question of genealogy: how does art arise from simpler forms of expression? We can best understand Warburg's answer to this question, Wind went on to explain, if we contrast it with a conventional notion in post-Kantian philosophy, exemplified, for instance, by Friedrich Schleiermacher: the idea that art arises through the creation of a distance, a gap of reflection [*Besinnung*], between sensory stimuli and our reactions to those stimuli. While Warburg would have accepted this basic assumption, he would have distanced himself from another aspect of Schleiermacher's theory, namely his dualism. Schleiermacher saw the 'artless' and the 'artistic' phenomena as separated by a cleavage. Artless phenomena are the realm of immediacy and are marked by an absence of reflection; artistic phenomena, on the contrary, are the realm of *Besinnung*, a 'higher faculty' that remains, however, unexplained.[6]

Warburg, by contrast, postulated no break, but rather a robust continuity, between the artless and the artistic. The key to making this continuity plausible, according to Wind, is to claim that the emergence of *Besinnung* is gradual. This idea is supported by physiological observations, which show that 'even in its most elementary form the phenomenon of expression is associated with a minimum of reflection'. Which is why Wind concluded that in order to reject Schleiermacher's dualism it is sufficient to look at 'the way the human body functions'. Far from being a separate and purely intellectual faculty, *Besinnung* is an ever-present element, even in minimal measure, in every act of expression.[7]

6 Wind, 'Warburg's Concept of *Kulturwissenschaft*', 29–30. See Friedrich Schleiermacher, 'Über den Umfang des Begriffs der Kunst in Bezug auf die Theorie derselben' (1831), in Martin Rössler and Lars Emersleben, eds, *Akademievorträge* (Berlin: De Gruyter, 2002), 727–42. On Wind's reference to Schleiermacher, see Gregorio Tenti, 'Estetica del *Bilderatlas*: Schleiermacher con Warburg', *La rivista di engramma* 184 (September 2021), 15–30.

7 Wind, 'Warburg's Concept of *Kulturwissenschaft*', 30–1.

To explain further in what sense this is true, Wind focused on the physiological role of memory, drawing upon the work of German physiologist Ewald Hering, one of Aby Warburg's key sources.[8] According to Hering, memory is not a purely mental faculty, but rather a 'function' of organic matter. It is, in other words, the ability to retain traces of past experiences and develop mental and bodily habits based on the accumulation of those traces. These mental and bodily habits, in turn, play a pivotal role in the genesis of higher cognitive faculties. According to this view, the concept of memory serves as a bridge between matter and spirit, elucidating the gradual emergence of mental capacities, or *Besinnung*. Moreover, Hering's theory of memory promised to offer an explanation of how culture is transmitted across generations, since Hering thought that the habits acquired by an individual could be inherited by their offspring. Wind did not endorse this latter assumption (which relies on the no longer accepted idea of the biological transmission of acquired cultural traits), but the relevance of Hering's study to debates on cultural or social memory is nonetheless crucial to understanding its continued influence on the Warburg circle.[9]

Equipped with Hering's physiological account of memory, Wind could go on to suggest that the act of expression is made possible by the presence of mnemic traces. More specifically, it is made possible by the ability to react to stimuli that are no longer present but have nonetheless left a trace on the body. Repetition and habit make some of these traces particularly salient, and this explains how some movements acquire a mimetic function over and above their immediate physical function. Instead of reacting to a stimulus that is immediately present, muscles may react mimetically to

8 Ewald Hering, 'Über das Gedächtnis als eine allgemeine Funktion der organisierten Materie' (1870), in Ewald Hering, *Fünf Reden* (Leipzig: Engelmann, 1921), 5–31.

9 See Andrea Pinotti, 'Materia è memoria: Aby Warburg e le teorie della Mneme', in Benedetta Cestelli Guidi, Micol Forti and Manuela Pallotto, eds, *Lo sguardo di Giano: Aby Warburg tra tempo e memoria* (Turin: Nino Aragno, 2004), 53–78; Claudia Wedepohl, 'Mnemonics, Mneme and Mnemosyne: Aby Warburg's Theory of Memory', *Bruniana & Campanelliana* 20/2 (2014), 385–402; Giovanna Targia, 'Modelli biologici per la trasmissione culturale: Tracce del dialogo con Jolles nei Frammenti sull'espressione di Aby Warburg', *Cahiers d'études italiennes* 23 (2016), 61–71. I return to this point in the conclusion.

stimuli that have presented themselves in the past but have since subsided, and of which only a trace is left. For instance, when we express disgust we use the same muscles that are activated when we are actually sick. That is, we use those muscles mimetically, by reacting to stimuli that are not present at that moment (the stimuli of physical malaise) but which have left a mark on our body and have therefore contributed to the development of a habit of action.[10]

This mimetic (or expressive) function of muscles is in turn the first step on a scale of increasing complexity that culminates in artistic expression. Going one step beyond the boundaries of our body, we find the same dynamic at play in the expressive use of practical implements: in the symbolic meaning we associate with clothes, for example. This entails a greater distance between stimulus and response (as well as a greater role for reflection) than the simple movement of our body. Increasing that distance even further, we reach the domain of art. Artistic expression is therefore not – as Schleiermacher had suggested – the product of a spiritual force that enters the scene more or less abruptly. Rather, it lies on the upper end of a continuous spectrum of expressive acts that starts with the simplest movements of the body.

Cassirer's objections to naturalism

We don't know whether Cassirer – the leading figure of the congress – attended Wind's lecture. (The lecture was not part of a plenary session but required extra registration.) However, the third volume of Cassirer's epoch-making *Philosophy of Symbolic Forms*, which had come out just the year before, contained some explicit objections to the philosophical presuppositions of the physiological literature on memory on which Wind's argument was based. These objections are located in the second and

10 Wind, 'Warburg's Concept of *Kulturwissenschaft*', 31.

central part of the volume titled 'The Problem of Representation and the Building of the Intuitive World'.[11]

Cassirer's project in this part of the book was to account for the way in which we articulate the manifold of perception and let stable objects emerge out of that manifold, thus contributing to the construction of an intersubjectively shared world. He divided the main bulk of this study into three closely connected chapters: one on the relationship between objects and their attributes (chapter II), one on the intuition of space (chapter III), and one on the intuition of time (chapter IV). These three chapters are tightly bound up to one another. In the latter two, in particular, the Kantian motive is quite explicit: the intuition of space and time are the two main avenues to an objective experience of the world.

The chapter on the intuition of time is particularly relevant for us, as it contains an explicit critical discussion of 'naturalistic' and empiricist philosophies. The overall problem here is figuring out how a subject acquires the ability to articulate the flow of experience along a temporal axis by distinguishing what comes before and what comes after. Or to put it in a slightly different way, Cassirer sought to understand how a subject differentiates between past, present and future in order to construct a representation of a temporal succession. The main problem with empiricism, in his opinion, is that it seeks to derive the representation of time from the mere sequence of impressions. Hume, for instance, argued that 'five notes played on a flute give us the impression and idea of time'. Thus the representation of time would arise 'from a certain form of noticing and considering sensuous impressions and objects'. But Cassirer objected that the 'succession of representations' [*Nacheinander der Vorstellungen*] is not enough to explain the 'representation of succession' [*Vorstellung des Nacheinander*], as there is a substantial qualitative difference between the

11 Ernst Cassirer, *Philosophie der symbolischen Formen. Dritter Teil. Phänomenologie der Erkenntnis* (1929), ed. Julia Clemens and Birgit Recki, Ernst Cassirer, Gesammelte Werke, vol. 13 (Hamburg: Felix Meiner, 2002), 119–322; Engl. trans.: Ernst Cassirer, *The Philosophy of Symbolic Forms. Volume 3: The Phenomenology of Knowledge*, trans. Ralph Manheim (New Haven: Yale University Press, 1957), 105–278.

two phenomena. You cannot derive a consciousness of a temporal succession from the mere succession of impressions.[12]

Cassirer levelled a very similar objection against more recent 'naturalistic psychology', which sought to explain memory on the basis of the 'retention' of traces. His most direct target here was a German biologist closely associated with Ewald Hering, namely Richard Semon.[13] Like Hering, Semon had been a crucial influence for Warburg. In a book entitled *Die Mneme als erhaltendes Prinzip im Wechsel des organischen Geschehens* (1904), he had coined concepts that the Hamburg art historian would subsequently adopt, such as *mneme* and *engram*. ('Mneme', in Semon's idiom, means the faculty of memory in the broadest sense of the word; 'engram' refers to the material trace that stimuli leave on organic matter.) Semon also explicitly acknowledged Hering's influence: both authors had in common the project of turning the concept of memory into the paramount and unifying principle of organic life, as well as into the most conspicuous link between matter and mind.[14]

Against Semon's attempt to turn the concept of 'engram' into the key to the analysis of mind, Cassirer observed that the 'retention' of the past is something very different from the 'representation' of it. It is impossible to acquire an intellectual awareness that the object of my representation lies

12 Cassirer, *The Philosophy of Symbolic Forms. Volume 3*, 173 (translation slightly modified). David Hume's quote is in David Hume, *A Treatise of Human Nature: A Critical Edition*, ed. David Fate Norton and Mary J. Norton (Oxford: Clarendon Press, 2007), 29. On Cassirer's argument, see Oswald Schwemmer, *Ernst Cassirer: Ein Philosoph der europäischen Moderne* (Berlin: Akademie, 1997), 99.

13 Cassirer would mention Hering and Semon together in a later reprise of the same criticism of naturalistic account of memory. See Ernst Cassirer, *An Essay on Man: An Introduction to a Philosophy of Human Culture* (1944), ed. Maureen Lukay and Birgit Recki, Ernst Cassirer, Gesammelte Werke, vol. 23 (Hamburg: Felix Meiner, 2006), 56–7.

14 Richard Semon, *Die Mneme als erhaltendes Prinzip im Wechsel des organischen Geschehens* (Leipzig: Wilhelm Engelmann, 1904), iii–v. Cf. Pinotti, 'Materia è memoria', 68–76. Cassirer did not mention Semon's influenced on Warburg. He was more explicit about his adoption in the work of Bertrand Russell. See Cassirer, *The Philosophy of Symbolic Forms. Volume 3*, 174.

in the past only because I have retained a trace of past events in my body. The two phenomena – retention and representation – are different in kind.

> Only a consciousness that knows how to distinguish between present, past, and future and to recognize the past in the present can link the present with the past, can see in the present a continuance of the past. This differentiation remains in every instance the radical act, the primordial phenomenon that cannot be explained by any causal derivation because it must be presupposed in every causal explanation [*das Urphänomen, das durch keine kausale Ableitung erklärt werden kann, weil es bei jeglicher kausalen Erklarung vorausgesetzt werden muss*]. [...] Even though engrams and traces of the 'earlier' may be left behind, these factual vestiges [*sachliche Rückstände*] do not in themselves explain the characteristic form of relation to the past [*Rückbeziehung*].[15]

Cassirer's reference to time as a 'primordial phenomenon' is particularly significant, and betrays the overall Kantian slant of his argument: it does not stand to reason, he argued, to try and reduce our representation of a temporal order to other causes, because that representation is itself a necessary condition of our perception of causes.

Cassirer's argument against Semon in the chapter on time parallels a similar argument against Hering in the chapter on objects and attributes. This argument concerns a problem wholly analogous to the one I just discussed: namely, the subject's ability to construct stable representations of objects out of the manifold of perception. According to Hering, memory plays a crucial role in integrating the immediate sensory impression in constructing a stable perception of objects. For example, we see an object as having a colour that remains relatively stable at all atmospheric conditions, because we combine the sensory impressions that hit our nerves at a given time with the colour of that object as it has been sedimented in our memory. This explanation, commented Cassirer, allowed Hering to interpret perception as a 'mnemic' phenomenon. So he made essentially the same objection that he had levelled against Semon: the integration of sensory data with past experiences is not sufficient to explain our ability to articulate their perceptual world. Rather, we have to postulate a primordial

15 Cassirer, *The Philosophy of Symbolic Forms. Volume 3*, 176.

formative faculty that makes perception possible in the first place. This faculty is, for Cassirer, the faculty of productive imagination.[16]

In the opening lecture to the Hamburg congress, titled 'Mythical, Aesthetic and Theoretical space', Cassirer resumed his objections to naturalistic psychology, and further elaborated on their implications for the philosophical study of culture.[17] The lecture is mostly devoted to rejecting 'substantialistic' conceptions of space (and, more cursorily, of time). Substantialism is, in Cassirer's opinion, a view tightly related to naturalism. (Or to be more precise perhaps, naturalism is a kind of substantialism.)[18] It holds that space and time are 'things': concrete entities that subsist independently of our knowledge of them. According to Cassirer, this doctrine is flawed. It misleads us into assuming that we should look for a concrete starting point – a substantial basis, or a temporal beginning – out of which our ability to apprehend the manifold can be derived. (This was, in Cassirer's opinion, precisely the intention of the empiricist philosophers we have been discussing.)

Abandoning substantialism means adopting a conception of space and time as the form or condition of the possibility of experience. This will in turn allow us to go down the path of a genuine philosophical analysis of culture. For culture is definable as the irreducible plurality of different modes of experience and symbolization (such as the artistic, the mythical, the religious, or the scientific mode), and only by looking at space and time as the form, rather than as the substratum, of knowledge will we be able to reach such a pluralistic conception of experience.[19] In other words, on

16 Cassirer, *The Philosophy of Symbolic Forms. Volume 3*, 132–4.

17 Ernst Cassirer, 'Mythischer, ästhetischer und theoretischer Raum', in Ernst Cassirer, *Aufsätze und kleine Schriften (1927–1931)*, ed. Tobias Berben and Birgit Recki, Ernst Cassirer, Gesammelte Werke, vol. 17 (Hamburg: Felix Meiner, 2004), 411–32. Engl. trans.: 'Mythic, Aesthetic and Theoretical Space', trans. Donald Phillip Verene and Lerke Holzwarth Foster, *Man and World* 2/1 (1969), 3–17.

18 See for example Cassirer, *The Philosophy of Symbolic Forms. Volume 3*, 172, where Hume's empiricism is taken to be a form of substantialism in which time is not so much a metaphysical entity as it is objectified in the form of sensation.

19 Cassirer, 'Mythic, Aesthetic and Theoretical Space', 8: 'The concept of order, in contrast to the unity and rigidity of the concept of being, is from the beginning distinguished by the moment of differentiation and inner multiplicity.'

the functionalist view there is not just one way of articulating the flow of experience alongside the spatial and temporal axes, but many. Space is not an object but a possible order of relations that can be realized in different ways. And the same holds for time.

In his Hamburg lecture, Cassirer looked in particular at how we can differentiate the symbolic forms of art, myth and science on the basis of their reliance on different spatial and temporal articulations of the world. The space of myth, for instance, is organized in a very different way from the space of science. In myth, spatial distinctions are not neutral coordinates, but are immediately laden with symbolic meanings that refer to supernatural forces. To give an example: in many cultures the basic spatial orientation along the east–west axis takes on a specific meaning, linking the east to life, the west to death and decay.[20]

The artistic conception of space is in a sense intermediate between the mythical and the scientific conceptions. Although art shares with myth a strong dependence on creative imagination, it introduces a greater distance between subject and object than mythical space does, thereby facilitating the emergence of a stable perceptual world independent from the subject.[21]

This argument bears some analogies to Wind's aforementioned theory of the genesis of artistic expression. Both authors argued that different cultural formations (or symbolic forms) can be ordered on a scale that runs from a maximum bonding between subject and object to a maximum distance. Both, moreover, shared an interest in investigating the roots of art in less elaborate forms of expression. Cassirer, however, was decidedly more inclined than Wind to see art as a self-contained cultural formation, and he entrusted it with the role of initiating the process of critical detachment from the object. In this sense, his position is closer to the view expressed by Schleiermacher in the passage considered in the previous section.[22] Wind,

20 Cassirer, 'Mythic, Aesthetic and Theoretical Space', 12.
21 Cassirer, 'Mythic, Aesthetic and Theoretical Space', 9–13.
22 A textual coincidence can help us appreciate to what extent these ideas are indebted to German post-Kantian philosophy: whereas Wind had cited Schleiermacher, Cassirer referred to Friedrich Schiller: 'Schiller says in his letters on aesthetic education that contemplation, the "reflection" which he sees as the basic prerequisite and as the basic fact of artistic perception, is the first "liberal" relationship of man

on the other hand, sought to describe the gradual steps that make it possible for art to emerge out of more fundamental physiological processes.

We can conceptualize this difference in Cassirer's own terms by looking at another of his essays, the 1939 paper 'Naturalistic and Humanistic Foundation of the Philosophy of Culture'. There Cassirer reproaches naturalism first and foremost for being overly preoccupied with the historical beginnings of culture rather than describing the plurality of forms that make culture possible in the first place. If we follow this cue, we might say that Wind's theory, *qua* naturalistic, is interested in the beginnings of art, while Cassirer's transcendentally oriented perspective aims to grasp each cultural formation as the expression of an independent way of apprehending the world.[23]

Despite his criticism of the naturalist search for the beginnings of culture, however, it must be noted that Cassirer was far from rejecting diachrony or historicity as such. In fact, the philosophy of symbolic forms has an explicitly Hegelian component. On the assumption of a coincidence between historical and systematic investigation, it shows the different ways in which symbolic forms have manifested themselves over time following a logical–diachronic order.[24] This historical dimension of the inquiry comes to the fore most evidently in the analysis of mythical thought, which Cassirer conceptualized as a sort of bedrock of culture, a primitive layer out of which religion, art and science have sprung. We may describe his

to the universe which surrounds him. "When desire seizes its object, thought puts its object at a distance. The necessity of nature which ruled man in his state of mere sensation with undivided power, lets go of him when he reflects; his senses are appeased; time itself, the eternally changing, stands still while the dispersed rays of consciousness gather, and a copy of the infinite, form itself, makes an imprint on the fleeting ground." ' Cassirer, 'Mythic, Aesthetic and Theoretical Space', 12.

23 Ernst Cassirer, 'Naturalistische und humanistische Begründung der Kulturphilosophie' (1939), in Ernst Cassirer, *Aufsätze und kleine Schriften 1936–1940*, ed. Claus Rosenkranz and Birgit Recki, Ernst Cassirer, Gesammelte Werke, vol. 22 (Hamburg: Felix Meiner, 2006), 140–66. Engl. trans.: Ernst Cassirer, 'Naturalistic and Humanistic Philosophies of Culture', in Ernst Cassirer, *The Logic of the Humanities*, trans. Clarence Smith Howe (New Haven: Yale University Press, 1961), 3–38.

24 Cassirer, *The Philosophy of Symbolic Forms. Volume 3*, xiv–xvi.

approach as a form of rational reconstruction of the past. From the naturalistic philosopher's viewpoint, however, this approach may turn out to be insufficiently justified, because it tends to assume *a priori* the equivalence between two orders of explanation – the logical order and the historical order – which may instead come into tension with each other.[25]

Wind's anti-Kantianism

To better understand the degree to which Cassirer's objections to a naturalistic philosophy of culture affect Wind's project, and how the latter could have replied to them, we need to take into consideration Wind's philosophical book *Das Experiment und die Metaphysik* (1934).[26] Here, again, the dialogue with Cassirer is obvious. Wind submitted this book as his habilitation thesis to the University of Hamburg in 1930 (the same year as the congress of Aesthetics and *Kunstwissenschaft*), with Cassirer as a member of the jury. The book was an explicit attack on Kant's transcendental philosophy. For this reason, it met with considerable resistance among the members of the jury. It allegedly made Cassirer 'angry'[27] and convinced him that Wind's philosophy was, 'in a very refined [or purified] sense' [*in einem sehr geläuterten Sinne*], a kind of empiricism.[28] As scholars

25 This is precisely the critique that Wind formulated in 'Contemporary German Philosophy. I.', *The Journal of Philosophy* 22/18 (1925), 477–93 (485).

26 Edgar Wind, *Das Experiment und die Metaphysik: Zur Auflösung der kosmologischen Antinomien* (Tübingen: Mohr, 1934); new edition by Bernhard Buschendorf, with a foreword by Brigitte Falkenburg and an afterword by Bernhard Buschendorf (Frankfurt: Suhrkamp, 2001). Engl. trans.: Edgar Wind, *Experiment and Metaphysics: Towards a Resolution of the Cosmological Antinomies*, trans. Cyril W. Edwards, with an introduction by Matthew Rampley (London: Routledge, 2001).

27 Edgar Wind, 'On "Microcosm & Memory"', letter to the editor, *Times Literary Supplement* (30 May 1958).

28 Engel, '"In Einem sehr geläuterten Sinne"'. See also Oliver O'Donnell's contribution to the present volume (chapter 8).

have already noted, this judgement is not wrong, provided we take 're-fined empiricism' to stand for a variety of pragmatist experimentalism.[29] Here I would like to take a closer look at the implications of Wind's 're-fined empiricism' for the problem we have been discussing, namely the opposition between naturalistic and transcendental methodologies.

My natural point of departure will be Wind's explicit criticism of tran-scendental philosophy in the central paragraphs of his book.[30] Kant conceived of philosophy, *qua* investigation of the *a priori* conditions of experience, as neatly distinguished from empirical inquiry. Wind, by contrast, considered this conception to be inconsistent with the dynamic of scientific discovery. According to him, we should substitute the Kantian view with the image of a continuum between metaphysics and empirical observation, which pivots on the way in which metaphysical assumptions are always necessarily embedded in the functioning of an experimental setting.

Any observation or measurement of the world, Wind remarked, is made possible by the use of instruments. These instruments, however, are themselves parts of the world they are meant to observe or measure. This suggests that we should adopt a holistic view of how instruments work. On the one hand, their suitability for conducting a certain observation is predicated on the truth of certain fundamental principles that we must necessarily assume in order to operate those instruments. (For example, if we use a clock to measure a duration of time, we are assuming that time is a linear and constant quantity.) On the other hand, those fundamental principles, although metaphysical in nature, are testable by experience: they can be corrected or revised if the experiment fails or the instrument of observation proves inadequate. Thus the clear-cut Kantian distinction between empirical observation and metaphysical principles falls short.[31]

29 See, for instance, Buschendorf, '"War ein sehr tüchtiges gegenseitiges Fördern"'; Krois, 'Kunst und Wissenschaft in Edgar Winds Philosophie der Verkörperung'.

30 Wind, *Das Experiment und die Metaphysik*, 105–21.

31 Wind, *Das Experiment und die Metaphysik*, 115. Engel, '"In Einem sehr geläuterten Sinne"', 15–17, compares Wind's instrumentalist conception with Cassirer's more idealistically oriented understanding of the relation between instrument and scientific truths.

Crucially, an instrument of observation does not need to be a sophisticated experimental apparatus. It can be whatever allows us to have an ordinary experience of our surrounding environment. Or, to put it in different terms, there is a continuity between ordinary experience and scientific experiment. Taking this idea to its ultimate consequences, we reach an insight that is quite compatible with Wind's Hamburg lecture: the first and most fundamental instrument that is available to us is our body. Ultimately, therefore, Wind's concept of instrument is linked to his concept of symbol through the fact that both observation and symbolic expression have their roots in the functioning of the body. Indeed, we could say that Wind's concept of instrument is a pragmatist or experimentalist transformation of the very concept of the symbol. It is what enables us to have an experience by virtue of its establishing a relationship between a sensible and an ideal element – that is, by virtue of its embodying the ideal element into the sensible element.

This brings us to a second point of Wind's book that is relevant to our problem. Not only is Kant's conception of the transcendental method, in Wind's opinion, untenable. Similarly untenable is Kant's specific conception of a linear order of time as an *a priori* form of intuition. Wind indeed went as far as to question the very idea of a linear conception of time, which he substituted with a 'configural' conception, inspired by modern physics as well as by the philosophy of A. N. Whitehead. According to this conception, the present is not a point in a perfectly determined series of moments, but the 'zone' of events that can neither influence nor be influenced by the event we hold as a reference point.[32]

It is crucial to bear in mind, here, that the choice between linear and configural conceptions of time cannot be settled *a priori* but is always liable to be tested empirically. It is intimately bound up with the choice of competing scientific theories and with the design of different experimental settings.[33] This helps us understand to what extent Wind was able to defend

32　Wind, *Das Experiment und die Metaphysik*, 171–83. Cf. Edgar Wind, 'Mathematik und Sinnesempfindung: Materialien zu einer Whitehead-Kritik', *Logos: Internationale Zeitschrift für die Philosophie der Kultur* 21 (1932), 239–80.

33　Wind, *Das Experiment und die Metaphysik*, 176–7.

himself against Cassirer's critique of empiricism. Unlike Semon and Hering, Wind did not merely suggest that memory (that is, the representation of the past) arises from a linear succession of impressions [*Nacheinander der Vorstellungen*] and from the consequent accumulation of traces. Nor did he think, like Kant, that our ability to represent time as a linear order is an *a priori* condition of experience. Rather, he argued that our represent-ation of time – and, derivatively, our ability to represent something to ourselves as past – derives from our choice of a system of measurement, or a medium of observation. His empiricism is, in other words, a kind of experimentalism. As I already noted, moreover, the instrument or medium of observation need not be a sophisticated experimental setting. As the word *Verkörperung* suggests, the body is itself a kind of measuring instru-ment, and through it we form the first representation of the relationship between past, present and future. This representation is not *a priori* and absolute but stems from the practical encounter between the individual and the environment.

A final point about Wind's book should not be left unmentioned. This concerns the implications of his argument in the ethical and socio-political realm. The break with the linear conception of time allowed Wind to reject determinism and thus also to undermine the Kantian problem of the relationship between causality and freedom. Wind replaced Kant's idealistic conception of freedom with a naturalistic ethics that focused on the realizability of moral precepts rather than on the unconditionality of principles.[34] Here again, we can note a disagreement with Cassirer, who stuck to a Kantian understanding of freedom as autonomy, and hailed cul-ture as the main vehicle through which that freedom is put to the service of human self-realization.

It has already been noted that in the preface to *Das Experiment und die Metaphysik* Wind embarked on a bitter polemic against German idealist philosophers, whom he charged with failing to take a stand against the in-tellectual obscurantism that accompanied Hitler's seizure of power. Wind may have also indirectly referred to Cassirer. In 1929, Cassirer had conducted

34 Brigitte Falkenburg, 'Einleitung: Die Maßetzung im Endlichen', in Edgar Wind, *Das Experiment und die Metaphysik*, 11–59 (57–9).

a dispute with Heidegger revolving on the concepts of freedom and autonomy – a dispute in which the more aggressive Heidegger seemed to many contemporaries to have unambiguously prevailed.[35]

An irreconcilable alternative?

It is nevertheless worth noting that the fierce and polemical tone with which Wind conducted his critique of neo-Kantian philosophy conceals some deeper affinities between his position and the one he sought to criticize. Or, to put it differently, the disagreement between the two authors here considered – Wind and Cassirer – should not blind us to the fact that the philosophical perspectives they articulate retain considerable points of contact. On closer inspection, we may note that Wind preserved some crucial elements of neo-Kantian philosophy, while Cassirer brought the transcendental perspective a step closer to the pragmatist-empiricist one.

With regard to Wind, his outspoken opposition to Kantian philosophy and the transcendental method does not necessarily imply an outright rejection of certain argumentative schemes typical of that tradition. Indeed, Wind too, like Cassirer and the neo-Kantians, asked what conditions make cultural facts possible, although he rejected the idea that these conditions

35 Engel, '"In Einem sehr geläuterten Sinne"', 9, convincingly reaches this conclusion. See Wind, *Das Experiment und die Metaphysik*, 63–9. On the Cassirer–Heidegger debate, see Peter E. Gordon, *Continental Divide: Heidegger, Cassirer, Davos* (Cambridge, MA: Harvard University Press, 2010); Simon Truwant, *Cassirer and Heidegger in Davos: The Philosophical Arguments* (Cambridge: Cambridge University Press, 2022). On Wind's criticism of Heidegger, see Horst Bredekamp, 'False Ski-Turns: Edgar Wind's Critique of Heidegger and Sartre' (1998), trans. Johanna Wild and Iain Boyd Whyte, *Art in Translation* 6/2 (2014), 215–36. A provisional program for the 1931 Hamburg congress conserved in the Warburg Institute Archive (IV.6.4.4) mentions the name of Heidegger among the invited speakers. It would be worthwhile to investigate whether the fact that Heidegger did not appear on the final conference program is in any way connected to the disagreement with Cassirer.

are *a priori* and that their investigation is entirely separate from empirical inquiry. Rather than merely repeating the empiricist idea that the succession of representations yields a representation of time, Wind identified certain fundamental features of the relationship between the individual and the environment that are presupposed [*vorausgesetzt*] by our ability to produce a representation of a temporal order. These features are the creation of a distance between stimulus and response,[36] the act of measurement,[37] and the phenomenon of *Verkörperung* at large. If it is true that pragmatist philosophy, rather than breaking completely with the transcendental, sought to naturalize it,[38] Wind again proves to be in line with the spirit of pragmatism. In his case, the naturalization of the transcendental took place through an empirically informed reflection on corporeality and on the interaction between the body and the environment (an interaction mediated by tools and symbols) as a condition of human experience.

In a parallel manner, Cassirer's neo-Kantianism made transcendental philosophy more dynamic and more in dialogue with the empirical sciences than it was in Kant's original doctrine.[39] In this case, too, it is useful to look at Cassirer's relation with pragmatism,[40] and in particular with the philosopher William James. Cassirer drew on James's thought precisely in the

36 Wind, *Das Experiment und die Metaphysik*, 111: 'Der Akt der Verkörperung [setzt] ein endliches Wesen [voraus], bei dem die reflektierende Besinnung eingesetzt hat.'

37 Wind, *Das Experiment und die Metaphysik*, 175–6.

38 See for example Sami Pihlström, *Naturalizing the Transcendental: A Pragmatic View* (Amherst: Humanity Books, 2003); Gabriele Gava and Robert Stern, eds, *Pragmatism, Kant, and Transcendental Philosophy* (New York: Routledge, 2016); Phillip Honenberger, ed., *Naturalism and Philosophical Anthropology: Nature, Life, and the Human between Transcendental and Empirical Perspectives* (London: Palgrave, 2015).

39 Sebastian Luft has claimed that a dynamic conception of the *a priori* is a distinctive hallmark of Marburg philosophy of culture. See Sebastian Luft, *The Space of Culture: Towards a Neo-Kantian Philosophy of Culture (Cohen, Natorp, and Cassirer)* (Oxford: Oxford University Press, 2015), 58–70.

40 On Cassirer and pragmatism, see Stefan Niklas and Sascha Freyberg, 'Rekonstruktive Synthesis: Zur Methodik der Kulturphilosophie bei Ernst Cassirer und John Dewey', in Stefan Niklas and Thiemo Breyer, eds, *Ernst Cassirer in systematischen Beziehungen: Zur Kritisch-Kommunikativen Bedeutung seiner Kulturphilosophie* (Berlin: De Gruyter, 2019), 47–68.

chapters of the *Philosophy of Symbolic Forms* that I have been considering in this essay. He saw in James a resource for reflecting on how we can articulate the manifold of perception (or the 'stream of experience', to use the Jamesian idiom) into cultural constructs. In doing so, he embraced some of James's pragmatist assumptions. Human beings' capacity to represent time – and, derivatively, to be conscious of both the past and the future – stems from their pragmatic involvement with the world. This holds particularly true for the capacity to envision the future: this capacity is predicated on the fact that the present is never the theatre of mere contemplation but rather the theatre of action and choice. But something similar also applies to the representation of the past (which is, from the pragmatist viewpoint, never completely separable from the expectation of the future). Memory is not a purely physiological phenomenon (as in Hering), but it is not a purely spiritual affair either (as in Bergson). Rather, it goes hand in hand with the pragmatic transactions between individuals and the environment.[41]

It thus seems that Wind's naturalism and Cassirer's transcendental perspective can meet when considering the pragmatic interplay between the individual and the environment. It is, in both authors, precisely this interplay that provides the fundamental condition for the articulation of experience and thus for the process of symbolization. However, Cassirer understood this process of articulation *qua* symbolization in essentially Kantian terms, that is, as the apprehension of the manifold of experience. For him, the main question was the following: how are subjects capable of apprehending the world as always already carrying a meaning beyond immediate perception? And, on this basis, how are they able to create art, myth, science and religion?[42] Wind, on the other hand, committed himself to a less idealistic approach, thereby accentuating the potential tension between the sensible and ideal dimensions that converge in the phenomenon

41 See Cassirer, *The Philosophy of Symbolic Forms. Volume 3*, 180–5. On p. 185 in particular, Bergson's theory of memory is pitted against Hering's. I have analysed Cassirer's reading of James in Tullio Viola, 'Courant de conscience et philosophie de la culture: Les Principles of Psychology lus par Ernst Cassirer', *Revue philosophique de la France et de l'étranger* 147/4 (2022), 509–24.

42 See in particular the chapter on 'symbolic pregnance' in Cassirer, *The Philosophy of Symbolic Forms. Volume 3*, 191–204.

of symbolization. In his view, the symbol's main task is not so much to apprehend the manifold of perception by constructing an ideal content, but rather to 'realize' [*verwirklichen*] an abstract idea 'by intruding into a world that is heterogeneous to the idea itself'.[43]

Conclusion: Memory and the study of culture

It is perhaps appropriate to conclude our comparison of Wind and Cassirer by sketching some implications of the philosophical problem we have been analysing (the relationship between time, memory and symbols) for the concrete historical study of cultural artefacts. For this was, after all, the main intellectual goal that Wind set himself from the mid-1930s on; that is, right after the exchange with Cassirer that I have tried to reconstruct in this essay.

The first issue that is worth mentioning is the question of cultural memory. I have already said that Hering's and Semon's theories of memory made it possible to think of the transmission of culture across generations as, essentially, an extension of the individual ability to remember. The basic ingredient in this extension was a broadly Lamarckian assumption, namely the idea that a habit, once acquired by an individual, could be passed on to the subsequent generation. In the course of the early twentieth century, the credibility of this Lamarckian assumption faded, but the concept of 'engram', the cultural trace that is deposited in the collective memory of a social group, remained at the centre of the theoretical preoccupations of the members of the Warburg Library.[44]

43 Wind, *Das Experiment und die Metaphysik*, 108. See also p. 109, where Wind defines the embodiment of the ideal into the sensible as 'a *metabasis eis allos genos*' – an Aristotelian expression (meaning 'transformation into a different genus') that Cassirer repeatedly used to describe the transformative power of symbols.

44 Members of the Warburg Library were still grappling with the challenge of establishing a strong theoretical basis for the concept of social or cultural memory many years after the death of Aby Warburg. See for instance a revealing letter sent in April 1940 by Gertrud Bing to Edgar Wind. The letter is discussed in Claudia

In the writings immediately following the ones I have analysed in this essay, Wind developed a series of remarks on cultural memory that focus on the active role of the individual both in recreating and re-interpreting symbols and in remembering them.[45] Symbols are not simply deposited in a supposed collective consciousness in which they continue to live as inert traces. Rather, cultural transmission presupposes a recollection and *Auseinandersetzung* with the past. This *Auseinandersetzung* is an active and creative element, an element of disruption and re-interpretation of culture.[46] This is in line with Wind's attempt to take up the empiricist theories of memory but reorient them in a more pragmatist and experimentalist direction, thereby avoiding a hasty embrace of the idea (so explicitly criticized by Cassirer) that the mere retention of the past can create the representation of that past.

There is robust textual evidence that Wind had an even more articulated theory of how the philosophical conceptions of time and memory I have reconstructed in this chapter played out at the level of cultural memory. In a series of unpublished lectures on the philosophy of culture given in Hamburg in 1932–3, for instance, he suggested that the very 'fact of symbolism' obliges us to hold a configural conception of time ['Aus dem Faktum der Symbolik ergibt sich, dass die Zeitbegriff konfigural sein muss'].[47] In other words, the dynamic of symbolic transmission contradicts

Wedepohl, 'Critical Detachment: Ernst Gombrich as Interpreter of Aby Warburg', in Uwe Fleckner and Peter Mack, eds, *The Afterlife of the Kulturwissenschaftliche Bibliothek Warburg: The Emigration and the Early Years of the Warburg Institute in London* (Berlin: De Gruyter, 2015), 131–64, n. 236.

45 See in particular Edgar Wind, 'Introduction', in Warburg Institute, *A Bibliography on the Survival of the Classics. First Volume: The Publications of 1931*, ed. Hans Meier, Richard Newald and Edgar Wind (London: Cassell, 1934), v–xii; as well as Edgar Wind, 'In Defence of Composite Portraits', *Journal of the Warburg Institute* 1/2 (1937), 138–42.

46 On the disruption and 'disturbance' of past historical documents, see Edgar Wind, 'Some Points of Contact between History and Natural Science', in Raymond Klibansky and Herbert James Paton, eds, *Philosophy and History: Essays Presented to Ernst Cassirer* (Oxford: Clarendon Press, 1936), 255–64.

47 Edgar Wind, 'Grundbegriffe der Geschichte und Kulturphilosophie', 1932–3, Bodleian Libraries, University of Oxford, Edgar Wind Papers, MS. Wind 2, folder 3, 18. See also p. 9: 'Linearer Zeitbegriff bedingt [...] dass [Vorstellungen]

linear conceptions of time. Our relation with the past does not arise from a mere accumulation of traces but from an activity of recollection that consists in picking up signals from the past and re-interpreting them.[48]

The second point I would like to mention is the problem of the differences between symbolic forms. Here again, the comparison with Cassirer is useful. In line with his functionalistic and morphological approach, Cassirer deemed it possible and fruitful not only to outline a plurality of forms in which subjects may apprehend the manifold of perception – that is, a plurality of symbolic forms – but also to insist on some essential differences between these forms. Art, myth, 'pure thought':[49] these are all different ways of creating culture that have their own relative independence and self-sufficiency – although Cassirer, in his Hamburg lecture, pointed out that such self-sufficiency should not be exaggerated and that the differences should never become 'caesuras'.[50] Cassirer certainly believed in the existence of a unity of culture over and above the different symbolic forms. This is the unity of the whole, the unity of a human process of self-realization of which the individual symbolic forms are but individual aspects.[51] But

immer in der Zeit da sind.' and p. 14, where Wind explicitly linked Hering and the conception of a configural time: 'Hering (Biologie) "Das Gedächtnis als Funktion der organisierten Materie". Wiederholung des Vorgangs verändert die Objekte, mit denen der Vorgang geschieht. Materie bewahrt die Spuren der vergangenen Handlung auf. (Beispiel Muskelstärkung Phänomen des Habitus). Problem: wie ist Gedächtnisverlauf zeitlich vorzustellen? – Auseinandersetzungsprozeß – Formen (Vorschriften), mit denen das Individuum sich auseinanderzuseten hat. Ähnlich wie beim konfiguralen Zeitbegriff: hier Spielraum der Handlungsweise gegeben.' (*Spielraum* is the concept Wind used to characterize the indeterminacy of the present in the configural conception of time. See Wind, *Das Experiment und die Metaphysik*, 178). For a very helpful discussion of these lectures, see Buschendorf, 'Das Prinzip der inneren Grenzsetzung', 295–6.

48 Note also Wind's use of 'Faktum', a neo-Kantian term related to the Marburg school in particular (see Luft, *The Space of Culture*, 12). This seems to indicate once again that his rupture with Marburg neo-Kantianism was not total.

49 Cassirer, 'Mythic, Aesthetic and Theoretical Space', 13.

50 Cassirer, 'Mythic, Aesthetic and Theoretical Space', 7.

51 Cassirer, 'Mythic, Aesthetic and Theoretical Space': 'each transformation of an individual moment implicitly contains a new form of the whole'.

within this philosophical and normative unity, each symbolic form can be distinguished on the basis of the differences in its generating principle. Things appear different for Wind. A central tenet of his *Kulturwissenschaft* is precisely the idea that the different cultural formations – science, philosophy, art, technology – are inextricably linked with one another. In an important sense, the 'pure thought' of which Cassirer spoke does not exist. Rather, the theoretical use of reason is always imbued with myth and images; art is unintelligible without its philosophical-scientific background. The historical study of artefacts – texts, images, implements – can unveil their full purport the moment it succeeds in bringing to the surface the fullness of these entanglements. This conviction provided Wind with one of the crucial rationales for the iconological studies to which he would devote himself almost exclusively from the mid-1930s on.[52] His first major art-historical work, *Hume and the Heroic Portrait*, dates from 1932.[53] It is, among many other things, a study of empiricism.[54]

52 This is also what motivates Wind's criticism of formalistic art history. See Giovanna Targia's contribution to the present volume (Chapter 3). For an excellent reconstruction of the differences between empiricist and neo-Kantian approaches to the art-historical discipline among the Warburg circle, see Oliver O'Donnell, 'Two Modes of Midcentury Iconology', *History of Humanities* 3/1 (2018), 113–36.

53 Edgar Wind, 'Humanitätsidee und heroisiertes Porträt in der englischen Kultur des 18. Jahrhunderts', in Edgar Wind, *Heilige Furcht und andere Schriften zum Verhältnis von Kunst und Philosophie*, ed. John Michael Krois and Roberto Ohrt (Hamburg: Philo Fine Arts, 2009), 112–236; Engl. trans.: Edgar Wind, *Hume and the Heroic Portrait: Studies in Eighteenth-Century Imagery*, ed. Jaynie Anderson (Oxford: Clarendon Press, 1986). See Oliver O'Donnell's contribution to the present volume (Chapter 8).

54 Many thanks to Elio Antonucci, Franz Engel, Gabriele Gava, Stefan Niklas, Oliver O'Donnell and Giovanna Targia for their feedback on a previous draft of this paper, as well as to Belinda Nemec for her very valuable editing work.

PART II

The Interpretation of Works of Art

FRANZ ENGEL

5 'Chaos Reduced to Cosmos': Reconstructing Edgar Wind's Interpretation of Dürer's *Melencolia I*

Introduction

In the introduction to a special edition of Ernest Hemingway's *A Farewell to Arms*, the novelist's grandson Seán Hemingway states: 'My grandfather said that he always tried to write on the principle of the iceberg. For the part that shows there are seven-eighths more underwater.'[1] It may be surprising to apply the same iceberg principle to the writings of Edgar Wind. In their erudition and use of an exquisite or – as Wind himself stated – 'exotic' English,[2] Wind's writings – notwithstanding the fact that he wrote scholarly texts and no fiction – could not be more different in style from the vivid simplicity of Hemingway's language. And yet, although Wind was scrupulous in annotating his texts with the most elaborate notes – which sometimes, in *Art and Anarchy* for example, become minuscule essays in their own right – not everything that lies beneath the surface is revealed.

1 Seán Hemingway, 'Introduction' [2012], in Ernest Hemingway, *A Farewell to Arms* (London: Vintage, 2012), xiv; he is referring to Ernest Hemingway, *Death in the Afternoon* (New York: Charles Scribner's Sons, 1932), 183.

2 Edgar Wind, *Art and Anarchy: The Reith Lectures 1960, Revised and Enlarged* (London: Faber & Faber, 1963), xii.

We encounter the iceberg problem especially in the closing remark of a short and dense text in which Wind faces the question of what he understands as the 'Eloquence of Symbols':

> Were I to name a figure which might serve as an emblem for the dangers and chances of symbolic studies, it would be the irregular solid in the background of Dürer's *Melancolia*. The surface of this unwieldy block – a truncated rhombohedron – is largely formed by irregular pentagons. It is an image of confusion. But while completely irregular on the surface, the configuration of the block defines on the inside two perfect equilateral triangles. Pico della Mirandola thought this to be the nature of chaos: an aggregate of irregular shapes in which the perfect shapes lie hidden within. This is a most Socratic disorder, and recalls the Silenus of Alcibiades, inciting the spectator through its confusion to extract, if he can, the hidden forms: *perche Chaos non significa altro che la materia piena di tutte le forme, ma confusa et imperfetta.*[3]

In this section Wind summarizes parts of his interpretation of Dürer's engraving *Melencolia I* (Figure 5.1), the seven-eighths of an iceberg on which Wind had worked in the preceding years, but which he did not publish anywhere at length. Based on documents from the Wind Papers, correspondence, and references from other texts by Wind, the following article attempts to reconstruct Wind's argument.

3 Edgar Wind, 'The Eloquence of Symbols', *The Burlington Magazine* 92 (1950), 349–50 (350), italics in original; the only reference that Wind provides in this section is to a quotation from Giovanni Pico della Mirandola's *Commento sopra una Canzona de Amore*, II:14: 'chaos means simply "matter filled with all the forms but forms which are confused and imperfect"': Giovanni Pico della Mirandola, *Commentary on a Canzone of Benivieni*, ed. and trans. Sears Jayne (New York: Peter Lang, 1984), 110. For the genesis of Wind's interpretation of Bellini's *Madonna of the Meadow* in the National Gallery in London in the same article, see Jaynie Anderson, 'Edgar Wind and Giovanni Bellini's "Feast of the Gods": An Iconographic "Enfant Terrible"', *The Edgar Wind Journal* 2 (2022), 9–37 (27).

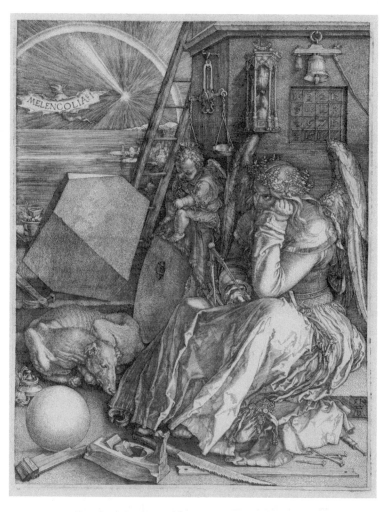

Figure 5.1: Albrecht Dürer, *Melencolia I*, 1514, engraving, 24.1 × 18.9 cm. Frick Collection, purchased 1940, 1940.3.61, New York.

Socratic disorder

The question of whether the polyhedron in Dürer's engraving *Melencolia I* is actually a 'truncated rhombohedron' as Wind states, or another geometric body, has been discussed by several authors.[4] But what did Wind mean by claiming to see in it an emblem of chaos? The text in *The Burlington Magazine* has no illustrations. But even if it had been illustrated with Dürer's engraving, it would not have been immediately obvious what Wind was alluding to.

A number of drawings by Wind himself in the Wind Papers in Oxford may illuminate this problem (Figures 5.2–5.4).[5] In these, Wind transforms the three-dimensional body of the polyhedron into a two-dimensional representation, in several steps. The first step (Figure 5.2) is an outline of the analysis of Dürer's truncated rhombohedron, supplemented by the dotted lines made by G. Niemann and which Panofsky and Saxl included in their early study of 1923.[6] On the second sheet (Figure 5.3), however, Wind copies Dürer's preparatory drawing of the polyhedron (Figure 5.5), along with two analytic drawings of it below. The cross-section that effects a surface of an

4 Erwin Panofsky and Fritz Saxl, *Dürers 'Melencolia I': Eine quellen- und typengeschichtliche Untersuchung* (Leipzig: Teubner, 1923), vi; Appendix, 136–9; Raymond Klibansky, Erwin Panofsky and Fritz Saxl, *Saturn and Melancholy: Studies in the History of Natural Philosophy, Religion, and Art*, ed. Philippe Despoix and Georges Leroux [1964] (Montreal: McGill-Queen's University Press, 2019), Appendix 1, 400–2 n. 150; Giancarlo Bizzi, *Il poliedro della* Melencolia I *di Dürer* (Florence: Cadmo, 2003); Hans Weitzel, 'Zum Polyeder auf A. Dürers Stich *Melencolia I*: Ein Nürnberger Skizzenblatt mit Darstellungen archimedischer Körper', *Sudhoffs Archiv* 91/2 (2007), 129–73; Ishizu Hideku, 'Another Solution to the Polyhedron in Dürer's "Melencolia": A Visual Demonstration of the Delian Problem', *Aesthetics: The Japanese Society for Aesthetics* 13 (2009), 179–94; Andrea Bubenik, 'The Shape of Things to Come: Dürer's Polyhedron', in Andrea Bubenik, ed., *The Persistence of Melancholia in Arts and Culture* (New York: Routledge, 2019), 68–93.

5 Bodleian Libraries, University of Oxford, Edgar Wind Papers (hereafter Bodleian, EWP), MS. Wind 144.

6 Panofsky and Saxl, *Dürers 'Melencolia I'*, 138.

equilateral triangle, which was identified as such by Niemann, is marked by Dürer with 'a b c' on top and '1 2 3' on the bottom. The third sheet concerns this equilateral triangle (Figure 5.4). Here the two drawings that resemble a distorted three-armed propeller are two-dimensional representations of the rhombohedron. In the right-hand representation of these, Wind – as if to reassure himself – highlights the two equilateral triangles by tracing their contour several times with the pencil.

In *Melencolia I*, the way the instruments and tools are scattered on the ground has led many viewers to apply standards of domestic order to their interpretation: 'Rubbish', was Henry Fuseli's annoyed comment on the many objects surrounding the female figure, which he felt weakened her sublime expressiveness.[7] In orderly verse, Théophile Gautier described 'a thousand objects scattered chaotically around her'.[8] Similarly, Wölfflin spoke of a 'chaos of things […] everything unused, untidy, scattered' – a judgement eventually taken up by Klibansky, Panofsky and Saxl: 'Geometria's workshop has changed from a cosmos of clearly ranged and purposefully employed tools into a chaos of unused things; their casual distribution reflects a psychological unconcern.'[9]

Wind's approach contrasts with these interpretations, in that it starts from a notion of chaos as something positive, rather than equating it with disorder. Along with Pico, Wind could claim the opposite: insofar as the actual world – however confused it may appear – is the reduction of an originally continuous abundance, it has overcome the chaotic state.

In identifying Pico's notion of chaos as a 'most "Socratic disorder"' that recalls the Silenus of Alcibiades, Wind is alluding to a passage of Plato's

7 Gisela Bungarten, *J. H. Füsslis (1741–1825) 'Lectures on Painting': Das Modell der Antike und die moderne Nachahmung* (Berlin: Mann, 2005), vol. 1, 76.

8 'Sans ordre autour de lui mille objets sont épars', Théophile Gautier, *Melancholia* [1834], *Œuvres complètes. Section 2, Poésies*, ed. Peter White and François Brunet (Paris: Honoré Champion, 2022), 361–70 (367).

9 Heinrich Wölfflin, *Die Kunst Albrecht Dürers* (Munich: Bruckmann, 1926), 255. In his monograph on Dürer, Panofsky speaks of 'bestürzende Unordnung' [dismaying disorder]. Erwin Panofsky, *Das Leben und die Kunst Albrecht Dürers*, trans. Lise Lotte Möller (Munich: Rogner & Bernhard, 1977), 209.

Figures 5.2–5.4: Edgar Wind, studies of the polyhedron in Dürer's *Melencolia I*, before 1950, pencil on paper. Bodleian Libraries, University of Oxford, Edgar Wind Papers, MS. Wind 144, folder V, 13, 6–7.

Figures 5.2–5.4 (Continued)

Figures 5.2–5.4 (Continued)

Taf. 131. (182ᵇ. 183ᵇ.)

Figure 5.5: Albrecht Dürer, study of a polyhedron. Drawing from a sketchbook formerly held at the Königliche Bibliothek Dresden, MS R. 147, now missing.

Symposium (215a–b; 216d–e; 221d–e), in which the beautiful Alcibiades alludes to the ostensible contradiction between Socrates' rather ugly physical appearance and the beauty of his mind, which is not in accordance with the equation of beauty with truth put forward by Socrates himself. Socrates appears to Alcibiades as a type of Silenus figurine, carved out of wood and with an opening in the front to house another figure of one of the gods from Olympus. Unfortunately, none of these Silenus figurines has survived, but the medieval type of the *Vierge ouvrante* – a sculpture representing the Virgin Mary, concealing under her mantle an image of, for instance, the Trinity – suggests what such figurines may have looked like in the time of Plato.[10]

The 'Wind dilemma'

In 1923, Erwin Panofsky and Fritz Saxl published a comprehensive study on Dürer's engraving.[11] Later, they expanded this into a larger account, titled *Saturn and Melancholy*. Many hurdles encountered during the preparation of the book meant that it was not published until 1964.[12]

Parallel to Panofsky and Saxl's investigations into 'Saturn and Melancholy', Wind was working on an alternative interpretation of Dürer's engraving, which he titled 'Chaos and Melancholy'. Wind presented his ideas on at least two occasions in the United States: first at the annual meeting of the New England Conference on Renaissance Studies, held on 24 and 25 May 1946 at Smith College in Northampton, where Wind

10 See Susan Woodford, '*Silonoi ouvrants*: On Alcibiades' Image of Socrates in Plato's "Symposium"', *Source: Notes in the History of Art* 26/4 (2007), 1–5.

11 Panofsky and Saxl, *Dürers 'Melencolia I'*.

12 Klibansky, Panofsky and Saxl, *Saturn and Melancholy*. For the genesis of *Saturn and Melancholy*, see the contributions in part 3 of Philippe Despoix and Jillian Tomm, eds, *Raymond Klibansky and the Warburg Library Network: Intellectual Peregrinations from Hamburg to London and Montreal* (Montreal: McGill-Queen's University Press, 2018).

was teaching at the time,[13] and then on 11 January 1947 as part of a lecture series at the Frick Collection in New York.[14]

In response to a letter of 7 March 1947 in which Saxl informs Panofsky that one-third of their *Saturn and Melancholy* book has been translated from German into English, Panofsky argues that he does not want to be participate in the translation work because he is too deeply involved in other things. He adds, however, that he has heard that Wind had given a lecture on Dürer's *Melencolia I*:

> I hear that in the meantime Edgar Wind has found several new solutions. Somebody told me (from the lecture he had attended) that Wind brings in the idea of chaos and cosmos, what with the putto and the polyhedron, and that he thinks that the dog is to be interpreted in connection with the ink pot, the dog being a writing dog (cf. the hieroglyph of the dog as a symbol of sacred letters) who suffers from his temporary inability to exercise this valuable faculty. I do not know whether this report is correct.[15]

In the subsequent correspondence, Panofsky becomes more and more alarmed:

> What really worry me are the new theories of Edgar Wind mentioned in my letter of March 14 [13]. For obvious reasons I do not like to ask him for details or even

13 F. W. Sternfeld, 'Renaissance News', *Journal of Renaissance and Baroque Music* 1/2 (1946), 149–58 (149).

14 The Frick Art Reference Library Archives at the Frick Collection holds the relevant correspondence with Wind; I thank Susan Chore for delivering copies of it to me. Wind regularly gave lectures at the Frick Collection: 'Justice and Love in Michelangelo's "Last Judgment"' (4 February 1940); 'Leonardo da Vinci's "Last Supper"' (16 March 1941); 'Shakespeare in the Eighteenth Century' (19 October 1941); 'Portraits and Symbols of Erasmus' (29 November 1942); 'Titian and Pietro Aretino' (19 March 1944); 'Chaos and Melancholy in the Renaissance' (11 January 1947); 'Grandeur and Wit in Reynolds' Portraiture' (25 October 1947); 'The Imagery of Hogarth' (30 October 1948) and 'The Studio of Alfonso d'Este' (20 May 1950).

15 Erwin Panofsky to Fritz Saxl, 13 March 1947, London, Warburg Institute Archive, General Correspondence (hereafter WIA, GC). I thank Claudia Wedepohl for sending me copies of this correspondence.

whether he plans to publish it, but it might be well to wait awhile with printing the translation until he has made up his mind.[16]

In his reply of 22 April, Saxl shares Panofsky's preoccupation:

> I am rather worried about your hint concerning Wind's lecture and the Melencolia. We are in the middle of the translation, and I am sorry to say that it is costing a lot of money (£400), and I am not sure whether we should go on doing it before we clear up this matter. What you said in your letter of 14th [13th] March was not quite explicit. I can still stop the translation, and regard the money that has been spent up to now as gone down the drain; but as it is public money I do not really want to run the risk of our feeling that Wind's explanation is so clear and certain that we cannot in the end publish the book. The only thing that occurs to me is whether you can find someone who remembers the details of the lecture. Personally I do not think the danger is very great, but it would be much better if you could make certain. Sorry to bother you, but I really don't see how I can make the decision on my own.[17]

In the postscript of the same letter, Saxl calls the whole matter the 'Wind dilemma'.[18] In the following letter, Panofsky discusses the scope of Wind's lecture:

> Concerning Wind's lecture on the Melencolia, my only source of information is Rens Lee who can only remember the following: According to Wind, the whole thing revolves around the idea of the transformation of Chaos to Cosmos which he also connects, mysteriously, with the shape of the famous Polyhedron. The dog, as mentioned before, would be a writing dog, suffering from his temporary inability to make use of the ink pot (source probably Pierio Valeriano or some other hieroglyphic gentleman); the ladder, finally, would be an allusion to obsidium and therefore 'obsession.' All this sounds very dark to me, but Wind is generally a man who knows what he is talking about although, as we all know, he may occasionally go astray.[19]

16 Erwin Panofsky to Fritz Saxl, 14 April 1947, WIA, GC. See also Erwin Panofsky, *Korrespondenz 1910 bis 1968: Eine kommentierte Auswahl in fünf Bänden*, ed. Dieter Wuttke (Wiesbaden: Harrassowitz, 2001), vol. 2, 827–8.

17 Fritz Saxl to Erwin Panofsky, 22 April 1947, WIA, GC; see also Panofsky, *Korrespondenz 1910 bis 1968*, vol. 2, 828.

18 'P.S. I am looking into the matter of the 1514 Comet, but as long as we are faced with the difficulty of the Wind dilemma I shan't do anything.' Saxl to Panofsky, 22 April 1947.

19 Erwin Panofsky to Fritz Saxl, 29 April 1947, WIA, GC. See also Panofsky, *Korrespondenz 1910 bis 1968*, vol. 2, 826–7. Panofsky's 'source' was Rensselaer W. Lee

Panofsky's tactical considerations in the following passage from the same letter to Saxl testify to the deep mutual mistrust that had developed after Wind's break with the Warburg Institute in 1945:[20]

> Concerning our policy, I find it very difficult to make a suggestion. Whatever we do would look as though we were trying to steal his [Wind's] thunder unless you [Saxl], as the official editor, think it possible to write to him that you had heard about his magnificent lecture without having a clear picture as to its contents, and ask him (a) if and when he plans to publish it, or (b) whether he would be willing to publish it as an appendix to the forthcoming translation of our own book. I have no idea whether your relations with Wind make such a course possible. If not, you could just as well go ahead as planned without doing anything and leave it to him to 'publish and be damned' afterwards.[21]

In a letter of 7 October 1947, Panofsky no longer speaks of 'transformation' but of 'chaos reduced to cosmos':

> The only thing which seems convincing is really the block which may well be a kind of handy tool for astronomical observation. But then, all the better as far as we are concerned, and all the worse for Edgar [Wind] who, from what I gather from the reports, interprets this block as something like chaos reduced to cosmos, or the like.[22]

As sceptical as Panofsky is about Wind's interpretation, his formulation 'chaos reduced to cosmos' seems to be an accurate description of it, as in his lecture, Wind might have cited another passage from Pico's *Commento*, according to which the world was reduced innumerable times from the disorder of chaos into order.[23]

(1898–1984), at that time professor of art and a colleague of Wind at Smith College (1941–8).

20 For an account of Wind's break with the Warburg Institute in 1945, see Franz Engel, ' "Though This Be Madness": Edgar Wind and the Warburg Tradition', in Sabine Marienberg and Jürgen Trabant, eds, *Bildakt at the Warburg Institute* (Berlin: De Gruyter, 2014), 87–115. See also Ianick Takaes de Oliveira, ' "L'esprit de Warburg lui-même sera en paix": A Survey of Edgar Wind's Quarrel with the Warburg Institute', *La rivista di engramma* 153 (2018), 109–81.

21 Panofsky to Saxl, 29 April 1947.

22 Erwin Panofsky to Fritz Saxl, 7 October 1947, WIA, GC, published in Panofsky, *Korrespondenz 1910 bis 1968*, vol. 2, 877–9, letter no. 1178.

23 Pico, *Commento* I:7.

Unfortunately, no manuscripts of the lecture survive, perhaps because Wind usually gave his lectures without using notes. The Warburg Institute Archive, however, holds a letter by Wind from 1938, which provides some clues as to what Wind might have been talking about some seven years later.

'Iconography' and other 'cumbersome phrasings'

The letter in question is addressed to Fritz Saxl in London and is dated 1 September 1938.[24] It was written in Otterton in Devon, where Wind apparently spent the late summer, working on some detailed studies and writing letters. In it Wind summarizes some thoughts that came to his mind while reading Giovanni Pico della Mirandola.[25] The letter contains the core ideas of Wind's interpretation of the polyhedron quoted at the beginning of the present chapter, and gives indications of an overall interpretation of Dürer's *Melencolia I*. This document is surprising insofar as it is a strong indication that as early as 1938 Saxl had been informed – and indeed at first hand – of Wind's interpretation of Dürer's engraving. His ignorance on the subject, apparent in his 1947 correspondence with Panofsky, in which he even urges Panofsky to obtain information about Wind's interpretation through third parties, thus appears in a strange light.

To present Pico's *Commento* as the underlying text to Dürer's *Melencolia* is a strong iconographical claim, to which Wind adheres in his 1950 article. The postulated text–image relationship also played a role in the choice of title for his 1947 lecture at the Frick Collection. In response to the invitation to give this lecture, Wind writes:

24 An English translation of the letter is reproduced in full as the appendix to the present chapter.

25 Wind also dealt with Giordano Bruno in detail at this time, as can be seen from his lengthy letter to Frances Yates dated 4 September 1938 (also written in Otterton); see Bernardino Branca, 'The Giordano Bruno Problem: Edgar Wind's 1938 Letter to Frances Yates', *The Edgar Wind Journal* 1 (2021), 12–38.

I shall be delighted to lecture at the Frick Collection on January 11th. I remember having seen in your collection one of the most beautiful impressions of Dürer's *Melancholia* I know. Would that be a suitable subject? I recently stumbled over some new material relevant to that engraving. I only hope that the following title will not sound too forbidding: 'Chaos and Melancholy in Renaissance Iconography.'[26]

Wind rarely used the word 'iconography'. Methodological writings dominate Wind's early writings of the 1920s. In the course of the 1930s until the end of his life, Wind increasingly avoided referring explicitly to his method. If Wind in his writings achieved a high degree of elegance characterized by brevity, this is partly because they nowhere flaunt the traces of their making.[27]

Wind's fear, expressed in his letter to the Frick administrator, that the lecture title might appear 'forbidding', was justified. On 24 October 1946, the director of the Frick Collection, Frederick Mortimer Clapp, replied:

> You ask me whether your title is too forbidding. May I be bold enough to suggest a slight change? Would you agree to 'Chaos and Melancholy in the Renaissance', leaving out the word 'iconography'? I think there would then be in the title a broader implication and a greater novelty for many who still think of the Renaissance as a bright, gay period of the whole-hearted enjoyment of life and of man's potential powers.[28]

According to a message sent to Clapp's administrator, Wind was downright relieved to receive this alternative proposal:

26 Edgar Wind to Beatrice Magnuson (administrator at the Frick Collection), 15 July 1946, New York, The Frick Collection/Frick Art Reference Library Archives, The Frick Collection – Lecture Records – Lectures, 1947 – Lectures, Special, 1947 (hereafter Frick Collection, Lectures, Special, 1947). The engraving was acquired for the Frick Collection in 1940; see David P. Becker, 'Melencolia I', in Joseph Focarino, ed., *The Frick Collection: An Illustrated Catalogue. Vol. 9: Drawings, Prints, and Later Acquisitions* (New York: Frick Collection, 2003), 143–8.

27 See Bernhard Buschendorf's contribution to the present volume (Chapter 6) for a detailed analysis of this methodological approach, which Wind adopted from Aby Warburg and his writings.

28 Frederick Mortimer Clapp to Edgar Wind, 24 October 1946, Frick Collection, Lectures, Special, 1947.

I am most grateful for Dr. Clapp's improvement of the title of my lecture. 'Chaos and Melancholy in the Renaissance' is far better than my cumbersome phrasing.[29]

'Inwendig voller Figur'

The decisiveness with which Wind represents this iconography, however, seems to be unfounded in light of the fact that the *Commento*, although written in 1486, was published posthumously, in 1519 – five years after Dürer's *Melencolia I*.[30] Before that, the *Commento* circulated in manuscripts, six of which have survived. This problem of chronology calls for an explanation.

Sears Jayne assumes a distribution of the *Commento* limited to Florence and the surrounding area,[31] without giving any weight to the claim by Girolamo Benivieni, Pico's friend and author of the *Canzoni* addressed in his *Commento*, quoted by Jayne himself, that more than a thousand copies circulated.[32] As difficult as it may be to prove that someone knew a particular fact, it is even more difficult to prove that someone did *not* know

29 Edgar Wind to Beatrice Magnuson, 29 October 1946, Frick Collection, Lectures, Special, 1947. Wind's reply to Clapp as indicated in this letter is not to be found in the Frick Collection Archive.

30 The *Commento* was published as part of an edition of works by the poet and friend of Pico to whose canzoni the *Commento* was dedicated: Girolamo Benivieni, *Opere di Hierony. Benivieni* (Florence: 1519). The Warburg Institute owned a copy, which is now missing. I thank Clare Lappin for references in this regard. The modern edition by Garin, which is still authoritative, did not appear until 1942: Giovanni Pico della Mirandola, *De hominis dignitate. Heptaplus. De ente et uno. E scritti vari*, ed. Eugenio Garin (Florence: Vallecchi, 1942).

31 See Sears Jayne's scheme illustrating the distribution of the manuscripts, in his edition of Pico della Mirandola, *Commentary on a Canzone of Benivieni*, 45, 263–5; See also Eugenio Garin, *Giovanni Pico della Mirandola: Vita e dottrina* (Florence: Le Monnier, 1937), 48.

32 Pico della Mirandola, *Commentary on a Canzone of Benivieni*, 16.

a particular fact. What is certain is that Willibald Pirckheimer, Dürer's longtime friend and advisor in intellectual matters, knew the writings of Ficino's academic circle very well.[33]

Wind's studies on Renaissance Orphism, as evidenced by the letter to Saxl, were reflected not only in his *Pagan Mysteries*, but also in a text about an engraving of Hercules and a drawing of Orpheus by Dürer, whose admiration of the writings of Polizian and Pico was, according to Wind, strongly supported by the evidence.[34] Wind argues that Dürer, through Pirckheimer's connections with the bearers of Giovanni Pico's intellectual legacy, his nephews Gianfrancesco Pico and Alberto Pio, was extensively informed, even to the point of saturation, on the fashion for Orphism that was spreading at the time, and that Dürer mocked it in his depiction of Hercules and Orpheus.

Pirckheimer's relationship with Gianfrancesco Pico has been meticulously researched.[35] Pirckheimer and Gianfrancesco maintained a close relationship, corresponding and meeting in person. Pirckheimer received manuscripts from Gianfrancesco, and published one of them.[36] Even if there is no direct reference to the *Commento* in the correspondence between Gianfrancesco and Pirckheimer, it is possible that a manuscript of the *Commento* could have crossed the Alps before 1514 and was brought to Dürer's attention through Pirckheimer.

By quoting the well-known phrase '*inwendig voller Figur*' [inwardly full of figure], Wind gives an indication of Dürer's knowledge of Pico.

33 See Niklas Holzberg, *Willibald Pirckheimer: Griechischer Humanismus in Deutschland* (Munich: Fink, 1981), 51–2.

34 Edgar Wind, '"Hercules" and "Orpheus": Two Mock-Heroic Designs by Dürer', *Journal of the Warburg Institute* 2/3 (1939), 206–18.

35 Gian Mario Cao, 'Pico della Mirandola goes to Germany: With an Edition of Gianfrancesco Pico's "De reformandis moribus oratio"', *Annali dell'Istituto storico italo-germanico in Trento* 30 (2004), 463–525 (480–1).

36 See Cao, 'Pico della Mirandola goes to Germany', 484–5; Holzberg, *Willibald Pirckheimer*, 89, 339–43.

The quotation stems from the drafts of Dürer's unfinished treatise on painting:

> For a good painter is inwardly full of figure, and if it were possible for him to live forever, he would always have something new to pour out through the works from the inner ideas of which Plato writes.[37]

In his *Oratio de hominis dignitate*, Pico deals with the formlessness of man intended by God at his creation. God placed man at the centre of the world, so that he would be his own creative sculptor, forming himself into the shape he preferred. Man could therefore degenerate into the lower, or animal, but could just as well be reborn into the higher, the divine.[38] A trace of this thought could have led to Dürer's aphorism. God has not overcome chaos with the creation, but uses it instead as the formless principle to generate free spaces, through which man experiences himself as free and self-determined. The persistence of chaos in the created world, however, is not only the precondition for human freedom, but also, in art-theoretical terms, the precondition for artistic creativity.[39] In short, Pico's concept of man is the concept of man as artist.

As Wind notes in the letter, Panofsky and Saxl had referred in their 1923 study on *Melencolia I* to another quotation of Dürer from the London manuscripts, which in turn recapitulates a famous passage from the Book of Wisdom, according to which God created the world according to 'measure, number and weight'.[40] According to Panofsky and Saxl, the devices scattered around the figure of Melancholia illustrate that the underlying subject-matter of the engraving is the Saturnian art of measurement.

37 Albrecht Dürer, *Dürers schriftlicher Nachlaß*, ed. Konrad von Lange and F. Fuhse (Halle: Max Niemeyer, 1893; reprint Niederwalluf bei Wiesbaden: Martin Sändig, 1970), 295. My translation.

38 Giovanni Pico della Mirandola, *Über die Würde des Menschen*, ed. August Buck, trans. Norbert Baumbarten (Hamburg: Meiner, 1990), 5–7.

39 See *Commento* I:12.

40 Panofsky and Saxl, *Dürers 'Melencolia I'*, 66–7.

'Hieroglyphic gentlemen'

Based on the devices of the balance, the clock and the number-square as interpreted in Wind's letter, as well as the details of the polyhedron, the dog, the ink pot and the ladder mentioned in Panofsky's letters, it does seem possible that Wind could have interpreted each device individually. The hope that an overall interpretation could result from assembling the individually interpreted details was and is based on the fact that the inscription on Dürer's London sheet with the preliminary study of the compass-handling putto claims that a fixed meaning can be assigned to each detail: 'Schlüssell betewt gewalt, pewtell betewt reichtum'.[41]

If one accepts Rens Lee's report as rendered by Panofsky, Wind wanted two elements of the engraving – the dog and the inkpot – to be understood as a single hieroglyph. Likewise, the ladder leaning against the tower should be interpreted as a hieroglyph. A slide list in Wind's hand refers to the most important books on hieroglyphs, dubbed by Panofsky the 'hieroglyphic gentlemen': Horapollon's *Hieroglyphica*, written in the second or fourth century AD, and Pierio Valeriano's book of 1556 with the same title. It is likely that this list was the slide list for Wind's lecture at the Frick Collection.[42]

Wind's interpretation of the details probably followed a trail connected with Dürer's illustrations, made around 1512, for a Latin translation of Horapollon's *Hieroglyphica*, commissioned from Pirckheimer by Emperor

41 [Key means power, purse means richness.] See Albrecht Dürer, sketch of Putto, drawing, London, British Library, Add MS 5229, fol. 60.

42 At the top of the list in pencil: 'Titian + Melancholia, M.M.A. [illegible]'; the slide list is titled: 'Chaos + Melancholy in Ren. Iconogr.' It lists the following images: '1.) Titian, Feast of Venus / 2.) Titian, Feast of Venus, Detail / 3.) Michelangelo, Children's Bacchanal / 4.) Dürer, Melencolia I. / 5.) Dürer, Construction of Block / 6.) Dürer, Melencolia I. / 7.) Horus Apollo, *Hieroglyphica*, Cynocephalus / 8.) Pierio Valeriano, *Hieroglyphica*, Cynocephalus with ink pot / 9.) Dürer, Melencolia, Detail, block, dog and Cupid / 10.) Dürer, Melencolia I. / 11.) Horus Apollo, *Hieroglyphica*, "Obsidio["] / 12. Dürer, Melencolia I. / 13.) Cranach, Melancholia, with 3 children / 14.) Cranach, Melancholia, with many Children / 15.) Titian, Feast of Venus'. Bodleian, EWP, MS. Wind 144, folder 3, 2pp.

Maximilian I but never undertaken. Only a few of these drawings have sur-
vived in the original, but in 1915 Karl Giehlow published an anonymous
copy of the translation together with the drawings that he had discovered
in the National Library in Vienna (MS 3255) and dated to 1514–17.[43]
With regard to the dog and the inkpot, Wind took his cue from a
meaning of 'Cynocephalus' discussed in Horapollon's *Hieroglyphica*, ac-
cording to which this dog-headed creature represented writing, since there
was a species of cynocephalus that knew Egyptian writing:

> And [a cynocephalus signifies] letters, because here in Egypt a race of baboons
> [cynocephaluses] exists who know their letters, in accordance with which, when a
> baboon [cynocephalus] was first cared for in a temple, the priest handed him a tablet
> and pen and ink. This was to attempt to find out whether he was of the race which
> knew its letters and whether he could write.[44]

When Dürer illustrated Pirckheimer's translation, no illustrated
edition of the *Hieroglyphica* existed, only the edition published by Aldus
Manutius in 1505 along with Aesop's *Fables* and other classical texts,
which reproduced the Greek text without illustrations.[45] To illustrate
his argument, Wind might have used the copy of Dürer's hieroglyph
of a chained dog (Figure 5.6), and also the hieroglyph from Pierio
Valeriano's *Hieroglyphica* of 1556 (Figure 5.7).[46] Thus one is inclined

43 Karl Giehlow, 'Die Hieroglyphenkunde des Humanismus in der Allegorie der
 Renaissance, besonders der Ehrenpforte Kaisers Maximilian I.: Ein Versuch',
 Jahrbuch der Kunsthistorischen Sammlungen des Allerhöchsten Kaiserhauses 32/1
 (1915), 1–232; Engl. trans.: Karl Giehlow, *The Humanist Interpretation of Hieroglyphs
 in the Allegorical Studies of the Renaissance: With a Focus on the Triumphal Arch of
 Maximilian I*, trans. Robin Raybould (Leiden: Brill, 2015); Panofsky, *Das Leben
 und die Kunst Albrecht Dürers*, 231–2.
44 *The Hieroglyphics of Horapollo*, trans. George Boas (Princeton: Princeton University
 Press, 1993), 53.
45 *Vita et fabellae Aesopi [...] Ori Apollinis Niliaci hieroglyphica [...]* (Venice: Aldus
 Manutius, 1505).
46 Giehlow, 'Die Hieroglyphenkunde des Humanismus', 183; Pierio Valeriano,
 *Hieroglyphica sive sacris Aegyptiorvm literis commentarii Ioannis Pierii Valeriani
 Bolzanii Bellvnensis* (Basel: Isingrin, 1556), 47.

Figure 5.6: Copy after Albrecht Dürer, *Cynocephalus*, from Horapollon, *Hieroglyphicon liber I et liber II introductio cum figuris*, Latin translation by Willibald Pirckheimer, manuscript, 1505–15. Österreichische Nationalbibliothek, Vienna.

to see the inkpot and dog in Dürer's *Melencolia I* as previously related to each other but now separate: the pitifully skinny, curled-up dog rejecting the inkpot standing beside him, the object of his despair, which he does not dare to look at.

Figure 5.7: *Cynocephalus*, from Pierio Valeriano, *Hieroglyphica sive sacris Aegyptiorvm literis commentarii Ioannis Pierii Valeriani Bolzanii Bellvnensis* (Basel: Isingrin, 1556), 47.

The ladder leaning against the tower is, according to Panofsky's letter, an allusion to '*obsidio*' [siege or blockade].[47] A ladder, it is written in the second book of the *Hieroglyphica*, means 'siege'. In his lecture Wind might have used an illustration from Jacques Kerver's French translation of 1543

47 The Latin translation 'obsidio' for πολιορκίαν (*The Hieroglyphics of Horapollo*, 90: 'siege') was used in the two earliest editions with Latin translations, of 1517 and 1518 respectively: Horapollon, *Hori Apollonis Niliaci hieroglyphica* [...] (Bologna: Hieronymus Platonides, 1517), ch. 28 (n.p.); Horapollon, *Ioannes Frobenivs Stvdiosis S. D. Damus nunc uobis Orum Apolline[m] Niliacu[m] de Hieroglyphicis* (Basel: Johannes Frobenius, 1518), 33.

(Figure 5.8).[48] Although the Viennese manuscript comprises only the first book, presumably Pirckheimer read Horapollon's entire text, and it is possible that Dürer may also have known of the second book and thus heard of the ladder. The mental leap from 'obsidio' to 'obsession' seemed particularly obscure to Panofsky, which is astonishing in view of Panofsky's knowledge of Latin, since 'obsidio' is etymologically derived from 'obsessio'.[49] In his hieroglyphic interpretation of the dog, characterizing the inkpot as a form of 'writer's block' and the ladder as 'obsession', Wind seems to have focused on melancholy as a pathological condition.

Children's chaos

In Plato's *Symposium*, the birth of Amor from Chaos is described in two ways: on the one hand according to the Hesiodic account in the *Theogony*; on the other hand, Amor is reported to have been born at Venus's birthday celebration in the Garden of Jupiter in the presence of all the Olympic gods, as a result of the coupling of Poros (Plenty) and Penia (Poverty).[50] These two contrasting myths are used as arguments for the thesis that Amor is the oldest and the youngest god, respectively. In his letter, Wind deals with this problem on the basis of Pico's interpretation. Wind's fascination with Pico's philosophy lies in the fact that it is motivated by an unending oscillation of contradictions. That which is hidden under poetic veils[51]

48 Horapollon, *De la signification des notes hiéroglyphiques des Aegyptiens*, trans. Jean Martin (Paris: Jacques Kerver, 1543), n.p.

49 Cf. Alois Walde, *Lateinisches etymologisches Wörterbuch*, 3rd rev. edn by J. B. Hofmann (Heidelberg: Carl Winter, Universitätsverlag, 1954), vol. 2, 197; Robert Maltby: *A Lexicon of Ancient Latin Etymologies* (Leeds: Francis Cairns, 1991), 422.

50 Plato, *Symposium*, 178a–179b; 203a–e.

51 See *Commento* I:8.

Figure 5.8: *Obsidio*, from Horapollon, *De la signification des notes hiéroglyphiques des Aegyptiens*, trans. Jean Martin (Paris: Jacques Kerver, 1543), n.p.

is for Pico a symbolic expression of a dialectical understanding of the world.[52]

Under this premise, chaos is not a state to be avoided, but a condition that makes possible the development of worldly relationships. Only from the interaction between mutually driving opposites – such as the One, which splits itself into the Many, or the Many, which tries to connect to the One – can the world emerge. This concept is inherent in the letter's

52 Similarly, Cassirer tried to establish the main category to describe Pico's way of thinking as 'symbolic thought'. See Ernst Cassirer, 'Giovanni Pico della Mirandola: A Study in the History of Renaissance Ideas (Part I)', *Journal of the History of Ideas* 3/2 (1942), 123–44 (137–8).

section on the 'Descent of Venus' from the angelic spheres (the sphere of the intellect), to the sphere of Jupiter, the Garden of Jupiter (the material world), and is developed in Wind's chapter on Botticelli's *Birth of Venus* in his *Pagan Mysteries in the Renaissance.*[53] There Wind refers to the myth, related by Hesiod, according to which Venus came into being by the castration of Uranus.[54] The castration could be understood as the original dismemberment of the One, which produced a multiplicity, a chaos, which in turn was the condition for the emergence of beauty, understood as a moderate mixture or proportional composition of individual elements. Wind now interprets Pico as inverting the commonplace of world creation as the overcoming of chaos: in the fragmentation of the original One, the act of creation becomes an agonizing sacrificial death:

> Creation is conceived in this way as a cosmogonic death, by which the concentrated power of one deity is offered up and dispersed: but the descent and diffusion of the divine power are followed by its resurrection, when the Many are 'recollected' into the One.[55]

Against this cosmogonic background of Orphic origin, Wind interprets Lucas Cranach the Elder's depictions of melancholy (see for instance Figure 5.9). In the lectures Wind may, on the basis of Cranach including in his imagery several children as opposed to Dürer's one, have referred to the 'deeper degree of chaos', as he does in the letter.[56] Yet Cranach's paintings do not come as a surprise, since they explicitly have melancholy as their topic.

What may come as a surprise, however, is the mentioning of Titian's *The Feast of Venus* (Figure 5.10), the children's chaos of which Wind identifies with the 'Orphic primordial state from which [...] "the" Amor is

53 See appendix to the present chapter, 158; Edgar Wind, *Pagan Mysteries in the Renaissance* (New York: Norton, 1968), 128–40.

54 Wind, *Pagan Mysteries in the Renaissance*, 132–3.

55 Wind, *Pagan Mysteries in the Renaissance*, 133.

56 Dagmar Hoffmann-Axthelm, 'Vanitas: Lukas Cranachs Melancholia-Gemälde (1533)', *Music in Art* 37/1–2 (2012), 191–206 (202), interprets the children as dancing the Moresca, a Spanish Moor's dance, which represents ignorance, immaturity and cluelessness – an interpretation contrary to Wind's positive image of the children's chaos.

Figure 5.9: Lucas Cranach the Elder, *Melencolia*, 1528, oil on panel, 112.5 × 71.0 cm. National Galleries of Scotland, Edinburgh, loan from private collection. Image from Bodo Brinkmann, ed., *Cranach der Ältere* (Ostfildern: Hatje Cantz, 2007), 317.

Figure 5.10: Titian, *The Feast of Venus*, 1518/19, oil on canvas, 172 × 175 cm. Museo
Nacional del Prado, Madrid.

lifted out and thus "born" '.[57] As becomes clear from the letter, Wind was
of course aware of the fact that the painting exemplifies the Amores of
Philostratus' *Imagines*. But his short methodological comment on what
he understands by 'program', namely the ' "argument" through which one
interprets the ancient ekphrasis', i.e. the Amores, anticipates a statement
put forward in his book *Bellini's Feast of the Gods* according to which 'there

57 See appendix to the present chapter.

Figure 5.11: Michelangelo Buonarroti, *A Children's Bacchanal*, 1533, red chalk on paper,
27.4 × 38.8 cm. Royal Collection Trust, RCIN 912777, Windsor Castle.

was considerably more to the program than "mere Philostratus".[58] Wind's
description can be characterized as a blending of Philostratus and Orphism:

> Hesiod and the Orphics and Plato had asserted (and Ficino and Pico repeated the
> doctrine) that Love originated in Chaos; and as Love, according to Plato's *Symposium*,
> was first conceived on the feast of Venus, the picture bearing this title represents
> the Beginning of Love, the whirlpool of the passions which is Love's infancy. As in
> Philostratus, this scene is a wild turmoil of cupids shooting at each other with arrows,
> embracing, wrestling, and playing with apples – the fruit of strife.[59]

We can only speculate on what Wind might have said about
Michelangelo's drawing of a Children's Bacchanal (Figure 5.11), which ap-
pears in the slide list for the Frick Collection lecture, since no references

58 Edgar Wind, *Bellini's Feast of the Gods: A Study in Venetian Humanism* (Cambridge,
 MA: Harvard University Press, 1948), 60.
59 Wind, *Bellini's Feast of the Gods*, 61.

to it can be found in his writings or papers. But we can imagine an argument similar to the one he applied to Titian's *Feast of Venus*: a chaos of children, cheerfully – and at times cruelly – playing in a landscape permeated by symbols of the four elements: earth, water, air and fire, which are also symbols of chaos, the junction of which is a prerequisite for the creation of the world.

Conclusion

In a passage in *Pagan Mysteries* Wind challenges the prevailing view of his day, that the values of the Middle Ages had largely continued into the Renaissance. He argues that the 'transvaluation of values' in the theory of morals introduced by Ficino and his circle is underestimated. For instance, the vice of sloth, *acedia*, was re-evaluated in the Renaissance as 'noble melancholy' and became the privilege of men of genius.[60] As evidence, Wind cites Dürer's engraving *Melencolia I* with reference to the studies of Panofsky and Saxl as well as that of Giehlow, without asserting any objections to their views.[61] Wind's eloquent silence should not, however, be interpreted as capitulation. Wind had already made clear in the letter of 1938 that the astrological-medical interpretation was not wrong but incomplete, needing an Orphic-poetic supplement. In fact, Wind's chapter on Titian's *Venus Blinding Cupid* is framed in response to Panofsky's interpretation, and emphasizes the Orphic aspects within the neo-Platonic circles.[62]

As Wind argues in 'The Eloquence of Symbols', the irregular appearance of Dürer's polyhedron possesses those qualities essential to a good symbol: it must not be too easy to understand, and must not be totally

60 Wind, *Pagan Mysteries in the Renaissance*, 68–9.
61 Wind, *Pagan Mysteries in the Renaissance*, 69 n. 58.
62 For a systematic comparison of Panofsky's and Wind's respective readings of Titian's *Venus Blinding Cupid*, see Charles Oliver O'Donnell, 'Two Modes of Midcentury Iconology', *History of Humanities* 3/1 (2018), 113–36.

absorbed once the meaning has been found; on the other hand, it must not be too obscure. A symbol is eloquent when it sets the opacity of materiality in oscillation with the transparency of conceptuality.[63]

The word 'opaque' can be read as a neutral term for persisting chaos. If in Dürer's *Melencolia I* the descent of Venus to earth suggests a disintegration of the original One, an agonizing sacrifice accompanied by sombreness for the genesis of the world, then in Titian's *Feast of Venus* the melancholy in the Orphic primordial state of the children's chaos is reversed into serenity.

Appendix

Letter, Edgar Wind (in Otterton) to Fritz Saxl (in London), 1 September 1938, Warburg Institute Archive, General Edgar Wind Correspondence, folder Dr. Edgar Wind [1937/38], 9 pp.
Footnotes and translation from German by Franz Engel.

My dear Fritz:

Please don't laugh at me, but I am very worried about your and Panofsky's interpretation of 'Melancholia'.[64] Can the publication really, as you told me, no longer be stopped?

My suspicion that Dürer's engraving does not illustrate the astrological-medical notion of Saturn, but the Orphic-poetic one found in Pico, has been confirmed. I can explain to you Pico's text on the block in the background, and also on the figure of Melancholy itself. The block is a symbol of chaos, which, according to Pico's definition, is the world of unordered matter, but in which the totality of forms is, so to speak, hidden inside: – 'la materia piena di tutte le forme'.[65] As I already told you, this irregular block is constructed in such a way that it is – to quote Dürer – 'inwardly full of figure'.[66] Above this chaos, which holds perfection in its bosom,

63 Wind, 'The Eloquence of Symbols', 349.
64 Here Wind is referring to Klibansky, Panofsky and Saxl, *Saturn and Melancholy*.
65 *Commento* II:14.
66 Dürer, *Dürers schriftlicher Nachlaß*, 295.

reigns, according to Pico, a Venus-Saturnia, which has the characteristics of a Saturnine angel.[67] She descends from the sphere of Saturn (which Pico equates with the angelic sphere) into the sphere of Jupiter (= anima mundi),[68] where she unites with Nemesis, who alone rules matter until this descent of Venus (which is at the same time an ascension of Cupid, who, according to Orpheus, is born out of chaos).[69] The union of these three powers – Saturn, Jupiter, Nemesis – is represented in the three devices on the tower: hourglass, number-square, and balance; with the sign of Saturn, as the dominant element, in the centre. Your interpretation of 'measure, number, and weight' is correct, but incomplete;[70] for this Biblical expression receives an Orphic exegesis. The scale weighs the weight of the soul, the hourglass measures the duration of life, and the number is the expression of consummated (divine) harmony.

The relationship of the Amor and the dog to the main character will frighten you: – It is the Amor and the dog that so often belong to Venus (see Titian).[71] You remember that this dog sometimes sleeps and sometimes barks. (He can scratch himself, by the way!) This marks the various states of the 'canine part of the soul' (see Plato, Republic).[72] In one of Cranach's 'Melancholias', this part of the soul is split into two dogs, one of which sleeps and the other barks.[73] Corresponding splitting (or multiplication) is carried out there also for the role of Amor, and Venus splits a staff. This means a deeper degree of chaos than in Dürer's 'Melancholia'. Absolute chaos is reached when Venus-Saturnia descends completely to the level of Nemesis. Then the simple or multiplied Cupid perishes in the 'children's-chaos' which denotes the Orphic primordial state from which – by the beneficent attraction of Venus – 'the' Amor is lifted out and thus

67 *Commento* II:13 and III:1.

68 *Commento* I:8 and III:1.

69 *Commento* II:14 and 16.

70 See Panofsky and Saxl, *Dürers 'Melencolia I'*, 66–7, with reference to *Wisdom* XI, 20.

71 Titian, *Venus and the Organ Player*, c. 1550 (Gemäldegalerie, Berlin); Titian, *Venus of Urbino*, 1538 (Gallerie degli Uffizi, Florence).

72 *Politeia*, 374e–375e.

73 Lucas Cranach the Elder, *Melancholy* (1528), oil on panel, 112.50 × 71.0 cm (Edinburgh, National Galleries of Scotland, loan from private collection).

'born'. According to Plato (Symposion) Amor is conceived at the feast of
Venus, – namely by the fact that the 'abundance' gets drunk with nectar
and loses self-control.[74] This Platonic motive – (creation of love from the
abundance at the festival of Venus) – is connected by Pico to the Orphic
motive of the birth of Amor out of chaos. The program of Titian's Venus
festival comes from this circle of ideas.[75] (By 'program' I mean the 'argu-
ment' through which one interprets the ancient ekphrasis).[76] The 'children's
chaos' is here – with positive sign – the same as with the 'Venus-Saturnia'
in the sign of the Nemesis: – the chaos before – or at – the birth of Amor.

I would be reluctant to present this brew to you in this half-cooked
state, if I were not troubled by the thought that this thick book now ap-
pears under the title 'Dürer's Melancholia' and in it everything can be found
that one can only know about melancholia, except what one needs just for
Dürer's melancholia. If it is already printed, I would suggest changing the
title and calling it what it is: a history of the astrological-medical concept
of melancholy.[77] Then no one can blame you for having come just so far
with Dürer, and no further. For as a 'white print' the picture that comes
out is certainly correct.

With Agrippa von Nettesheim you were already on the right track.
The first three books of the 'Occulta Philosophia' (– the fourth I have not
yet got to grasp –) are a simplified and somewhat banalized reproduction
of Pico's ideas, interspersed with formulations, which are literally written
out from Pico. I think it is actually impossible that Dürer, who had such
close relations with Italy, could have drawn from such an indirect and

74 Plato, *Symposion*, 203b–e.
75 Titian, *Feast of Venus*, 1518 (Madrid, Museo Nacional del Prado).
76 Philostratus, *Imagenes*, I:6.
77 Panofsky had already suggested the general title *Melancholia* in a letter to Saxl
 of 7 February 1936, and repeated it in a letter of 2 September 1938 – coinciden-
 tally one day after Wind's letter – and added a subtitle: 'MELANCHOLIA.
 A Source- and Image-Historical Study of the Type of the Saturnian Melancholic'
 (Panofsky, *Korrespondenz*, vol. 2, 138); see also Davide Stimilli, 'The Melancholy of
 the (Co-)Author: Panofsky and the Authorship of "Saturn and Melancholy"', in
 Despoix and Tomm, eds, *Raymond Klibansky and the Warburg Library Network*,
 269–88 (279 n. 51); and 'Afterword', in Klibansky, Panofsky and Saxl, *Saturn and
 Melancholy*, 455.

thereby rather second-rate source. Also Pirckheimer knew these things much more exactly.[78]

I expect to be in London on Monday evening.[79] By then I will also have finished reading Gombrich's book, which I like very much.[80]

Hopefully you both have recovered a bit!

I have been writing here – more or less – day and night on the Pico (– no longer Pio –) book, with the success that I can only bear the brain decay that has already occurred thanks to the stupor that comes with it. By Monday I may have dissolved into the 'children's chaos'.

A thousand greetings to you both!

Your Edgar.

P. S. I am sending this 'Registered' because letters have been proven to be lost at the local village post office.

Post scriptum to the letter above, 2 September 1938, 2 pp.

Dear Fritz:

To correct yesterday's letter. I see just now that I introduced the 'Nemesis' one step too early. The three devices on the tower refer only to the union of Saturn and Jupiter; for I read just now in Pico that when the Saturnine force descends into Jupiter, Jupiter himself decomposes into a contemplative and an active function, which then have a Saturnine effect. Just as the square of numbers denotes the contemplative function of Jupiter, so the scales denote his active function (government; I think in the Tarocchi, for example, he holds a scales). In between stands Saturn as the 'transcendent' principle, between the 'intellectual' and the 'active' principle, – a configuration which Pico tries to show in all groups of three (e.g. three Graces, three Parcenes, etc.).[81] It is of course no coincidence that the

78 See above, 142–144.

79 5 September 1938.

80 This is either Ernst Gombrich's doctoral dissertation, 'Giulio Romano als Architekt' (University of Vienna, 1933), which was possibly available to Wind in copy or in the excerpted sections published in the *Jahrbuch der Kunsthistorischen Sammlungen in Wien* 8 (1934), 79–104; and 9 (1935), 21–150; or Gombrich's *Eine kurze Weltgeschichte für junge Leser* (Vienna: Steyrermühl, 1936).

81 *Commento* II:17.

contemplative figure of Melancholy sits under the square of numbers, the busy Amor under the scales. Unfortunately, I don't have the sheet here, so I don't know if the bell hangs directly above the Saturn sign. If so, it probably signifies Uranus.

Sincerely
Your Edgar.

By the way, I bring a special surprise for you: – 'Death of Procris'.

BERNHARD BUSCHENDORF

6 Symbol, Polarity and Embodiment: The Composite Portrait in Aby Warburg and Edgar Wind

Between January 1928, when on the offer of Aby Warburg Edgar Wind joined the Warburg Library, and Warburg's death in October 1929, an intensive exchange between the two scholars took place, focusing on Warburg's concept of *Kulturwissenschaft*. Wind viewed Warburg's writing through the lens of the pragmatist philosophy of Charles Sanders Peirce, which since 1924 had significantly shaped his own thinking.[1] In fact, Wind demonstrated that Warburg's research program basically complied with core maxims put forth by Peirce. As the diary ['Tagebuch'] of the Kulturwissenschaftliche Bibliothek Warburg (KBW) reveals, Warburg appreciated that Wind, whom he famously called 'eine Denktype bester Sorte' [a first-rate type of thinker],[2] was

1 Peirce's theory of embodiment is a key concept in Wind's habilitation thesis, in which he aims at a pragmatist foundation of the humanities by explicating the concept of nature in modern physics: Edgar Wind, *Das Experiment und die Metaphysik: Zur Auflösung der kosmologischen Antinomien* (Tübingen: Mohr, 1934); new edition by Bernhard Buschendorf, with a foreword by Brigitte Falkenburg and an afterword by Bernhard Buschendorf (Frankfurt: Suhrkamp, 2001); English translation: Edgar Wind, *Experiment and Metaphysics: Towards a Resolution of the Cosmological Antinomies*, trans. Cyril W. Edwards, with an introduction by Matthew Rampley (Oxford: European Humanities Research Centre, 2001).

2 The 'Tagebuch' was published as part of the collected writings of Aby Warburg. All references are to this published version: Aby Warburg, Gertrud Bing and Fritz Saxl, *Tagebuch der Kulturwissenschaftlichen Bibliothek Warburg*, ed. Karen Michels and Charlotte Schoell-Glass, Aby Warburg, Gesammelte Schriften, vol. VII (Berlin: Akademie, 2001) [hereafter *Tagebuch*], 104.

able to connect his concept of *Kulturwissenschaft* to the reflections of contemporary avant-garde epistemology.[3] In turn, Wind's presentations of Warburg's thinking – for example, his seminal lecture 'Warburgs Begriff der Kulturwissenschaft und seine Bedeutung für die Ästhetik'[4] – were based on explanations that Warburg had passed on to him. As Wind wrote in 1969: 'In my paper of 1931 […] I tried to put Warburg's basic ideas into a systematic order which I had learned from him in long conversations.'[5] While it is by now a commonplace that Wind considered Warburg and Peirce his two major teachers,[6] the

3 Warburg notes, for example, that he had talked with Wind 'very generally about the epistemological site of Mnemosyne', 23 September 1928, *Tagebuch*, 344 (my translation). See also Warburg's entry for 11 October 1929, *Tagebuch*, 547: 'Gave Edgar Wind the "grundlegende Bruchstücke", which he reads; unexpected perspectives open up with regard to the common ground of the "method" between my stammering 40 to 30 years ago and today's epistemology' (my translation).

4 Edgar Wind, 'Warburgs Begriff der Kulturwissenschaft und seine Bedeutung für die Ästhetik', *Zeitschrift für Ästhetik und allgemeine Kunstwissenschaft* 25 (1931), supplement, 163–79; Edgar Wind, 'Warburg's Concept of *Kulturwissenschaft* and its Meaning for Aesthetics', in Edgar Wind, *The Eloquence of Symbols: Studies in Humanist Art*, ed. Jaynie Anderson, with a biographical memoir by Hugh Lloyd-Jones (rev. edn, Oxford: Clarendon Press, 1993), 21–35.

5 Edgar Wind, 'Concerning Warburg's Theory of Symbols (from notes compiled for George Watson)', Bodleian Libraries, University of Oxford, Edgar Wind Papers, MS. Wind 4, folders 1, 1–2; 2; quoted fully in Bernhard Buschendorf and Franz Engel, 'Edgar Winds Cambridger Rede Lecture "On Classicism" von 1960', *Pegasus: Berliner Beiträge zum Nachleben der Antike* 18/19 (2018), 237–77 (270 n. 21). Wind refers here to his 1931 article 'Warburg's Concept of *Kulturwissenschaft*'; see, however, the misleading paraphrase of Wind's statement in the editor's note to Wind's article in *The Eloquence of Symbols*, 21: 'Wind is here attempting to put into systematic order the basic ideas he had learnt from Warburg in long conversations.'

6 Bernhard Buschendorf, "'War ein sehr tüchtiges gegenseitiges Fördern": Edgar Wind und Aby Warburg', *Idea: Jahrbuch der Hamburger Kunsthalle* 4 (1985), 165–209 (173, 203); John Michael Krois, 'Kunst und Wissenschaft in Edgar Winds Philosophie der Verkörperung', in Horst Bredekamp, Bernhard Buschendorf, Freia Hartung and John Michael Krois, eds, *Edgar Wind: Kunsthistoriker und Philosoph* (Berlin: Akademie, 1998), 181–205 (184 n. 5); see also Buschendorf and Engel, 'Winds Cambridger Rede Lecture', 271 n. 25; Franz Engel, 'Though This Be Madness: Edgar Wind and the Warburg Tradition', in Sabine Marienberg and Jürgen

consequences of this fact for the shaping of the Warburgian method of *Kulturwissenschaft* have yet to be investigated in greater detail. What deserves closer scrutiny is above all the combination of a pragmatist modification of Warburg's concept of symbol with the appropriation of Peirce's understanding of the circle of research and his theory of embodiment, both of which Wind transferred onto Warburg's historical psychology. In the following, I will illustrate the methodological congruity between Warburg and Wind by comparing Warburg's study on Francesco Sassetti (1907)[7] with Wind's article on Albrecht von Brandenburg (1937).[8] In both case studies, the basic theoretical assumptions that guide the respective historical analyses remain implicit and have to be uncovered. As Wind explains, instead of reconstructing the interdependencies between art and culture by way of basic theoretical reflection, that is, '*in abstracto*', one can instead 'search for them where they may be grasped historically – in individual objects. In studying this concrete object [...] we can develop and test the validity

Trabant, eds, *Bildakt at the Warburg Institute* (Berlin: De Gruyter, 2014), 87–116; for research on Wind and Peirce, see Tullio Viola, 'Peirce and Iconology: Habitus, Embodiment, and the Analogy between Philosophy and Architecture', *European Journal of Pragmatism and American Philosophy* 4/1 (2012), 6–31; Tullio Viola, 'Edgar Wind on Symbols and Memory: Pragmatist Traces on a Warburgian Path', *Visual History: Rivista internazionale di storia e critica dell'immagine* 6 (2021), 99–116.

7 Aby Warburg, 'Francesco Sassettis letztwillige Verfügung' (1907), in *Die Erneuerung der heidnischen Antike: Kulturwissenschaftliche Beiträge zur Geschichte der europäischen Renaissance*, Aby Warburg, Gesammelte Schriften, ed. Gertrud Bing in co-operation with Fritz Rougemont, vol. I (Leipzig: Teubner, 1932; repr. Nendeln, Liechtenstein: Kraus, 1969), 127–58, 353–65; Aby Warburg, 'Francesco Sassetti's Last Injunctions to His Sons', in Aby Warburg, *The Renewal of Pagan Antiquity: Contributions to the Cultural History of the European Renaissance*, introduction by K. W. Forster, trans. D. Britt (Los Angeles: Getty Research Institute, 1999), 222–62.

8 Edgar Wind, 'Studies in Allegorical Portraiture, I: 2. Albrecht von Brandenburg as St Erasmus [by Grünewald]', *Journal of the Warburg Institute* 1 (1937), 142–62; Edgar Wind, 'An Allegorical Portrait by Grünewald: Albrecht von Brandenburg as St Erasmus', in Wind, *The Eloquence of Symbols*, 58–76.

of categories which can then be of use to aesthetics and the philosophy of history. This [...] course is the one Warburg adopted.'[9] By the time he wrote 'Hume and the Heroic Portrait' (1932), Wind followed the path Warburg had taken.[10]

Francesco Sassetti: Between medieval trust in God and Renaissance enjoyment of the vivacity of life

Warburg's study on Sassetti is based upon his theory of the polarity of symbol, a kind of psychology of balance [*Ausgleichspsychologie*]. Warburg assumes that on the broad scale of symbolic relation to the world there are two extreme poles. On the one side, there is the pole of uninhibited expression, where humans are ruled so strongly by affect that they tend to compulsively transform the emotional pressure they feel into ritual actions, falling back to a level of mythical-magic object relations. On the other side, there is the pole of distanced level-headedness, where human beings are free of emotional pressure and thus are able to face objects in a purely rational manner. To Warburg, the symbols situated between these poles – that is, the cultural symbols proper – are then products of an interpolar balance, and each symbol's specific form can be determined only by reconstructing the concrete circumstances under which the particular balance is implemented. In his case study on Sassetti, Warburg conceptualizes the latter's state of mind as the following combination of polar-contrary dispositions. On the one side, Warburg identifies the pole

9 Wind, 'Warburg's Concept of *Kulturwissenschaft*', 24; see also Buschendorf, 'Edgar Wind und Aby Warburg', 189.
10 Edgar Wind, 'Humanitätsidee und heroisiertes Porträt in der englischen Kultur des 18. Jahrhunderts', in Fritz Saxl, ed., *England und die Antike: Vorträge der Bibliothek Warburg: 1930–1931* (Leipzig: Teubner, 1932), 156–229; Edgar Wind, 'Hume and the Heroic Portrait', in Edgar Wind, *Hume and the Heroic Portrait: Studies in Eighteenth-Century Imagery*, ed. Jaynie Anderson (Oxford: Clarendon Press, 1986), 1–52.

of Christian trust in God. In the realm of the *vita contemplativa* it manifests itself either as monastic-escapist asceticism or as magic adoration of saints; in the *vita activa* it appears as the medieval culture of loyalty, which, founded on good faith, is rooted in a deep sense of the honour of family and social caste. On the other side, there is the pole of a radically worldly self-confidence characteristic of the Renaissance individual steeped in humanist learning, which manifests itself, for example, in the 'worldly intelligence'[11] of the entrepreneurial patrician.

Warburg explicates the psychological balance between these two poles by interpreting Sassetti's last injunctions, which are written not in the modern form of a legally certified testament, but follow the medieval custom of an informal moral appeal to his sons' sense of honour and loyalty. Sassetti instructs them that in the case of his death they should for the sake of his salvation inter his mortal remains in the chapel of his patron saint; but he also obligates them for the sake of the honour of the family to bravely engage in a worldly battle with the pagan goddess Fortuna, the emblematic personification of contingent fate.

As Warburg explains, the balance to which Sassetti aspired, namely between medieval-Christian trust in God and a modern-pagan parade of the sensual pleasures of the world, is most prominently expressed in the centrepiece of Ghirlandaio's fresco cycle in the Sassetti Chapel of the Basilica di Santa Trinità in Florence (Figure 6.1): the altarpiece *Adoration of the Shepherds* (Figure 6.2). The cycle, which narrates the *vita* of Sassetti's personal patron saint, St Francis of Assisi, transposes central episodes of the hagiography into contemporary Florence, thus integrating its citizens as virtual participants in the sacred act, among whom Sassetti himself appears twice in life size. According to Warburg, the genre of the life-size realistic portrait, as well as that of the respective donor portrait, goes back to the practice of the wax figure *ex voto*, 'the coveted privilege of setting up wax effigies of themselves, dressed in their own clothes, in their own life-times'.[12] Thus, Warburg argues, the

11 Warburg, 'Sassetti's Last Injunctions', 233.
12 Aby Warburg, 'The Art of Portraiture and the Florentine Bourgeoisie: Domenico Ghirlandaio in Santa Trinità. The Portraits of Lorenzo de' Medici and His Household' (1902), in Warburg, *The Renewal of Pagan Antiquity*, 185–221 (189); see

Figure 6.1: Domenico Ghirlandaio, altar wall of the Sassetti Chapel, 1483–6, fresco.
Basilica di Santa Trinità, Florence.

intrusion of the realistic portrait into the devotional image is not indica-
tive of advanced secularization, but quite to the contrary: a remnant of

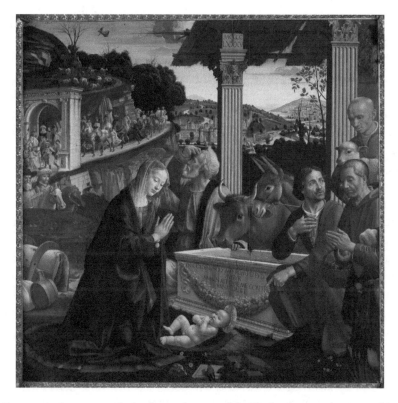

Figure 6.2: Domenico Ghirlandaio, *Adoration of the Shepherds*, 1485, altarpiece of the Sassetti Chapel, fresco. Basilica di Santa Trinità, Florence.

the magic picture charm of primitives, by which 'the Catholic Church, in its wisdom, had left its formerly pagan flock a legitimate outlet for the inveterate impulse to associate oneself, or one's own effigy, with the Divine as expressed in the palpable form of a human image'.[13] Or, as

13 Warburg, 'Bildniskunst und florentinisches Bürgertum'. In his excellent study on the Sassetti Chapel, Michael Rohlmann justly points to Warburg's emphasis on magic in his interpretation of the Sassetti portrait groups: 'Warburg compared such assisting portraits [Assistenz-Porträts] to the realistic life-size wax effigies that at the time were donated to images of grace [Gnadenbildern] as votive offerings in

Warburg observes: 'Opfer im Bild, *ex voto*, keine Blasphemie' [Sacrifice in the image, *ex voto*, no blasphemy].[14]

According to Warburg, Ghirlandaio intensifies this magical approach to the Divine by presenting an identification figure of Sassetti in his altarpiece. With their own sarcophagi behind them, Francesco and his wife, Nera Corsi, worship the newborn Christ child. 'In this way they lastingly demonstrate to posterity their piety and immortalize their intercession: Nera on the left, standing in the succession of her female model Mary, Francesco on the right, in the cortege of the male shepherds.'[15] The praying shepherd at the right-hand edge of the painting is in physiognomy and hairline somewhat reminiscent of the Bargello marble bust, made around 1464 in the workshop of Antonio Rossellino, that shows an idealized Sassetti in his prime representing a Roman emperor attired in a toga (Figure 6.3). As Warburg points out, Sassetti loved to be represented in the garb of religious, mythological or historical prototypes; after all, the traditional costume allowed him magically, as it were, to incorporate – or as Warburg used to say, 'to install in one's soul' [*einverseelen*] – the polar-opposite aspects of his world view.[16]

gratitude for having received heavenly support. The portraits in scenes of saints were a similar form of an almost magical approach to and entrustment in the divine. The plastic as well as the life-size painted image represented – before and in the pictures of saints – the real donor.' Michael Rohlmann, 'Bildernetzwerk: Die Verflechtung von Familienschicksal und Heilsgeschichte in Ghirlandaios Sassetti-Kapelle', in Michael Rohlmann, ed., *Domenico Ghirlandaio: Künstlerische Konstruktion von Identität im Florenz der Renaissance* (Weimar: VDG, 2003), 165–243 (170) (my translation).

14 Aby Warburg, quoted in Ernst Gombrich, *Aby Warburg: An Intellectual Biography, with a Memoir of the Library by F. Saxl* (London: Warburg Institute, 1970), 120.

15 Rohlmann, 'Bildernetzwerk', 204 (my translation).

16 It is interesting to note that in Warburg's last lecture, 'Römische Antike in der Werkstatt des Domenico Ghirlandaio' ('Roman Antiquity in the Workshop of Domenico Ghirlandaio'), which he gave at the Biblioteca Hertziana in Rome on 19 January 1929, the Sassetti Chapel figures prominently; for a detailed editorial description of the various fragmentary texts and notes of the Hertziana Lecture, see Aby Warburg, *Gesammelte Schriften: Studienausgabe*, ed. Ulrich Pfisterer, Horst Bredekamp, Michael Diers, Uwe Fleckner, Michael Thimann and Claudia

Figure 6.3: School of Antonio Rossellino, bust of Francesco Sassetti, 1464, marble, height: 50 cm. Museo Nazionale del Bargello, Florence.

The ideal of medieval-Christian devotion is emphatically expressed in the worshipping shepherds of the altarpiece. Although Ghirlandaio based his depiction on the corresponding group of shepherds in the Portinari altarpiece by Hugo van der Goes (Figure 6.4), he does not give his Bethlehemite shepherds a Flemish rustic-coarse appearance, but instead the refined countenances of Florentine citizens. In fact, he lends his own features to the shepherd on the left of the trio,[17] who with his left hand points to the inscription

Wedepohl (Berlin: Akademie, 1998–2021), vol. II.2; *Bilderreihen und Ausstellungen*, ed. Uwe Fleckner and Isabella Woldt (Berlin: Akademie, 2012), 303–10 (306, 309 n. 31).

17 On the self-portraits by Ghirlandaio in the scene of *The Expulsion of Joachim from the Temple* in the main chapel of Santa Maria Novella and, respectively, in the *Resurrection of the Boy* in the Sassetti Chapel of Santa Trinità, see Eva Borsook and Johannes Offermann, *Francesco Sassetti and Ghirlandaio at Santa Trinità, Florence: History and Legend in a Renaissance Chapel* (Doornspijk, The Netherlands: Davaco, 1981), 41; on the two Ghirlandaio self-portraits mentioned above and for his self-portrait in the altarpiece of the Sassetti Chapel, see Andreas Quermann, *Domenico di Tommaso di Currado Bigordi Ghirlandaio: 1449–1494* (Cologne: Könemann, 1998), 61–3.

on the manger-sarcophagus predicting the birth of the Saviour, as well as to
the fulfilment of this prophecy: the infant Christ lying before him.[18] With
his right hand – that is, the painter's – Ghirlandaio, not without pride,
points to his heart, while turning left to his fellow shepherd kneeling in
prayer who, according to Warburg, is yet another idealized personification
of Sassetti.[19] At the same time, Ghirlandaio looks beyond the painting;

18 As Warburg notes, the inscription on the front of the sarcophagus 'records the
 prophetic words of a Roman augur: "One day my sarcophagus will give the world
 a God."' Warburg, 'Sassetti's Last Injunctions', 247. Picturing so impressively the
 old world's submission to the new (a common topic in contemporary Christmas
 celebrations) allowed Ghirlandaio to simultaneously indulge in the artistic delight
 that the Renaissance took in 'unbridled pagan exuberance' (245), indicated here
 by the triumphal arch, through which 'the Three Kings' lively antique cavalcade
 passes' (249). The illusion of the compatibility between medieval trust in God and
 Renaissance enjoyment of the vivacity of life staged *all'antica* was only to be des-
 troyed by Savonarola's bonfire of the vanities.

19 Warburg repeatedly suggests that Sassetti figures in the kneeling shepherd; in the
 Sassetti article his claim can easily be overlooked due to ambiguous wording: 'In all
 good faith, Francesco Sassetti could thus display his Christian piety amid the signs
 and portents of the Roman world; not because he was at all capable of kneeling
 in guileless prayer, like one of the shepherds, oblivious of the alien stonework all
 around, but because he believed that he had laid the unquiet spirits of antiquity
 to rest by building them into the solid conceptual architecture of medieval
 Christianity.' Warburg, 'Sassetti's Last Injunctions', 249. An explicit identification
 of Sassetti with the kneeling shepherd can be found in Warburg's 'Draft of a Report
 on the Hertziana Lecture', 31 August 1929, London, Warburg Institute Archive,
 III, 115.3.7, fol. [13]. Warburg merges here two figures of the group of shepherds
 into one – the kneeling shepherd and the one standing behind him carrying the
 lamb: 'In den Zwickeln des Grabmales von Francesco Sassetti sind die Aktionen
 seines Lebens nach römischen Medaillen angedeutet, während er im Altarbilde der
 Kapelle als guter Hirte mit dem Lamm auf dem Arm vor dem Sarkophag kniet,
 genau in dem Stile der drei Hirten auf der Anbetung des Hugo van der Goes' [In
 the spandrels of the tomb of Francesco Sassetti, the actions of his life are indicated
 after Roman medals, while in the altarpiece of the chapel he kneels as a good shep-
 herd with a lamb in his arm before the sarcophagus, exactly in the style of the three
 shepherds in the Adoration of Hugo van der Goes] (my translation), (by permis-
 sion of the Warburg Institute Archive).

Figure 6.4: Hugo van der Goes, detail of shepherds from the Portinari altarpiece, 1475, oil on panel. Gallerie degli Uffizi, Florence.

yet he directs his gaze not towards the viewer but towards the aged donor Sassetti, who analogous to his identification figure is also kneeling in prayer, imploring the Last Judgement for protection and intercession (Figure 6.5). While the donor, for the sake of securing his own salvation, had commissioned from the painter the cycle of St Francis and the *Adoration of the Shepherds*, Ghirlandaio, having speedily fulfilled the commission, now in the role, as it were, of a pastoral mystagogue, reassures Sassetti in his faithful Christian devotion.

Figure 6.5: Domenico Ghirlandaio, altarpiece of the Sassetti Chapel, accompanied by the portraits of Nera Corsi and Francesco Sassetti, 1483–6, fresco. Basilica di Santa Trinità, Florence.

On the theory of magic and the composite portrait as magical instrument

In his studies on the composite portrait, Wind drew methodically on Warburg's theory of the polarity of symbols, yet again refining the theory in a pragmatist way. Of particular importance is Wind's two-part pilot piece, the material study 'Albrecht von Brandenburg as St. Erasmus' and the study of genre theory entitled 'In Defence of Composite Portraits'.[20]

20 Originally published under the title 'Studies in Allegorical Portraiture I' in the *Journal of the Warburg Institute* 1 (1937), 138–42, 'In Defence of Composite Portraits' served as a theoretical introduction to the case study on Albrecht

In the latter, Wind discusses the genre of the composite portrait by applying Hegel's concept of the concrete universal as a correlation of a series of succinct elements, all of which exist in historically documented shapes. Wind explicates the configuration of these elements as a series of polar-contrary opposites, and distinguishes between several types of composite portrait, which can be positioned along an imaginary scale.

At the pole of enthusiastic-ritualistic imitation, Wind locates the Pueblo Indians' dance of the antelope as studied by Warburg,[21] as well as the antique hero cult of the Roman emperor Commodus, who had himself portrayed with the attributes of the club and lion skin of Hercules, so that the 'honours due to the ancient demi-god were transferred to the emperor in whom he was embodied' (Figure 6.6)[22] At the counter-pole, there is the composite portrait of the tradition-building type that Reynolds had coined. It is a product of the Enlightenment, in the course of which the antique deities lost their original symbolic and magical powers, fading into mere metaphors. The middle position is occupied by the composite portraits in the style of Louis XIV; here individuals of high rank underline their identity through contemporary dress, while simultaneously posing as antique gods. Although the initial picture magic is somewhat diminished, it is not

von Brandenburg in the same issue (142–62), whereby the numeration suggests that Wind had planned a series of such studies. Based on exclusively art-historical criteria, the complementary parts were split up and the theoretical reflections were published in Wind, *Hume and the Heroic Portrait*, 120–4. In the following, I quote Wind's article from the *Journal of the Warburg Institute*, with additional page references to the edited version in *Hume and the Heroic Portrait* and *The Eloquence of Symbols*, respectively. It is in line with separating theory from case study that in the edited version of 'In Defence of Composite Portraits' some theoretical passages were left out (see below, Footnote 26).

21 Aby Warburg, 'A Lecture on Serpent Ritual' (1939), first published in *The Journal of the Warburg Institute* 2 (1938–9), 277–92, and reprinted in *Bilder aus dem Gebiet der Pueblo-Indianer in Nord-Amerika*, ed. Uwe Fleckner, Aby Warburg, Gesammelte Schriften, vol. III.2 (Berlin: De Gruyter, 2018), 129–50; for the original version, a lecture in German held on 25 April 1923, see 'Reise-Erinnerungen aus dem Gebiet der Pueblo-Indianer in Nordamerika, 1923', Aby Warburg, Gesammelte Schriften, vol. III.2, 105–21.

22 Wind, 'In Defence of Composite Portraits', 138 (*Hume and the Heroic Portrait*, 121).

completely obliterated. Or, in Warburg's famous paraphrase of Jean Paul, in this type of portrait 'trope and metaphor' blossom, 'grafted to a single stem'.[23] The magic that unites opposites derives from the art of grafting, the charm of convincing play-acting. 'What began in fiction terminates in reality, so that the human beings who acted the gods were venerated really as god-like beings.'[24]

According to the Peircean principle of internal determination that Wind expounded in his habilitation thesis, it is only God who can view the world in its totality. Human beings can explore it only approximately, and in doing so they depend on earthly and thus necessarily insufficient means that they come across and must use as instruments. To Wind, the 'Distorted Gods'[25] of the composite portraits are such instruments. Whether as artists or as cultural historians, we must learn

> to look upon distortions as *instruments* rather than as mere *obstructions* of a living mind, and we may yet find that we are none the worse for being in a world in which the limitations of our powers determine their use. [...] These conceits of our imagination are signs of both our frailty and our strength. Viewed *sub specie aeternitatis*, they may seem to make men behave like fools, yet it is they who, *sub specie temporis*, keep gods and heroes alive.[26]

Wind extends his explanation in a note, thereby confirming the principle of internal determination:

> I may add that the *species aeternitatis* can be proved to be a contradiction in terms, much as the notion of an 'infinite mind' or of 'infinite physical extension'. Not *beyond* but *within* our temporary limitations do we find the tools for distinguishing between truth and error and achieving our measure of each of them. Whether we like it or not, we are committed to the *species temporis*.[27]

23 Warburg, 'Pagan-Antique Prophecy in Words and Images in the Age of Luther' (1920), in Warburg, *The Renewal of Pagan Antiquity*, 597–697 (599).

24 Wind, 'In Defence of Composite Portraits', 139 (*Hume and the Heroic Portrait*, 121). As Wind adds, from *Hamlet*: 'Though this be madness, yet there is method in 't.'

25 Wind, 'In Defence of Composite Portraits', 139 (*Hume and the Heroic Portrait*, 121).

26 Wind, 'In Defence of Composite Portraits', 141–2 (*Hume and the Heroic Portrait*, 124).

27 Wind, 'In Defence of Composite Portraits', 142 n.; this note was deleted in the edited version.

Figure 6.6: Bust of Commodus as Hercules, Roman, c. AD 180–93, marble, height: 133 cm. Musei Capitolini, Rome.

Albrecht von Brandenburg as saint and humanist

Like Warburg in his study on Sassetti, Wind in his article on Albrecht von Brandenburg seeks on the basis of the ' "psychology of equilibrium" (Ausgleichspsychologie)' to reconstruct the mindset of an era of 'transition

and conflict',[28] and like Warburg he demonstrates that the historical agents are struggling to reconcile the inherent contradictions of their respective dispositions, without always being fully aware of it. Whereas Warburg's case study exposes the disposition of a deeply religious and at the same time highly secular patrician of the early Renaissance, Wind's case study reveals the disposition of a high dignitary of the Catholic church steeped in humanism at the beginning of the Reformation. And just as Warburg understands Ghirlandaio's *Adoration of the Shepherds* as a painting that combines a magic and a world-embracing pole and interprets it in the manner of *Kulturwissenschaft* as a perceptive visual artistic expression of the Sassettean habitus,[29] Wind conceives of Grünewald's Erasmus-Mauritius panel (Figure 6.7) as a painting that combines a magical pole of the Catholic cult of relics with the rational counter-pole of humanist learning, and he explicates it – including its style – as a visual manifestation of Albrecht von Brandenburg's contradictory habitus.

28 Wind, 'Warburg's Concept of *Kulturwissenschaft*', 26, 34.
29 Rather than speaking of 'mentality' in the tradition of Peter Burke or the Annales School, I would prefer the term 'habitus' explicated by Pierre Bourdieu. First, Bourdieu's concept of habitus makes clear that the disposition to be reconstructed includes not only mental but also emotional and bodily dimensions. Second, the disposition in question consists of a bundle of habits that are determined by the social figuration of the agents, thus shaped by class, race or gender, embodied and largely sunk into the unconscious. Third, Bourdieu's 'habitus' accounts for the fact that the ensemble of embodied habits, in turn, is a generative principle producing various ways of orientation and action that, again, correspond to the social situation of the agents. On the connection between Bourdieu's concept of habitus and Panofsky's understanding of habit in the latter's *Gothic Architecture and Scholasticism*, see Viola, 'Peirce and Iconology'. It is interesting to note that Bourdieu drew on Wind's 'Some Points of Contact between History and Natural Science' in order to 'better underline the methodological assumptions of Panofsky's model; he thus included a long excerpt from it in the 1968 handbook on sociological method.' Viola, 'Peirce and Iconology', 2, 22 n. 5. For the text of this excerpt, see German edition: Pierre Bourdieu, Jean-Claude Chamboredom and Jean-Claude Passeron, *Soziologie als Beruf: Wissenschaftstheoretische Voraussetzungen soziologischer Erkenntnis*, ed. Beate Krais (Berlin: De Gruyter, 1991), 231–4.

Figure 6.7: Matthias Grünewald, *St Erasmus and St Maurice*, c. 1517–24, oil on wood, 226 × 176 cm. Alte Pinakothek, Munich.

Grünewald's painting shows an encounter between two saints: 'On the left St. Erasmus, Bishop of Antioch holds in his right hand the symbol of his martyrdom: the windlass [...]. On the right, St. Maurice, the Moorish knight, [...] is accompanied by members of the Theban legion, who

followed him into martyrdom.'[30] Wind reconstructs this scene of their meeting, not recorded in any of the legends of the saints, by drawing on an abundance of documents in a circuitous process of collecting evidence, on the basis of which he argues that St Erasmus was Albrecht's favourite saint, in whose character he often chose to be portrayed. He also expounds that Albrecht, after having assumed the office of archbishop, tried to introduce, incrementally, the cult of his patron saint as a stronghold against the growth of Protestantism in his city of residence, Halle, a city that traditionally stood under the protection of St Maurice.

Measures taken by Albrecht to achieve this goal included the establishment of a research facility for humanist studies dedicated to his patron saint, and the renovation and expansion of what today is the Dom of Halle to a church of monumental size co-consecrated to his favourite saint and embellished with immense riches, first and foremost a huge collection of relics, crowned by Grünewald's altarpiece. On the basis of a series, or in Peirce's terminology a 'cable' of arguments, Wind dates the painting, traditionally thought to be from about 1524, back to about 1517, the year of Luther's posting of the ninety-five theses on the Wittenberg church door, and reveals its subject as follows: 'Albrecht appears in the character of the saint whose relics he secured for the church in Halle, and St. Maurice is painted in the attitude of the host who greets and receives the newcomer – and the newcomer is, at the same time, Albrecht himself who was instrumental in bringing about this meeting.'[31]

Wind sees a significant manifestation of the strange junction of medieval sensibility and modernity in Albrecht's personality in the latter's conviction that his cult-like adoration of St Erasmus and his plan to promote humanist studies in the manner of Erasmus of Rotterdam, whom he greatly

30 Wind, 'Albrecht von Brandenburg as St. Erasmus', 143 (*The Eloquence of Symbols*, 58).

31 Wind, 'Albrecht von Brandenburg as St. Erasmus', 146 (*The Eloquence of Symbols*, 61). On the debate over Wind's revised dating, see Arpad Weixlgärtner, *Grünewald* (Vienna: Anton Schroll, 1962), 83–92, who agrees with Wind, as well as the summary of the predominantly critical reception in François-René Martin, 'Grünewald und seine Kunst', in François-René Martin, Michel Menu and Sylvie Ramond, *Grünewald*, trans. Birgit Leib from the French original (Cologne: Dumont, 2013), 193–9, 331–2.

admired, were not only fully compatible but would even reinforce each other. As Wind explains, Albrecht's conviction was rooted in his belief in the magic of names, or name similarity, which in 1517 even led him to solemnly invite to Halle the great humanist himself, proposing in all seriousness and in a panegyric tone that Erasmus should write, in the style that he had mastered so perfectly, 'humanist lives of the very saints' whose relics Albrecht had collected in '8133 particles' and '42 complete bodies' – a suggestion that Erasmus not surprisingly declined 'with elegant modesty'.[32]

In the section 'The Ritual Place of Grünewald's Painting', Wind demonstrates, again through an elaborate process of gathering evidence inscribed in the painting itself, that there is a secondary subject: the encounter between Abraham and Melchisedek, the archetype of the priest, at which the latter 'is said to have brought bread and wine to the knight',[33] thus turning the meeting into a typological scene prefiguring the Last Supper. This superimposition of yet another symbol 'upon this picture, already packed with meaning' produces, as Wind explains, a second – and double – composite portrait: Albrecht becomes ' "another Melchisedek". To allude to that age-old power of priesthood invested in him was quite appropriate in this particular picture, since St Erasmus himself had been a priest. He, too, was "another Melchisedek".'[34]

This multi-layered design leads Wind to formulate a maxim for the methodological reconstruction of a thesaurus of ideas that is embodied in works of the past, but that has become unfamiliar to us. He demands that, in order to 'judge of the "psychological plausibility" '[35] of his reconstruction, we should conduct a kind of thought experiment, by imagining a contemporary individual, acquainted with the recent history of the local church service and sufficiently versed in the Bible and familiar with humanist thinking, who when looking at the painting would immediately

32 Wind, 'Albrecht von Brandenburg as St. Erasmus', 151 (*The Eloquence of Symbols*, 67–8).

33 Wind, 'Albrecht von Brandenburg as St. Erasmus', 154 (*The Eloquence of Symbols*, 70).

34 Wind, 'Albrecht von Brandenburg as St. Erasmus', 156–7 (*The Eloquence of Symbols*, 71–2).

35 Wind, 'Albrecht von Brandenburg as St. Erasmus', 157 (*The Eloquence of Symbols*, 72).

grasp, in all its ramifications, that which the cultural historian had so laboriously reconstructed.

If this 'ideal spectator'[36] were 'gifted with a sense for colour and form', he might even enjoy the visual correspondences with the painting's abundance of meaning, for example 'the vividness of the background figures, which are handled with an impressionist's brush stroke', juxtaposed against and thus intensifying 'the stilted, mummified appearance of the two principal actors in the foreground', with the effect that although 'they seem to perform a living scene, they have actually the look of relics'[37] – or wax figures *ex voto*. Providing further examples, such as Grünewald's reversal of the classical contrapposto in the figure of Mauritius (Figure 6.7), which at the time was considered modern and was applied by Dürer (Figure 6.8), Wind claims that the painting betrays an 'attachment of the medieval form [...] united with a hypertrophic sensibility in the rendering of the surface of things: The white kid gloves, the [...] bare black skin [...], the silver armour, all these are handled and juxtaposed with a gusto for exploring the visible world'. Thus, 'the "technique" of the picture is one with the "story": a unique blending of medievalism with a striking sense of modernity'. And Wind adds: 'It marks the tragedy of Albrecht's career that the same pattern which was of triumphant grandeur in art proved to be a failure in politics.'[38]

36 Similarly, Warburg, in the 'Introduction' to the Hertziana Lecture 'Römische Antike in der Werkstatt des Domenico Ghirlandaio', had presented such an ideal (medieval) spectator, who when entering Rome from the Via Appia would perceive 'the awe-inspiring contrast of pagan and Christian culture in the threatening symbol of pagan masonry' (my translation): 'Die Stadt des Lorbeers und der Palmenzweige ragte auf im Konstantinsbogen und im Kolosseum. Superbia und Pietas forderten Entscheidung am Lebenswege.' Fleckner and Woldt, eds, *Bilderreihen und Ausstellungen*, 307, 309 n. 31.
37 Wind, 'Albrecht von Brandenburg as St. Erasmus', 158 (*The Eloquence of Symbols*, 73).
38 Wind, 'Albrecht von Brandenburg as St. Erasmus', 159–60.

Figure 6.8: Albrecht Dürer, Lucas Paumgärtner as St Eustace, from Paumgartner altar-piece, c. 1500, oil on wood, 157 × 61 cm. Alte Pinakothek, Munich.

The implicit theory disclosed

Both studies of cultural exegesis focus then on an era of transition and on individuals who are shaped by the contrasting trends of their times. Since neither Sassetti nor Albrecht mentions the tension of opposing forces that drives them, Warburg and Wind attempt to get behind their backs, a perspective gained by following the famous Peircean research maxim, based on Peirce's theory of embodiment, that we should explore

the convictions that human beings lay bare unwillingly through their act-
ions, rather than those they display ostentatiously and deliberately: 'it is
the belief men *betray* and not that which they *parade* which has to be
studied'.[39] In 1936, in his article 'Some Points of Contact between History
and the Natural Sciences', Wind explained this Peircean maxim by con-
trasting it with Dilthey's 'doctrine of immediate experience [*Erlebnislehre*]
with its direct appeal to a state of feeling'.[40] Moreover, Wind explicitly
refers to Warburg's concept of cultural studies and especially to his essay
on Francesco Sassetti as a paradigm that fulfils this research maxim in the
discipline of history:

> In Warburg's writings of cultural exegesis, the demand for a 'historical psychology'
> that until then had remained abstract, has been transformed into a genuine organon
> of the theory of symbolic expression [*symbolische Ausdruckskunde*]. Whereas Dilthey
> carried himself with the intention to write a 'critique of historical reason', a supple-
> mentary counterpart to the enlightenment systematics of the sciences, Warburg
> implemented this supplement according to a program that was as radical as it was
> articulate: Drawing on historical testimony documenting what was the superstitious
> and enthusiastic component in the formation and tradition of symbolic images and
> signs he designed – as a foundation for interpreting all documents of the human
> race – a 'critique of pure unreason', which the most perceptive of enlightenment
> intellectuals had demanded themselves, in order to teach themselves self-constraint
> amidst their urge for conceptual purification.[41]

39 Charles Sanders Peirce, 'Issues of Pragmatism', *The Monist* 15 (1905), 481–99 (485).
40 Edgar Wind, 'Some Points of Contact between History and the Natural
 Sciences', in Raymond Klibansky and Herbert James Paton, eds, *Philosophy and
 History: Essays Presented to Ernst Cassirer* (Oxford: Clarendon Press, 1936), 255–64
 (258); on the genesis and systematic significance of this essay for Wind's interpret-
 ation of Warburg, see Buschendorf and Engel, 'Wind's Cambridger Rede Lecture',
 273–4 n. 48.
41 Edgar Wind, 'Über einige Berührungspunkte zwischen Naturwissenschaft und
 Geschichte' (first published in Thomas Herzog, ed., *Wissenschaft: Zum Verständnis
 eines Begriffs* (Cologne: Rudolf Müller, 1988), 34–9), new and rev. edn in Wind,
 Das Experiment und die Metaphysik, ed. Buschendorf, Appendix VII, 254–69
 (258–9) (my translation). Against Wind's wishes, this passage was omitted from
 'Some Points of Contact'; for a discussion of potential reasons for this omission,
 see Buschendorf and Engel, 'Winds Cambridger Rede Lecture', 273–4 n. 48. For

It is important to note that there is a crucial difference between Dilthey's concept of immediate experience and Warburg's concept of '*Einfühlung*', or empathy. Empathy, as Warburg conceived of it,[42] is the innate capability to gain access to the emotional states of another human being, based on the perception of the characteristics of the individual's face or body, physiognomic features, and body language in general. Although empathy grants a first intuitive access to manifestations of human expression – for example, a certain pathos formula – we must know the context of its usage in order to understand how it was appropriated. Both Warburg and Wind use the concept of empathy as a first approach to their objects of investigation, when, for example, Warburg characterizes the two sides of Sassetti as 'a principled attachment to his medieval roots' and his 'worldly intelligence',[43] and Wind sees the effort 'to combine Catholic orthodoxy with a taste for humanism'[44] as typical of Albrecht and his age. Yet, in contrast to Dilthey, they spare no effort in testing their intuition by trying to match it with the historical sources available to them. Thus, the insight gained through empathy must be verified by a continuous process of scrutiny, whereby we must be prepared to integrate into our perspective new insights that modify or sharpen our initial understanding.

While it is not unusual for a historian to examine a great number of historical documents, Warburg has been criticized for carrying the practice too far.[45] However, the manner in which Warburg and Wind gather

Wind's reference to Warburg's article on Sassetti, see Wind, *Das Experiment und die Metaphysik*, 258 n. 5.

42 For Warburg's understanding and application of Robert Vischer's concept of empathy, see Buschendorf, 'Edgar Wind und Aby Warburg', 185, 206–7 n. 84.

43 Warburg, 'Sassetti's Last Injunctions', 233.

44 Wind, 'Albrecht von Brandenburg as St. Erasmus', 151 (*The Eloquence of Symbols*, 68).

45 See, for example, Gombrich's introductory remarks to his summary of Warburg's paper on Sassetti, where he claims that 'here as elsewhere in Warburg's published works the underlying idea is apt to elude the reader who is led from personal documents to paintings, from philosophical texts to heraldic devices, and from economic history to the consideration of linguistic usage. The rich texture of this presentation, which cost Warburg such pains, can be enjoyed in its own right for the vivid pictures of a bygone culture which it evokes. It is less easy, sometimes, not to lose the thread which ties these documents together.' Gombrich, *Aby Warburg*, 170.

and secure evidence is an important principle of this kind of theoretically guided empirical process.[46] Instead of stringing pieces of evidence together in a linear fashion, the method requires that we interconnect as many arguments as possible, as different as possible, and preferably conjoin weaker with stronger ones. Again, Wind takes this research maxim and its metaphors of 'chain' versus 'cable' from Peirce:

> It is essential to a mature science, according to the logic of Charles Peirce, to trust rather to the multitude and variety of its arguments than to the conclusiveness of any one. Its reasoning should not form a chain which is no stronger than its weakest link, but a cable whose fibers may be ever so slender, provided they are sufficiently numerous and intimately connected.[47]

In principle, what precedes the historian's final selection of sources is a process that is indebted to a methodological circle, a circle that involves two phases which constantly replace each other and change into one another, phases that both the natural sciences and history must pass through in their respective research processes. The first phase consists of formulating a hypothesis. The second phase, following immediately afterwards, consists both of the embodiment of this hypothesis and of verifying it against reality. While in the natural sciences the test of reality takes place in the experiment, in historical research it is realized in the exegesis of sources. This circle is not a vicious one, because after running through both phases,

46 In their fruitful exchange, Wind successfully conveyed to Warburg that, without being aware of it, he had adhered to pragmatist research maxims. Not surprisingly, Warburg reacted with enthusiasm, as he saw his intellectual endeavours theoretically improved by Wind. He expressed his newly arising hope for the consolidation of his life's work with the following pun on Saxl's name, juxtaposed to an Italian-Latin made-up composite for a substance of rock and iron hardness: 'Wird die Metamorphose von Saxlophon zu Sassoferrin gelingen?' (23 September 1928, *Tagebuch*, 344, where the composite is erroneously transcribed as 'Sassoferria').

47 Edgar Wind, quoting Charles Peirce, 'Some Consequences of Four Capacities', in *Collected Papers of Charles Sanders Peirce*, ed. Charles Hartshorne and Paul Weiss, vol. 5: *Pragmatism and Pragmaticism* (Cambridge, MA: Harvard University Press, 1934), 157, in Edgar Wind, 'Mantegna's Parnassus: A Reply to Some Recent Reflections', *The Art Bulletin* 31/3, 224–31; see also Viola, 'Peirce and Iconology', 15, 27 n. 98.

it will – like a spiral – start anew on a higher level, where, in turn, another hypothesis will be formulated, built upon the foregoing experiment or source exegesis.[48] As Wind puts it in *Experiment and Metaphysics*, 'what first appeared as a logical circle, and therefore as self-contradictory, thus turns out to be a methodological cycle, and therefore self-regulating.'[49]

At the centre of this process of formulating and probing hypotheses is the *experimentum crucis*, that is, an experiment considered to be crucial, because it will either negate or verify an hypothesis. In Warburg's and Wind's case studies, the interpretation of a painting forms the ultimate *experimentum crucis*, whereby not only is the hypothesis verified, but where in both cases the historical context, which Warburg and Wind reconstruct in great detail, adds considerably to the understanding of the paintings. The paintings by Ghirlandaio and Grünewald turn out to be embodiments of the world view of the patrons and artists, mirroring their tendency to harmonize the opposites of the epoch.[50] Notwithstanding the noticeable efforts of finding a balance between the opposing currents of their time, on the scale of the polarity of symbols, patrons, artists and the artworks in question confirm a propensity towards medieval piety, if not an inclination towards magical practices.

Manifested in Ghirlandaio's *ex voto* portraits as well as in Albrecht's collection of relics, the two patrons' belief in magic culminates in the

48 On Wind's understanding of the Peircean productive circle, see Wind, *Experiment and Metaphysics*, 7, 33–4; Buschendorf, 'Das Prinzip der inneren Grenzsetzung und seine methodologische Bedeutung für die Kulturwissenschaften', in Wind, *Das Experiment und die Metaphysik*, Buschendorf, ed., 281–2; Buschendorf and Engel, 'Winds Cambridger Rede Lecture', 256–7.

49 Wind, *Experiment and Metaphysics*, 34. Moreover, in a passage included in only the German original of 'Some Points of Contact', Wind stresses: 'The circle is thus as inescapable in the natural sciences as it is in history' (my translation). Wind, 'Über einige Berührungspunkte', 257.

50 What Wind claims about the accordance between Albrecht and Grünewald is also true of Sassetti and Ghirlandaio: 'Rarely has there been a more complete harmony between the intentions of the patron who ordered the picture and those of the artist who painted it. If a curious interpenetration of the old and the new was characteristic of Albrecht's outlook, the same is true of Grünewald's artistic impulse.' Wind, 'Albrecht von Brandenburg as St. Erasmus', 159 (*The Eloquence of Symbols*, 74).

genre of the composite portrait. *All'antica*, Sassetti incorporates the power and 'worldly intelligence'[51] of a Roman emperor; *alla francese*, he hopes to gain God's special grace by embodying a shepherd's devoutness [*Hirtenfrömmigkeit*].[52] In turn, the composite portrait of Albrecht as St Erasmus allows Albrecht to participate in the saintliness to which he aspires, while simultaneously – by the magic of name – he hopes to acquire the moral and intellectual strength of the humanist he admires.[53]

To sum up, as the foregoing comparison of the studies on Sassetti and Albrecht demonstrates, Wind stood firmly in the tradition of Warburgian *Kulturwissenschaft*. However, he himself contributed substantially to its conceptualization, by bringing essential concepts of the Peircean pragmatist method to Warburg's idea of interdisciplinary historical research and its anthropological and psychological foundations. Wind conveyed to Warburg that, without having been aware of it, the latter had adhered to pragmatist research maxims. *Kulturwissenschaft*, as Warburg and Wind came to understand it in their fruitful exchange, should be conceived of as an integration of numerous theoretical and methodical approaches to form a complex research process. To Wind, Warburg and Peirce – the two main thinkers behind his own intellectual oeuvre – cannot be considered as independent of each other; on the contrary, symbol and embodiment are interdependent.

51 Warburg, 'Sassetti's Last Injunctions', 233; 'Sassettis letztwillige Verfügung', 139.
52 Warburg, 'Römische Antike in der Werkstatt des Domenico Ghirlandaio', Hertziana Lecture, quoted in Gombrich, *Aby Warburg*, 272–3.
53 As Wind points out: 'But a name and a word mean to a religious mind far more than to a purely rational one. [...] A man like Albrecht, who lived in this tradition, could not consider it a mere accident that the man whom he so much admired should have the name of Erasmus.' Wind, 'Albrecht von Brandenburg as St. Erasmus', 152 (*The Eloquence of Symbols*, 74).

BERNARDINO BRANCA

7 Edgar Wind: Metaphysics Embodied in Michelangelo's Sistine Chapel Ceiling

Introduction

This chapter explores the theoretical framework behind Edgar Wind's writings on Michelangelo's Sistine Chapel ceiling, paying particular attention to Wind's application of the notions of 'embodiment' and 'symbolic function', which are derived from his philosophy of science. His use of Aby Warburg's *Pathosformulae* is also examined. Moreover, the fragmentary nature of Wind's Renaissance studies necessitates the comparing and contrasting of his studies on Michelangelo with some of his other works.

Wind never wrote a general and systematic treatise on his art theory. Rather, his theoretical ideas are dispersed among various books, journal articles, letters and lecture notes, some of which are still unpublished.[1] In light of this, I compare Wind's notion of 'symbolic function' with the terminology used by Erwin Panofsky – another member of the Warburg circle – specifically the latter's notion of 'intrinsic meaning', in reference to the connection that Wind drew between the imagery of the ceiling and the spiritual world of the age of Pope Julius II.

1 Wind conceived such theoretical notions primarily in 1930–3 in Hamburg, before moving to London. See Bernardino Branca, 'Edgar Wind in Hamburg, 1930–33: Searching for "The Essential Forces of the Human Mind and its History"', *The Edgar Wind Journal* 4 (2023), 32–64.

Wind's article 'Michelangelo's Prophets and Sibyls', the final product
of his lifelong studies on Michelangelo, was first published in 1965, and
subsequently republished in 2000 by Elizabeth Sears as part of a collection
of Wind's writings on Michelangelo.[2] Wind's 1965 article is the final version
of a manuscript conceived during his 1936 stay in Rome, and was part of
a broader draft manuscript on the Sistine ceiling, titled 'Die Bildsprache
Michelangelos'. This 1936 manuscript was not published during Wind's
lifetime, coming to light only in 2017.[3] Why the first draft was not pub-
lished in the 1930s remains a matter of speculation. According to Pablo
Schneider, it was meant to be part of a broader program on religious sym-
bolism.[4] At the beginning of the 1936 draft, Wind states his point: 'the
cycle of images of the Sistine ceiling is a symbol of the hope for redemp-
tion',[5] that is, a complex and articulated metaphysical statement embodied
in one single symbolic image. The 1936 draft was Wind's first attempt to
write on Renaissance art, and his last manuscript composed in German,
his native language.[6]

However, Wind's subsequent studies on Michelangelo were not
always appreciated in England. Margot Wittkower – the wife of Rudolph
Wittkower, co-editor with Wind of the *Journal of the Warburg [and*

2 Edgar Wind, 'Michelangelo's Prophets and Sibyls', *Proceedings of the British
 Academy* 51 (1965), 47–84. In the present chapter, I refer to 'Michelangelo's Prophets
 and Sibyls', Chapter 10 in Edgar Wind, *The Religious Language of Michelangelo*,
 ed. Elizabeth Sears (Oxford: Oxford University Press, 2000), 125–47. Robert
 Gaston, in his review of the 2000 volume, contrasts Wind's interpretation of the
 ceiling with Ernst Gombrich's (*The Burlington Magazine* 145/1208 (November
 2003), 797–8).

3 Edgar Wind, *Die Bildsprache Michelangelos*, ed. Pablo Schneider
 (Berlin: De Gruyter, 2017).

4 Schneider, in Wind, *Die Bildsprache Michelangelos*, 9.

5 'Der Bilderzyclus der Sixtinische Decke ist ein Sinnbild des Harrens auf die
 Erloesung.' Wind, *Die Bildsprache Michelangelos*, 13.

6 For a detailed history of the conception and later development of this text, see
 Elizabeth Sears, 'Die Bildsprache Michelangelos: Edgar Winds Auslesung der
 Sixtinischen Decke', in Horst Bredekamp, Bernhard Buschendorf, Freia Hartung
 and John Krois, eds, *Edgar Wind: Kunsthistoriker und Philosoph* (Berlin: Akademie,
 1998), 49–76.

Courtald] Institute[s] from 1937 to 1942 – opined that Wind did not produce any genuinely new and original research after that period.[7] She said that his 1965 article received a lukewarm reception:

> [Wind's 1965 article on Michelangelo] was a terrible disappointment because we all expected that now would come *the* work on Michelangelo and the Sistine Ceiling, and what came was […] not particularly convincing. I think Wind really was a talker, you know, the way Saxl was an essayist and Panofsky was a book writer. Edgar Wind was a lecturer, a talker, but there was hard and long work behind that.[8]

In 1973, Isaiah Berlin, Wind's friend and colleague at Oxford, reminisced:

> What a terrible hater he was. Reminiscent in some ways of Trevor-Roper's polemics. […] I am not sure that *terribilità* is quite the word – it was all too feline in a way – *terribilità* to me means fiery ferocity like Toscanini or Salvemini or Housman – there was something of a velvet glove about Edgar. I do not know what word I would use – something like 'implacable quality' seems to me nearer to it. If you are to account for the negative emotions felt towards him, perhaps the marvellous flights of imagination, the ingenuity built upon ingenuity – those marvellous constructions in his lectures, *not always supported by conclusive factual evidence*, but beyond refutation by mere facts – irritated the 'solid and sound' who felt uncomfortable and even shocked to be transported into such realms outside their sober disciplines (to put it mildly).[9]

In 1975, when evaluating Wind's legacy, Kenneth Clark wrote:

> Edgar Wind was perhaps the most brilliant lecturer on art of our time and, while he was talking, one would be persuaded of the most fantastic hypothesis

7 Margot Wittkower, *Partnership and Discovery: Margot and Rudolf Wittkower*, interviews by Teresa Barnett (Los Angeles: J. Paul Getty Trust, 1994), 212, <https://archive.org/stream/partnershipdiscooowitt/partnershipdiscooowitt_djvu.txt>.

8 Wittkower, *Partnership and Discovery*, 208–9.

9 Isaiah Berlin to Colin Hardie, 5 April 1973, Bodleian Libraries, University of Oxford, Edgar Wind Papers (hereafter Bodleian, EWP), MS. Wind 21, folder 3 (my italics). Reproduced with the permission of the Trustees of the Isaiah Berlin Literary Trust. For the full text and background of this letter, see Jaynie Anderson, ' "Posthumous Reputations": Edgar Wind's Rejected Review of Ernst Gombrich's Biography of Aby Warburg', *The Edgar Wind Journal* 3 (2022), 14–35.

[…] the kind of scholar to whom the term 'brilliant' rather than 'sound' is usually applied.[10]

These statements by Wittkower, Berlin and Clark are perhaps the quintessential examples of the mixture of admiration and scepticism that Wind's lectures and publications evoked among fellow scholars, both during and after his lifetime.[11] To support my view that such scepticism and equivocations concerning Wind's research and intellectual mission were misguided, I discuss the conceptual tools of 'embodiment' and 'symbolic function', which he applied in his interpretation of the Sistine ceiling. Such concepts were not explained explicitly in his writings on Michelangelo.

Embodiments and symbolic functions

Wind's mission was not to produce yet another connoisseurial or formalist series of studies in art history; rather, he sought to explain *die Geistliche Welt* – the spiritual world – to which an artwork belonged.[12] This connection of metaphysics with art would enhance our aesthetic appreciation: 'The eye focuses differently when it is intellectually guided.'[13] 'Embodiment' and 'symbolic function' are the key concepts through which Wind understood the spiritual world of the Sistine ceiling.

10 Kenneth Clark to Janet Stone, 9 February 1975, in James Stourton, *Kenneth Clark: Life, Art and Civilisation* (London: Harper Collins, 2016), 265. Clark (1903–83) was Wind's colleague at the Warburg Institute in the 1930s.

11 For a positive new evaluation of Wind's 1965 article, see Stephen J. Campbell and Michael W. Cole, *A New History of Italian Renaissance Art* (2nd edn, London: Thames & Hudson, 2017), 682.

12 See Max Dvorak, *Kunstgeschichte als Geistesgeschichte: Studien zur abendlandischen Kunstentwicklung* (Munich: Piper, 1928). Dvorak (1874–1921) taught Wind in Vienna in 1920.

13 Wind, *Art and Anarchy: The Reith Lectures 1960, Revised and Enlarged* (New York: Knopf, 1964), 63.

Wind laid out these concepts – referring exclusively to the natural sciences – in his 1934 book *Das Experiment und die Metaphysik*.[14] In that treatise, which is instrumental for the understanding of his studies on the Sistine ceiling, Wind argued that scientific instruments are empirical symbols or 'embodiments' of mathematical – that is, metaphysical – concepts, asserting that such physical embodiments are 'symbolic representations'.[15] Matthew Rampley explains that what Wind meant is that such instruments have a 'symbolic function', a definition I will use for heuristic purposes.[16] As early as in *Experiment and Metaphysics*, Wind anticipated that:

> However 'unreasonable' this assumption may seem, it is possessed in common by those two branches of enquiry the method of which are usually considered as diametrically opposed: namely, physics and history. What has proved to be true of the physical instrument can be shown to be true of the historical document.[17]

Wind also identified the philosophy of science notions of 'embodiment' and 'symbolic function' in the process of image-making, and from 1934 onwards he dedicated his life to applying these notions to the 'historical documents' he studied.[18] Wind conceived these dual notions through a synthesis of pragmatist philosophy (which he studied during his 1924–7 stay in the United States) and his mentor Ernst Cassirer's studies on symbolic forms.[19] Wind never set forth to explore, in a single broader and systematic treatise, the theoretical relationships between texts and

14 Edgar Wind, *Das Experiment und die Metaphysik: Zur Auflösung der kosmologischen Antinomien* (Tübingen: Mohr, 1934); new edition by Bernhard Buschendorf, with a foreword by Brigitte Falkenburg and an afterword by Bernhard Buschendorf (Frankfurt: Suhrkamp, 2001). Engl. trans.: Edgar Wind, *Experiment and Metaphysics: Towards a Resolution of the Cosmological Antinomies*, trans. Cyril W. Edwards, with an introduction by Matthew Rampley (Oxford: Legenda, 2001).
15 Wind, *Experiment and Metaphysics*, 17, 30, 60.
16 Matthew Rampley, 'Introduction', in Wind, *Experiment and Metaphysics*, xvi.
17 Wind, *Experiment and Metaphysics*, 18.
18 See Bernardino Branca, *Edgar Wind, filosofo delle immagini: La biografia intellettuale di un discepolo di Aby Warburg* (Milan: Mimesis, 2019), 109–37.
19 For a more detailed discussion of Wind's notion of embodiment, see Fabio Tononi and Bernardino Branca, 'Edgar Wind: Art and Embodiment', *The Edgar Wind Journal* 2 (2022), 1–8.

images, nor the issues involved in applying the notion of 'embodiment' to interpreting symbolic representations in art. By leaving his art theory dispersed in this way, he may have inadvertently invited some of the criticism levelled at his work.

A rejected draft of Wind's introduction to his 1958 book *Pagan Mysteries in the Renaissance* sheds additional light on the relationship between texts and images in Wind's studies on Michelangelo:

> In studying a philosophical text, we may find that a singularly bothersome series of arguments becomes suddenly lucid and transparent because we remember a picture that reflects it. When we have reached this point, where a picture helps us to place the right accents in a text and a text to place the right accents in a picture, they will both acquire a new luminosity. And this is all we should aim for. But it is only when this experience begins to spread, when more pictures and more texts reinforce this sensation, that we may be allowed to trust it. To convey this experience, a method of demonstration is required which is radically different from the mathematical proofs. In the place of linear logic, in which each proposition has its own well-defined antecedents by which it is linked to a well-defined set of premises, *we must aim to a configurational logic, by which contingent arguments are interlocked.* In the words of Charles Pierce, it is essential to this form of study that our reasoning 'should form a chain which is no stronger than its weakest link, but a cable whose fibres may be ever so slender, provided they are sufficiently numerous and intimately connected'.[20]

In a paper delivered at the Warburg Library in Hamburg in October 1930, at a special meeting held a year after Aby Warburg's death, Wind

20 My italics. Quoted from Edgar Wind, 'Picture and Text', draft introduction to the first edition of Edgar Wind, *Pagan Mysteries in the Renaissance* (Boston: Norton, 1958). The publisher forced Wind to abandon this introduction on the grounds that its content would be too unfamiliar to English-speaking readers. It was replaced by a conclusion titled 'Observations on Method'. 'Picture and Text' was first published in German, in 1998, in Horst Bredekamp, Bernhard Buschendorf, Freia Hartung and John Krois, eds, *Edgar Wind: Kunsthistoriker und Philosoph* (Berlin: Akademie, 1998), 259–62. The English original of 'Picture and Text' was published in 2000 in Wind, *The Religious Language of Michelangelo*, ed. Sears, 191–3. In the last paragraph, Wind quotes Charles Pierce, 'Some Consequences of Four Incapacities', in *Collected Papers of Charles Sanders Peirce*, ed. Charles Hartshorne and Paul Weiss, vol. 5: *Pragmatism and Pragmaticism* (Cambridge, MA: Harvard University Press, 1934), 157.

underscored what he considered to be one of the most critical aspects of Warburg's intellectual legacy vis-à-vis his own research:[21] 'It was one of Warburg's basic convictions that any attempt to detach the image from its relation to religion and poetry, cult and drama, is like cutting off its life-blood.'[22] In other words, Wind agreed with Warburg's position that artistic images are always indissolubly bound with culture as a whole. Wind also accepted Warburg's definition of a symbol as a connection between a physical image and its conceptual meaning.[23] Wind surmised that in Warburg's theory of the 'polarity of the symbol', there is a coexistence of 'logos' with 'magic', that is, of 'rational' ideas intermingled with 'irrational' beliefs and emotions.[24] In an unpublished manuscript from 1971, Wind agrees with Warburg's argument that a symbol should not reveal its mystery without some measure of disguise, because 'in a good symbol, as in a good costume, concealment and revelation are combined'.[25]

In 1938, Wind published a study on Michelangelo's fresco *The Punishment of Haman*, which is located in the Sistine Chapel above *The Last Judgement*.[26] In the article, Wind uses Warburg's concept of 'Social Memory' to explain the metaphysical concept of the dogma of 'salvation through the passion of Christ', which is embodied in *The Punishment of Haman*.[27] Referring to Frazer, Wind explains that 'the passion of Christ bears some of the traits of an ancient spring ritual which appears to have

21 Wind worked as Warburg's research assistant from January 1928 until his death in October 1929. See Branca, *Edgar Wind*, 47–69.

22 Edgar Wind, 'Warburg's Concept of *Kulturwissenschaft* and Its Meaning for Aesthetics' (1931), in Edgar Wind, *The Eloquence of Symbols: Studies in Humanist Art*, ed. Jaynie Anderson (Oxford: Clarendon Press, 1983), 21–35 (25).

23 Wind, 'Warburg's Concept of *Kulturwissenschaft*', 27.

24 Wind, 'Warburg's Concept of *Kulturwissenschaft*', 27–30.

25 Edgar Wind, in 'Wind's First Draft of His Review of Gombrich's Biography of Aby Warburg, Rejected by the *Times Literary Supplement*' (1971), reproduced in full in Jaynie Anderson, ' "Posthumous Reputations": Edgar Wind's Rejected Review of Ernst Gombrich's Biography of Aby Warburg', *The Edgar Wind Journal* 3 (2022), 14–35 (35).

26 Wind, 'The Crucifixion of Haman', *Journal of the Warburg Institute* 1 (1938), 245–8.

27 Wind, 'The Crucifixion of Haman', 248. In this context Wind uses the term 'Social Memory' as a synonym of '*Nachleben der Antike*'.

been enacted over the whole of Western Asia'.[28] As this 'magic' ritual was converted into a 'rational' Christian dogma, 'the older custom naturally vanished – or was repressed into the uncontrollable regions of popular magic and superstition'.[29] However, 'Michelangelo recognized in this image the metaphor of an act of redemption […] The student of religion may observe with amazement that Michelangelo's image thus restores the anthropological sense of the story'.[30] Hence, the polarity of the symbol allows the coexistence of logos with magic through their embodiment in this image's symbolic function.

Wind stated that during the Italian Renaissance, the coexistence of rational ideas with obscure and irrational mysteries ensured that 'a great art did flourish on that impure soil'.[31] In order to show this coexistence in the Sistine ceiling, Wind extensively used Warburg's conceptual tools of *Pathosformulae* and *Nachleben der Antike*, albeit without mentioning them explicitly.[32] However, the notion of 'embodiment', as he applied it to art-historical research, distinguishes Wind as an independent thinker, distinct from Warburg. As early as 1939, Panofsky already understood this clearly: 'Edgar Wind is certainly the one man who has developed the ideas of the late Professor Warburg in an entirely independent spirit, and is able to carry them on in a most stimulating form.'[33] Panofsky's research thus provides useful insights into Wind's application of the notion of symbolic function in his own art-historical research.

Erwin Panofsky was among Wind's most important mentors and colleagues in Hamburg. He was also a fellow member of the Warburg circle

28 Wind, 'The Crucifixion of Haman', 246–7.
29 Wind, 'The Crucifixion of Haman', 247.
30 Wind, 'The Crucifixion of Haman', 247.
31 Edgar Wind, *Pagan Mysteries in the Renaissance* (Boston; New York: Norton, 1968), 16.
32 See Warburg Institute, *A Bibliography on the Survival of the Classics. First Volume: The Publications of 1931*, ed. Hans Meier, Richard Newald and Edgar Wind (London: Cassell, 1934). This paper introduces the English-speaking public to Warburg's *Nachelben* notion.
33 Erwin Panofsky to George Boas, 5 October 1939, quoted in Pablo Schneider, 'Nachwort', in Edgar Wind, *Die Bildsprache Michelangelos*, ed. Pablo Schneider (Berlin: De Gruyter, 2017), 126.

and, like Wind, an 'émigré' since 1933.[34] In 1953, Panofsky explained the scepticism towards his research as a result of 'the contact of the German-born "iconological" approach to art history with Anglo-Saxon Positivism, which, by principle, was wary of any kind of abstract speculation'.[35]

In 1939 Panofsky stated, in a single systematic treatise, that the purpose of iconology is to understand the 'intrinsic meaning' – the history of the cultural symptoms or 'symbols' – of a work of art.[36] According to Panofsky, the relationship between a work of art and its epoch's literary, religious and philosophical sources is essential for such understanding.[37] Panofsky's and Wind's conceptual frameworks, such as the notions of 'intrinsic meaning' and 'symbolic function', although distinct and separate, shared Warburg's interdisciplinary approach. For example, in *Perspective as Symbolic Form* (1927), Panofsky discussed not only the history of the different methods of spatial representation from antiquity to the Renaissance, but also the new mathematical and geometrical (that is, metaphysical) notions necessary for the development of single-point perspective in Renaissance drawings and paintings.[38] Panofsky's and Wind's efforts in investigating the relationships between philosophy and art can also be ascribed to the pre-1945 Warburg circle's common interest in this topic.[39] After Wind's departure in 1945, the Warburg Institute's research focus departed sharply from Wind's, eventually contributing to his *damnatio memoriae*.[40]

Wind's art theory shares Panofsky's criticism of positivistic and formalist art-historical scholarship.[41] Wind's notion of 'symbolic function' is

34 Branca, *Edgar Wind*, 13–15, 54–7.

35 Erwin Panofsky, 'The History of Art', in Franz L. Neumann, ed., *The Cultural Migration: The European Scholar in America* (Princeton: Princeton University Press, 1953), 82.

36 Erwin Panofsky, *Studies in Iconology: Humanistic Themes in the Art of the Renaissance* [1939] (London: Routledge, 1972), 16.

37 Panofsky, *Studies in Iconology*, 16.

38 Erwin Panofsky, *Perspective as Symbolic Form* [1927], trans. Christopher S. Wood (New York: Zone Books, 1997).

39 Wind, *Experiment and Metaphysics*, xvi.

40 See Monica Centanni, 'The Rift between Edgar Wind and the Warburg Institute', *The Edgar Wind Journal* 2 (2022), 75–106.

41 Panofsky, *Perspective*, 7.

not quite as self-evident in his writings as 'intrinsic meaning' is in Panofsky's, but it is one of the distinguishing features of Wind's art-historical research.[42] On this basis, we can now consider the art theory embedded in Wind's Michelangelo writings.

The embodiments of metaphysics in Michelangelo's Sistine Chapel ceiling

In 1936, Wind visited Italy and Rome for the first time.[43] According to Wind's 1936 *Bildsprache Michelangelos*, the relationship between the metaphysics of sixteenth-century theology and Michelangelo's imagery in the ceiling of the Sistine Chapel is essential to the understanding of the fresco.[44] For this reason, in 1936 Wind spent most of his time in Rome at the Pontificio Istituto Biblico in Piazza della Pilotta, the theological library run by the Jesuit Order.[45] Through the Istituto's abundance of primary sources illustrating spiritual doctrines, the didactic nature of the Sistine ceiling became evident to Wind.[46] Following his 1936 research at the Istituto Biblico, Wind's efforts to understand Michelangelo's theological – that is, metaphysical – sources would continue until the very end of his life.[47]

42 See Bernardino Branca, ed., *Edgar Wind's Raphael Papers: The School of Athens* (Wroclaw: Amazon KDP, 2020).

43 London, Warburg Institute Archive (hereafter WIA), Wind Folder 1935–6; Branca, *Edgar Wind*, 267.

44 Wind, *Die Bildsprache Michelangelos*, 15.

45 Edgar Wind to Fritz Saxl, July 1936, WIA, General Correspondence. See also Wind, *The Religious Language of Michelangelo*, xxvii.

46 Wind, *Art and Anarchy*, 57.

47 On 17 March 1971, an ailing Wind, a few months before his death, wrote a letter to Barral Editores in Barcelona, stating that 'I am still busy completing a two-volume study on the THEOLOGICAL SOURCES OF MICHELANGELO, a subject which has occupied me for some forty years.' Bodleian, EWP, MS. Wind 81, folder 1.

To understand how Wind identified the metaphysics embodied in the ceiling in his 1965 article, it is important to consider two of his earlier texts, which anticipated its content. The first is an article written during his 1950 stay in Rome, in which he locates the metaphysical sources of the ceiling in the texts of Pope Julius II's theologians, especially those penned by Sante Pagnini.[48] These texts rest upon a 'mystical technique of theological arbitration'.[49] This technique – *coincidentia oppositorum* – was conceived by the Greek and Latin Fathers, Origen in particular.[50] 'If it was Pico who produced the crisis that released Origen from the cave of shadows, it was left for Aldus to inaugurate the classical period of Origenist studies.'[51] Hence, Pagnini, 'who was a Dominican, composed his *Isagogae ad mysticos sacrae scripturae sensus* after the model of Origen and Augustin'.[52] Origen's and Augustin's Platonist metaphysics were at the very core of the age of Julius II's spiritual world.[53]

The second text is 'Art and Scholarship in the Age of Julius II', the unpublished table of contents of a series of four lectures that Wind delivered at Oxford during the 1954 Michaelmas term.[54] In this typescript, Wind outlines the relationship between art and theological scholarship in Rome under the patronage of Pope Julius II.[55] However, this vast program was

48 Wind, 'Typology in the Sistine Ceiling: A Critical Statement', *The Art Bulletin* 33 (1951), 41–7.

49 Wind, 'Typology in the Sistine Ceiling', 45.

50 Wind, 'Typology in the Sistine Ceiling', 45.

51 Edgar Wind, 'The Revival of Origen', in Edgar Wind, *The Eloquence of Symbols: Studies in Humanist Art*, ed. Jaynie Anderson, with a biographical memoir by Hugh Lloyd-Jones (Oxford: Clarendon Press, 1983), 42–55 (54).

52 Wind, 'Typology in the Sistine Ceiling', 45.

53 Edgar Wind, 'Maccabean Histories in the Sistine Ceiling: A Note on Michelangelo's Use of the Malermi Bible', in E. F. Jacob, ed., *Italian Renaissance Studies: A Tribute to the Late Cecilia M. Ady* (London: Faber & Faber, 1960), 324.

54 Edgar Wind, 'Art and Scholarship in the Age of Julius II' (1954), typescript, Bodleian, EWP, MS. Wind 12, folder 1/5. The lectures helped Wind secure the position of professor of history of art at Oxford in 1955.

55 Wind, 'Art and Scholarship in the Age of Julius II'. In a footnote on the front page of this table of contents, Wind wrote 'Chichele Lectures 1954'. In the Edgar Wind Papers at the Bodleian there are no transcripts of the actual content of the lectures, as Wind did not use notes to deliver them.

never completed. In the typescript, Michelangelo's Sistine ceiling and the prophets and sibyls, along with Raphael's *School of Athens* and *Disputa*, relate to *die Geistliche Welt*, the metaphysics of the spiritual world of Renaissance Rome. According to Wind, examples of that spiritual world – 'cultural symptoms' in Panofsky's terminology – are the libraries of the della Rovere in the Vatican, and the writings of the theologians at Pope Julius II's court, such as Egidio da Viterbo and Sante Pagnini.[56] The topic 'The Programme of the Sistine Ceiling' includes excerpts from the following theological texts and ideas that Wind sees embodied in the ceiling's imagery:

> Documentary evidence of the original plan – Apostles replaced by Prophets and Sibyls: Adumbration instead of literal programme – Prophetic symbols in the early works of Michelangelo – The Madonna della Scala compared with Domenico Benivieni's treatise Scala sopra il nome di Maria [...] Augustinian features of the programme – Egidio da Viterbo, general of the Augustinian order under Julius II – Egidio's vision of the Cumean Sibyl – Imitation of Virgil – The Sibyls in Sannazaro's De Partu Virginis – Hebrew learning of Egidio – Translations of the Old Testament by Sante Pagnini, pupil and successor of Savonarola – Sante Pagnini and Julius II – Pagnini's Isagoga ad mysticos sacrae scripturae sensus.[57]

Wind's table of contents for 'Art and Scholarship in the Age of Julius II' reiterates the particular 'symptomatic' importance that he placed upon the Platonist theologians Egidio da Viterbo and Sante Pagnini. In *Isagogae ad*

56 Edgar Wind, 'Sante Pagnini and Michelangelo', in Wind, *The Religious Language of Michelangelo*, 10. Sante Pagnini (Lucca 1470 – Lyon 1541) was a Dominican friar and disciple of Girolamo Savonarola. He is best known for his 'mystic' translations of the Bible from Hebrew, *Veteris et Novis Testamenti nova translatio*, 1527/8, and for *Isagogae ad mysticos sacrae scripturae sensus*, 1536. See E. H. Fuellenbach, 'Bibel und Hebraischstudien italienischer Dominikaner des 15. und 16. Jahrhunderts', in Viliam Štefan Dóci and Thomas Prügl, eds, *Bibelstudium und Predigt im Dominikanerorden: Geschichte, Ideal, Praxis* (Rome: Angelicum University Press, 2019), 255–71.

57 Wind, 'Art and Scholarship', 1–2. Reproduced with the permission of the Literary Executors of the Estate of Edgar Wind. Concerning Wind's extensive interest in Egidio da Viterbo's 'mystical' biblical hermeneutics, see John O'Malley, *Giles of Viterbo on Church and Reform: A Study in Renaissance Thought* (Leiden: Brill, 1968), 212.

mysticos sacrae scripturae sensus, Pagnini explains the allegorical and mystical approach to biblical hermeneutics.[58] Wind refers to this text – the summary of Pagnini's lifelong biblical studies – as the 'biblical summa' of the mystical approach to biblical hermeneutics during the Italian Renaissance,[59] writing that:

> If we are to comprehend the particular shade of religious doctrine expressed in Michelangelo's frescoes on the Sistine Ceiling, we shall find it less in Savonarola's own writings than in those of the learned Sante Pagnini. Respected and honoured as Savonarola's successor in the circle of the younger Pico della Mirandola, he appears to have been the favourite theologian of Julius II himself.[60]

Wind discussed the mystical approach to biblical hermeneutics several times in his writings, including in a 1938 letter to Frances Yates, which is of great assistance in understanding the core message of Wind's interpretation of 'Michelangelo's Prophets and Sibyls'.[61] In the letter, Wind explains the importance of this approach:

> The man believing in a *literal* interpretation of the Gospels must reject it as heresy to sympathize with worshippers of Dionysus. Dionysus was a god of mirth and revelry, Christ a god of sorrow and humility. Taken *literally*, their traits contradict each other. Yet in the *mystical* interpretation, sorrow can become a form of revelry, and humility a form of mirth; and it will be found that both the Dionysian and Christian agree in teaching that the soul must be purged of sin, that this purge is a form of death, and that both describe this death as 'passion'. A Christian mystic will, therefore, have a very much more tolerant attitude to doctrines which the rational Christian rejects as heresies. He will say of the 'Dionysians': – these people believe exactly what St. Paul taught to us. They only use a somewhat different language. We must teach them our language, that is the only way to make them Christians. But we cannot teach them our language successfully, unless we take the trouble to learn theirs.

58　Sante Pagnini, *Santis Pagnini lucensis praedicatorii ordinis, Isagogae ad sacras literas, liber unicus, eiusdem Isagogae ad mysticos sacrae scripturae sensus, libri XVIII* (Lyon: Hugues de la Porte, 1536).

59　Wind, 'Sante Pagnini', 5, 22.

60　Wind, 'Sante Pagnini', 4.

61　Bernardino Branca, 'The Giordano Bruno Problem: Edgar Wind's 1938 Letter to Frances Yates', *Edgar Wind Journal* 1 (2021), 37. The full transcript of the letter is reproduced on pp. 35–8.

> I think I can prove that this mystical approach to Christianity was one of the strongest forces in the revived interest in Paganism, which is symptomatic of the so-called Renaissance.[62]

This conceptual background to biblical hermeneutics is the basis of Wind's tables of contents for 'Art and Scholarship in the Age of Julius II' and 'Michelangelo's Prophets and Sibyls': the Sistine ceiling is the 'embodiment' of the *mystical* approach to biblical hermeneutics, in stark contrast with the literal one.

The draft of a letter dated 1952 sheds further light on the understanding of Wind's 1965 article. Wind sent this letter to the Guggenheim Foundation in New York, applying for a grant to fund another trip to Rome. In explaining the purpose of his proposed journey (further research on the textual sources of Raphael's *Disputa*), Wind writes that his previous work, which dealt with the scholarly sources of the *School of Athens* discovered during his 1950 trip to Rome, was part of the comprehensive program 'Art and Scholarship in the Age of Julius II'. Moreover, Wind provides a philosophical explanation for his research:

> For some twenty years my chief interest has been to explore the boundaries between the histories of art and of philosophy. My aim has been to demonstrate that in the production of some of the greatest works of art the intellect has not thwarted but aided the imagination; and I have tried to develop a method of interpreting pictures which shows how ideas are translated into images, and images sustained by ideas.[63]

This crucial effort is also evident in 'Michelangelo's Prophets and Sibyls'. For this purpose, Wind was the first to point out that 'the early sixteenth century in particular, is a terra incognita in theological thought, often mistaken for a period without theology, even though it produced the two greatest theological monuments of the Renaissance, the Sistine Ceiling and *Disputa*.'[64] John O'Malley agrees with Wind that, contrary

62 Wind to Yates, 1938, in Branca, 'The Giordano Bruno Problem', 36. Emphasis in original.
63 Edgar Wind to Guggenheim Foundation, 15 April 1952, Bodleian, EWP, MS. Wind 216, folder 1.
64 Wind, *The Religious Language of Michelangelo*, 1.

to the conventional wisdom that a 'Pagan Renaissance' took place during Julius II's papacy, there was a strong revival in theological studies in Rome at the time.[65] The popes of the early sixteenth century focused on promoting appropriate worship, particularly in the papal chapels.[66] The Sistine Chapel, in particular, was open primarily to a select number of learned visitors; because of this, Julius II was particularly interested in its renovation.[67] The belief that pagan metaphysical sources (if interpreted allegorically and mystically) were compatible with Christian ones was part of Julius II and Leo X's 'New Order'.[68]

Wind identified two kinds of theology embodied in Michelangelo's ceiling: one of them was the Platonist 'High Theology' of Sante Pagnini and Egidio da Viterbo, contemporaries of Michelangelo at Julius II's court;[69] the other was 'Popular Theology', comprising the elements of popular belief and the practice of popular catechism. Such elements made up the '*Christianitas*' and, in the case of Michelangelo, refer to the views of Gerolamo Savonarola in particular.[70] Wind underscored that 'Michelangelo in his youth had been a follower of Savonarola – a staunch Platonist too – and that he retained a vivid recollection of the preacher's doctrine and voice.'[71] Both strains of Renaissance Platonist theology were embodied in Michelangelo's Sistine ceiling, according to Wind in his 'Prophets and Sibyls' paper; Panofsky agreed that 'Michelangelo could be defined as the only genuine Platonist among the many artists influenced by Neoplatonism.'[72]

Wind's conception of the allegories of mirth and revelry originated in late-antique funerary friezes inspired by the Dionysian mysteries – such

65 John O' Malley, 'The Religious and Theological Culture in Michelangelo's Rome: 1508–1512', in Wind, *The Religious Language of Michelangelo*, xliii.

66 O'Malley, 'The Religious and Theological Culture', xlvii.

67 John Shearman, 'The Apartments of Julius II and Leo X', in Guido Cornini, ed., *Raphael in the Apartments of Julius II and Leo X: Papal Monuments, Museums, Galleries* (Milan: Mondadori, 1993), 15.

68 O' Malley, 'The Religious and Theological Culture', xlviii.

69 Wind, 'Sante Pagnini', 1.

70 Wind, 'Sante Pagnini', 1.

71 Wind, 'Sante Pagnini', 1.

72 Panofsky, *Studies in Iconology*, 180.

friezes had been openly displayed in Rome since the late fifteenth century.[73] The Dionysian mystery cults had blended easily with early Christianity's Platonist metaphysics. Jesus Christ himself had said, 'I am the True Vine.'[74] Dionysian sarcophagi had syncretistic religious meanings and provided a mystical eschatological message based upon a mythological world of mirth and revelry after death – of wine, dance, love and music.[75] Also, according to Panofsky, 'late antiquity's and early Christianity's funerary art, through the representation of Bacchic scenes, produced *symbols* which anticipated the spiritual salvation of the dead.'[76] In 1467, this attitude towards life and death returned to the fore in Rome when St Constantia's fourth-century red porphyry sarcophagus (Figure 7.1) was removed from her mausoleum in St Agnes Church in the via Nomentana and publicly displayed in the Piazza San Marco. Constantia, who died in AD 354, was a daughter of Emperor Constantine. The frieze shows a joyful and mystical Dionysian theme of putti and the wine harvest, translated into a mystical Christian one, with the wine grapes symbolizing Christ's Passion.[77] The vault mosaic of Constantia's mausoleum shows the embodiment of late antiquity's metaphysics through the same Dionysian theme of the grape harvest. This is an example of what Wind meant when he wrote to Yates, 'I think I can prove that this mystical approach to Christianity was one of the strongest forces in the revived interest in Paganism, which is symptomatic of the so-called Renaissance.'[78]

73 See Paul Zanker and Björn Christian Ewald, *Vivere con i miti: L'Iconologia dei sarcofagi romani*, trans. Flavio Cuniberto (Turin: Boringhieri, 2004).

74 John 15:1.

75 See Jaś Elsner, 'Some Observations on Dionysiac Sarcophagi', in Catherine Mary Draycott, Rubina Raya, Katherine E. Welch and William T. Wootton, eds, *Visual Histories of the Classical World: Essays in Honour of R. R. R. Smith* (Turnhout: Brepols, 2019), 425–6.

76 Panofsky, *Studies in Iconology*, 184 (my italics).

77 See Jaś Elsner, *The Art of the Roman Empire: AD 100–450* (Oxford: Oxford University Press, 2018), 185–219.

78 Wind to Yates, in Branca, 'The Giordano Bruno Problem', 36.

Figure 7.1: Sarcophagus of St Constantia (d. 354), red porphyry, 194 × 233 × 155 cm. Vatican Museums, Rome. Photograph by Bernardino Branca.

The organic unity of the Sistine ceiling explained by its symbolic function

An overall view of the ceiling of the Sistine Chapel (Figure 7.2) shows the metaphysical concepts of the seven gifts of the Holy Spirit, embodied in the images of the seven prophets, set against the five sibyls. Throughout his 1965 article, Wind identifies the meaning of the symbolic language of such figures, noting the gestures, psychological expressions and bodily postures that characterize specific moods of 'prophetic seizure'.[79] Wind identifies the Sistine ceiling's 'symbolic function' through an iconographic exercise drawn from Warburg's *Pathosformulae*. Although Wind does not explicitly mention the term *Pathosformulae* in his article, by

79 Wind, 'Michelangelo's Prophets and Sibyls', 127.

reading between the lines we can recognize his use of the iconographic tools developed by Warburg in his *Bilderatlas Mnemosyne*.[80]

Bearing this in mind, Wind interprets the facial expressions and bodily postures of the seven prophets and five sibyls by relating them to one another: each figure can be understood only as part of the overall organic unity of the ceiling's composition. The prophet Zacharia embodies the theological notion of *sapientia* [wisdom]. According to Wind, it is vital to 'suspend judgement' of Zacharia's spiritual temperament until the character is contextualized as part of the entire series of prophets and sibyls on the ceiling.[81] Taken by itself, Zacharia's likeness here might be that of any elderly sage, wise and detached from worldly concerns. It is not until viewers see *intellectus*, which follows *sapientia*, appearing in the determined physiognomy of the prophet Joel, that they identify the figure before them as Zacharia. Wind points out clues to Joel's state of mind, including the cool eyes and frowning lips that illustrate his intellectual vanity and self-esteem, and the putto just above, who lectures with a superior air, adding to Joel's aura of authority.[82]

Following *sapientia* and *intellectus* is the prophet Isaiah, the embodiment of *consilium* [counsel]. According to Wind, Isaiah is reluctantly turning from a half-closed book, listening to the call of the spirit with a facial and bodily expression of doubt and concern. With his downward stare and twisted and hesitant posture, he resembles the river god portrayed in scene 11 of panel 55 in Warburg's *Bilderatlas Mnemosyne*.[83] According to Wind, the tension between the opposing psychological forces embodied in Isaiah as the prophetic state seizes him – the active call and the retarding

80 With the help of Gertrud Bing in Rome, Wind, from Hamburg, provided bibliographical support and scientific guidance to Warburg in structuring the *Bilderatlas Mnemosyne*. This is evident from the letters exchanged by Wind and Warburg between March 1928 and April 1929. See excerpts in Branca, *Edgar Wind*, 59–69, and WIA, Wind Folder 1928 and Wind Folder 1929.

81 Wind, 'Michelangelo's Prophets and Sibyls', 127.

82 Wind, 'Michelangelo's Prophets and Sibyls', 127.

83 Aby Warburg, *L'Atlas Mnémosyne*, trans. Sacha Zilberfarb, preface by Roland Recht (Rouen: L'Ecarquillé, 2019), 199.

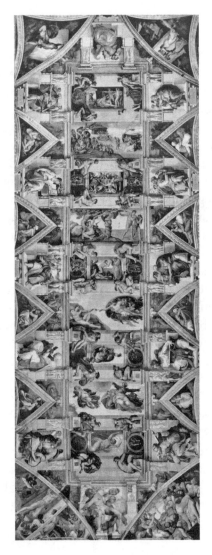

Figure 7.2: Michelangelo Buonarroti, Sistine Chapel ceiling, 1508–12, fresco. Vatican Museums, Rome. Photograph published under Creative Commons licence.

thought – embodies the inspired state of suspense that belongs to the gift of counsel.[84]

Opposing forces express opposing psychological postures, merged in the organic unity of the ceiling's composition. In contrast to the inaction of *consilium*, the gift of *fortitudo* – which Wind translates as 'might' – is embodied in the 'prophetic seizure' of Ezekiel (Figure 7.3): 'The force and rage, concentrated in the bull-like neck, are threateningly expressed by the gesture of the hand, the lips being pressed together in a state of prophetic fury.'[85] The figure's posture embodies the idea of the will to act. The scenes in panel 45 of *Bilderatlas Mnemosyne* (which Warburg subtitles 'superlatives of gestural language') provide the related *Pathosformeln*, of which the most important is the hand (Figure 7.4).[86] To explain the symbolic meaning of Ezekiel's hand in the Sistine ceiling, Wind refers to the statement 'The hand signifies the deed' – a 'cultural symptom' found in medieval and Renaissance biblical interpretations of Ezekiel.[87]

Scientia [science] is the fifth gift of the Holy Spirit, embodied in the ceiling by the 'prophetic seizure' of Daniel, who is zealously transcribing a text from a large book to a smaller one. 'I, Daniel, understood by books' (Daniel 9:2), quotes Wind. Wind also quotes Belshazzar, who says to Daniel, 'I heard of thee that thou canst make interpretations of obscure meanings and untie knots' [*audivi de te quod possis obscura interpretari et ligata dissolvere*] (Daniel 5:16). Wind finds a clue for the interpretation of this passage in Augustine's commentary on the allegorical meaning of Daniel and the Holy Spirit's gift of science. Daniel was distinguished among the prophets because he combined the capacity of conceiving 'mystic' visions with a probing intelligence that could discern their rational meaning: 'Thus Daniel's excellence was tested and proved because he both told the king the dream he had seen and revealed to him what it signified.'[88]

84 Wind, 'Michelangelo's Prophets and Sibyls', 127.
85 Wind, 'Michelangelo's Prophets and Sibyls', 127.
86 Warburg, *L'Atlas Mnémosyne*, 162.
87 Warburg, *L'Atlas Mnémosyne*, 162.
88 Augustine of Hippo, *De Genesi ad litteram*, XII, ix, in Jacques Paul Migne, ed., *Patrologia Latina* (Paris: Migne, 1841–65), XXXIV, col. 461.

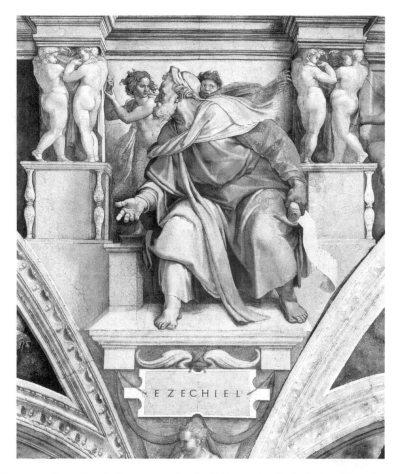

Figure 7.3: Michelangelo Buonarroti, *Ezechiel* (the prophet Ezekiel): detail from Sistine Chapel ceiling, 1508–12, fresco. Vatican Museums, Rome. Photograph in the public domain.

Jeremiah, the author of Lamentations, is the prophet of the sixth gift of the Holy Spirit: *pietas*, an empathic form of worship. His posture – one of withdrawn gloom and meditation – is, says Wind, the traditional pose of melancholy (Figure 7.5).[89] Albrecht Dürer, in his engraving *Melencolia I*

89 Wind, 'Michelangelo's Prophets and Sibyls', 129.

Figure 7.4: Reproduction of Giovanni Bellini, *The Blood of the Redeemer* (1465): detail from panel 45 of Aby Warburg, *Bilderatlas Mnemosyne*. Courtesy of the Warburg Institute, London.

(1514), aimed to depict the state of mind experienced during intellectual labours.[90] *Melencolia I* is part of scene 8 of table 58 of Warburg's *Bilderatlas Mnemosyne* (Figure 7.6).[91] In the Sistine ceiling, however, the embodiment of the emotions of melancholy and sorrow is again counterbalanced by the different bodily postures of the two spirits near Jeremiah.[92]

The series of embodiments of the metaphysical concepts of the gifts of the Holy Spirit ends with the prophet Jonah, who embodies *timor Domini* [fear of the Lord]. But, Wind says, 'Michelangelo did not shrink from this outstanding piece of religious logic: [he] painted Jonah's disequilibrium, his titanic form thrown back from the overwhelming impact of the divine command, which he obeys in reluctance and fear.'[93] Wind's ultimate understanding of Michelangelo's goal in painting the Sistine ceiling is that of embodying a sequence of opposing forces that reach equilibrium when considered as an entire group. For example, Wind argues that Michelangelo's iconographic plan must have provided that Jonah, the last and most emotionally agitated of the prophets, should lead the eye back to Zachariah, the most composed among them.[94]

The opposing forces depicted in the ceiling, plastically embodied by Michelangelo in each image, balance each other when considered together; they are the embodiment of the metaphysical sequence of the seven gifts of the Holy Spirit as explained by Ambrose. Wind quotes Ambrose's metaphor 'All the other gifts originate from the Fear of the Lord and arise from it as a column rises from a pedestal; like a column, they transfigure the support upon which they rest.'[95] However, 'The Fear of the Lord,' Wind

90 See Joseph Leo Koerner, *The Moment of Self Portraiture in German Renaissance Art* (Chicago: Chicago University Press), 21–7.

91 Warburg, *L'Atlas Mnémosyne*, 211. For a discussion of *Melencolia I*, see Franz Engel's contribution to the present volume.

92 Wind, 'Michelangelo's Prophets and Sibyls', 128.

93 Wind, 'Michelangelo's Prophets and Sibyls', 128.

94 Wind, 'Michelangelo's Prophets and Sibyls', 128.

95 Wind, 'Michelangelo's Prophets and Sibyls', 130.

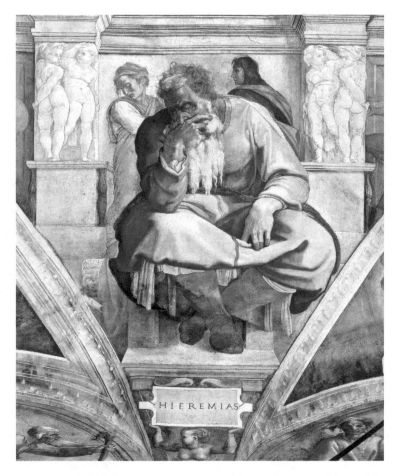

Figure 7.5: Michelangelo Buonarroti, *Hieremias* (the prophet Jeremiah): detail from Sistine Chapel ceiling, 1508–12, fresco. Vatican Museums, Rome. Photograph in the public domain.

writes, quoting Ambrose, 'is informed by Wisdom, instructed by Intellect, guided by Counsel, made firm by Might, governed by Cognition, enhanced by Pity; take these away from the Fear of the Lord, and it is an unreasonable and incipient fear.'[96]

96 Wind, 'Michelangelo's Prophets and Sibyls', 130. Wind is referring to Ambrose of Milan, *Expositio in Psalmum CXVIII*, 38 (*Patrologia Latina* XV, col. 1265).

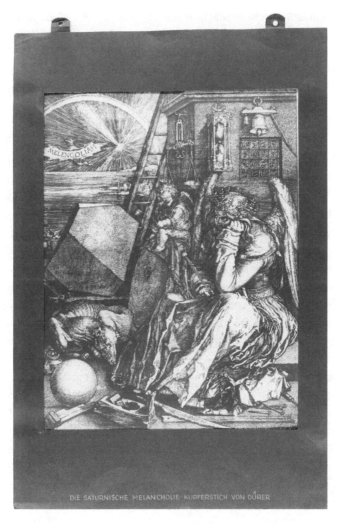

Figure 7.6: Reproduction of Albrecht Dürer, *Melencolia I* (1514): detail from panel 58 of Aby Warburg, *Bilderatlas Mnemosyne*. Courtesy of the Warburg Institute, London.

The seven gifts/prophets counterbalance one another in a symmetrical game of counterforces; the rational ideas and irrational emotions used to animate the images counteract each other and merge in the organic unity of the composition. This can be understood only by looking again at the

Sistine ceiling as a whole: 'each of the prophets finds his spiritual partner not so much in his immediate neighbour in the canonical list, as in the figure that answers him by providing a symmetrical counterforce.'[97] This is the core of Wind's interpretation of the symbolic function of the ceiling. The reason for his implicit use of some of Warburg's *Pathosformeln* is to identify such emotions.

Wind's discussion of the ideas and emotions embodied in the different prophetic states includes consideration of the five sibyls, who play an essential role in interpreting the fresco. The sibyls, who provided prophecies to the heathens, preached the divine word without training in the Mosaic faith; hence, to the humanists, they seemed more miraculous than the prophets.[98] Wind cites Mantegna's *Sibyl and Prophet* (Cincinnati Art Museum) and Titian's *La Gloria* (Madrid, Museo Nacional del Prado) as iconographical evidence for this statement.[99]

The clue to understanding the 'mystical' meaning of the five sibyls in the Sistine ceiling is to be found in St Paul's First Letter to the Corinthians, in which he speaks of the 'spiritual gifts' – psalm, doctrine, tongue, revelation, interpretation – designed for the Gentiles.[100] With the help of Thomas Aquinas, Wind identifies two of these gifts – 'mystic song' [*psalmus*] and the 'gift of tongues' [*lingua*] – with two extreme types of prophetic exaltation, which he sees as two opposing forces counterbalancing each other. The sequence embodied in Michelangelo's sibyls, if read from the entrance towards the altar, begins with *lingua* and ends with *psalmus*. *Lingua* corresponds to the Delphic sibyl (Figure 7.7), a manic/ecstatic *Pathosformulae* that could potentially be identified with the postures of the maenads in images of the triumph of Bacchus and Ariadne. An etching after Botticelli depicts such postures, which Warburg included in the scenes of panel 40 of *Bilderatlas Mnemosyne* and defined as a 'breakthrough of the antique

97 Wind, 'Michelangelo's Prophets and Sibyls', 133. Wind is referring to Augustine of
 Hippo, *Sermones*, CCXLIX (*Patrologia Latina* XXXVIII, col. 1161).
98 Wind, 'Michelangelo's Prophets and Sibyls', 133.
99 Wind, 'Michelangelo's Prophets and Sibyls', 133.
100 Paul, 1 Corinthians 14:11–13.

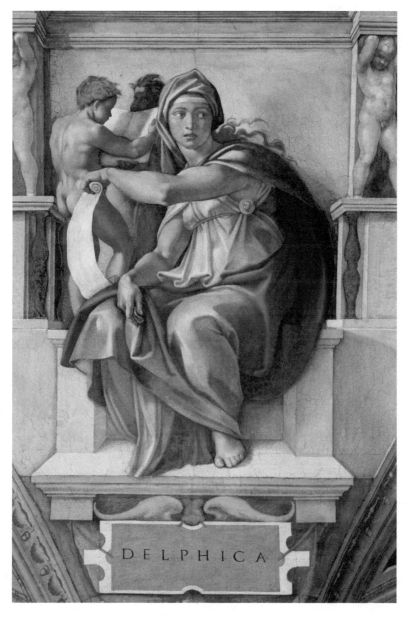

Figure 7.7: Michelangelo Buonarroti, *Delphica* (the Delphic sibyl): detail from Sistine Chapel ceiling, 1508–12, fresco. Vatican Museums, Rome. Photograph published under Creative Commons licence.

Figure 7.8: Reproduction of etching by unknown artist after Sandro Botticelli,
Triumph of Bacchus and Ariadne (1490): detail from panel 40 of Aby Warburg,
Bilderatlas Mnemosyne. Courtesy of the Warburg Institute, London.

spirit'.[101] In one of the scenes, the maenads taking part in a Bacchic frenzy
express their ecstatic state through the specific *Pathosformulae* of manic
excitement (Figure 7.8).

It is plausible that a posture expressing ecstatic inspiration is mystic
rather than manic; the Libyan sibyl shows this (Figure 7.9). Thus the
Delphic and Libyan sibyls, located at opposite ends of the ceiling, express
respectively 'demonic' and 'angelic' ecstasy or 'manic obsession' and 'mystic
release'. The Libyan sibyl embodies the gift of *psalmus* (a mystic song in
praise of God) and balances out the manic frenzy of the Delphic sibyl.

101 Warburg, *L'Atlas Mnémosyne*, 139.

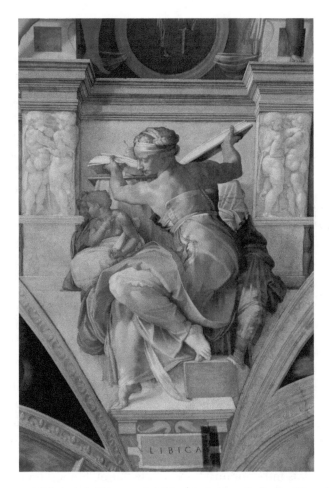

Figure 7.9: Michelangelo Buonarroti, *Libica* (the Lybian sibyl): detail from Sistine Chapel ceiling, 1508–12, fresco. Vatican Museums, Rome. Photograph published under Creative Commons licence.

They express opposing yet 'deranged' states of mind, which the organic unity of the fresco merges.[102] The *Pathosformeln* of the Libyan sibyl can

102 Wind, 'Michelangelo's Prophets and Sibyls', 136, 141.

be identified in scenes of panel 25 of Warburg's *Bilderatlas*, especially in
Agostino di Duccio's dancing maenad in (Figure 7.10).[103] The derangement
depicted in the images of the Delphic and Libyan sibyls is, according to
Wind, a typical expression of the ancient pagan prophetic state – whereas
the Hebrew prophets, he argued, never reached such extremes.[104] The
opposing but 'deranged' states fit Wind's definition of the state of mind
characterizing 'mirth and revelry', the distinguishing feature of the meta-
physics of late antiquity's 'Dionysian' Christianity, which experienced a
revival during the Italian Renaissance.[105]

In the centre of the depiction of the sibyls, Wind identifies more re-
flective moods, which express the gifts of interpretation, doctrine and revel-
ation [*interpretatio, doctrina, revelatio*], represented by the Erythraean,
Cumaean and Persian sibyls respectively.[106] Wind underscores yet again the
importance of 'balance' in the organic unity of the Sistine ceiling's imagery:

> In the Sistine Ceiling, 'positive' and 'negative' theology are held in balance: the
> Erythraeid Sibyl is as important as the Persian; Joel and Ezekiel do not yield to
> Jeremiah. Without the open eyes of the Delphic Sibyl, the closed eyes of the Libyan
> would lose part of their meaning, and both these Sibyls would appear uprooted
> without the central weight of the Cumae.[107]

Wind's concluding remarks on the imagery of the Sistine ceiling focus
on the twenty *ignudi* spread across the ceiling (see Figure 7.2). *Ignudi* are
wingless angels, seraphs who support the Ten Commandments and confer
the divine gift of effusion.[108] Michelangelo's *ignudi* could be said to com-
plete the 'balance' of the ceiling's organic unity. The 'balance' of such
opposing ideas and emotional forces is thus one of the most important fea-
tures of Wind's interpretation of the ceiling. He also felt that the Platonist

103 Warburg, *L'Atlas Mnémosyne*, 82.
104 Warburg, *L'Atlas Mnémosyne*, 82.
105 See Edgar Wind's discussion of this theme in his 1938 letter to Frances Yates, in
 Branca, 'The Giordano Bruno Problem', 36.
106 Wind, 'Michelangelo's Prophets and Sibyls', 136.
107 Wind, 'Michelangelo's Prophets and Sibyls', 142.
108 Wind, 'Michelangelo's Prophets and Sibyls', 147.

Figure 7.10: Photograph of Agostino di Duccio, *Dancing maenad*, 1450–7, marble relief, Tempio Malatestatiano, Rimini: panel 25, scene 11, of Aby Warburg, *Bilderatlas Mnemosyne*. Courtesy of the Warburg Institute, London.

theologians who helped Michelangelo plan the program of the ceiling conceived the cycle as a mystical hymn to the spirit who confers the divine gift of effusion.[109] Conspicuous among them was, again, Sante Pagnini: 'Like

109 Wind, 'Michelangelo's Prophets and Sibyls', 147.

the theologian Egidio da Viterbo, Sante Pagnini favoured the use of relig-
ious metaphors in which the prophetic learning of the Hebrews was height-
ened by the felicities of Pagan intuition.'[110]

The balanced coexistence of the opposing forces of logos and magic
in the ceiling's symbolic function produces an element of disguise, which
was meant to both reveal and hide the truth at the same time. This is be-
cause 'in a good symbol, as in a good costume, concealment and revelation
are combined'.[111] Wind explains that this Platonist element of 'haze' and
disguise – simultaneously illuminating and baffling the viewer – is present
because the ceiling's symbolic function was not exclusively descriptive. Its
function was also to foster a particular state of mind, suitable for the pur-
suit of the 'mystic' and allegorical approach to meditation.[112]

Thus, Wind's interpretation of the ceiling connects metaphysics with
imagery. He achieves this through an 'experiment', whose 'test' is the fol-
lowing: 'There is one – and only one – test for the artistic relevance of an
interpretation: it must heighten our perception of the object, and thereby
increase our aesthetic delight.'[113]

Conclusion

This chapter identifies the concepts of embodiment and symbolic func-
tion as the most important elements of Wind's interpretation of the Sistine
Chapel ceiling. Wind, with the implicit help of Warburg's *Pathosformulae*
conceptual tools, viewed Michelangelo's ceiling as the synthesis of 'mystic'
Christian metaphysics and *Nachleben der Antike*. This innovative com-
bination, centred upon a distinctively Platonist and mystical approach to
biblical hermeneutics, is a central feature of the spiritual world in the age
of Pope Julius II. The complex balance between the sequence of opposing

110 Wind, 'Michelangelo's Prophets and Sibyls', 148.
111 See Footnote 25, above.
112 Wind, 'The Ark of Noah', in Wind, *The Religious Language of Michelangelo*, 56–7.
113 Wind, *Art and Anarchy*, 66.

psychological forces of the seven gifts of the Holy Spirit (embodied in the seven prophets), and the five gifts to the Gentiles (embodied in the five sibyls), is the symbolic function or intrinsic meaning of the ceiling. Its symbolic function also has a Platonist element of 'haze' and disguise, because 'in a good symbol, as in a good costume, concealment and revelation are combined'. In the time of Julius II, this aspect was instrumental in helping the learned viewer achieve a 'mystic' state of meditation. Wind theorized that the spiritual world of the age of Julius II – and the metaphysics of Sante Pagnini's 'mystical' studies of the Bible in particular – were embodied in the ceiling's imagery, which could be understood only as a whole. This understanding of the organic unity of opposing forces is the essence of Wind's interpretation of the Sistine ceiling's symbolic function, which, along with the concept of embodiment, has proved to be the hallmark of his intellectual legacy, centred upon the relationship between ideas and images. In this regard, Wind's legacy merits re-appraisal.

C. OLIVER O'DONNELL

8 A Crucial Experiment: An Historical Interpretation of Edgar Wind's 'Hume and the Heroic Portrait'

In an unpublished draft preface to the 1986 volume that collects and translates her late husband's scholarship on eighteenth-century imagery (Figure 8.1), Margaret Wind equivocated on the origins of the essay after which the volume takes its name: 'Humanitätsidee und heroisiertes Porträt in der englischen Kultur des 18. Jahrhunderts', which was given as a lecture at the Warburg Library in 1931 and published in the *Vorträge der Bibliothek Warburg* the following year.[1] Noting that the essay emerged from an early visit to London in 1929 'in pursuit of Hume', Margaret Wind subsequently crossed out the specifying date; the published version of the preface, by Jaynie Anderson, does not include this ostensible quotation from Wind himself.[2] Perhaps the quotation was excluded because it was just a memory; perhaps its source proved elusive or untraceable in Wind's then extant papers. Whatever the case, Margaret Wind's crossing-out suggests that there has long been a certain amount of doubt surrounding the origins of 'Hume and the Heroic

1 The full details of the original publication are: Edgar Wind, 'Humanitätsidee und heroisiertes Porträt in der englischen Kultur des 18. Jahrhunderts', in Fritz Saxl, ed., *Vorträge der Bibliothek Warburg 1930–1931: England und die Antike* (Leipzig: Teubner, 1932), 156–229. For the English translation, see Edgar Wind, 'Hume and the Heroic Portrait', in Edgar Wind, *Hume and the Heroic Portrait: Studies in Eighteenth-Century Imagery*, ed. Jaynie Anderson (Oxford: Clarendon Press, 1986), 1–52.

2 Margaret Wind, unpublished and undated draft preface to Wind, ed. Anderson, *Hume and the Heroic Portrait*. Bodleian Libraries, University of Oxford, Edgar Wind Papers (hereafter Bodleian, EWP), MS. Wind 130, folder 1.

(Hume & the heroic Portrait)

This volume takes its title from a paper Wind gave in 1931
at the Bibliotheque Warburg in Hamburg, one of a series of
lectures by leading German and English scholars on England und
die Antike_ . Its concept, which had developed from from a
visit to London in 1929 'im pursuit of βHUme' marked a changeof
direction in his thought, a move from the aesthetci and
philosophical problems that had preoccupied him during his early years
to the concrete analysis of particular works of art. He
was the first scholar of the original Waburg groups to make a study
of English art, and his phiosophica; approach to portrait-painting
and other ascpects of the Enlightenment was unique.

These eighteeenht-century studies continued to occupy (Wind him
during the London years. After 1939 they were driven aside aby an absorbing
interest in Renaissance imagery, which had begun under the influence
of Warburg and was to become the dominant concern of his later
research. The interconnextion of Renaissance and eighteetn-century ideas
and images is congisely demontrsated in in his short note on Reynolds's
parody of the School of Athens, where Belloris importrant observation
about subject matter in Raphaels painting is illustrated in Reynolds(s y
cariacature of English visitors to Rome.

Figure 8.1: Margaret Wind, undated and unpublished draft preface to Edgar Wind,
Hume and the Heroic Portrait: Studies in Eighteenth-Century Imagery, ed. Jaynie
Anderson (Oxford: Clarendon Press, 1986). Bodleian Libraries, University of Oxford,
Edgar Wind Papers, MS. Wind 130, folder 1. Courtesy of the Literary Executors of
Edgar Wind.

Portrait', even among those closest to Wind himself. In what follows, I recount some previously unpublished and unsynthesized facts about those origins, while at the same time weaving those facts into an interpretation that helps us better understand Wind's essay as the historiographic lynchpin that it is.[3]

As a text, 'Hume and the Heroic Portrait' was Wind's first foray into concrete art-historical interpretation, meaning that its origins have considerable import, especially in the context of the present volume. Moreover, and as is widely known, the essay has cast a long and distinguished, but also controversial, shadow over studies of eighteenth-century British art, a field that was largely connoisseurial before, and for some time after, 'Hume and the Heroic Portrait' appeared.[4] It is my unsurprising conviction that

3 My research on this essay, which is a primary inspiration for my forthcoming book, *Portraits of Empiricism: Art Historical Essays on an Intellectual Tradition* (Penn State University Press), has been developing for some years. Starting with a chapter of my PhD dissertation (University of California Berkeley, 2016), which resulted in an article, 'Two Modes of Midcentury Iconology', *History of Humanities* 3/1 (2018), 113–236, my interest in Wind then shifted to his work on the eighteenth century when I relocated to London to take a position in the Bilderfahrzeuge Project at the Warburg Institute in the autumn of 2018. There I had ready access to the archive of the Warburg Institute and wrote two blog posts about Wind's essay: 'Edgar Wind: "Hume and the Heroic Portrait"', Bilderfahrzeuge Blog, 13 May 2019, <https://bilderfahrzeuge.hypotheses.org/3767>; and 'Kenwood House: 91 Years On', Bilderfahrzeuge Blog, 21 October 2019, <https://bilderfahrzeuge.hypothe ses.org/4041>. Much to my delight, Giovanna Targia also turned her attention to Wind's essay around the same time, speaking on 23 November 2019 at a conference dedicated to 'Die Vorträge der Bibliothek Warburg' at the Leibniz-Zentrum für Literatur- und Kulturforschung in Berlin. Her essay is now forthcoming in that conference's proceedings, and complements my efforts here in being broader in its contextual focus. See Giovanna Targia, 'Edgar Winds Vortrag vom Juli 1931: "Abschiedsvorstellung" der Bibliothek Warburg in Hamburg', in Ernst Müller and Barbara Picht, eds, *Die "Vorträge der Bibliothek Warburg": Das intellektuelle Netzwerk der KBW* (Göttingen: Wallstein, forthcoming). I thank Giovanna for sharing her essay with me before publication.

4 Scholars of British art have long cited and struggled with this essay. See for instance Douglas Fordham, 'Allan Ramsay's Enlightenment: Or, Hume and the Patronizing Portrait', *Art Bulletin* 88/3 (2006), 508–24, which begins by noting the important place of Wind's essay in the historiography of eighteenth-century British art, and

Wind's text cannot be fully understood independently of the much more philosophical work by Wind that immediately preceded it, especially his habilitation, *Experiment and Metaphysics*, defended in 1930 but not published until 1934.[5] Obvious as my thesis might at first appear, understanding how the philosophical and art-historical sides of Wind's work relate has never been a self-evident task. To tease out the relevant relationships, my interpretation is divided into two parts: the first pays particular attention to the references to and resonances with David Hume's work in Wind's early writing, and the second tracks in detail Wind's trips to England around the original formulation of 'Hume and the Heroic Portrait' as a lecture and subsequent publication. In addition to doing some basic documentation and explication, I ultimately argue that 'Hume and the Heroic Portrait' is itself best understood as a 'crucial experiment', to use one of Wind's favourite phrases: an experiment, on the one hand, about the very applicability of experimentation to humanistic research and, on the other, about the purchase of Hume's idea of humanity in eighteenth-century British culture. In this sense, Wind's essay is less about Hume the man, or heroic portraiture as a genre, than about testing how a quite particular concept of humanity became manifest or embodied in a given time and place.

That concept of humanity can be found throughout David Hume's various writings, both in his highly erudite early work and in his later, more

does so by citing Brian Allen's review of the book, published in *Apollo* in 1987. There Allen wrote, 'To a generation who had hitherto experienced only the anecdotal writings of Lady Victoria Manners and Dr. G. C. Williamson, Wind's philosophical approach to portrait painting must have been exceedingly intimidating, and, half a century later, this essay is still powerfully persuasive in its application of new theoretical principles to the study of eighteenth-century English art.'

5 Edgar Wind, *Das Experiment und die Metaphysik: Zur Auflösung der kosmologischen Antinomien* (Berlin: Teubner, 1934). This original edition has been helpfully republished with extensive commentaries and contextual documents in a newer German edition, edited by Bernhard Buschendorf, with a foreword by Brigitte Falkenburg and an afterword by Bernhard Buschendorf (Frankfurt: Suhrkamp, 2001) and also in an English translation: Edgar Wind, *Experiment and Metaphysics: Towards a Resolution of the Cosmological Antinomies*, trans. Cyril W. Edwards, with an introduction by Matthew Rampley (London: Routledge, 2001).

Figure 8.2: Joshua Reynolds, Self-portrait, c. 1747–9, oil on canvas, 63.5 × 74.3 cm.
© National Portrait Gallery, London.

popular, essays.[6] According to Wind, it is legible in much of the period's portrait production, though the opposition between the early self-portraits of Reynolds (Figure 8.2) and Gainsborough (Figure 8.3), which mark a self-evidently heroic attitude in the former and a self-consciously natural one in the latter, makes it especially evident.[7] Such an opposition, according

6 For an example of the former, see David Hume, 'Of Pride and Humility', in David Hume, *A Treatise of Human Nature* [1739], ed. L. A. Selby-Bigge (Oxford: Clarendon Press, 1928), 275–328. For an example of the latter, see David Hume, 'Of the Dignity or Meanness of Human Nature' [1777], in David Hume, *Essays, Moral, Political, and Literary*, ed. Eugene M. Miller (Indianapolis: LibertyClassics, 1987), 80–6.

7 Wind would have seen these two self-portraits during his trips to London in 1930 and 1931, and he illustrates both of them in the published version of his lecture. Reynolds's self-portrait of 1747–9 was then already in the collection of the National Portrait Gallery, and Gainsborough's self-portrait of 1754 was then on display in the collection of Philip Sassoon, which from his correspondence we know that

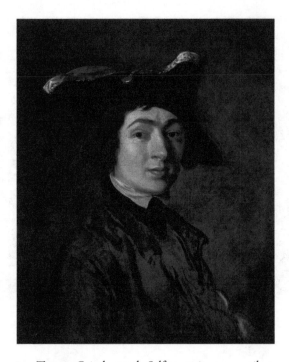

Figure 8.3: Thomas Gainsborough, Self-portrait, c. 1754, oil on canvas,
58.0 × 49.0 cm. Private collection (Houghton Hall). Reproduced courtesy the
Marquess of Cholmondeley.

to Wind, can be correlated to Hume's famous critique of the imagination,
itself fundamental to how Hume conceived of humanity. That critique
can be summarized as follows: the principal danger that the human im-
agination poses is its relentless drive to compare humanity to lowly beast
on the one hand –over which man feels infinitely superior – and to the
divine forces of perfection on the other – under which man feels com-
pletely insignificant. Hume dubs the resulting pride and humility of these
two imaginative extremes 'enthusiasm' and 'superstition', and he forcefully
critiques them both as harmfully artificial. It is only by recognizing that
the ostensibly opposing attitudes of enthusiasm and superstition are both
our own imaginative creations and are not based in common human needs
that anything approximating a transcultural moral code can develop. This

is not to deny that the evidently conventional practices of diverse cultures have important functions, only to assert that the validity of those functions comes from their ability to, and here I quote Wind, 'serve natural needs common to all'.[8] For Wind and Hume, then, something is natural when it eschews artificial extremes and strives to be based on a usefulness or agreeableness common 'to ourselves or others'.[9] But how, we should ask, did Wind come to define Hume's concept of humanity this way? And why, even more fundamentally, did Wind come to be interested in Hume at all?

Wind and Hume

Wind's earliest familiarity with the writing of David Hume is likely lost to history; presumably it dated to his days as a schoolboy, when he visited England on numerous occasions and when his father dreamed of sending him to Oxford or Cambridge.[10] However, after graduating from the Kaiser Friedrichs-Gymnasium in Charlottenburg, Wind stayed in Germany, matriculating at the University of Berlin in 1918. There he began his formal study of philosophy under Ernst Cassirer and would have surely been confronted by Cassirer's *Das Erkenntnisproblem in der Philosophie*

Wind visited. See Edgar Wind to Philip Sassoon, 3 March 1931, London, Warburg Institute Archive, General Correspondence (hereafter WIA, GC) 1931/2618. For a contextualization of Sassoon's collection, see Marc Fecker, 'Sir Philip Sassoon at 25 Park Lane: The Collection of an Early Twentieth-Century Connoisseur and Aesthete', *Journal of the History of Collections* 31/1 (2019), 151–70.

8 Wind, 'Hume and the Heroic Portrait', 5.

9 Wind, 'Hume and the Heroic Portrait', 6. This is also a close paraphrase of Hume, which Wind deploys in his own account. See David Hume, *An Enquiry Concerning the Principles of Morals*, ed. Tom L. Beauchamp (Oxford: Clarendon Press, 1998), 72.

10 Hugh Lloyd-Jones, 'A Biographical Memoir', in Edgar Wind, *The Eloquence of Symbols: Studies in Humanist Art*, ed. Jaynie Anderson (Oxford: Clarendon Press, 1983), xiii–xxxvi.

und Wissenschaft der neureren Zeit, the second volume of which contains chapters on the three classic British empiricists – Locke, Berkeley and Hume – and which first appeared in 1907. A copy of this book was contained in Wind's Oxford library, though we cannot presume it to be the earliest copy he owned.[11] Considering Wind's well-known rebellion against Cassirer, a complementary interpretive reference on Hume also found in Wind's Oxford library is William James' *Principles of Psychology*, which frequently refers to Hume, and which Wind would have encountered during, if not before, his trips to the United States in the 1920s. In addition to James' *Principles* and Cassirer's *Das Erkenntnisproblem*, Wind would have been familiar with numerous other books that comment on Hume. Many other writers who were important references for Wind explored Hume's legacy – including Charles Sanders Peirce, John Dewey and Morris Cohen on the Anglophone side, and Heinrich Rickert, Wilhelm Windelband and Hermann Cohen on the Germanic.

What is surely more important than Wind's knowledge of secondary literature on Hume, however, is his reading of Hume himself. And unsurprisingly, Wind's Oxford library contained no fewer than nine books by Hume, including the major works one would expect: Hume's *Treatise on Human Nature*, his *Enquiries*, his *Essays*, his *Dialogues on Natural Religion*, his *Letters* and, importantly, his *History of England*. Interestingly, the edition of Hume's *Treatise* that Wind owned was a German translation edited by Theodor Lipps, and it carries the subtitle 'Ein Versuch, die Methode der Erfahrung in die Geisteswissenschaft einzuführen'.[12] As Wind himself would have surely known, the famous original English subtitle of that work is 'an attempt to introduce the experimental method of reasoning into moral

11 For a catalogue of Wind's Oxford library, see 'The Wind Library', catalogued by T. J. Kirtley, J. Stemp and A. Yorke (Oxford, 1998), available at Bodleian Libraries, University of Oxford, 'Subject and Research Guides. Art and Architecture: Library Collections; Edgar Wind's Personal Library Collection', <https://libguides.bodleian.ox.ac.uk/art-architecture/edgar-wind-library-collections>, accessed 15 July 2023.

12 David Hume, *Traktat über die menschliche Natur: Ein Versuch, die Methode der Erfahrung in die Geisteswissenschaft einzuführen*, ed. Theodor Lipps (Leipzig: Voss, 1906, 1912).

subjects'.[13] The slippages here between 'experimental method' as 'Method der Erfahrung' and 'reasoning into moral subjects' as 'Geisteswissenschaft' in many ways mark the distance between the two cultures of England and Germany, the natural sciences and the humanities, that Wind himself was traversing. It is this fact about the translation, rather than Theodor Lipps' prominent reputation as a major proponent of empathy theory or *Einfühlung*, that makes the book a fitting addition to Wind's library. The translation itself, moreover, is accompanied by extensive footnotes that gloss Hume's original and quite particular English terminology, making Lipps' edition almost a dual-language book, something that Wind would have surely appreciated.[14]

The close reading of Hume that Lipps' edition of the *Treatise* would facilitate also speaks to Wind's initial interest in Hume being grounded in Hume's famous interventions in epistemology, rather than in Hume's rather minor essays on taste. Indeed, for Wind taste was something that he strove to omit from his scholarship and, as he wrote in his dissertation, he drew a strong distinction between aesthetics and proper art-historical method.[15] Accordingly, the first detectible trace of Hume's work in Wind's is found in Wind's habilitation, and stems from one of Hume's classic epistemological arguments. In writing about the incompatibility of a world governed completely by natural causation that nevertheless still contains free will – itself one of the cosmological antinomies named in the subtitle of Wind's habilitation – Wind summarizes Kant's gloss, in the *Critique of Pure Reason*, of Hume's famous argument about the infinite regress entailed by causal explanations. Wind then writes:

> The fundamental difference between cause and effect – precisely *because*, as Hume has shown, it makes a *demonstration* of the relation of cause and effect impossible – thus

13 Hume, *A Treatise on Human Nature*, ix.
14 Lipps' glosses on Hume's English terminology can be extreme. An indicative example is Lipps' footnote to the term 'perception', which is central to Hume's work and which Lipps spends almost an entire page contextualizing. See Hume, *Traktat*, ed. Lipps, 8–9.
15 Edgar Wind, 'Theory of Art Versus Aesthetics', *The Philosophical Review* 34/4 (1925), 350–9.

permits variation in the *application* of the concept of causality. This variation makes it seem justifiable to understand by the single concept 'causal' on the one hand the necessary connection of two different objects as they are perceived by the senses in time, on the other the necessary connection of two different aspects of the event in a single object.[16]

Such a passage makes clear that Hume's argument about causation was integral to identifying one of the very antinomies upon which Wind's habilitation focused, a fact that is, naturally, directly related to how Hume's scepticism played a role in the formulation of Kant's transcendental method itself. Wind, however, described *Experiment and Metaphysics* as an anti-Kantian book, and even appealed to Hume's description of *A Treatise on Human Nature* when describing his own habilitation's ill-fated reception; both, according to Wind, fell 'dead-born from the press'.[17] *Experiment and Metaphysics* was, as Cassirer recognized, a 'reformed' form of empiricism, one with a capacious understanding of experimentation at its centre.[18] To put it bluntly, for Wind the parts of a given system of measurement – for instance, a physical metre under the metric system – not only embody that

16 Wind, *Experiment and Metaphysics*, 94. The original German reads as follows: 'Die grundsätzliche Verschiedenheit von Ursache und Wirkung gestattet also, gerade *weil* sie, wie Hume gezeigt hat, eine *Demonstration* des Kausalzusammenhanges unmöglich macht, eine Variabilität in der *Anwendung* des Kausalbegriffs, welche es als berechtigt erscheinen läßt, daß man unter ein und demselben Begriff "kausal" das eine Mal die notwendige Verbindung zweier verschiedener Gegenstände in der sinnlichen Anschauungsweise der Zeit, das andere Mal die notwendige Verbindung zweier verschiedener Aspekte des Geschehens in ein und demselben Gegenstande versteht.' All translations in this chapter are my own.

17 Edgar Wind, 'Microcosm and Memory', *Times Literary Supplement* (30 May 1958), 297.

18 The original German term that Cassirer used was 'geläutert', which carries a religious connotation. I thank Franz Engel for noting this subtlety of translation. For a contextualization of this comment by Cassirer, which Wind inscribed and attributed to Cassirer on an endpaper of a copy of his own *Experiment and Metaphysics*, see Franz Engel, '"In einem sehr geläuterten Sinne sind sie doch eigentlich ein Empirist!": Ernst Cassirer und Edgar Wind im Streit um die Verkörperung von Symbolen', in Ulrike Feist and Markus Rath, eds, *Et in imagine ego: Facetten von Bildakt und Verkörperung* (Berlin: Akademie, 2012), 369–92.

system but also allow for the testing of the very same system that they presuppose. Wind called this practice 'internal delimitation' and he believed that it was applicable not only to arguments in the natural sciences but also to those in the humanities.[19] As he explained to his publisher:

> It is in fact the goal of my study to point out, through the analysis of the methods currently employed in the sciences, just what consequences they have (regarding our concept of the world and freedom), in particular for the methods employed in the humanities. One of the causes of the sharp division between the sciences and the humanities is a concept of nature that modern scientists have completely abandoned, and which scholars in the humanities may no longer today take for granted.[20]

The concept of nature that Wind here refers to is Newtonian and, as Wind had learned from his neo-Kantian mentors, Kant himself had problematically presupposed it. Rather than follow Cassirer down the road of updating Kant in the wake of non-Euclidian geometry and Einsteinian relativity, Wind jumped ship, disputing the inaccessibility of spatial and temporal intuitions of the mind by claiming that the concepts that accorded with those intuitions could be tested in experience. In so doing, we might even say that Wind, much like Hume in the *Treatise*, was applying the 'experimental method of reasoning'; Wind's object of experimentation, however, was not what Hume called 'moral subjects', but rather what had come to be known as the *Geisteswissenschaften*.

Confronting a group of neo-Kantian philosophers with such an argument was, of course, no easy task, a fact that Wind surely recognized when

19 For Wind's own definition of 'internal delimitation', see Edgar Wind, 'Internal Delimitation and Indetermination', in Wind, *Experiment and Metaphysics*, 107–10.

20 Edgar Wind to Oskar Siebeck, 6 March 1933, reproduced in the English translation of Wind, *Experiment and Metaphysics*, 133–4. The original German letter, held in the Warburg Institute Archive (WIA, GC, 1933/2708), reads as follows: '[E]s ist die eigentliche Absicht meiner Arbeit, durch eine Analyse der gegenwärtigen Methode der Naturwissenschaften auf Folgerungen, (mit Bezug auf den Welt- und Freiheitsbegriff) hinzuweisen, die gerade für die Methode der Geisteswissenschften von Wichtigkeit sind. Die scharfe Trennung von Natur- und Geisteswissenschaften war mit bedingt durch eine Auffassung von der Natur wie sie die heutigen Naturforscher garnicht mehr teilen, und wie sie die heutigen Geisteswissenschaften nicht mehr als selbstverständlich hinnehmen dürfen.'

going into his habilitation's test lecture [*Probevorlesung*]. The anecdote of
Panofsky intervening on that occasion is well known among Wind scholars.
What has been less remarked upon is Wind's decision, documented in a
letter of 1 November 1930, to change the topic of the third theme for his
public entrance lecture [*öffentliche Antrittsvorlesung*] as a *Privatdozent*. It
is in that letter that 'Hume's concept of humanity' first appears as a dedi-
cated topic of Wind's research, potentially because, and here I speculate,
Hume's subtle form of empiricism was an effective weapon against what
Panofsky called a 'court of the neo-kantian inquisition' [*neukantianisches
Inquisitionsgericht*].[21] Be that as it may, Wind must have also recognized
that following through on his habilitation's argument also meant applying
it himself. And what better way to apply it than to investigate how a hol-
istic concept fundamental to a figure at the heart of his own work, David
Hume, became embodied in the cultural parts of its time and place.

An experimental visit to Britain

In the months between passing his *Probevorlesung* on 29 November 1930 and
his inaugural address as a *Privatdozent* on 28 January 1931 – both of which
occurred in Hamburg – Wind travelled to London to begin his research 'in
pursuit of Hume', as his widow later recalled. We know this because of a letter
from Wind to Fritz Saxl dated 1 January 1931, where Wind writes:

> From the picture and theatre-historical side the material flowed to me immediately
> so richly that I decided to limit myself during the four weeks completely to this and
> to leave the philosophical things aside. Therefore I did not search for Hume docu-
> ments at all (especially since the main stock seems to be in Edinburgh). Instead,
> I looked around in the museums and the private collections (with Witt's serving

21 For Wind's full letter to Panofsky, which includes his addition of 'Hume's
 Concept of Humanity' to his public entrance lecture options, see Edgar Wind to
 Erwin Panofsky, 1 November 1930, Bodleian, MS. Wind 2, folder 1. For Wind's
 full memory of his experience going into his habilitation's test lecture, see Edgar
 Wind to William Heckscher, 3 November 1968, in Erwin Panofsky, *Korrespondenz,
 1910 bis 1968: Eine kommentierte Auswahl in fünf Bänden*, ed. Dieter Wuttke
 (Wiesbaden: Harrassowitz, 2011), vol. 5, 1160–63.

as my 'guide') and searched around in the 'Print Room' and in the library of the British Museum, especially in the Enthoven Theatre Collection. And so I now have everything together that I think I need according to the oh! four-weekly state of my knowledge, including some things that are really new and fun. (I already feel like a 'travelling salesman').[22]

As this letter was written from Wind's last stop before returning to Hamburg, the four-week timeline he mentions means that, almost immediately after passing his *Probevorlesung* on 29 November, Wind departed for London. From the letter we learn that Wind had, as his wife remembered, intended to do research on Hume in London, but was so overwhelmed by the available historical material that he limited himself to collections of images and of theatre history. These included the library of Robert Witt, itself a huge reference collection of photographs of works of art that passed to the Courtauld Institute in 1952; the Print Room of the British Museum, one of the great collections of works on paper in Europe; the Library of the British Museum, now largely passed into the British Library; and the Enthoven Collection, a massive pool of memorabilia from English theatre history, donated to the Victoria and Albert Museum in 1924. Later letters reveal that on this trip Wind also visited the collection of Philip Sassoon – where he would have seen Gainsborough's self-portrait of 1754 – the National Gallery, the National Portrait Gallery, and the National Gallery of British Art, now known as the Tate Britain. Already, in this visit, it seems important to note, theatre history is clearly important to him, a fact that harmonizes well with his focus on an 'idea

22 Edgar Wind to Fritz Saxl, 1 January 1931, WIA, GC 1931/3144. The original German reads: 'Von der bild- und theatergeschichtlichen Seite floss mir das Material gleich so reichhaltig zu, daß ich beschloß mich während der vier Wochen ganz hierauf zu beschränken und die philosophischen Dinge beiseite zu lassen. Nach Hume-dokumenten habe ich daher erst gar nicht gesucht (zumal der Hauptbestand in Edinburgh zu liegen scheint). Dafür habe ich mir in den Museen und den Privatsammlungen (wobei mir Witts als 'Leitfaden' dienten) die Augen satt geguckt und im 'Print-Room' und in der Bibliothek des British Museum, vor allem auch in der Enthoven-Theater-Sammlung herumgesucht. Und so habe ich jetzt alles beisammen, was ich nach dem ach! vier-wöchentlichen Stand meines Wissens zu brauchen glaube, darunter auch manches, was wirklich neu und spaßhaft ist. (Ich komme mir schon vor wie ein travelling salesman).'

of humanity', itself something that actors have to literally embody every time they perform. As Wind put it:

> The actor is [...] a living metaphor; and a painter who tends to emphasize the metaphorical element in portraiture [...] will certainly not miss this opportunity of showing a man playing a part. Indeed, Reynolds' portraits of actors are almost invariably portraits of their roles, whereas Gainsborough without exception takes the actor out of his role and depicts him so naturally in his social situation that his theatrical calling goes unnoticed.[23]

Comparing Reynolds' portrait of the famous actor David Garrick (Figure 8.4) with Gainsborough's portrait of the same man (Figure 8.5) reveals this contrast especially well.

Before being able to fully test the material he gathered on this trip against his habilitation's argument, however, Wind had to return to Hamburg to give his public debut speech as a *Privatdozent*, which occurred on 28 January 1931.[24] After that watershed event Wind was allowed to lecture at the University of Hamburg, and he did just that. During the summer term of that year, Wind delivered courses on aesthetics and, notably, on the religious and moral philosophy of David Hume, further testifying to the intertwining of his art-historical and philosophical interests.[25] Before giving those university courses, however, Wind was also working on the original

23 Wind, 'Hume and the Heroic Portrait', 34. The original language, found on p. 203 of the first German edition, reads: 'Der Schauspieler ist ja gleichsam die lebende Metapher, und ein Stil, der ohnehin in der Porträtdarstellung das Metaphorische betont, [...] wird sich gerade im Schauspielerporträt die durch das Objekt gegebene Gelegenheit nicht entgehen lassen, den Menschen in einer Rolle darzustellen. So sind denn in der Tat die Schauspielerporträts von Reynolds fast durchweg Rollenporträts, während Gainsborough ausnahmslos den Schaupieler aus seiner Rolle herausnimmt, ihn in einen Gesellschaftsmenschen zurückverwandelt und ihn in seiner Zuständlichkeit als Gesellschaftsmensch so natürlich schildert, daß man die Berufsfunktion des Schauspielerischen dabei überhaupt nicht bemerkt.'

24 A photocopy of an original announcement of this event is preserved in Bodleian, EWP, MS. Wind 2, folder 3.

25 An original listing of the lectures that were offered in the summer term of 1931 at the University of Hamburg is preserved in Bodleian, EWP, MS. Wind 2, folder 3. One can imagine Wind himself saving this document as a memento of his first official work as a university lecturer.

Figure 8.4: Joshua Reynolds, *David Garrick Between Tragedy and Comedy*, 1760–1, oil on canvas, 147.6 × 183.0 cm. Waddesdon (Rothschild Family), acc. no. 102.1995. Photo: Waddesdon Image Library, The Public Catalogue Foundation, Art UK.

version of 'Hume and the Heroic Portrait' as an evening lecture, which would be delivered on 11 July in the famous lecture room of the Warburg Library. In preparation for that event, Wind travelled back to England that March, this time making the collections of the Shakespeare Memorial Theatre in Stratford-upon-Avon his focus and revealing his interest in English country houses, where he could see eighteenth-century paintings displayed in settings closer to their original surroundings. We know this because Wind sent a telegram back to Hamburg from Stratford-upon-Avon in March, wrote to the Iveagh Bequest in May to request photographs of works he would have seen in Kenwood House, and similarly wrote to Knole and Petworth that November.[26] The potential effect that these physical

26 See Wind's telegram from Stratford upon Avon: Edgar Wind to Fritz Saxl, 27 March 1931, WIA, GC 1931/3145; for Wind's correspondence with the Iveagh

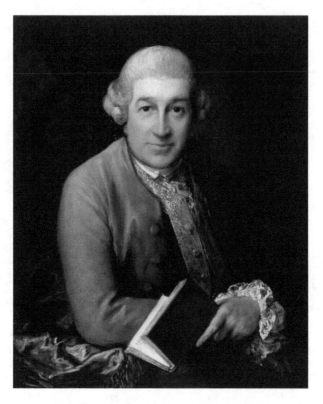

Figure 8.5: Thomas Gainsborough, *David Garrick*, 1770, oil on canvas, 75.6 × 63.2 cm.
© National Portrait Gallery, London.

installations of paintings had on Wind in 1931 is far from a trivial matter;
some of the spaces, especially Knole (Figure 8.6), Kenwood (Figure 8.7),
and the National Gallery, dramatized in forceful terms the famous oppos-
ition between Gainsborough and Reynolds, often dedicating entire rooms

Bequest, see Edgar Wind to the Iveagh Bequest, 6 and 13 May 1931, WIA, GC 1931/
1755 and 1757; and for Wind's letters to Petworth and Knole respectively, see Wind
to Lady Leconfield, 9 and 27 November 1931, WIA, GC 1931/1628 and 1630, and
Wind to Charles John Sackville-West, 9 November 1931, WIA, GC 1931/2593.

Figure 8.6: Postcard: *Reynolds Room, Knole*, Geo. P. King Ltd, c. 1939, 8.5 × 13.1 cm. Author's collection.

to it, thereby potentially reinforcing the opposition in Wind's mind.[27] Such installations might be best analogized to the controlling conditions under

27 The installation of rooms in these collections principally dedicated to the work of Reynolds and Gainsborough is documented in catalogues and photographs of the time. Wind would have had access to these catalogues, all of which are currently held in the Warburg Institute library. For the Knole collection, see Lionel Sackville West, *Knole House: Its State Rooms, Pictures and Antiquities* (Sevenoaks: J. Salmon, 1906), esp. 68–73, which documents the individual pictures then hung in the 'Reynolds Room' (Figure 8.6 in the present volume), including two works by Gainsborough. For the collection at Kenwood, see *The Iveagh Bequest: Ken Wood* (London: Pullman, c. 1928), esp. 18–21, which documents the pictures hung in the lobby and music room (Figure 8.7 in the present volume), principally works by Reynolds and Gainsborough. And for the collection of the National Gallery, see National Gallery (Great Britain), *An Abridged Catalogue of the Pictures in the National Gallery; with Short Biographical Notices of the Painters* (London: His Majesty's Stationery Office, 1912), esp. ii–iii, which details the general arrangement

Figure 8.7: Postcard: *Ken Wood. The Music Room*, c. 1928, 10.5 × 15.0 cm. Author's Collection.

which Wind's experimental research took place. The accumulation of historical data and primary information that such visits enabled, of course, was only part of Wind's work. He also had to synthesize and present the results to the public.

From records at the Warburg Archive and from a prominent letter by Panofsky to Cassirer about Wind's lecture, a fair amount about Wind's original presentation of 'Hume and the Heroic Portrait' in known. Eighty-three people are listed as having attended, and Panofsky described the event as 'a great success, with an unusually large audience, only a small percentage of whom were Aryan, and almost roaring applause'.[28] Such a comment

of the collection, and labels Gallery XXV as 'British School: Reynolds and Gainsborough'.

28 A visitor list of the signatures of those who attended the lecture is preserved in the Warburg Institute Archive. See WIA, I.9.18.9.12. For Panofsky's letter to Cassirer

reveals the self-consciousness that marked the Warburg circle at the time due to the rising tide of Nazism. Perhaps more importantly, we also know that Wind equivocated about the lecture's title, moving between several variations – for instance, 'Die Auffassung des Menschen in der englischen Moralphilosophie und Porträtkunst des 18. Jahrhunderts' and 'Die englische Humanitätesidee des 18. Jahrhunderts in ihrer Beziehung zum Stil des heroisierten Porträts'.[29] Such alternative titles might help explain why the posthumous English translation of the essay dons yet another name, one that does not refer to conceptions or ideas about man or humanity at all, but which was given by Wind before he died in 1971.[30] Nevertheless, what I feel the English translation of the essay has long suffered from is the possible perception that 'Hume and the Heroic Portrait' is a late or even derivative form of *Geistesgeschichte*. Since Wind's paper is trading on general period conceptions and is effectively arguing that general ideas or beliefs do or can become manifest in a given period, a *geistesgeschichtliche* reading of the essay is easy to make. Moreover, because of Hume's prominent reputation as a leading British empiricist, and the stereotype of empiricism being a kind of British or Anglophone mode of thought, it is all the easier to read Wind as arguing that the cultural purchase of Hume's idea of humanity rested on more popular or widespread period conceptions.

However, such a reading, though certainly possible, is also ironic, because in this very year Wind positioned himself as opposed to *Geistesgeschichte*, specifically criticizing it in the German edition of his 1931 *Introduction to the Bibliography on the Survival of the Classics*. There he wrote, in a section titled 'Kritik der Geistesgeschichte', which, quoting Warburg, sharply opposed the tendency to separate humanistic objects of

about the lecture, see Erwin Panofsky to Ernst Cassirer, 13 July 1931, in Erwin Panofsky, *Korrespondenz 1910 bis 1968: Eine kommentierte Auswahl in fünf Bänden*, ed. Dieter Wuttke, vol. 1: *Korrespondenz 1910–1936* (Wiesbaden: Harrassowitz, 2001), 388–90.

29 These alternative titles are preserved on documents in the Warburg Institute Archive relating to Wind's lecture. WIA I.11.4.1.1.

30 Jaynie Anderson, in her preface to the English translation, notes that the English title was approved by Wind. See Wind, *Hume and the Heroic Portrait*, ed. Anderson, v.

study from the natural sciences, and in which he complained of the 'life attitudes and conceptions' that stand at the centre of *Geistesgeschichte*,

> from whose change, which cannot be further explained, from which all historical destinies are supposed to derive, gain the meaning of an almost mystical metaphysical substance, to which all individual substance, to which all individual actions and individual achievements appear 'accidental'. However, this leads – with that consistency to the end which is more frequent with the followers than with the founders – methodologically to a way of looking at things, which basically renounces articulated individual analyses in the name of 'pure description' and 'empathetic understanding'.[31]

To this evident criticism, Wind rhetorically asked:

> Hasn't 'Geistesgeschichte' become almost a cover name for the fact, that everyone, immersed in his internal 'problem history', through side glances – analogies and parallels – finds his 'sense of the whole'? The whole, however, which lies beyond the parts, is methodologically a contradiction.[32]

In Wind's attention to the relation between parts and wholes in historical explanation, we see his conviction about the importance of concrete, individual analyses, and his conviction that the mystical wholes that so often lie at the centre of humanistic inquiry must be traceable in the

31 Edgar Wind, 'Einleitung', in Bibliothek Warburg, *Kulturwissenschaftliche Bibliographie zum Nachleben der Antike. Erste Band: Die Erscheinungen des Jahres 1931*, ed. Hans Meier, Richard Newald and Edgar Wind (Leipzig: Teubner, 1934), vii. The original German reads: 'Diese "Lebensstellungen und -auffassungen", aus deren nicht weiter zu erklärender Wandlung sich alle geschihctlichen Schicksale herleiten sollen, gewinnen die Bedeutung einer fast mystisch wirkenden metaphysischen Substanz, der gegenüber alle Einzelhandlungen und Einzelleistungen "akzidentell" erscheinen. Dies führt aber – mit jener Konsequenz zu Ende gedacht, die bei den Nachfolgern freilich häufiger ist als bei den Begründern – methodisch zu einer Betrachtungsweise, die im Namen der "reinen Deskription" und des "nachfühlenden Verstehens" auf artikulierte Einzelanalysen grundsätzlich verzichtet.'

32 Wind, 'Einleitung', viii. The original German reads: 'Aber ist "Geistesgeschichte" nicht fast ein Deckname dafür geworden, daß jeder, in seine interne " Problemgeschichte" versenkt, durch Seitenblicke – Analogien und Parallelen – seinen " Sinn für das Ganze" kundzutun sucht? Das Ganz aber, das jenseits der Teile liegt, ist methodisch ein Widersinn.'

cultural parts that compose them. There is no such thing, Wind effectively asserts, as a cultural whole independent of its parts. And so, to choose the example that Wind chose, if Hume's grand 'idea of humanity' really was the widely known, debated, and controversial idea that it supposedly was in eighteenth-century Britain, then there must be individual cultural parts that mark its historical purchase, its historical reality. This is also essential to explaining why in my interpretation here I have put so much effort into tracing Wind's trips to England, and why I believe it is important that Wind travelled to England three times in the span of one year. He was there to look for the historically real, manifest, or embodied parts of history that would bear witness to Hume's holistic conception and that he had effectively predicted in his habilitation.

Admiring as he clearly did Wind's pioneering effort, Panofsky was not completely convinced by it, writing to Cassirer two days later that Wind had to 'concede' [*einräumt*] that Gainsborough's paintings were still quite conventionally heroic, which suggests that Wind's association of Gainsborough with Hume's critique of artificial heroism didn't fully hold.[33] So began a long line of similar criticisms of Wind's essay, one that has continued to this day and that counts among its distinguished list Arthur Danto in the 1980s and Werner Busch more recently.[34] Such criticisms, however, fail to recognize the intervention on *Geistesgeschichte* that Wind was trying to make. As he would write in the published version of the essay, in a line that was, unfortunately, omitted from the English translation:

> The concept of the 'pure artist', who creates his figures for a perception that is free of all reference to the conceptual, and the concept of the 'pure thinker', who calculates his propositions on the basis of a power of judgment that is free of all reference to perception, prove to be ideal borderline constructions that find no exact counterpart

33 Panofsky to Cassirer, 13 July 1931, Panofsky, *Korrespondenz, 1910 bis 1968*, vol. 1, 388–90.
34 See Arthur Danto, review of 'Hume and the heroic portrait', *Times Literary Supplement* (17 October 1986), Werner Busch, 'Heroisierte Porträts? Edgar Wind und das englische Bildnis des 18. Jahrhunderts', in Horst Bredekamp, Bernhard Buschendorf, Freia Hartung and John Krois, eds, *Edgar Wind: Kunsthistoriker und Philosoph* (Berlin: Akademie, 1998), 33–48.

within historical experience, because here the differently tuned functions of consciousness are never completely detached from each other.[35]

It seems to me that these lines make clear that it didn't matter to Wind that Gainsborough was an openly anti-intellectual figure who surely didn't know, let alone study, any of Hume's texts. Wind's point is that even the absolute anti-intellectual has a form of thinking that can – indeed must – be describable in philosophical terms, a point that fittingly parallels a claim made by Wind's other great inspiration: 'Find a [...] man', Charles Sanders Peirce once wrote, 'who proposes to get along without any metaphysics [...] and you have found one whose doctrines are thoroughly vitiated by the crude and uncriticized metaphysics with which they are packed.'[36]

Wind's acceptance of such an argument, admittedly, begs many questions and leaves many unanswered. I do not pretend to answer them here. However, Wind did do his best, and that meant not merely sitting in his armchair like the philosopher that he was and trying to analytically resolve the ambiguities that his own argument had created. Wind's was not an armchair argument about the applicability of experimentation to humanistic research, however much art historians today might understandably dislike his lack of thick description or his lack of engagement with the

35 Wind, 'Humanitätsidee und heroisiertes Porträt in der englischen Kultur des 18t. Jahrhunderts', 159–60. The original German reads: 'der Begriff des "reinen Künstlers", der seine Gestalten für eine Anschauung schafft, die von allem Bezug auf Begriffliches frei ist, und der Begriff des "reinen Denkers", der seine Sätze auf eine Urteilskraft berechnet, die von allem Bezug auf Anschauung frei ist, als ideelle Grenzkonstruktionen, die innerhalb der historischen Erfahrung kein genaues Gegenstuck finden, weil sich hier die verschieden gestimmten Bewußtseinsfunktionen niemals vollständig voneinander lösen.' The only justification that I have found for why this important passage was not included in the English translation is a marginal note next to this passage in one of Margaret Wind's copies of the original German text: 'This passage has been omitted in the translation. Rather dated by now.' Bodleian, EWP, MS. Wind 129, folder 1.

36 Charles Sanders Peirce, *Collected Papers of Charles Sanders Peirce*, ed. Charles Hartshorne and Paul Weiss (Cambridge, MA: Harvard University Press, 1934), vol. 1, 129.

social hierarchies that portraiture often betrays. Quite to the contrary, and nevertheless, Wind's was an empirical argument and it rested on Wind's own concrete, *in situ* experimental experience of British art in Britain in 1931. That is why, I would further posit, 'Hume and the Heroic Portrait' brings together in its analysis so many different types of portraits – from portraits of children to soldiers to actors to ladies and gentlemen – and that is also why it is illustrated by so many images: fifty-five in a single essay. By showing how the evidently diverse material in the essay can be related to period debates about humanity, Wind was effectively following through on his convictions.[37]

What this also suggests, by way of conclusion, is that the empirical nature of Wind's argument was doubly fitting; for Wind had argued in his habilitation that there was no way to escape the circular relations of parts and wholes presupposed by inquiry, be those inquiries scientific or humanistic. For Wind, it was only possible to recognize those circles as circles and to explicitly try to test their coherence. But since Wind himself was a kind of empiricist and his own terminology was taken from the British tradition of empiricism – *experimentum crucis*, after

37 In an argument fundamentally indebted to the pragmatism of Charles Sanders Peirce, it comes as no surprise that Wind even quoted Peirce on this very point, both of them claiming 'to trust rather to the multitude and variety of [...] arguments than to the conclusiveness of any one. [...] reasoning should not form a chain which is no stronger than its weakest link, but a cable whose fibers may be ever so slender, provided they are sufficiently numerous and intimately connected.' Wind cites this passage in his exchange with Erica Tietze-Conrat about his book on Bellini. See Edgar Wind, 'Mantegna's Parnassus: A Reply to Some Recent Reflections', *The Art Bulletin* 31/3 (1949), 224–32. He then cites the same passage again in an early draft introduction to *Pagan Mysteries in the Renaissance*, which was posthumously published as an appendix to Edgar Wind, *The Religious Symbolism of Michelangelo: The Sistine Ceiling*, ed. Elizabeth Sears, with essays by John O'Malley and Elizabeth Sears (Oxford: Oxford University Press, 2000), 191–3. The original line comes from 'Some Consequences of Four Incapacities', in *The Collected Papers of Charles Sanders Peirce*, vol. 5, 157.

all, is Bacon's term and its most widely noted expression is Newton's
famous experiment dividing white into coloured light – the problem
that confronted Wind following his habilitation was not just to apply
his theory to the historical record but also to test the extent to which his
own empiricist metaphysics was indeed applicable to historical research
in the first place.[38] This makes 'Hume and the Heroic Portrait' neces-
sarily two-fold, being an experimental inquiry into the extent to which
a particular idea became embodied in a specific time and place, yes,
but also an experimental inquiry into the applicability of a pragmatic
metaphysics to history in general. Whether or not Wind was successful
in his argument, in his experiment, is of course fittingly open to inter-
pretation. Whatever the case, the twin registers in which it functions
reveal Wind's agreement with a Peircean proposition that undoubtedly
inspired him: 'It is unphilosophical to suppose that, with regard to any
given question (which has any clear meaning), investigation would not

38 What exactly Wind's pragmatist metaphysics was, of course, is an important
 matter; unfortunately I do not have the space to elaborate on it here. I would, how-
 ever, contend that Wind's metaphysics followed quite closely from the pragmatic
 maxim as articulated by Peirce, which famously asked its reader to 'consider what
 effects, which might conceivably have practical bearings, we conceive the object
 of our conception to have. Then, our conception of those effects is the whole of
 our conception of the object.' For Wind as for Peirce, such a statement is more
 a theory of concepts than, as it was for William James, a theory of truth. For the
 pragmatic maxim itself, see Charles Sanders Peirce, 'How to Make Our Ideas
 Clear' [1878], in Charles Sanders Peirce, *The Essential Peirce: Selected Philosophical
 Writings, Volume 1 (1867–1893)*, ed. Nathan Hauser and Christian Kloesel
 (Bloomington: Indiana University Press, 1992), 124–41. The most extensive inter-
 pretation of how the philosophical tradition of pragmatism has changed through
 history remains H. S. Thayer, *Meaning and Action: A Critical History of Pragmatism*
 (Indianapolis: Hackett, 1968); see also Max H. Fisch, 'American Pragmatism Before
 and After 1898', in Max H. Fisch, *Peirce, Semeiotic, and Pragmatism: Essays by Max
 H. Fisch*, ed. Kenneth L. Ketner and Christian J. W. Kloesel (Bloomington: Indiana
 University Press, 1986), 283–304. For prominent interpretations of how this trad-
 ition shaped Wind's thinking, see the work of John Michael Krois, Bernhard
 Buschendorf, Tullio Viola and Sascha Freyberg.

bring forth a solution of it, if it were carried far enough.'[39] The best kind of response to Edgar Wind's 'Hume and Heroic Portrait', therefore, might not even be to agree with it, but rather to merely carry its registers of inquiry – both the abstractly philosophical and the concretely art-historical – a little farther forward.

39 Wind quotes this very passage at the beginning of his habilitation. See Wind, *Experiment and Metaphysics*, 6. The original quotation comes from Peirce, 'How to Make Our Ideas Clear', in *The Essential Peirce*, 124–41.

IANICK TAKAES DE OLIVEIRA

9 'That Magnificent Sense of Disproportion with the Absolute': On Edgar Wind's Critique of (Humourless) Modern Art

The idiom 'sweetness and light' is at once droll and dead serious.[1] Coined by Jonathan Swift in the short satire 'The Battle of the Books' (1704), it is spoken by a shape-shifting Aesop as a war cry to rally the Ancients against the Moderns. According to the Greek fabulist, the Ancients were like bees; and like bees they provide humankind with aesthetic delight and intellectual illumination – or, as the metaphor puts it with more than a hint of flippancy, 'honey and wax'.[2] But the

1 For providing either feedback or observations crucial to the development of my thoughts in this essay, I thank Elizabeth Sears, Adrian Rifkin, Michael Cole, David Freedberg, Jaś Elsner, Caroline Elam, Maurizio Ghelardi, Michele Dantini, Oliver O'Donnell, Ben Thomas and Claudia Dellacasa.

2 'As for us, the Ancients, we are content with the bee, to pretend to nothing of our own beyond our wings and our voice: that is to say, our flights and our language. For the rest, whatever we have got has been by infinite labour and search, and ranging through every corner of nature; the difference is, that, instead of dirt and poison, we have rather chosen to till our hives with honey and wax; thus furnishing mankind with the two noblest of things, which are sweetness and light.' Jonathan Swift, 'The Battle of the Books', in *The Works of the Rev. Jonathan Swift*, vol. 2 (London: Nichols, 1801), 226. The idiom and the simile derive from Horace's statement in *Ars poetica* that literature should be 'sweet and instructive' [*dulce et utile*]. Horace, in turn, is reflecting on Lucretius' celebrated 'honeyed cup' simile in *De rerum natura*; the Roman writer, however, equates aesthetic delight with philosophical instruction, while the Greek philosopher is fundamentally concerned with sugar-coating Epicureanism for a wider readership. Swift, quite aware that his educated contemporaries knew *De rerum natura* well, often satirized Lucretius in his texts, especially by way of saccharine similes such as 'honey and wax'. See Charles

idiom only became truly popular more than a century and a half later, when the Victorian pedagogue and sage writer Matthew Arnold used it to advance a militant view of high culture. In his seminal *Culture and Anarchy* (1869), Arnold propounded that the growing masses of the late nineteenth century should be inculcated with the best of human knowledge and artistic output. This was the way, or so he judged, to ease the growing class conflicts that began in the late eighteenth century and thus dispel the spectre of social anarchy, so that 'all [may] live in an atmosphere of *sweetness and light*'.[3] After another time leap, now of almost ninety years, we find the German art historian Edgar Wind in a radio recording booth addressing a much larger audience in his 1960 BBC Reith Lectures – his own take on the quarrel between the Ancients and the Moderns. While the announced title of *Art and Anarchy* might have evoked in the British public some sense of kinship with Arnold's work, impressions of the sort were soon dispelled by Wind's opening remarks: 'I hope that the word "anarchy" in the title of these lectures will not suggest that I shall speak in defence of order. I shall not. A certain amount of turmoil and confusion is likely to call forth creative energies.'[4] Clearly, 'anarchy' to the art historian meant something different from what it meant to the pedagogue.[5]

Scruggs, 'Swift's Use of Lucretius in *A Tale of a Tub*', *Texas Studies in Literature and Language* 15/1 (1973), 39–49.

3 Matthew Arnold, *Culture and Anarchy* [1869] (Oxford: Oxford University Press, 2006), 53 (my italics).

4 Edgar Wind, 'Reith Lectures 1960: Art and Anarchy. Lecture 1: Art and Anarchy: Our Present Discontents', BBC Radio 4, <http://downloads.bbc.co.uk/rmhttp/radio4/transcripts/1960_reith1.pdf>, accessed 5 November 2022.

5 I thank Caroline Elam for the suggestion that in his choice of title Wind was probably spoofing Arnold's book. I first advanced and substantiated this hypothesis in ' "A Tract for the Times": Edgar Wind's 1960 Reith Lectures', *Journal of Art Historiography* 21 (2019), 4–7, 19. Ben Thomas is also of the opinion that Wind's *Art and Anarchy* alludes to Arnold's *Culture and Anarchy*. See Ben Thomas, *Edgar Wind and Modern Art: In Defence of Marginal Anarchy* (London: Bloomsbury, 2020), 178.

But Wind might as well have been at odds with the haughty use of 'sweetness and light'. For Arnold accepted the idiom's dead-seriousness – 'culture is,' he pontificates, 'the study and pursuit of perfection' – but not its droll obverse; he either failed or refused to integrate into his discourse Swift's satirical overtones and rather ambivalent approach to culture wars.[6] Whereas the Victorian descants with a preacher's fervour, Wind's tone in *Art and Anarchy* is much more lighthearted. Not that he considered the subject of his lectures to be whimsical or lightweight. Far from it. Outwardly focused on the manifold trends leading to post-Romantic art's wide dissemination and diminishing returns (or so the thesis goes), inwardly the lectures are a far-ranging survey of the frictionless interaction between social structures and artistic experiences in the post-war West. Deeper still, they are an exploration of the artificiality of forms, be they artistic or political, and their an-archical cesspools. The lectures stemmed from Wind's own bittersweet life experiences as a diasporic Jewish intellectual, interpreted in his later years with some irrepressibly ironical resistance to gloom.[7] According to Colin Hardie, one of his Oxford friends, Wind had greatly enjoyed giving his Reith Lectures, 'in which he could recast the philosophy of his youth in the light of experience'.[8] Published as a book in 1963, *Art and Anarchy* now stands as a kind of high-spirited yet mordant intellectual testament.[9]

6 Arnold, *Culture and Anarchy*, 53.

7 Wind's sense of humour is probably a generational trait shared with other Jewish diasporic intellectuals from Germany. Commenting on her 'irrepressible irony' [*burschikose Ironie*], Hannah Arendt observes that it was her 'most precious inheritance from Germany – or more precisely, from Berlin'. Quoted in Marie Luise Knott, *Unlearning with Hannah Arendt* (New York: Other Press, 2013), 8. Wind was born in Berlin in 1900; Arendt, who was born in 1906, spent part of her youth in the city.

8 Colin Hardie, 'Edgar Wind – A Personal Impression', in Bodleian Libraries, University of Oxford, Edgar Wind Papers (hereafter Bodleian, EWP), MS. Wind 21, folder 3.

9 Edgar Wind, *Art and Anarchy* (New York: Knopf, 1963). A third – and, thus far, last – edition was published in 1985 by Northwestern University Press with an added introduction. I will henceforth refer to the latter.

Fortunately, almost three centuries after Swift – and in the wake of Wind's Reith Lectures by about twenty-five years – another great satirist took on the matter of lightness. Or, given that the author is Italian, *leggerezza*. In the opening essay of his *Lezioni americane* (published posthumously in 1988), Italo Calvino concentrates on the seemingly paradoxical distinction between a lightness of frivolity and a lightness of thoughtfulness: the first, the frivolous, Calvino judges ultimately to be heavy and opaque, while the thoughtful kind, by being grounded, is able to take flight and soar above the sound and fury of the world.[10] After some ruminations on Guido Cavalcanti and Dante, Cervantes and Shakespeare, the author drives his point further by mentioning the peculiar connection between melancholy and humour, or, as he puts it, 'sadness that has taken on lightness'.[11] This is a point of inflection of special interest to art historians. Not only because Calvino here refers to the Warburgian tradition by way of Saturn and Melancholy, but also because he advances a line of methodological resonance. 'Humour,' states the writer, 'casts doubt on the self, on the world, and on the whole network of relationships that are at stake.'[12] Wind might have been of the same mind – this is the contention that this essay will sustain, especially with regard to his critique of modern art.

Edgar Wind as public performer

It is perhaps fruitless to try to pin down Wind's personality – and, most likely, counterproductive. But given that the notion of sense of humour

10 Italo Calvino, *Lezioni americane: Sei proposte per il prossimo millenio* (Milan: Mondadori, 2016), 7–14. Engl. trans: Italo Calvino, *Six Memos for the Next Millennium*, trans. Patrick Creagh (Cambridge, MA: Harvard University Press, 1988), 3–10. It is worth noting that both Lucretius and Swift figure heavily in Calvino's essay on lightness.

11 '[L]a melanconia è la tristezza diventata leggera'. Calvino, *Lezioni americane*, 23 (Engl. trans., *Six Memos*, 19).

12 '[L]o *humour* […] mette in dubbio l'io e il mondo e tutta la rete di relazioni che li costituiscono.' Calvino, *Lezioni americane*, 23 (Engl. trans., *Six Memos*, 19).

is so connected to that of social performance, it is tempting to attempt a general sketch of his contemporaries' perceptions of him. A scholar of formidable training and great ease with the spoken word, Wind possessed an on-stage persona that has often been described as that of a magician, a rock star, an Olympian and even a kind of prophet.[13] His colleague Rudolf Wittkower purportedly once said that Wind was 'the one true genius' of his acquaintance.[14] One ought to take these superlatives with a grain of salt, though. In an interview for the Getty Institute, Margot Wittkower disputed that her husband had ever characterized Wind as a 'genius', countering that he must have said that of Warburg. Margot's remin-iscences are also noteworthy for her merciless description of Wind's more difficult side. 'I don't know any person who knew Wind well,' she said, 'who didn't have a break in their relationship with him.'[15] Indeed, Wind could be vicious with his colleagues whenever he felt offended by

13 According to William Heckscher, 'Edgar Wind was a magician with words; he had spent a long period in America where he earned much-needed money by hand-colouring black and white films; he also taught at a Manhattan high school – "the best way to learn to overcome stage-fright"'. William Heckscher, 'Ist Das Alles?', *Art Bulletin of Victoria* 28 (1987), 9. On the 'rock star' and 'prophet' appellations, see James McConica's reminiscences of Wind's lectures in Oxford: 'Edgar Wind Oxforder Jahre', in Horst Bredekamp, Bernhard Buschendorf, Freia Hartung and John Krois, eds, *Edgar Wind: Kunsthistoriker und Philosoph* (Berlin: Akademie, 1998), 3–12. Regarding 'Olympian', Dolly Frisch stated in a letter to Margaret Wind on 5 July 1984: 'You might be amused by an encounter I had in the 60's with an Oxford student. I asked him if he knew Dr. Wind. The answer came back that of course he knew Dr. Wind, that Dr. Wind dwelt on Olympus. Because I looked puzzled he explained that any Oxford professor who can fill an auditorium at 8 a.m. dwells among the gods.' Bodleian, EWP, MS. Wind 9, folder 3.

14 The quotation attributed to Wittkower is mentioned by Creighton Gilbert in 'Edgar Wind as Man and Thinker', *New Criterion* 3/2 (October 1984), 36–41. The article was later reprinted in H. Kramer, ed., *The New Criterion Reader: The First Five Years: Events and Controversies of the 1980s in Art, Architecture, Music, Literature* (New York: Free Press, 1988), 238–43.

15 Margot Wittkower, *Partnership and Discovery: Margot and Rudolf Wittkower*, interviewed by Teresa Barnett (Los Angeles: Getty Research Institute, 1994), 210–11.

them – his notorious rupture with the Warburg Institute in 1945 has been partially attributed to his harsh words, irascible nature and unforgiving attitude.[16]

Some of Wind's contemporaries went further than Margot Wittkower, portraying him as a kind of monster. Hugh Trevor-Roper, in one of his gossip-dripping letters to Bernard Berenson, described the German art historian as a hideous, lecherous fiend who seduced his gullible female audience with lascivious gestures, fraudulent arguments and a set of slides.[17] Not a far cry from an earlier letter, in which the British historian moderates his anti-Semitic and misogynistic innuendos but nonetheless characterizes Wind as 'that splendid character, that Protean figure, compounded as he is of the Ancient Mariner, the Welsh Wizard, King Arthur, St Athanasius *contra mundum*, and the Foul Fiend Flibbertigibbet', a kind of con man who drew 'his various arts alternately from Winchester College, Tammany Hall, and those ancient rocks on which the sirens sang.'[18] Oddly enough, Trevor-Roper's phantasmagoric description of Wind contains in a nutshell the gist of the art historian's critical reception in the decades following his death: a certain consensus had crystallized by then, according to which Wind had been a 'brilliant' but not particularly 'sound' scholar, one more suited to entice and excite than to instruct and inform.[19]

16 On Wind's rupture with the Warburg Institute in 1945, see Ianick Takaes de Oliveira, ' "L'esprit de Warburg lui-même sera en paix": A Survey of Edgar Wind's Quarrel with the Warburg Institute', *La rivista di engramma* 153 (February 2018), 109–82. See also Franz Engel, 'Though This Be Madness: Edgar Wind and the Warburg Tradition', in Sabine Marienberg and Jürgen Trabant, eds, *Bildakt at the Warburg Institute* (Berlin: De Gruyter, 2014), 87–116; Monica Centanni, 'The Rift between Edgar Wind and the Warburg Institute, Seen through the Correspondence between Edgar Wind and Gertrud Bing; A Decisive Chapter in the (mis)Fortune of Warburgian Studies', *The Edgar Wind Journal* 2 (2022), 75–106.

17 Hugh Trevor-Roper, *Letters from Oxford: Hugh Trevor-Roper to Bernard Berenson*, ed. Richard Davenport-Hines (London: Weidenfeld & Nicolson, 2015), 218.

18 Trevor-Roper, *Letters from Oxford*, 192.

19 It was Kenneth Clark who described Wind as a 'brilliant' but not 'sound' scholar. See James Stourton, *Kenneth Clark: Life, Art and Civilisation* (New York: Knopf Doubleday, 2016), 265. In his 1985 review of *The Eloquence of Symbols*, the cultural

Of Wind's portraitists, Isaiah Berlin has usually been the most insightful. Regarding the imputations of scholarly fraud, Berlin stated that although Wind built his arguments not wholly supported by conclusive evidence, they were 'beyond refutation by mere facts'. According to Berlin, this annoyed those all-too-solemn scholars 'who felt uncomfortable and even shocked to be transported into such rich realms outside their sober disciplines (to put it mildly).' As for the image of an irascible and Old Testament Wind, of his perceived *terribilità*, Berlin noted that this was not the case: his friend had been too 'feline' and had had 'something of the velvet glove' about him.[20] His occasional defences of Wind's reputation notwithstanding, Berlin did not shy away from a back-handed compliment to his colleague. When describing the success of Wind's lectures in the 1950s, Berlin defined them as 'Cagliostro-like' – he was an inspired talker, yes, but one who knew how to conjure a glamorous show.[21]

Again, Berlin is not far off the mark. From 1961 until his retirement in 1967, Wind regularly lectured at the Oxford Playhouse theatre, packed with more than eight hundred spectators. With some modesty, he ascribed this unprecedented phenomenon to a widespread surge of interest in the visual arts in England, and not to his talents as a public intellectual and stage performer.[22] Wind thus obfuscated his own rhetorical devices, the

historian Ivan Gaskell observes that '[Wind's] work has never been without critics who have accused him of employing his formidable erudition in attempts to establish correspondences between visual and philosophical or literary material with insufficient evidence and scant regard for historical contingencies.' Ivan Gaskell, review of *Eloquence of Symbols: Studies in Humanist Art*, by Edgar Wind, ed. Jaynie Anderson, *British Journal of Aesthetics* 25 (1985), 79. Perhaps the most sceptical comment on Wind's scholarship comes from Charles Hope, who stated in 1984 that '[Wind] opened up a new world, and no one was to know that it was largely fantasy.' Charles Hope, 'Naming the Graces', *London Review of Books* (15 March 1984), 13.

20 Isaiah Berlin to Colin Hardie, 5 April 1973, Bodleian Libraries, University of Oxford, MS Berlin 202, fol. 16.

21 Isaiah Berlin, *Enlightening: Letters 1946–1960*, ed. Henry Hardy and Jennifer Holmes (London: Chatto & Windus, 2009), 600.

22 In 1958, Wind observed in a letter that students at Oxford were eager for some kind of visual education: 'I am not affecting a false kind of modesty in saying that the

degree to which he modulated his speech, gestures and surrounding atmosphere to deliver a calculated message.[23] From the collected memories of his spectators, here is a composite picture of one of his lectures: arriving five minutes late in order to generate tension in the room, Wind enters the stage from the right corner and deposits his clock on the lectern. The only elements visible in the dark auditorium are himself, the chiaroscuro glow of the projected images, and the light of his torch, which falls on the significant detail of each work. 'In this corner of the picture,' says he to preface an in-depth analysis of a pictorial detail. The black-and-white pictures succeed each other seamlessly, due to a hidden button in the lectern, so that the movements of his hand will not attract attention. Having apparently memorized the content to be spoken, he lectures for exactly fifty-five minutes,

cause for this is not in myself but in the fact that the students are starved for visual instruction.' Edgar Wind to M. W. Lowry, 17 July 1958, Bodleian, EWP, MS. Wind 13, folder 1. One year later, he commented that this surge in interest occurred at a national level: 'The problem is not peculiar to Oxford. The same phenomenon is occurring all over England: lectures on the history of art are crowded, because (for good or for ill) the subject has become of predominant interest. In Oxford the large attendances at the eight annual Slade lectures, no matter which Slade professor has lectured (there have been four diverse professors since 1956), show that we are faced with an interest in the visual arts which has deeper causes, and which will be more permanent, than the personal influence of any individual lecturer.' Edgar Wind to C. H. Paterson, 14 November 1959, Bodleian, EWP, MS. Wind 13, folder 5.

23 Reminiscing about Wind, Stuart Hampshire commented that 'a characteristic anecdote about Edgar and our joint seminars [...] is the occasion where Edgar insisted that I should enter the seminar room (with him) rather late to read my paper, so as to raise the tension in the room, and when he at the same time instructed me on how I should sit so as best to dominate the audience: a histrionic technique that amazed me.' Stuart Hampshire to Colin Hardie, 20 January 1972, Bodleian, EWP, MS. Wind 21, folder 3. On Wind's performativity as a lecturer, see also Michael Bawtree, *As Far as I Remember: Coming of Age in Post-war England* (Cirencester, UK: Mereo, 2015), 308; Isaiah Berlin, *Building: Letters 1960–1975*, ed. Henry Hardy and Mark Pottle (London: Random House, 2013), 21; McConica, 'Edgar Wind', 7–8; John Pope-Hennessy, *Learning to Look* (New York: Doubleday, 1991), 126; T. J. Reed, 'Among Languages', *Oxford Magazine* 74 (1991), 1.

without notes, on a labyrinthine range of subjects.[24] The intonation of his erudite English tinted with a thick German accent is perhaps contrived to enhance this uncanny atmosphere.[25] The final phrase, the last word, is calculated as an overturn – not a closure, but an opening. By the end, the mesmerized audience breaks into a massive ovation. Cagliostro-like indeed.

It is possible that Wind's showmanship had a purpose other than simply carving out a dazzling name for himself in the stuffy Oxford environment. According to the Reverend James McConica, one of Wind's students at the time, the art historian's lectures at their apex seemed to disclose to his audience 'an intellectual Promised Land'.[26] The haughty Biblical reference notwithstanding, what the recollection speaks to is a fundamental aspect of Wind's pedagogical and hermeneutical approach. On the one hand, he presented to his students only primary documentary and visual sources, which, despite being beyond their level of understanding, were collated in a way that evoked a sense of the whole from which they emerged; the problem here, as he puts it, 'is how to make the beginner grasp the universal through the particular; and this is a vivid study which sometimes lies at

24 In a note, Colin Hardie observes: 'It was widely believed that in his famous lectures in the Playhouse here [Wind] had written out every word of his text and memorised it. This was not so: he had deeply pondered his matter and manner, in absolute quietude during the whole day before [...] [Wind] arrived at the lectern without a single note to be spontaneous and unhampered (like a Homeric oral-extemporising bard – and Homer certainly prepared and premeditated his recitations, though not word by word).' Colin Hardie, 'Some personal impressions', n.d., Bodleian, EWP, MS. Wind 21, folder 3. Wind had been famous for delivering his lectures without notes since his years as a young professor in Hamburg in the 1930s. See William Heckscher, *Gratia Dei sum qui sum: William Heckscher*, interviewed by Richard C. Smith (Los Angeles: Getty Research Institute, 1995), 76. See also Albi Rosenthal to Margaret Wind, 15 May 1990, Bodleian, EWP, MS. Wind 25, folder 6.

25 A German accent in post-war UK had double-edged consequences. While it could suggest central European gravitas, it could also grate on an audience for its 'exoticism'. After Wind's Reith Lectures, one of his critics complained that 'if your listening ear is English you have a right to ask that you should be able to hear what the speaker says, not to have someone who is – whose accent is so – exotic that you can't really follow it.' Freda Bruce Lockhart in 'The Critics', draft transcript of debate, BBC, 11 December 1960 (Bodleian, EWP, MS. Wind 95, folder 3).

26 McConica, 'Edgar Wind', 8.

the very frontiers of knowledge.'[27] On the other hand, it was a matter of
squaring a panoramic image of the past, an aggregate of dimly lit historical facts, with present-day interpretations, born partly out of the scholarly
apparatus, partly of the anarchic ferments of lived experience. Despite his
reputation for arcane erudition, Wind emphasized the latter as much as the
former. Stating that a 'pure mind' cannot 'study history', he added that to do
so, 'one must be historically affected; caught by the mass of past experience
that intrudes into the present in the shape of "tradition": demanding, compelling, often only narrating, reporting, pointing to other past experience
which has not as yet been unfolded.'[28] If we are to take McConica at his
word, Wind's on-stage performances were calculated to 'overwhelm the
listener and excite both imagination and intellectual curiosity.'[29] These lofty
intentions, however, did not prevent him from having fun in upending the
expectations of his audience.

A perceptive newspaper article of the time, reviewing Wind's Oxford
lectures, hinted at his relish in rhetorical subterfuges: 'Well aware of the
effect of his intelligence, he is not averse to back stairs manoeuvring, and his
beaky face wreathes with smiles at the prospect of a coup.'[30] We find traces
of such sly oratorical awareness right in the opening salvo of the 1960 Reith
Lectures. Wind not only spoofed Matthew Arnold, but also played with
the expectation of an audience used to the centuries-old negative connotations of the word 'anarchy' – Hobbes associated it with crude savagery and
Milton with primordial chaos; Shelley evoked by it apocalyptical horsemen;
and, aghast at the war and plague that had ravaged Europe, Yeats wrote
in 1919 that 'Things fall apart; the centre cannot hold; / Mere anarchy is
loosed upon the world'.[31] Aware of these negative implications, Wind set

27 Edgar Wind, 'Humanities 292a – Experimental', *Smith Alumnae Quarterly* 44/3
 (1953), 136.
28 Edgar Wind, 'Some Points of Contact between History and Natural Science', in
 Raymond Klibansky and Herbert James Paton, eds, *Philosophy and History: Essays
 Presented to Ernst Cassirer* (Oxford: Oxford University Press, 1936), 258–9.
29 McConica, 'Edgar Wind', 8.
30 'Maestro from the Playhouse', *Time and Tide*, 19 November 1960, n.p.
31 W. B. Yeats, 'The Second Coming'. I have dealt with the philological development of 'anarchy' in the UK from the mid-sixteenth century to the late twentieth

up his ironical trap, a kind of rhetorical parlour trick. Anarchic forces, he seems to say, are not as bad as the listener might think; in fact, they are probably the necessary ingredient for that icing on the civilizational cake that is great art (to misuse a Baudelairian metaphor).[32]

Unfortunately, the BBC lost its sound recordings of several of the earlier Reith Lectures, including Wind's first lecture.[33] There is no way then to ascertain whether Wind's opening remarks sounded ponderous and sermonizing or light and mordant; judging from his intonation in the extant fourth and fifth lectures, he probably delivered it with a tone of charming irony.[34] This impression is confirmed by the Jesuit Father Vincent Turner, who, in a eulogy emphasizing Wind's mischievousness, observed that 'hilarity and gaiety (never far from the surface in *Art and Anarchy*) marked the mood in which he usually greeted the world.'[35]

century in Ianick Takaes, 'The Demented, the Demonic, and the Drunkard: Edgar Wind's Anarchic Art Theory', *La Rivista di Engramma* 176 (October 2020), 43–98, esp. 55–6.

32 Charles Baudelaire, 'Le peintre de la vie moderne', in *Œuvres complètes de Charles Baudelaire*, vol. 3 (Paris: Calmann Lévy, 1885), 55.

33 'BBC Radio 4 unveils 60 years of Reith Lectures archive', BBC News – Entertainment & Art, 26 June 2011, <https://www.bbc.com/news/entertainment-arts-13891740>, accessed 5 November 2022.

34 The extant lectures are available in 'Edgar Wind – Art and Anarchy', BBC Reith Lectures, <https://www.bbc.co.uk/programmes/p00h9lbs>, accessed 5 November 2022.

35 Vincent Turner, 'Edgar Wind – Some Personal Impressions' [typewritten eulogy], 2 April 1973, Bodleian, EWP, MS. Wind 21, file 3. On Wind's rather playful approach to lecturing (and to academia in general), Turner observes that 'for Edgar Wind academic discipline, however rigorous, was not a dry business to shrivel up pleasure in the subject matter, so that he found himself compelled to lecture in the Oxford Playhouse […] The particular occasion was a series of lectures on 20th century painters. The more solemn among art critics reports of them gave some offence. It was whispered that the Professor had been lacking in a proper respect, even to Picasso. But irreverence and an endless amusement at the antics of solemnity were distinctive qualities of this so powerful mind. That names or reputations were well established meant nothing at all to him.'

Wind would have probably agreed with Turner. In a letter to the first translator of *Art and Anarchy* into German, Wind refuses a proposal to replace 'Anarchie' with 'Chaos', arguing that the 'sinister Nietzschean tone' evoked by the latter term 'is so far removed from the book'.[36] He wanted to distance his good-humoured discourse from the operatic resonances of *Thus Spake Zarathustra*, a level of intended meaning that a contemporary reader must strive to recover.[37] This historical loss of paralinguistic granularity is presumed in *Art and Anarchy*. Following its publication, Wind – perhaps in a nod to an impish poem by his friend W. H. Auden – sometimes humbly described the book as a 'tract for the times': something written in response to contemporary events and highly dependent on lived context for subtle shades of meaning.[38] But a 'tract for the times' is also an exacting instrument, meant to redress a current course of action and provide an antidote to social afflictions. The excesses and deficiencies of modern art had to be

36 ' "Anarchie" durch "Chaos" zu ersetzen scheint mir nicht möglich, da dieser finstere Nietzsche'sche Ton dem Buch ganz fernliegt [...] Schliesslich sind beide Worte griechischer Abkunft, beide kommen im Englischen wie im Deutschen vor, und in keiner dieser drei Sprachen sind sie vertauschbar. Für einen Zusammenhang von Kunst und Anarchie kann ich mich [...] auf Plato, Goethe und Burckhardt berufen. Für "Kunst und Chaos" wäre das undenkbar. Auch Baudelaire's *passion frénétique* [...] ist anarchisch, nicht chaotisch: ihre zerstörende Kraft beruht gerade auf ihrer Zielsicherheit. Nebenbei bemerkt: Selbst die politischen "Anarchisten" waren keineswegs bestrebt, das "Chaos" herbeizuführen.' Edgar Wind to Hansjörg Graf, 24 July 1953, Bodleian, EWP, MS. Wind 101, folder 1.

37 See Takaes, 'The Demented, the Demonic, and the Drunkard', 68–9.

38 Auden wrote in 1946 'Under Which Lyre: A Reactionary Tract for the Times'. See W. H. Auden, *Selected Poems* (New York: Vintage, 2007), 178–83. For Wind's relationship with Auden, see Christa Buschendorf, 'Kunst als Kritik: Edgar Wind und das Symposium Art and Morals', in Bredekamp et al., eds, *Edgar Wind: Kunsthistoriker und Philosoph*, 117–33. Wind describes *Art and Anarchy* as a 'tract for the times' in a letter dated 25 February 1964 to Jean-François Revel, at the time an editor at Faber & Faber: '[*Art and Anarchy*] is clearly not a historical book but a tract for the times. Its problems, if there are any, are therefore quite different from those of the two other books [*Pagan Mysteries in the Renaissance* and *Bellini's Feast of the Gods*].' Bodleian, EWP, MS. Wind 105, folder 1.

put on the pillory and chastised by mockery.[39] Wind's light touch had a sharp edge to it.[40]

Art and Anarchy

For all its merits, *Art and Anarchy* is not a succinct expression of Wind's critique of modern art. He best summarized it at Masterpieces of the Twentieth Century, a conference held in 1952 in Paris, then the epicentre of the cultural Cold War.[41] Financed by the Congress for Cultural Freedom, its purpose was to hype Western liberalism as embodied by avant-garde artworks.[42] In his talk, entitled 'Un art de caprice, de recherches, un art marginal', Wind mocked the pretentiousness of turning contemporary artistic endeavours into a serious geopolitical tool.[43] His seemingly paradoxical thesis was that modern art is essentially an art of caprice – that is, of wondrous invention, refined irony and enticing playfulness; yet its advocates suppressed this lightness under a sophistic veneer of pedantry

39 On Wind's reference to the 'pillory' metaphor in relation to the chastising purpose of mockery, see his 'The Crucifixion of Haman', *Journal of the Warburg Institute* 1/3 (January 1938), 245 n. 2. See also Thomas, *Wind and Modern Art*, 65. According to Arendt, Brecht made a similar remark: 'The great political criminals must be exposed, and exposed especially to laughter [...] One may say that tragedy deals with the sufferings of mankind in a less serious way than comedy.'

40 On Wind's lightness of touch, a former attendee to his lectures observed: 'His speaking style was so very stylish – not that his writing isn't extraordinary – but his lectures contained a special spark, a very special light touch.' Dolly Frisch to Margaret Wind, 5 July 1984, Bodleian, EWP, MS. Wind 9, folder 3.

41 On the 1952 Paris conference and the secret backing of the CIA, see Frances S. Saunders, *The Cultural Cold War: The CIA and the World of Arts and Letters* (New York: New Press, 1999), 98–107.

42 On Wind's presence at the 1952 Paris conference (as well as his ambivalent involvement with the Congress for Cultural Freedom), see Ben Thomas, 'Freedom and Exile: Edgar Wind and the Congress for Cultural Freedom', *The Edgar Wind Journal* 1 (2021), 67–85. See also Thomas, *Edgar Wind and Modern Art*, 126–9.

43 Wind's talk was published as 'Un art de caprice, de recherches, un art marginal', *Problèmes de l'art contemporain: Supplément de la revue 'Preuves'* 29 (1953), 16–17.

while its practitioners aimed for a new grand manner by aping the scientific method. Wind lamented that instead of profiting from the greater clarity provided by their newly acquired marginality, most modern artists were engaged in playful activities parading as solemn endeavours. Hence the pretentious monumentality of the abstract expressionists, the association of Cubism with Platonic mathematics, or the allusions to quantum mechanics by the serialists.[44] Wind reserved a final mockery for the debate following the formal round of talks: the notion that a liberated avant-garde stands as an index of socio-political developments is mistaken, he ripostes, for art has an enormous power that should not be so freely wielded – and at least the communist Russians take it seriously when they censor Viennese waltzes out of fear that the bourgeois spirit might be reborn.[45]

A year later, in 1953, Wind expressed similar opinions in a droll interview published by the *New York Times* as 'Religion and Art in our Time'.[46] Here he states that, except for the all-too-subjective paintings by the likes of Rouault, the door has closed on great religious art. In an argument later recycled in *Art and Anarchy*, Wind notes how contemporary spectators behave according to an old Hegelian prophecy – while many great paintings of religious subjects have been produced from the nineteenth century onward, they do not compel the viewers to their knees anymore; they do not

44 Wind advances these critiques of abstract expressionism, Cubism and serialism in *Art and Anarchy*, 53, 84–5, 123. Since I take his talk in 1952 to contain *in nuce* the more comprehensive criticisms of his 1960 radio conferences, I have interpolated the latter's observations in the former.

45 'Les Russes ont peur de la peinture et de la musique, et ils ont raison. Si l'on jouait, par exemple, trop de valses viennoises en Russie, l'esprit bourgeois pourrait renaître. L'art a un pouvoir énorme, et les gens qui on peur de l'art montrent qu'ils comprennent ce pouvoir mieux que ceux qui se croient tout à fait en sécurité.' A transcript of Wind's debate intervention can be found in Bodleian, EWP, MS. Wind 10, folder 3.

46 Aline Louchheim, 'Religion and Art in Our Time: Noted Scholar Discusses Relation of the Two in Life Today', *New York Times* (5 April 1953), 12.

exude a whiff of spiritual perfume.[47] In this interview, Wind beats about the burning bush of one of his central themes: art as a poison-remedy. Artists, he argues, can potentially determine behaviour by shaping the reception of sensations. There is a double edge to the artistic experience then, and one cannot experience its beneficial results – say, the purge of emotions – without being susceptible to its poisonous effects – that is, to the disruptive and capricious forces of artistic imagination.[48] But this pharmacological loss is not the sole reason, Wind adduces, for the poor showing of modern religious art: it has no sense of humour, pure and simple. Most modern artists, he continues, have 'lost that magnificent sense of disproportion with the absolute' that was purportedly pervasive in pre-modern Christian art. Citing widely, from the ridiculing portrayals in the Renaissance of Saint Joseph to the drolleries in medieval religious art, Wind's point is that there used to exist a kind of intermarriage between good-natured humour and mysticism. A lightness of thoughtfulness then, and not merely frivolity. In that vein, one other congenial example advanced in the interview is that of Michelangelo's *Drunkenness of Noah* (1509) (Figure 9.1). A humorous work, argues Wind, but one that is nonetheless 'still strong with mystical connotations', for Noah's intoxication with wine prefigures that of Christ with his Passion, and the Patriarch's derision by his son Ham prefigures that of the Messiah by his accusers.

Both themes, Wind points out in his studies on the ceiling of the Sistine Chapel, had been treated with light and piety by Pietro Aretino,

47 In his Reith Lectures, Wind expands his argument concerning the powerlessness of modern religious art to include post-Romantic art in general; see Wind, *Art and Anarchy*, 10.

48 Wind expressed his concerns about the double-edged nature of artistic experiences in several articles and talks throughout his career, but perhaps never as succinctly as in 'The Critical Nature of a Work of Art'. He states: 'And so we are back at the old battle of the Muses and the Sirens, and may have to decide which of the two parties we are to serve: the Muses who are so difficult to court, or the Sirens who make us so easily their prey. Certainly, to enter this battle is to become exposed to both; and possibly we must know the Siren before we can recognise the Muse.' In Richard Frederick French, ed., *Music and Criticism: A Symposium* (Cambridge, MA: Harvard University Press, 1948), 65.

Figure 9.1: Michelangelo Buonarroti, *The Drunkenness of Noah* (with *ignudi* and medallions), 1509, fresco. Sistine Chapel, Vatican Museums, Rome. Image in the public domain.

whom he defines as 'that splendid combination of jester and prophet' – and perhaps this portrayal of the Tuscan satirist should be taken as a *figura* for Wind's interpretation of Michelangelo's drunken Noah.[49] At this point, it is worth reviewing his thesis regarding the Sistine Chapel ceiling. These frescoes, Wind argues, were not meant to simply instruct or delight; in fact, they were conceived as meditative apparatuses. As such, they ought not to reveal their arcana without some measure of deferral or obfuscation, some semiotic hurdle. For it is only through the observer's hermeneutical exertions that the anagogical light will shine forth. Wind sustained that

49 Edgar Wind, *The Religious Symbolism of Michelangelo: The Sistine Ceiling*, ed. Elizabeth Sears, with essays by John O'Malley and Elizabeth Sears (Oxford: Oxford University Press, 2000), 48.

Michelangelo was embedded in the kind of mystical tradition that valued allegorical instruction and incongruous symbolism.[50] In this regard, much of Noah's story is better understood from a soteriological perspective: the deluge refers to baptism, the Ark prefigures the Cross, and Noah's burnt offerings to God the Father suggest the sacrifice of the Son. All these associations are themselves monstrous; it seems abominable that the death of most of antediluvian humanity by drowning could be in any way associated with its future warranty of eternal life. This disparity, Wind suggests, is the aim of the exercise, so that the god of vengeance may be revealed as the deity of love.[51] The interpreter must first hypothesize a connection between the literal image and a potential allusion; then they ought to test this linkage by resolving its apparent conflicts and, through analogical reasoning, discover shared qualities. In this sense, both the deluge and the baptismal ritual are related through the element of water: the flood purges the sinful by death; baptism, less violently, by immersion. But this cleansing is also an image, an embodied metaphor for spiritual salvation, rooted in such quotidian actions as the washing of hands – or the pouring of a drink. There is a lesson then to be learned from the drunken Noah. It is by sharing in his shameful condition that we can gain an understanding of what divine ecstasy must feel like. Another kind of *discordia concors*.

Hence why Wind found Rouault's Christian imagery interesting, but ultimately insufficient: it is an art of extreme personal devotion and self-indulgent earnestness, which aims at depicting transcendental reality short of most worldly signifiers. Never is a sacramental wound shown by the artist, who seems to prefer a style of heartfelt, intimate spirituality to the divine comedy of religious ritual.[52] In his *Christ and the Evangelists* (1937–8) for example, the physiognomical traits of the Gospel writers – traditionally well marked as to better convey the distinct four major temperaments – are mostly absent, so as to better blend with Christ's vacant expression, which hints at mystical detachment. Regarding this picture, Wind states: 'The Absolute [...] has rarely been symbolized

50 Wind, *The Religious Symbolism of Michelangelo*, 56–7.
51 Wind, *The Religious Symbolism of Michelangelo*, 56.
52 Edgar Wind, 'Traditional Religion and Modern Art', *Art News* 52 (May 1953), 62.

Figure 9.2: Leonardo da Vinci, *The Last Supper*, c. 1495–8, tempera on gesso, pitch, and mastic. Santa Maria delle Grazie, Milan. Image in the public domain.

so convincingly'; yet, he adds, this a picture that can no longer excite public worship.[53] Indeed, Rouault is able to express maximum piety with minimum resources, but such pictorial economy comes at a cost. It cuts short the empathetic bridges through which a diverse public connected to devotional art. Commenting on Leonardo's *Last Supper* (1495–8) (Figure 9.2), Wind observes that the 'extravagant physiognomies' of the Apostles both deviate from and flock to the centre, 'like many colours which are meant to coincide in Christ and be extinguished in Christ's own serenity'.[54] As centrifugal forces, they force the viewer to confront the variety of human folly; conversely, in their centripetal impetus, they invite a plurality of observers to resolve their dissonant passions in the Saviour's perfect harmony. By contrast, Wind thought, Rouault's shorthand religious art could but preach to the few converted.

53 Wind, 'Traditional Religion', 21.
54 Edgar Wind, 'Leonardo as a Physiognomist', *The Listener* 47 (15 May 1952), 788. See also Edgar Wind, 'The Last Supper', *The Listener* 47 (8 May 1952), 747–8.

'Spoken in a tone of irony'

Wind's critical remarks on the French painter should not be taken as a conservative indictment, a kind of narrow-minded *laudator temporis acti*, nor his mockery of certain aspects of modern art seen as a whole-sale refusal. As Ben Thomas shows in *Edgar Wind and Modern Art*, the émigré art historian not only had a great affinity for contemporary art-istic production – having been a friend and mentor to Pavel Tchelitchew and Ronald B. Kitaj – but was also very much part of the scene, rubbing shoulders in Manhattan in the 1940s with the likes of Louise Bourgeois, Alfred H. Barr, Jr and Josephine Crane.[55] He also had a deep knowledge of the burgeoning modern tradition, as the footnotes in *Art and Anarchy* amply demonstrate; in one of them, about Alfred Jarry's sway over fin-de-siècle poetry, Wind adroitly discusses a 'curiously refined' book-binding of *Ubu Roi* by Marcel Duchamp (1935).[56] He was well aware of the Frenchman's sophisticated antics, and one is entitled to ask if Wind has wilfully ignored a host of examples that might contradict his thesis of humourless modern art. Or did, say, the graphical witticisms of Paul Klee go unmentioned by him?

Not at all. In fact, Wind was so enamoured of the artist that he bought two of his works, including a drawing in the early 1940s, a joyful depic-tion of a young girl holding a toy sheep (1908).[57] His interest in Klee was also intellectual. Wind talked about him on several occasions, such as in a

55 See Thomas, *Edgar Wind and Modern Art*, 51, 75, 80, 86, 77–115, 155–201. According to Margaret Wind, 'artists and musicians [...] took to [Wind]: they did not find his learning formidable, but thought he understood what they were after.' Margaret Wind, note, n.d., Bodleian, EWP, MS. Wind 23, folder 2.

56 Wind, *Art and Anarchy*, 99–100 n. 16. Wind fails to mention that although Duchamp did design the cover, it was Mary Reynolds who did the bookbinding.

57 See Thomas, *Edgar Wind and Modern Art*, 117–20. According to Margaret Wind, her husband was so enamoured of modern art that he 'bought long ago two early drawings by Klee, three marvellous prints by Braque, and a Soulages which are here in the house. He would have bought much more if he could have.' Margaret Wind to B. Rundle, 24 September 1981, Bodleian, EWP, MS. Wind 14, file 2.

symposium at the Museum of Modern Art in 1950. Then, he spoke on Klee's art alongside the works of modernist luminaries such as the architect Marcel Breuer, the art dealer J. B. Neumann and the painter Ben Shahn.[58] Klee also makes important appearances in *Art and Anarchy*, usually in a favourable light. When Wind does criticize him, it is through a counterfactual: just consider, he proposes, what kinds of contributions to plant cytology or palaeontology could have been made by a sharp-witted draughtsman like Klee, who had serious scientific interests. 'Yet,' Wind bemoans, 'a great artistic curiosity for science was here left unused.'[59] Klee explained why he wasted his scientific inquisitiveness in a lecture in 1924, when he was a Bauhaus instructor: 'Does then the artist concern himself with microscopy? History? Palaeontology? Only for purposes of comparison, only in the exercise of his mobility of mind [...] Only in the sense of freedom.'[60] Interchangeably, one might as well say 'only for the sake of freedom' – or, in good avant-garde lingo, *art pour l'art*. And here we have reached the crux of the problem for Wind. Klee's interest in science is but a prod for wondrous invention; his graphic humour is innocent and pure, resounding of something primordial. Thus, it is unrelated to the public sphere, to a regenerative criticism of human follies, to the depiction of the world through a glass darkly. It is anarchic not in the socio-political sense, but in the cosmogonical.[61]

58 Entitled 'Aspects of the Art of Paul Klee', the symposium took place on 2 February 1950 on the occasion of an exhibition of Klee's works from the Paul Klee Foundation. The talks by Marcel Breuer and Ben Shahn were published in *The Bulletin of the Museum of Modern Art* 17/4 (1950), 3–9. Wind also lectured on Klee in 1949 at Smith College and in 1957 at Oxford.

59 Wind, *Art and Anarchy*, 53–4.

60 'Also befasst sich denn der Künstler mit Mikroskopie? Historie? Palaeontologie? Nur vergleichsweise, nur im Sinne der Beweglichkeit [...] Nur im Sinne der Freiheit.' Paul Klee, *Über die moderne Kunst* (Bern: Benteli, 1945), 45–7. Engl. trans.: Paul Klee, *On Modern Art*, trans. Paul Findlay (London: Faber & Faber, 1948), 49.

61 In his *De l'essence du rire*, Baudelaire states that grotesque laughter has in itself something 'deep, axiomatic, and primitive', and hence akin to pure art; by contrast, he

By using such a Hesiodic term, we are perhaps permitted to rewind a couple of millennia. The Ancient Greek philosopher Democritus, now celebrated as an *ante litteram* philosopher of science for his proposal of atomism, was known to his contemporaries as the 'laughing philosopher' or 'the mocker', someone who kept scoffing at human vanity. As such, early modern European painters often portrayed him with a grin, sometimes accompanied by a gloomy Heraclitus in order to contrast two philosophical attitudes.[62] Wind, in a short piece from 1937 entitled 'The Christian Democritus', summarizes the pictorial tradition that paired the two philosophers and argues that, contrary to current expectations of religious solemnity, Democritus was consistently portrayed as the most Christian of the two.[63] So much so that when Cornelis van Haarlem painted the subject in 1613, he portrayed the atomist in the guise of a half-figure *Ecce Homo*. Strangely enough, instead of pious suffering, we find a Christ-like Democritus depicted as a jolly fellow, greatly at odds with the iconography of the Passion. This contradiction, says the art historian, is a provocative device – and, as such, a much more poignant one than a plain analogy would be.[64] It is hard to find a better example of Wind's lightness of thought than this iconographical paradox. It sums up what he took to be the key to understanding vast swathes of Renaissance imagery: one is prone to misjudge them, Wind says, if oblivious to the fact that 'they were sponsored by men of letters who had learned from Plato that the deepest things are

takes satirical laughter to be related to engaged art. In *Œuvres complètes de Charles Baudelaire*, vol. 2 (Paris: Michel Lévy, 1886), 375. Wind refers to Baudelaire's distinction when referring to the less intense but more significant laughter caused by Molière's comedies in comparison to Callot's *drôleries*. See *Art and Anarchy*, 15.

62 For an extended analysis of early modern depictions of Democritus and Heraclitus, see John L. Lepage, 'Laughing and Weeping Melancholy: Democritus and Heraclitus as Emblems', in John L. Lepage, *The Revival of Antique Philosophy in the Renaissance* (New York: Palgrave Macmillan, 2012), 81–134.

63 Edgar Wind, 'The Christian Democritus', *Journal of the Warburg Institute* 1/2 (October 1937), 180–2.

64 Wind, 'The Christian Democritus', 181–2.

13 RADIO TIMES • November 10 1960

THE REITH LECTURES 1960

Art and Anarchy

**Professor
Edgar Wind**

INTRODUCES HIS SUBJECT

*

Professor Edgar Wind, born in Berlin in 1900, is an art scholar with an international reputation. He studied at the Universities of Berlin, Freiburg, Vienna, and Hamburg. He went to the United States in 1925 as an assistant professor of philosophy at the University of North Carolina and he was deputy director of the Warburg Institute in London from 1932 to 1942, when he returned to America as Professor of Art at Chicago University. Since 1955 he has been Professor of the History of Art at Oxford, and he is a Fellow of Trinity College. He has written many works on art and philosophy in both German and English.

*

The lecture is repeated on Tuesday at 8.25 in the Third Programme and will also be printed in 'The Listener'

IN CHOOSING *Art and Anarchy* as the title for the Reith Lectures, I have drawn on certain remarks about the relationship of art and society made by some great philosophers and historians of the past, notably Plato, Hegel, and Burckhardt. Their views upon the subject do not agree with the broad and sanguine opinion held by many persons today that the widest possible diffusion of art automatically brings with it the greatest good. I believe that with the immense diffusion of art as we have it today, particularly in the visual arts, we have lost much in the density of our aesthetic experience, which has become a quick, superficial, and often vivid enjoyment that does not last.

Of the many causes of our predicament, perhaps the most important is the loss of what Plato called 'the sacred fear' of the imagination, a fear which we no longer feel because works of the imagination seem to have lost the power to hurt or to shape us. Art is so well received because it has lost its sting, a development that was foreseen and analysed in a masterly way by Hegel over a century ago. The lectures will raise the question whether this development can be reversed.

To this end some of the forces that have fashioned our present outlook on art will be examined; among them the mechanisation of art, the fear of intellect, the influence of connoisseurship, and above all our dispassionate acceptance of art, which is perhaps our fundamental weakness.

Plato

Of the many causes of our predicament, perhaps the most important is the loss of what Plato called 'the sacred fear' of the imagination.

From the bust in the Carlsberg Glyptotek, Copenhagen

Figure 9.3: Edgar Wind, 'The Reith Lectures 1960: Art and Anarchy', *Radio Times* 64/ 1650 (10 November 1960), 12. Reproduced courtesy of the BBC.

best spoken in a tone of irony.'[65] Perhaps the same admonition applies to Wind's works. When asked by the BBC in October 1960 for a photographic portrait to advertise the coming Reith Lectures, he simply refused. Instead, he sent a photo of a bust of the Greek philosopher (Figure 9.3).[66]

65 Edgar Wind, *Pagan Mysteries in the Renaissance* (New York: Barnes & Noble, 1968), 236.

66 In response to the BBC Pictorial Publicity department, Wind stated that 'I should be so very grateful if we could manage to do without [photographic portraits]. This is a personal idiosyncrasy and I hope you will forgive it. However, I could supply you with a list of a few works of art related to the substance of the lectures.' Edgar Wind to P. Ridz, 16 October 1960, Bodleian, EWP, MS. Wind 95, folder 2. The announcement of Wind's Reith Lectures in *Radio Times* (Figure 9.3 in the present volume) displayed a bust of Plato from the New Carlsberg Glyptotek, Copenhagen.

Aesthetic delight

Now, before concluding, back to *leggerezza* and lightness. Back to Calvino, who defined his method as a fiction writer as the subtraction of burdens. 'I have tried to remove weight,' he writes, 'sometimes from people, sometimes from heavenly bodies, sometimes from cities; above all I have tried to remove weight from the structure of stories and from language.'[67] Wind might have been once more of the same mind with the Italian writer. When briefly discussing in *Art and Anarchy* the so-called iconological method, the art historian states that a given interpretation is aesthetically useless if all it does is bury the work under a burdensome apparatus. 'There is one – and only one – test for the artistic relevance of an interpretation,' Wind asserts, 'it must heighten our perception of the object and thereby increase our aesthetic delight.'[68] As with Calvino's writing, an art-historical interpretation ought to be both lightweight and enlightening.

It is possible that Wind is here being either glib for glibness's sake or a tad naughty and provocative (especially if we consider his late animosity towards Panofsky).[69] After all, the passage does seem to strike an

67 '[H]o cercato di togliere peso ora alle figure umane, ora ai corpi celesti, ora alle città; soprattutto ho cercato di togliere peso alla struttura del racconto e al linguaggio.' Calvino, *Lezioni americane*, 7 (Engl. trans., *Six Memos*, 3).

68 Wind, *Art and Anarchy*, 62. According to Margaret Wind, 'aesthetic delight' was the main goal of Wind's art-historical method: 'It would be very helpful to include at the end of Lecture IV a brief reference to what Edgar regarded as the crucial test for the artistic relevance of an interpretation: whether it succeeds in removing impediments to perception and by doing so whether it increases our aesthetic delight and enjoyment – or something like that. This was at the heart of Edgar's view of iconography, and perhaps it should be stated. Not everyone understands what the subject should be about. The historical validity of an interpretation is quite another matter.' See Margaret Wind, note, n.d., Bodleian, EWP, MS. Wind 23, folder 2.

69 In a veiled rebuke to the Panofskyan brand of iconology, written in 1950, Wind states that 'the primary aim of iconography should therefore be cathartic.' See Edgar Wind, 'The Eloquence of Symbols', *The Burlington Magazine* 92/573 (December 1950), 350. On the theoretical and methodological differences between Wind and Panofsky (and the mutual animosity between them in their later

all too facile note. It may not be the case; in fact, this is probably one of the few moments in *Art and Anarchy* in which Wind is not being at some level droll and facetious, but dead serious. He assumes that, although the gap between the interpretative subject and the object of interpretation is unavoidable, the latter – that is, the artwork – has been crafted by a subjectivity bound to a specific body-and-action environment. Such a situated maker encodes the artistic artefact with indexical signs, traces of the inceptive self–world interrelationship. An inquisitive act of perception tries to square these inferred indexes with a relevant historical schema, either adding to this model or leading it to a regenerative crisis of some sort. The hurdle in this process is always some kind of difference: say, cultural, geographical, historical, biological. How can we be sure that the interpretative mapping captures the essential features of the genetic landscape? That is, those lived factors that most came into play in a given artistic creation? Wind's answer is that this not a point-by-point operation; a wealth of piled-up facts, no matter how historically accurate, simply will not do. The art historian ought to advance a plausible past universe, one that affords a definite range of vicarious sensations, and sharpen this construction over and over against the object of perception.[70]

years), see C. Oliver O'Donnell, 'Two Modes of Midcentury Iconology', *History of Humanities* 3/1 (2018), 113–36. See also Rebecca Zorach, 'Love, Truth, Orthodoxy, Reticence; or, What Edgar Wind Didn't See in Botticelli's *Primavera*', *Critical Inquiry* 34 (2007), 221–2. For a personal reminiscence of the relationship between the two art historians, see William Heckscher, 'Ist das Alles?', *Art Bulletin of Victoria* 28 (1987), 9–15.

70 When prompted by Margaret to comment on Wind's embattled method of interpretation, Lorenzo Minio-Paluello penned in 1977 a thoughtful letter that bears on my construing of Wind's art-historical approach (here partially reproduced): 'Well, Margaret, you ask me to produce a verdict on the "validity" of Edgar's interpretation. Certainly, the interpretation given by Edgar, inspired historian of visionary poets and painters, is based on evidence gathered from what remains of all their works, and from the works of much that remains of other poets, painters, sculptors, philosophers; and he collates hard facts and ideas and products of meditation, to construct a probable world in which new interpretations fit coherently with the past. He adds a unique poetical insight, and brings the reader in that world which is

When these sensations are felt to match most strongly the ones inferred from the indexical signs, so that an enhanced bodily sense of 'feeling the artwork' is triggered, then the observer has validated their interpretation via 'aesthetic delight'.[71] A surge in skin electricity, heart pounding faster, the drowning of eyes unused to flow: these are the telltale signs of a successful interpretation.

But what exactly do we have to gain from this arduous task of looking, reading, interpreting, and feeling? To wilfully misquote Calvino: through this process we cast doubts on ourselves, the world, and the network of relationships between the two. We remove weight by breaking up a habitus, the first step towards a reorientation of belief and action. If Wind

much more valid in its mental reality than a stingy collection of fragmentary information, unable in itself to help one to see the threads that connect the fragments, and unable to lead to the more vital evidence which is only accessible to the perceptive mind of those who can throw on to the balance a much vaster experience of "documents." And if there is audacity in Edgar's reconstructions, it is the audacity of bringing together that much vaster acquaintance with the manyfold [*sic*] human nature; the audacity of one who can embrace with his own experience of life something of the experience of life of poets and painters and sculptors and philosophers. All this documentation, gathered from outside and from inside has no validity only for those who cannot see the world in which lies the true "reality" of poets like Dante. It has validity for those who are prepared to follow Edgar into this other world, not visible to the sleepers who have not even dreams, let alone open eyes, those who can say that "Dante si limita" because *their* world has very narrow limits.' Lorenzo Minio-Paluello to Margaret Wind, 15 November 1977, Bodleian, EWP, MS. Wind 22, folder 2.

71 Wind posited that a historical interpretation was essentially akin to a scientific experiment. See Edgar Wind, *Das Experiment und die Metaphysik: Zur Auflösung der kosmologischen Antinomien* (Tübingen: Mohr, 1934); new edition by Bernhard Buschendorf, with a foreword by Brigitte Falkenburg and an afterword by Bernhard Buschendorf (Frankfurt: Suhrkamp, 2001). See also Edgar Wind, 'Some Points of Contact between History and Natural Science', in Raymond Klibansky and Herbert J. Paton, eds, *Philosophy and History: Essays Presented to Ernst Cassirer* (Oxford: Clarendon Press, 1936), 255–64. On the need to take risks in

is to be trusted, we thus loosen some of our shackles, acquire a new voice, and become a tad sharper.[72] That is, we end up as the butt of a rather enlightening, bittersweet joke – honey and wax.

<hr />

an experiment, see Edgar Wind, 'Humanities 292a: Experimental', *Smith Alumnae Quarterly* 44/3 (1953), 136; see also Wind, *Art and Anarchy*, 75–89.

72 In a congress in Hamburg in July 1953 on scientific freedom, Wind defined what he understood to be C. S. Peirce's notion of liberty, stating that: 'Und seine entscheidende Definition der Freiheit war die, daß, wenn sich ein Habitus, eine Gewohnheit, in uns entwickelt hat – und es ist gut, daß sie sich entwickelt, denn dadurch werden wir alle etwas berechenbar, und ohne sie würden wir unberechenbar sein –, Durchbrüche durch diese Gewohnheiten Vorkommen, und die Tendenz zum *breaking up of habitus*, dieses Durchbrechen der Gewohnheit, ist für Peirce das Zeichen der Freiheit. Wer seine Gewohnheit nicht durchbrechen kann, ist versklavt, er verstummt, er verdummt.' ['And his crucial definition of freedom was that when we develop a habitus, a custom – and it is good that it develops, because that makes us all somewhat predictable, and without it we would be unpredictable – breakthroughs through these habits occur, and the tendency to the *breaking up of habitus* is, for Peirce, the sign of freedom. He who cannot break his habit is enslaved, falls silent, becomes dull.'] Edgar Wind, 'Schluss-Sitzung', Congress for Cultural Freedom, *Wissenschaft und Freiheit: Internationale Tagung, Hamburg, 23.-26. Juli 1953* (Berlin: Grunewald, 1954), 281.

Career as Émigré Scholar and Public Intellectual

10 Edgar Wind and the Saving of the Warburg Institute

The foundation of the Warburg Library is shrouded in myth. It began in 1879, when the two eldest sons of the Jewish banking family of Warburg in Hamburg were children. The eldest, Aby (1866–1929), aged 13, said to his 12-year old brother Max, 'You can have the bank, provided you buy me all the books I want for the rest of my life.' Max later said it was the only blank cheque he ever signed.[1] When his family later objected to this frivolous expense, Aby is said to have replied, 'Other bankers have racing stables, and are fleeced by their jockeys. You have a library with a head jockey, and that is me.'[2] He went on to amass an enormous private library, and in 1926 to found the Kulturwissenschaftliche Bibliothek Warburg (KBW), devoted to the *Nachleben der Antike*, the ways in which the ancient Greek and Roman world had influenced the Renaissance and European culture, in literature, thought and art.

Aby Warburg himself had become an important historian and theoretician of Renaissance art and of the relation between reason and imagination in the classical tradition. Traumatized by the fact that Germany and Italy had fought on opposite sides in the Great War, he suffered a long period of mental illness – for six years until 1924 – during which time his

1 Ron Chernow, *The Warburgs: The Twentieth-Century Odyssey of a Remarkable Jewish Family* (New York: Random House, 1993), 30.

2 'Andere Banquiers halten sich einen Rennstall und werden von ihren Jockeys betrogen. Ihr habt eine Bibliothek mit einem Herrenreiter, und der bin ich.' Bodleian Libraries, University of Oxford, Edgar Wind Papers (hereafter Bodleian, EWP), MS. Wind 3, folder 4/6.

librarian, Fritz Saxl (appointed in 1919), developed his ideas. As K. W. Forster describes it:

> From the chrysalis of a private library – in an unexpected metamorphosis, after years of secret evolution – there emerged a scholarly institution that still subsists to this day, though not on its original site. The founder's researches, deeply personal though their motivation had been, were now to be subsumed – having been supported, expanded, and modified by Saxl –within an Institute of 'Cultural Studies.'[3]

By the time Aby Warburg died in 1929, the library was attached to the new University of Hamburg (founded in 1919), through its first professor of philosophy, Ernst Cassirer (1874–1945), who was also Rektor of the university from 1929 until his resignation as a result of the Nazi election victory in 1933 – a century after the death of Goethe. Although still technically a private institution under the direction of Warburg and later Saxl, the KBW had established a programme of lectures and publications, and through its research grants had brought together the most distinguished group in the world of researchers into *Kulturgeschichte* and the relation between art and thought in Western civilization, attracted both by its library and by the philosophical ideas of Cassirer.

The library was and remains unique. As Cassirer said when he first visited it, 'This library is dangerous. I shall either have to avoid it altogether or imprison myself here for years.'[4] It is still organized without regard to different traditional areas of research or chronology, but rather according to categories developed by Warburg himself, with four main sections devoted to 'Orientation' (philosophy, religion, magic, science), 'Image' (art history, archaeology), 'Word' (literature, rhetoric) and 'Action' (history, society, festivals, theatre, technology).[5] It has also developed the practice of selecting

3 K. W. Forster, introduction to Aby Warburg, *The Renewal of Pagan Antiquity: Contributions to the Cultural History of the European Renaissance*, trans. David Britt (Los Angeles: Getty Research Institute, 1999), 31.

4 Ernst Cassirer, quoted in Fritz Saxl, 'Ernst Cassirer', in Paul A. Schilpp, ed., *The Philosophy of Ernst Cassirer* (New York: Tudor, 1958), 47.

5 Thus 'festivals and feasting' combines books from all periods; and 'Cicero' for instance is to be found on three of the four separate floors of the modern library, creating an instant liberating effect on any user.

important articles to be bound in card and placed on the bookshelves next to the books on the theme they illustrate, under Warburg's 'Law of the Good Neighbour'.[6] All decisions were and are made by the library staff, who must be trained scholars (since they need to read the works in order to determine their placement), more than professional librarians. It was and is the most powerful institute for the history of ideas and of art in its cultural context, encouraging cross-disciplinary research and intertemporal approaches. Its second great innovation was in art history: the creation of a photographic archive arranged according to iconographic principles, in order to investigate the continuing meaning (or iconology, as the term's originator Erwin Panofsky expressed it) of each representation.[7]

Almost all the staff and the scholars working in the library were classified as 'non-Aryan' under the Nazi law of the *Gesetz zur Wiederherstellung des Berufsbeamtentums* ('Law for the Purification of Public Services', 7 April 1933, reinforced in 1935, and known as the *Berufsbeamtengesetz*), and were therefore dismissed from whatever official posts they held. Two young scholars were instrumental in saving the library. Raymond Klibansky, researching medieval Platonism, had already been appointed at the age of 26 as a *Privatdozent* in the University of Heidelberg, and saw what was happening in his own university; he had himself refused to complete the required statement of 'race', instead sending a letter in which he proudly declared to the authorities that his ancestors since the Middle Ages had professed the Jewish faith. He was dismissed in August 1933 and hastened to Hamburg, convinced that the Institute must leave Germany immediately; he suggested founding a centre abroad for 'trying to preserve an

6 Michael P. Steinberg, 'The Law of the Good Neighbour', *Common Knowledge* 18 (2012), 128–33.

7 Erwin Panofsky, *Studies in Iconology: Humanistic Themes in the Art of the Renaissance* (New York: Oxford University Press, 1939), 3–17. To give an example, when I wanted to research the iconography of 'Europa and the Bull', I was directed to a series of filing cabinets entitled 'Zeus, Loves of'. There in the appropriate file I found all the relevant material, in the form of engravings, old postcards, pictures removed from books, and the like, and was rapidly able to discover that there were two basic representations in Western art of the Rape of Europa.

Anglo-German school of history and philosophy of civilisation'.[8] Saxl rec-
ognized the urgency, and asked Klibansky to prepare a memorandum for
Max Warburg, the head of the bank, who was responsible for providing
much of the funding of the Institute. It seems that the memorandum has
not survived (it was doubtless too sensitive to have been kept), but Max was
convinced by it, and discussions began on possible destinations: Leiden and
Jerusalem were ruled out for various reasons; it was decided that neither
Italy, France nor Palestine was safe; and the United States was not suitable
for an institution devoted to European culture. England was the only pos-
sible choice, and negotiations were begun with the University of London.

Edgar Wind was born in Berlin in 1900 of Argentinian and Russian
parents, and educated in Germany and the USA (Figure 10.1). After studies
at Berlin, Freiburg and Vienna he came to Hamburg to work under Erwin
Panofsky and Cassirer, where in 1922 he completed a dissertation on
the methodology of art history. From 1924 to 1927 he was in New York
and North Carolina (where he came to appreciate the philosophy of
C. S. Peirce), and married his first wife, Ruth Hatch (they were married
from 1926 to 1928).

In May 1926 the KBW had moved to a new, specially designed
building, separate from the private residence of Aby Warburg. The young
Edgar Wind met Warburg for the first time in the summer of 1927; from
then until Warburg's death in 1929 he acted as Warburg's private assistant,
especially in relation to the USA, in which Warburg had been interested
since his visit to study the Pueblo Indian dance rituals. In the archive of
the Warburg Institute there is extensive correspondence on this subject,
conducted by Wind for Warburg in the period 1928–9. Wind formally
joined the staff of the Institute in 1928, and a year later was appointed
Privatdozent at Hamburg University.

8 Klibansky, quoted in Elizabeth Sears, 'Keepers of the Flame: Bing, Solmitz,
 Klibansky, and the Continuity of the Warburg Tradition', in Philippe Despoix and
 Jillian Tomm, eds, *Raymond Klibansky and the Warburg Library Network: Intellectual
 Peregrinations from Hamburg to London and Montreal* (Montreal: McGill-Queen's
 University Press, 2018), 36–7.

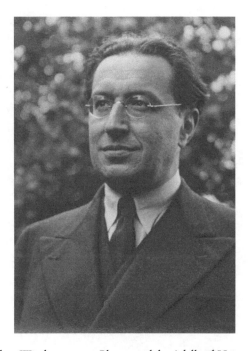

Figure 10.1: Edgar Wind, c. 1937–9. Photograph by Adelheid Heimann. © Warburg Institute, University of London.

During 1931–2 Wind made three visits to England, to study eighteenth-century heroic portraiture in relation to the philosophy of David Hume.[9] While in New York in 1924–7 he had stayed with an older cousin, whose stepdaughter had been married to the son of the Honorable Mrs Henrietta Franklin (1866–1964), the daughter of Lord Swaythling of the Montagu banking family (Figure 10.2). In May 1933 on his own initiative Wind visited London and stayed with her. Mrs Franklin was a hostess with a wooden leg; her luncheon parties were famous. She had wide contacts among the wealthy Jewish community in Britain, and introduced Wind

9 See Edgar Wind, *Hume and the Heroic Portrait: Studies in Eighteenth-Century Imagery*, ed. Jaynie Anderson (Oxford: Clarendon Press, 1986).

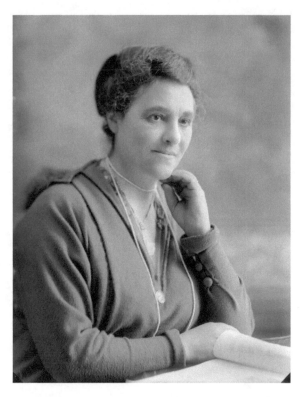

Figure 10.2: The Hon. Mrs Henrietta Franklin, née Montagu (1866–1964),
24 February 1936. Photograph by Bassano Ltd. © National Portrait Gallery, London.

to Sir Philip Hartog and through him to C. S. Gibson, professor of chem-
istry at Guy's Hospital, who was subsequently the first honorary secretary
of the Academic Assistance Council (discussed further below).

There is no doubt of the importance of Mrs Franklin's connec-
tions: Wind referred to the indefatigable efforts of 'die Matriarchin'
in letters to Saxl and Gertrud Bing in Hamburg. With her help and
his perfect command of English, he was the ideal intermediary in
negotiations between the University of London and the Warburg

Institute.[10] It was at one of Mrs Franklin's lunches that he met the dancer Agnes de Mille (Figure 10.3), niece of Cecil B. de Mille (and later famous choreographer of *Oklahoma!* and other musicals), and began a relationship with her. Agnes recorded her first impression:

> I spoke to a charming young German girl at the table, asking her by way of conversation if she intended to stay long in this country. 'I think so,' she said smiling sadly at the young Jew beside her, an impressive, large, black-haired person, Professor Edgar Wind. 'I think we'll all be here quite some time,' he said. He is transferring the Warburg Institute (art history) intact from Hamburg to London. Permanently.[11]

Mrs Franklin wrote a letter of introduction to Sir William Beveridge and his newly formed Academic Assistance Council on 25 May. From June 1933 Wind led these negotiations with Lord Lee of Fareham (who a year earlier had organized the creation of the Courtauld Institute), W. G. Constable (first director of the Courtauld) and Edwin Deller (principal of the university, reporting to the vice-chancellor). At their request Wind drew up a seven-page confidential report, which was approved by Saxl, on the purpose and function of the Warburg Institute in a London context. Its urgency is revealed in the first draft, which survives in the vice-chancellor's archive of the University of London, and is printed for the first time as an appendix to the present chapter.[12] It was a brief but comprehensive document with seven heads:

10 There were also tentative contacts with Oxford University through Sir Richard Livingstone, president of Corpus Christi College, and Ernest Jacob, later Chichele Professor of Medieval History at All Soul's, and Maurice Bowra of Wadham.

11 Agnes de Mille, *Speak to Me, Dance with Me* (Boston: Little, Brown, 1973), 65–6 and chs 17–19, pp. 331–62. She sums it up: 'Edgar Wind did not marry me. He married someone else, and they lived, I presume, with reasonable happiness. I saw them only once, some years after the wedding. He seemed embarrassed by my presence.' (p. 384). According to Margot Wittkower, in this period Edgar Wind broke the hearts of at least seven women. See Margot Wittkower, *Partnership and Discovery: Margot and Rudolf Wittkower*, interviews by Teresa Barnett (Los Angeles: J. Paul Getty Trust, 1994), 198–214, <https://archive.org/stream/partnershipdiscooowitt/partnershipdiscooowitt_djvu.txt>.

12 The original document is preserved in the University of London's Vice-Chancellor's Archive (UPI/10/1). It was subsequently revised (omitting the last two heads) to

Figure 10.3: Agnes George de Mille (1905–93) in the ballet *Three Virgins and a Devil*, Broadway, 1941. Photograph by Carl van Vechten. © Van Vechten Trust/Billy Rose Theatre Division, The New York Public Library for the Performing Arts.

form the first declaration of the purpose of the Warburg Institute, in which version it exists in the archive of the Warburg Institute, University of London.

1. The Purpose of the Warburg Institute
2. The Equipment of the Warburg Institute
3. The Activities of the Warburg Institute
4. The Reasons for Removing the Warburg Institute from Hamburg
5. The Reasons for Removing the Institute to England and to London in particular
6. The Organisation in London
7. The Cost of Maintenance.

Wind wired Saxl in Leiden from London, advising him to come to London for the first meeting of the executive committee of the Academic Assistance Council. At this meeting on 14 June 1933 the transfer of the Warburg to London was discussed with Wind; and Gibson and Constable – together with Sir Edward Denniston Ross, director of the School of Oriental and African Studies – were deputed to visit Hamburg. Wind returned to Hamburg on 17 June 1933 to obtain Max Warburg's approval. Since the library was a private institution and had a rule that books could be lent abroad, it was agreed that the entire library should be loaned to London for three years. The local Hamburg authorities were invited not to intervene with a promise of no adverse publicity and an affidavit from the American consul that the foundation was largely American owned; they were persuaded that Goebbels' central ministry did not need to authorize the transfer. The authorities made only one condition: two thousand books of Warburg's collection on the First World War were demanded as a 'Faustpfand'. In my own day as a research fellow of the Warburg (1967–8), the shelf entitled 'Prophecy and World War' still remained symbolically almost empty.[13]

The main problem was funding, both for the transfer and for the longer term. The University of London had nothing to offer, but the parties agreed to seek external funding for four staff and the librarian. The running costs were estimated at £7,000 per annum, while the Warburg family would provide a similar amount for the transfer. Sir Samuel Courtauld offered to guarantee funding for three years, which he later

13 The section now contains only a small number of books from before the exile (information from Philip Young, assistant librarian). See the section in the Warburg catalogue, FHO M258: 'Magic and Science: Divination and Prophecy: Prophecy and World War' (Warburg Institute, School of Advanced Study, University of London, 'Library Research Guides, Classification system', <https://warburg.libgui des.com/classification/magic-and-science>, accessed 14 July 2023).

extended for a further seven years until 1944. Max Warburg, as the banker behind the Hamburg shipping industry, was able to supply two small steamers, *Hermia* and *Jessica*, into which were loaded 531 boxes containing 60,000 books and 25,000 images, together with all the furniture and four members of staff. They arrived at London docks on 12 December 1933. Other donors covered the tiny costs of transport from the docks to London (£50) and temporary storage (£32 a week) until the Warburg Institute could be housed in Thames House, and subsequently in the Imperial Institute Buildings, South Kensington, and (after the death of the librarian in an air raid) in a country house at Denham (Uxbridge).[14] The Institute was only finally incorporated into the University of London in 1944. Lord Lee became first chairman of the board of management.

In London, Wind became deputy director of the Warburg Institute (in 1934), and his influence was clearly central in settling the new, and very German, Institute into its London environment. He effectively organized the public face of the Warburg; he created the first sets of lectures and programmes, which were outstanding in their range, including speakers such as the scientist Niels Bohr, and he was founding editor of the *Journal of the Warburg* [later *and Courtauld*] *Institute[s]*. In 1939 he went to America on leave, and when war broke out was advised by Saxl to remain there, in order to strengthen connections with the American branch of the Warburg bank. After the fall of France in 1940 he was indeed asked to investigate a possible transfer of the Institute to the United States, and remained there as an unofficial representative, until in 1945 Saxl came to try and persuade him to return to the Warburg as his successor as director. Meanwhile Wind had married Margaret Kellner in 1942 and was now settled in the United States. There were tense negotiations over questions of status, staffing,

14 I recall my close friend Anne-Marie Meyer, then Saxl's secretary, later administrator of the Warburg, telling me of her daily terror during this period at Denham, at having to catch an untamed horse to harness it to the well mechanism in order to provide Saxl, director of the Institute, with his daily bath. The whole picture of life with Jimmy the horse at Denham is brilliantly evoked in Wittkower, *Partnership and Discovery*, 156–65.

and the purpose of the Institute, which centred on Wind's disapproval of a new Saxl plan to create a 'Pauly—Wissowa', an encyclopedia of the Middle Ages and Renaissance. This led to a final breakdown of relations between the two men.[15]

After many attempts to return to Europe, in 1955 Wind came to the University of Oxford to be its first professor of art history. When I was an undergraduate (1958–61) I went to the amazing lectures he gave on Leonardo da Vinci, which were attended by the entire university in academic gowns. Indeed, the university proctors had excluded the wider public because the lectures were so popular that Wind filled the Oxford Playhouse twice a week, each time giving an identical lecture without notes (Figure 10.4). I remember too his famous lecture on Mantegna's *Parnassus*, and still possess (as my first student prize, received in 1960) an embossed edition of his *Pagan Mysteries in Renaissance* (1958). Wind was the star lecturer of his day in Oxford, when we undergraduates, fresh from military service, ranged across the academic disciplines – looking for inspiration.

15 Bernhard Buschendorf, 'Auf dem Weg nach England: Edgar Wind und die Emigration der Bibliothek Warburg', in Michael Diers, ed., *Porträt aus Büchern: Bibliothek Warburg und Warburg Institute Hamburg–London 1933* (Hamburg: Dölling und Galitz, 1993), 85–128; Ben Thomas, 'Edgar Wind: A Short Biography', *Stanrzeczy* 1/8 (2015), 117–37. Because of this break between Wind and Saxl, earlier accounts ignore or play down the role of Wind in the transfer. See Eric Warburg, 'The Transfer of the Warburg Institute to England in 1933', in *The Warburg Institute Annual Report 1952–3*, 13–16; Gertrud Bing, 'Fritz Saxl (1890–1948): A Memoir', in Donald James Gordon, ed., *Fritz Saxl, 1890–1948: A Volume of Memorial Essays from His Friends in England* (London: Nelson, 1957), 1–46; Fritz Saxl, 'The History of Warburg's Library', in Ernst Gombrich, *Aby Warburg: An Intellectual Biography, with a Memoir of the Library by F. Saxl* (London: Warburg Institute, 1970), 325–8; and Nicholas Barker, 'The Warburg Institute', *The Book Collector* 39/2 (1990), 153–73. See also Chapter 11 by Elizabeth Sears and Chapter 12 by Ben Thomas in the present volume.

Figure 10.4: 'Members of the University queueing for the lecture on Picasso, given by Prof. Edgar Wind at the Taylor Institution yesterday', *The Oxford Mail* (14 February 1957), 5. N.G.A. Oxon a. 108. © The Oxford Mail.

The Academic Assistance Council and the *Kosmopolis der Wissenschaft*

The rescue of the Warburg Institute can only be compared with the arrival in Italy of the future Cardinal Bessarion in 1439, fleeing the impending destruction of Byzantium and laden with ancient Greek manuscripts to become the catalyst for the Italian Renaissance.[16] But it was the first part of a far wider initiative, as a result of the new threat to the Republic of Letters, which had begun with the dismissal from government posts of all those German citizens who could not certify their 'Aryan' descent for

16 Lotte Labowsky, *Bessarion's Library and the Biblioteca Marciana: Six Early Inventories* (Rome: Edizioni di storia e letteratura, 1979). Lotte Labowsky was herself one of the Warburg refugees, who collaborated with Klibansky in his Plato project, and ended as a much-loved Fellow of Somerville College, Oxford.

two generations. The resulting exodus between 1933 and 1939 has been recorded in the individual memoirs of survivors of the Nazi Holocaust and in the story of the *Kindertransporten*.

One aspect of this mass expulsion was the large number of mainly 'Jewish' academics dismissed from their posts in Germany in 1933 and 1935 under the Nazi race laws, and from 1938 in Italy also. In response to this emergency, Sir William Beveridge, principal of the London School of Economics (subsequently Lord Beveridge, author of the Beveridge Report which created the post-war British welfare state), established the Academic Assistance Council, which was renamed the Society for the Protection of Science and Learning in 1935 when it became clear that the problem was a permanent one.[17] This society, now called the Council for At-Risk Academics (CARA), is still devoted to rescuing academics at risk of persecution, and enabling them to find equivalent research posts in the free world; in 2008 it celebrated seventy-five years of activity with a conference at the British Academy. Establishing this organization was the greatest act of generosity ever undertaken in the Republic of Letters, for it was funded initially by voluntary contributions from the salaries of British academics, as well as by many charities and academic institutions. A major appeal was launched, addressed by Albert Einstein in the Royal Albert Hall on 3 October 1933 to a packed audience; and between 1933 and 1939 the Society was responsible for saving the lives of some 2,600 Jewish academics and their families, and providing them with grants to continue research in Britain until they could find positions, either during or after the war.

Those assisted include most of the great intellectuals of the past generation: the doctor Ludwig Guttmann; scientists Albert Einstein, Max Perutz, Max Born, Hans Krebs and Klaus Fuchs (no less than sixteen Nobel laureates in the sciences); philosophers Ernst Cassirer, Karl Popper, Leo Strauss, Theodor Adorno and Richard Walzer; sociologists Karl Mannheim and Norbert Elias; classical scholars Eduard Fraenkel, Rudolf Pfeiffer, Günther Zuntz, Charles Brink, Otto Skutsch, Victor Ehrenberg and

17 William Henry Beveridge, *A Defence of Free Learning* (London: Oxford University Press, 1959); Jeremy Seabrook, *The Refuge and the Fortress: Britain and the Flight from Tyranny* (London: Palgrave Macmillan, 2022).

Arnaldo Momigliano; art historians Nikolaus Pevsner, Erwin Panofsky, Edgar Wind, Raymond Klibansky and Ernst Gombrich; Roman lawyers Fritz Schulz and David Daube; and many others. These were the personal friends and intellectual models of my youth. Their exodus led, in the Anglo-Saxon world, to the creation of modern art history and the renewal of classical scholarship, as well as being of direct benefit to the Allies in the war through the creation of the atomic bomb.

The archive of the Society for the Protection of Science and Learning (SPSL) exists in the Bodleian Libraries in Oxford, and reveals in detail the great care and humanity offered to the families of the refugees under the care of its secretary, the Quaker Tess Simpson, who devoted her life to them.[18] From May 1940, as a result of a vicious smear campaign by the *Daily Mail*, the government was forced to intern them in makeshift concentration camps, and finally on the Isle of Man. In this period, Tess Simpson did everything in her power to help the families of those interned.[19] A concerted campaign by the SPSL and British academics such as Gilbert Murray OM, emeritus Regius Professor of Greek, led to questions in Parliament, and the academics were eventually released. But throughout the war years the position of these refugees was precarious: no regular employment was available for most of them. After the Blitz, the offices of the SPSL moved from London to Cambridge; in Oxford a committee, composed of Hugh Last (professor of Roman history), W. D. Ross (provost of Oriel College), and Gilbert Murray dispensed funds provided by the SPSL, and the University

18 For Tess Simpson, who was of Jewish extraction and became a Quaker in youth, and was secretary of the Society from 1933 to 1978, see R. M. Cooper, ed., *Refugee Scholars: Conversations with Tess Simpson* (Leeds: Moorland, 1992); and John Eidinow, *Esther Simpson: The True Story of Her Mission to Save Scholars from Hitler's Persecution* (London: Robinson, 2023). See also, for the contribution of Oxford University: Sally Crawford, Katharina Ulmschneider and Jaś Elsner, eds, *Ark of Civilization: Refugee Scholars and Oxford University, 1930–1945* (Oxford: Oxford University Press, 2017).

19 Paul Jacobsthal's vivid memoir of internment is printed in Cooper, ed., *Refugee Scholars*, 198–228. See also Beveridge, *A Defence of Free Learning*, chapter 4, for other accounts, and Simon Parkin, *The Island of Extraordinary Captives: A Painter, a Poet, an Heiress, and a Spy in a World War II British Internment Camp* (London: Scribner, 2022).

of Oxford and its colleges were particularly generous in the early years. It was therefore natural for Oxford to become a centre for academic refugees. Kenneth Sisam, secretary to the delegates of the Clarendon Press of Oxford University, was also secretary of the Oxford committee, and in fact its chief fundraiser. Later, although the United States was always reluctant to admit any but the most eminent and useful Jewish refugees, the Rockefeller Foundation supplied funds to the Oxford University Press to enable it to enter into book contracts with the refugees in order to provide them with financial support.

The refugees survived, but they were not rich; the standard SPSL grant for a single scholar was £150 a year, for a family £250, from which were deducted any other earnings. They found whatever employment they could, and in Oxford lived in rooms or small houses, often on the outskirts of the town. Sophie Walzer (1902–79) was perhaps exceptional; she was the niece of Paul Cassirer, Berlin's famous art critic and the first and most important art dealer in the Impressionists, who ran the Kunstsalon Cassirer with her father Bruno; Bruno continued the business after Paul's suicide in 1926, and somehow managed to bring his collection with him into exile. Sophie inherited half of it: this was the greatest number of Impressionist paintings I have ever seen crammed into a tiny private house: a sketch for *Déjeuner sur l'herbe* above the doorway in the hall; a huge Monet scene behind the sofa (*Bathers at la Grenouillère* of 1869, bequeathed to the National Gallery), along with a Cézanne, a Van Gogh, and many others. When the Walzers died, the Cézanne and two other paintings were given to the Ashmolean Museum in lieu of death duties; the Cézanne was promptly stolen on New Year's Day 2000.[20]

20 In the Philadelphia Museum of Art there is a stunning portrait by Lovis Corinth of Sophie Cassirer aged 4; she still had those penetrating eyes in her late 70s. I was recently reminded of this extraordinary collection by the four-volume *Kunstsalon Cassirer*, eds Bernhard Echte, Walter Feilchenfeldt, Petra Cordioli (Wädenswil: Nimbus, Kunst und Bücher, 2011–13). For the Ashmolean holdings, see Colin Harrison and Catherine Caseley, eds, *The Ashmolean Museum: Complete Illustrated Catalogue of Paintings* (Oxford: Ashmolean Museum, 2004), 42. Paul Cassirer had been married twice: during his second divorce proceedings in 1926 from the famous actress Tilla Durieux (1880–1971, married 1910), he asked to be

Appendix

Edgar Wind's memorandum to the Vice Chancellor of the University of London, to transfer the Warburg Library from Hamburg to London (Figure 10.5)[21]

Confidential

Purpose of the Institute

The Warburg Institute, was founded as an intellectual laboratory for studying the survival of classical tradition within European civilisation. In studying this problem, the Institute developed the particular method of inter-connecting all those cultural sciences which are usually treated independently; namely, History of Art and History of Literature, History of Science and History of Religion. Thus, it serves as a connecting link between diverging fields of study, both as regards subject matter and period. The art historian who usually looks upon Art as a thing in itself, learns here to connect it with literary and religious documents. The historian of Science finds here all the material for the history of magic and superstition which is the antecedent of rational reflection, and, most, frequently,

excused, went into another room and shot himself. Tilla Durieux fled to Zagreb in 1934, where she lived until 1955; her own art collection is in the Zagreb City Museum (see Slavko Šterk, *Tilla Durieux und ihre Kunstsammlung im Museum der Stadt Zagreb* [Zagreb: Muzej Grada Zagreba, 2006]; and the excellent description online); for her long relationship with Paul Cassirer, see her lively memoir: Tilla Durieux, *Meine ersten neunzig Jahre: Erinnerungen* (Munich: Herbig, 1971).

21 From the Archive of the University of London, Senate House Library, London, UoL/VP/1/10/1. In this transcription the original punctuation is kept. We are grateful to Bernhard and Christa Buschendorf for identifying the original, first referred to by Bernhard Buschendorf in his 'Auf dem Weg nach England: Edgar Wind und die Emigration der Bibliothek Warburg'.

Figure 10.5: Edgar Wind, memorandum to the vice-chancellor of the University of London, 1933, first of seven pages. © Archive of the University of London, UoL/VP/1/10/1, Senate House Library, London.

also its concomitant; and all of them are referred to the History of those Social Customs which have come down from antiquity and find both expression and modification, in the medium of Art, Science and Religion. Also, those historians who are mainly concerned with antiquity, and

those whose main study is the modern period, find here a mediating institution; for, in tracing the classical tradition, the main stress is laid upon those periods of transition which (such as the Hellenistic and early Christian era, which mediates between the classical period and the Middle Ages, in the early Renaissance period, which mediates between the Middle Ages and modern times) give an opportunity to study the process of transformation at its critical points.

Equipment of the Institute

The Institute is equipped with a Library of some 60,000 books selected and arranged according to their relevance to the central problem of the classical tradition. The arrangement is such that, with regard to every specific phase of the problem (such as History of Legends or History of Festivals), the inter-connection between the different fields of research becomes evident.

The Institute also possesses a large group of photographs, the most important part of which is a complete collection of reproductions of Mediaeval illustrated manuscripts dealing with astrological and mythological matter. This material serves as a sort of pictorial encyclopedia for tracing the transmission and transformation of classical notions and symbols.

It is needless to say that both the books and the photographs are constantly supplemented by new material, as demanded by the research in progress.

Activities of the Institute

The Institute stimulates research on its own lines:

1. by directing post-graduate work; that is, advising students, supplying them with the materials (books and photographs)

 necessary for their studies, and enabling them, by small stipends, to make those travels which are necessary for their work. Thus, a community of studying has been established in Hamburg which, if possible, ought to be preserved.

2. by organising an annual series of lectures held by different scholars on different phases of one problem connected with our central theme (e.g. classical tradition in the drama, the religious motive of the Ascent to Heaven, some phases of classicism in England etc.). These lectures are delivered in the House of the Institute before a larger audience not confined to students only. They are published in yearly volumes.

3. by publishing those works which have been carried on our lines and have reached important results.

All these activities were carried on in close contact with the University of Hamburg. Two members of the Institute Staff were also members of the Philosophical Faculty of the University. On the other hand, those Professors of the University whose work coincided with one phase of the Institute (e.g. Philosophy, History of Art, Mediaeval literature, etc.) made it their custom to consult the Institute and to partake in its lectures and publications.

Reasons for removing the Institute from Hamburg

The present German government profoundly suspects any scientific enterprise, the subject and scope of which is professedly international. Now the problem of the survival of the classical tradition is distinctly such an international problem. It requires a scientific method which does not confine itself to one subject or one country alone, but is willing to enlarge its boundaries by co-operation with foreign scholars. On such lines the work of the Institute has been carried on in the past. It probably could not be carried on on these lines in the future without provoking a conflict with the government which insists that all forces should be concentrated on purely national issues.

One might question whether it might not be the best to face such a conflict and to influence the present development in Germany by co-operating with those scholars with whom the Institute has worked in the past. But such co-operation has been made impossible by the fact that almost all of these men have either been dismissed from their posts or have resigned their position in protest; so that the Institute, in continuing on its present lines, would have been condemned to move in a vacuum.

Reasons for removing the Institute to England, and to London in particular

England has most generously offered to provide (within the limits of its powers) for those scholars who have been dismissed for political or racial reasons and to secure somehow the continuation of their work. It is to England, therefore, that an Institution ought to be transferred which, in accordance with its past tradition, considers it as the main part of its programme to collect diverging scientific forces by concentrating them upon one problem, thus preventing them from being scattered.

However, besides these general considerations, there are two very specific ones which point to London as the best place for such enterprise;

1. The Institute could only function in a country which possesses a strong classical tradition of its own and to which the problem under discussion is therefore a vital one. The Institute has been very sensitive to the fact that England is such a country; and it has concentrated its forces in a fourfold form on English problems just recently; (a) by organising a series of lectures entirely dedicated to the classical tradition in England and worked out co-operatively by English and German scholars. (The volume was published

in 1932)[22] – (b) by encouraging Professor Cassirer to write his book on 'The Renaissance of Platonism in England', with special reference to the Cambridge School of Philosophers.[23] (This book was also published by the Institute). – (c) by preparing a catalogue of mythological and astrological manuscripts in the possession of British libraries. (This catalogue was worked out by professor Saxl and will be published by the Heidelberg Academy.)[24] – (d) by introducing, into the regular course of the University, lectures and seminars on English Aesthetics and English Art of the eighteenth century (These classes were conducted by Dr Wind who is carrying on research work on these lines).

2. The Institute can only function in a place where research Institutes of a corresponding nature exist with which it might co-operate. Being mainly concerned with the transmission of the classical inheritance, it is capable of supplementing but also needs for its own supplementation an Archaeological Institute which makes the classical work as such its proper domain. It will both need the co-operation of and offer co-operation to the Institute for Historical Research in London. And being interested in Art primarily in so far as it can be correlated to religious and literary documents and thus serve as a cultural symbol, it can, with great propriety, be supplemented by an Institute which, like the Courtauld Institute, treats Art for its own sake, – in fact the group of Institutes which

22 Fritz Saxl, ed., *England und die Antike: Vorträge der Bibliothek Warburg: 1930–1931* (Leipzig: Teubner, 1932), which contained Wind's 'Humanitätsidee und heroisiertes Porträt in der englischen Kultur des 18. Jahrhunderts', 156–229, now translated in Wind, *Hume and the Heroic Portrait*, ed. Jaynie Anderson.

23 First published as Ernst Cassirer, *Die platonischer Renaissance in England und die Schule von Cambridge* (Leipzig: Teubner, 1932), in the *Studien der Bibliothek Warburg*; and in translation (by James P. Pettegrove) as *The Platonic Renaissance in England* (Edinburgh: Nelson, 1953).

24 Published much later as Fritz Saxl and Hans Meier, *Verzeichnis astrologischer und mythologischer illustrierter Handschriften des lateinischen Mittelalters. III. Handschriften in englischen Bibliotheken*, ed. Harry Bober (London: Warburg Institute, 1953).

has been formed in connection with the London University seems to offer a proper place to an Institution which establishes an inter-connection between such diverging fields as the History of Science and the History of Religion, the History of Superstition and the History of Art.

Organisation in London

The ideal organisation of the Institute would imply:

1. that, while remaining a Research Institute with its own problems and methods, it should be attached to London University so that it may closely co-operate with the other Institutes.
2. that four members of its Scientific staff and, possibly, one trained Librarian should be transferred with the Institution, while the remaining technical Staff may be replaced.
3. that it should continue its present activities, that is,
 (a) training of postgraduate students (in not too large a number).
 (b) supplying them with the necessary materials of books and photographs, and small stipends for travel.
 (c) public lectures for wider audience delivered on one specific subject by different scholars and published annually.
 (d) publication of research work carried on on the problem of the Institute.
4. that, in connection with the scheme of providing for a number of German scholars who have been dismissed for political reasons, a number of Fellowships or Emergency Chairs should be established, with the Institute as their nucleus. This would secure the continuation, not only of the Institute as such, but also of the scientific community in connection with which it has worked in the past. This proposition has received the full approval of the Academic Assistance Council.

Cost of maintenance

The cost of maintenance (in which Article 4 of the last Section is not in-cluded) amounted – after the last reduction – to 105,000 marks (equals £7,000) annually. The Warburg family, in addition to transferring to London University the whole equipment of the Institute as a gift, might be prevailed upon to contribute annually for its maintenance a fraction of the sum mentioned above.

ELIZABETH SEARS

11 Edgar Wind and the 'Encyclopaedic Imagination'

In July 1943, one year into his brief period on the faculty of the University of Chicago, Edgar Wind drafted a proposal for a book series to be called 'Encyclopaedic Studies', which he hoped would be edited by the university's newly founded Committee on Social Thought, of which he was a member.[1] It began:

> The general public and the majority of scholars are equally unaware of the great trad-ition associated with the institution and the very name of Encyclopaedias. Contrary to the common belief that an encyclopaedia is nothing but a handy though some-what bulky instrument of reference, consisting of articles alphabetically arranged and therefore without any connection between them, the word *encyclopaedia* originally meant 'education in a cycle (or circle)' and referred to a harmonious organization of knowledge in which the different disciplines, reflecting and utilizing one another, were grouped around a common center. From classical antiquity down to the early nineteenth century this encyclopaedic tradition (in the original sense of the word) underwent a great variety of transformations but persistently reasserted, throughout all its changes, the underlying principle of a common 'universe of knowledge'.[2]

1 Edgar Wind, Memorandum, 'Encyclopaedic Studies', 1943, Bodleian Libraries, University of Oxford, Edgar Wind Papers (hereafter Bodleian, EWP), MS. Wind 8, folder 1. For the text of this and other archival documents, see Ianick Takaes de Oliveira, ' "L'esprit de Warburg lui-même sera en paix": A Survey of Edgar Wind's Quarrel with the Warburg Institute', *La rivista di engramma* 153 (February 2018), 109–82 (144–7). The material I present here is part of a larger study that I am completing: 'Warburg Circles, 1929–1964'.
2 Wind, Memorandum, 'Encyclopaedic Studies'.

Following upon this seemingly straightforward account of the afterlife of an ancient educational ideal, Wind went on the offensive, offering a barbed plea for a vital reorientation in academic study:

> It is only with the excessive growth of departmentalism in scholarship that the courage to pursue the encyclopaedic ideal abated and the ideal itself became suspect and was finally discarded as 'unscientific'. Yet regret alone will not help to overcome the impasse. It is necessary to revive the knowledge of those intellectual procedures, too willingly abandoned in recent years, which have produced encyclopaedic results in the past. By re-appraising their historical function and philosophic value, it is possible to train the mind in encyclopaedic thinking, thus helping to reawaken what might be called the encyclopaedic imagination.

'Encyclopaedic ideal', 'encyclopaedic results', 'encyclopaedic thinking', 'encyclopaedic imagination'. These are categories to keep in mind as we pursue Wind's thinking on training the intellect.

Though Wind's idea to launch a series of 'Encyclopaedic Studies' would never gain traction, through the very act of proposing it, he may be seen taking sides in a charged pedagogical debate. At the University of Chicago in just these years, the president of the university, Robert M. Hutchins, had been garnering praise and blame for thoroughgoing efforts to reshape the undergraduate curriculum. His broad aim was to counter early (and over-) specialization by means of a program of instruction that would provide a foundation for all further study, a program resting on lively discussion of large ideas contained in 'Great Books' of the Western tradition (Figure 11.1). Graduate training received attention as well. The Committee on Social Thought, which Hutchins founded in 1941–2, was tasked with creating and administering interdepartmental MA and PhD programs that emphasized 'interpretation, analysis, and general ideas' rather than mastery of facts.[3] Wind presented his series proposal at the end of his first year at Chicago, orally and then in written form. The economist John U. Nef, executive secretary of the Committee and Wind's staunch ally, wrote enthusiastically to William Benton in the vice-president's office, first bringing out a

3 'The Committee on Social Thought: Program of Studies, 1944–1945', Bodleian, EWP, MS. Wind 8, folder 2.

practical advantage, that the series would serve the larger mission of the Encyclopaedia Britannica: Benton had just been negotiating the purchase of the enterprise, which would soon, for a time, be edited with advice from the Chicago faculty.[4] But Nef also alluded to the 'special significance' that the project would have at Chicago, for, as he emphasized, the object of Wind's series was 'to bring out the importance of the interrelationships between all branches of knowledge and to emphasize the unity of learning and scholarship as a whole'.[5]

That Wind was in earnest is suggested by the practical cast of his proposal. He envisaged as many as two or three volumes appearing yearly and estimated the annual costs at $12,000. Authors (including himself) were to be given $600 up front in lieu of a share of royalties, irrespective of the length of the volume. He came up with a list of twenty-six possible topics: a 'Windian' list, in accord with his intellectual passions. He moved through the Western tradition from Plato's *Symposium* through medieval genres to the Renaissance and then focused on French, English and Italian milieus of the seventeenth to nineteenth centuries. He named potential authors for about half the proposed volumes, including two among his current colleagues, Richard McKeon and Mortimer Adler, both involved in Chicago's Great Books program. This was his list:

> The Greek Symposium and its Relation to the Encyclopaedic Tradition (Cornford)
>
> Isidore of Seville and the Origins of the Mediaeval Encyclopaedia (McKeon)
>
> Theory and History of the Mediaeval *Summa* (Maritain, Adler)
>
> Theory and History of the Mediaeval *Speculum*
>
> The Pictorial Illustrations of Mediaeval *Encyclopaedias* (Saxl)
>
> The Sculptured Encyclopaedias on French Cathedrals (Panofsky)

4 See the online finding aid, University of Chicago Library, 'Guide to the Encyclopaedia Britannica, Inc., Board of Editors Records 1949–1968', 2009, University of Chicago, Hanna Holborn Gray Special Collections Research Center, <https://tinyurl.com/3wrutvsr>, accessed 22 June 2023.

5 John U. Nef to William Benton, 19 July 1943, Bodleian, EWP, MS. Wind 8, folder 1. In his reply of 4 August 1943, Benton showed himself concerned about cost ($100,000) and wondered if a single survey of the encyclopaedic tradition might serve the Britannica quite as well as a series of 20–5 monographs.

Figure 11.1:　Robert M. Hutchins and Great Books, 1948. © University of Chicago Photograph Library (apf1-05140), Hanna Holborn Gray Special Collections Research Center, University of Chicago Library.

Iconography of the Seven Liberal Arts

Mirror and Microcosm (in the philosophical, medical and pictorial tradition) (Temkin)

Plan, Use, and History of the *Ars Memorativa* (Artin)

Pico della Mirandola's *Nine Hundred Theses* and Politian's *Pan-epistemon* (Kristeller)

The Renaissance Encyclopaedia in Raphael's Frescoes (Wind)

The Academies of Henri III (Yates)

The 'School of Night' and other Elizabethan Academies (Chew)

Encyclopaedic Patterns in English Political Clubs (Kit Cat Club, Bolingbroke's Circle, etc.)

The Encyclopaedia of the Arts in the Circle of Samuel Johnson (Reynolds – Garrick – Goldsmith)

Archaeological Research and Conviviality in the *Society of the Dilettanti*

Italian Academies and their Encyclopaedic Plans in the Sixteenth and Seventeenth Centuries (Crusca, Lincei, Virtuosi, etc.)

Universal History in the Seventeenth Century (Mommsen)

Leibniz' *Mathesis Universalis* in its Relation to his Doctrine of Pre-established Harmony

The Magic Flute: Free-Masonry in the Eighteenth Century

Voltaire's *Dictionnaire Philosophique* in its Purpose and Historical Mission

Plan and History of Diderot's Great *Encyclopédie*

Encyclopaedic Novels from *Wilhelm Meister* to *Bouvard et Péchuchet* (Seznec)

Humboldt's *Cosmos* (Nichols)

The Growth of Lexicography and the Decline of the Encyclopaedic Ideal

A History of Scientific Illustration (from Leonardo da Vinci to Darwin)

Three of the volumes, Wind noted, were already in progress. Significantly enough, the authors of all three hailed from the Warburg Institute: Fritz Saxl, its director; Frances Yates, soon to be appointed editor of publications; and Wind himself, deputy director since 1934, caught in the United States in 1939 at the outbreak of war. Thus it is to Wind's work in the Warburg circle in Hamburg and (after the library's Nazi-era transfer) in London that we first turn. In that *enkyklopaideia* was a Greek educational ideal that Wind regarded as relevant to debates on curricular reform, we will have occasion, too, to consider his longstanding, under-scrutinized involvement in experimental pedagogy, which began during the years he spent in the United States as a young philosopher, 1924–7.

My argument will be that the concept and model of the 'encyclopaedic' stand at a nexus in Wind's thinking and that they relate to and illuminate other aspects of his thought. The 'encyclopaedic' may be considered a factor in his growing interest in the power of the imagination [*Einbildungskraft*] and the awakening (and harnessing) of ideas; it takes us to the tension in his work between the theoretical and the historical, the conceptual and the concrete; and it shows him as a polemicist and provocateur. Moreover, it throws light on his consequential decision to sever ties with the Warburg Institute in 1945, for a major impetus lay in his intense opposition to a proposal from Saxl for an 'encyclopaedic' project quite different in orientation (also destined to fail). Saxl aimed to enter directly into the tradition of encyclopaedia production

by overseeing the creation of an 'Encyclopaedia of the Middle Ages and the Renaissance', one that would provide ready access to advances in twentieth-century scholarship as a service to 'scholars, senior university students and teachers of history'.[6] Wind's goal was rather to encourage historical reflection on problems in the organization of knowledge, so as to develop models for stimulating creative thought among a similar clientele.

Library logic

When Wind joined the staff of the Kulturwissenschaftliche Bibliothek Warburg (KBW) in February 1928, it was to work as an *Assistent* in the library, his hours adjusted so that he would have time to complete his habilitation thesis in philosophy ('Experiment and Metaphysics'). While conversations with Aby Warburg, lengthy and profound, would affect his entire scholarly trajectory,[7] daily work at the library had its effect as well. Here his task was precisely one of contemplating the 'harmonious organization of knowledge' as he determined the physical place of books within an intellectual armature that he would come to call 'encyclopaedic'. It was an armature that functioned to guide and stimulate research, thus, one might say, to activate the 'encyclopaedic imagination'.

Wind first met Aby Warburg late in the scholar's life, in June 1927, yet he knew the library from before, having made use of its holdings when preparing his doctoral dissertation, 'The Object of Analysis in Art Theory and Aesthetics'. Already Wind was working between two fields, art history and philosophy: when the dissertation was submitted in July 1922 at the

6 Fritz Saxl, 'Project of an Encyclopaedia of the Middle Ages and the Renaissance', 1945, London, Warburg Institute Archive (hereafter WIA), Saxl papers, 'Encyclopaedia'.

7 To start: Bernhard Buschendorf, '"War ein sehr tüchtiges gegenseitiges Fördern": Edgar Wind und Aby Warburg', *Idea: Jahrbuch der Hamburger Kunsthalle* 4 (1985), 165–209; most recently, Bernardino Branca, *Edgar Wind, filosofo delle immagini: La biografia intellettuale di un discepolo di Aby Warburg* (Milan: Mimesis, 2019).

new University of Hamburg, it was examined by both Erwin Panofsky and Ernst Cassirer.[8] Warburg was then absent, having suffered his post-war mental breakdown; by the time he returned to Hamburg in August 1924, Wind had decamped to the United States for four years. In the summer of 1927, with his American wife, Ruth Hatch Wind, Wind visited the library in Hamburg in its new quarters (Figure 11.2), and Warburg himself gave the couple a tour. Every tour doubled as a test. The visitors showed a gratifying degree of sympathetic understanding, leading Warburg to conclude: 'Herr Wind is a type of thinker of the very best sort.'[9] When Wind, in the fall of 1927, then teaching at the Cooper Union in New York City, decided to return to Hamburg, it was Saxl's idea to lure him to the library.[10] Warburg was impatient: 'When is Wind coming?' he inquired one January day in 1928.[11]

Gertrud Bing, scholarly assistant to Warburg in his later years, first oriented Wind in the library's workings. On the morning of 4 February 1928, she took him through, seeking to impress upon him the significance, range, subtleties and difficulties of the task before him. She held off explaining the mysteries of the signature system, focusing rather on the 'inner connections' among the books. Wind, she noted in the institutional diary, showed great understanding of the second floor – the floor then devoted to 'Orientation' (Symbols, Religion, Magic, Cosmology, Philosophy) – which 'occasioned great joy' for both. He said little, though always with understanding and an appreciation for the 'clarity and inner cohesion of the organism'.[12] By April she could acknowledge with pleasure that Wind's

8 Edgar Wind to Fritz Saxl, 2 September 1921, WIA, General Correspondence (hereafter WIA, GC) – Wind.

9 Aby Warburg, entry in the diary ('Tagebuch') of the Kulturwissenschaftliche Bibliothek Warburg, 25 June 1927, as published in Aby Warburg, Gertrud Bing and Fritz Saxl, *Tagebuch der Kulturwissenschaftlichen Bibliothek Warburg*, ed. Karen Michels and Charlotte Schoell-Glass, Aby Warburg, Gesammelte Schriften, vol. VII (Berlin: Akademie, 2001) [hereafter *Tagebuch*], 104: 'Herr Wind ist eine Denktype bester Sorte.'

10 Aby Warburg, 17 January 1928; *Tagebuch*, 182.

11 Aby Warburg, 20 January 1928; *Tagebuch*, 184.

12 Gertrud Bing, 4 February 1928; *Tagebuch*, 190.

Figure 11.2: Reading Room of the Kulturwissenschaftliche Bibliothek Warburg,
Hamburg, 1926. © Warburg Institute, University of London.

feeling for logical structure was everywhere apparent.[13] He made explicit his
debt to working in the Warburg circle at the end of the autobiographical
statement he submitted with his habilitation thesis (accepted in November
1930): 'The research pursued at this Institute, above all the linking of aes-
thetic and cosmological problems, has had decisive influence on my own
method of work.'[14] His success in probing the library's premises would later
be recalled in extravagant terms by Raymond Klibansky, historian of phil-
osophy, a member of the KBW inner circle in the 1920s who had played

13 Gertrud Bing, 2 April 1928; *Tagebuch*, 233: 'Eine sichere Besonnenheit und Gefühl
 für sinngemäßen Aufbau überall spürbar.' On 5 June, Bing noted that Wind had
 reordered modern philosophy 'superbly' (*Tagebuch*, 268).
14 Edgar Wind, 'Lebenslauf', Bodleian, EWP, MS. Wind 2, folder 2.

his part in rationalizing sections of the library: 'It is to Edgar Wind, who arrived in 1927, that the theoretical foundations of the library's organization are owed, the formulation of the very concept of *Kulturwissenschaft*.'[15]

In the turbulent years following Warburg's death on 26 October 1929, Depression-era budget crises and the brutalities following upon the Nazi *Machtergreifung* compelled the staff to seek a route out of Germany.[16] The clear-thinking Wind, eloquent in several languages (German, French, English), would find himself, often enough, preparing mission statements, laying out the library's rationale. In a memorandum of 1933, in English, supporting the transfer of library and staff to London (adapting a text he had prepared in German for the Italians in 1932), he would describe the Warburg Library as an 'intellectual laboratory for studying the survival of the classical tradition within European civilisation' and define its method as one of 'interconnecting all those cultural sciences which are usually treated independently'.[17] By 1935 he was making explicit use of the concept of the encyclopaedic in his explanations: 'Within that specialized field of cultural history and psychology which is circumscribed by the "Survival of the Classics," the Library endeavours to be encyclopaedic; i.e. it interconnects such seemingly independent subjects as the history of art, of science, of superstition, of literature, of religion, etc.'[18]

15 Klibansky recalled helping to order the sections 'Philosophy', 'Classical Antiquity' and 'Encyclopaedia'. Michèle Le Doeuff, 'Archéobibliographie: Raymond Klibansky. Périple d'un philosophe illustre', *Préfaces: Les idées et les sciences dans la bibliographie de la France* (1989), 136–7.

16 Lucas Burkart, ' "Die Träumereien einiger kunstliebender Klosterbrüder … "': Zur Situation der Kulturwissenschaftlichen Bibliothek Warburg zwischen 1929 und 1933', *Zeitschrift für Kunstgeschichte* 63/1 (2000), 89–119.

17 Edgar Wind, 'Denkschrift für die Italiener' (typescript, 1932); English recension (1933) inscribed 'Dr. Wind' and, in Wind's hand, 'Ursprüngliche Fassung', WIA, GC – KBW1933.

18 Edgar Wind, 'The Warburg Institute Classification Scheme', *The Library Association Record* 4/2 (May 1935), 193–5 (193).

When Wind, and other Warburgians, drew an analogy between the library and the encyclopaedia, they were thinking not of A–Z encyclopaedias, but of those pre-modern repositories of knowledge in which information was ordered systematically according to a conception of the world order. To be sure, A–Z compendia were to be found in the KBW Reading Room (Figure 11.3). Warburg, it was said, 'treasured, indeed revered virtually all learned hand tools: reliable reference works, special lexica'.[19] On a card from his personal files on the 'encyclopaedia', he can be seen classifying encyclopaedias by type (Figure 11.4). A distinctive feature of his encyclopaedic library was attention paid to the long history of the genre. Librarians purchased not only modern reference books but editions and analyses of pre-modern compendia. The genre would serve as both a focus of historical research and a source for problem-based study, diachronic and synchronic. Precisely because encyclopaedists regularly drew from previous compilations, the works furnished a means to track the transmission of ideas and images, preserving links in a chain extending back to antiquity. Equally, each new assemblage had the potential to reveal an altered world view: the massive effort of gathering, organizing and harmonizing useful knowledge was undertaken, it was seen, at given times for particular audiences, to satisfy culturally specific ends. This was a historical phenomenon manifest in the present.

The 1920s and 1930s saw the politicized production of vast A–Z encyclopaedias. In Italy between 1925 and 1936 a learned team under the direction of Giovanni Gentile compiled the *Enciclopedia italiana* [Italian Encyclopaedia of Science, Letters, and Arts] in thirty-five volumes. Between 1926 and 1947 specialists under the direction of Otto Yulievich Schmidt collectively prepared the Great Soviet Encyclopaedia [*Bol'shaia sovetskaia entsiklopediia*] in sixty-five volumes. In France in 1932, the *Encyclopédie française* was founded under Anatole de Monzie, French minister of national education, in response to parallel nationalist efforts.[20] Here Wind

19 Carl Georg Heise, *Persönliche Erinnerungen an Aby Warburg* (1947), ed. Björn Biester and Hans-Michael Schäfer (Wiesbaden: Harrassowitz, 2005), 14.
20 Hélène Harvitt, 'The Spirit of the Encyclopédie Française Permanente', *The French Review* 8 (May 1935), 481–5.

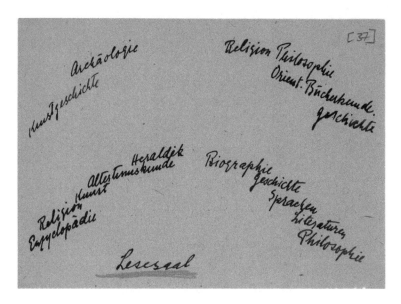

Figure 11.3: Gertrud Bing, diagram of the arrangement of reference books in the Reading Room of the Kulturwissenschaftliche Bibliothek Warburg, Hamburg, c. 1926. © Warburg Institute, University of London.

stepped in. In London, as deputy director, he became creatively involved in organizing lecture series, and in 1935 he invited de Monzie to speak on 'L'idée encyclopédique'. Although de Monzie's assistant would, in due course, loftily renege on the minister's behalf, Wind's efforts are telling: he saw the topic as 'urgent', open to investigation in the light of the philosophy of history.[21]

A few years later, Wind would organize an entire lecture series around the concept of the encyclopaedia – an effort that would prove to be among his last at the Warburg Institute. The timing was significant. On 16 February 1939, after a frustrating two-year hiatus, the Institute was at last able to reopen in its second London home, a wing of the Imperial Institute

21 Edgar Wind to Anatole de Monzie, 16 July 1935, WIA, GC – de Monzie.

Figure 11.4: Aby Warburg, index card identifying classes of encyclopaedia:
cosmological (philosophical, theological, scientific, astrological) and specialist
(scientific, historical), n.d. Warburg Institute Archive, Kasten 7. © Warburg Institute,
University of London.

Buildings in South Kensington (Figure 11.5).[22] The public needed to be
reminded of the library's distinctiveness, and the concept of the 'encyclo-
paedic' was chosen as the means. Five scholars spoke, each delivering a short
series (a 'course'), one lecture per week during a single month (February–
March, May–July). Two speakers were British affiliates (Anthony Blunt
and E. K. Waterhouse); the others were émigrés on the Institute staff:

Illustrated Mediaeval Encyclopaedias – Fritz Saxl

The Classical Heritage

22 'Warburg Institute Reopened', *The Times* (17 February 1939), 11; 'Lectures by
 Members of the Warburg Institute, February–July 1939', copy of brochure pre-
 served in Bodleian Libraries, University of Oxford, Archive of the Society for the
 Protection of Science and Learning, MS. SPSL 131/3–4, 389–90.

Figure 11.5: Reading Room, Warburg Institute, Imperial Institute Buildings, London, c. 1952. © Warburg Institute, University of London.

The Christian Transformation

The Renaissance Encyclopaedia in Raphael's Frescoes – Edgar Wind

The School of Athens

The 'Parnassus' and the 'Disputà'

The Concordance of Justice and Peace

The French Encyclopaedists and the Arts – Anthony Blunt

The Encyclopaedists and their Predecessors

Diderot and the Encyclopaedists

Diderot's Literary and Artistic Theories

Eighteenth Century British Painting and the Thought of the Encyclopaedists – E. K. Waterhouse

Sir Joshua Reynolds and his Discourses

Gainsborough in the Light of the Encyclopaedists

The Conception of Nature in British Art of the Eighteenth Century

Universal History in the Arts – Rudolf Wittkower

Mediaeval Schemes of History

Italian Picture Chronicles of the Renaissance

Illustrated Cosmographies

Saxl's and Wind's arguments are recoverable: Saxl's because his lectures were posthumously published, Wind's because he stayed true to method as he worked toward a never-completed book on Raphael's *School of Athens*. Their approaches, offering different takes on 'the Warburgian', imply distinctive notions of the 'historical function and cultural value' of the encyclopaedic genre.

Encyclopaedic studies: Saxl vs Wind

Saxl introduced his 1939 talk 'Illustrated Mediaeval Encyclopaedias' with these words:

> It was my friend Edgar Wind who suggested that we should open our courses in this new building with a series of lectures on the history of encyclopaedias. It is indeed not easy to find another subject more comprehensive than this in the whole storehouse of problems concerning classical tradition, nor one more ambitious to attempt, so little has it been studied.[23]

23 Fritz Saxl, 'Illustrated Mediaeval Encyclopaedias', in Fritz Saxl, *Lectures*, 2 vols (London: Warburg Institute, University of London, 1957), vol. 1, 228–41. The original typescript of Saxl's talks, containing this first paragraph, is preserved in the WIA among his papers on encyclopaedias.

Saxl's interest in the genre was longstanding. In his very first meeting with Warburg in 1910, as Bing would later write, he had been fascinated by Warburg's *Wanderkarte*, his map of the routes by which astrological images and texts had travelled westward as relics of earlier explanations of the universe: 'senselessly scattered leaves torn from lost Hellenistic encyclopedias'.[24] In the years following, with the backing of Warburg and Franz Boll, he would embark on a long-term project to prepare works of reference: catalogues of illustrated astrological and mythological manuscripts, beginning with those housed in Roman libraries.[25] Warburg's notes of 1911–14 show the two delighted by Saxl's discoveries of information-rich encyclopaedic compendia.[26] In 1923, during Warburg's absence, Saxl arranged for Adolph Goldschmidt – Warburg's friend, professor of art history at Berlin – to repeat at the KBW a lecture he had delivered in Berlin, entitled 'Early Medieval Illustrated Encyclopedias'.[27] And in the fateful summer semester of 1933, during which 'non-Aryans' were first dismissed from teaching, Saxl and Panofsky had planned to co-teach a seminar at the KBW, for advanced students, precisely on encyclopaedic imagery [*zum enzyklopädischen Bilderkreis*].[28]

In 1939 in London Saxl returned to the topic and set out to prove a hypothesis that Goldschmidt had rejected in 1923, namely that it was possible to posit the existence of a densely illustrated copy of the earliest surviving Latin encyclopaedia: Bishop Isidore of Seville's ever-popular, seventh-century compendium, the *Etymologies*. Proof, for Saxl, lay in an

24 Gertrud Bing, 'Fritz Saxl (1890–1948): A Memoir', in D. G. Gordon, ed., *Fritz Saxl, 1890–1948: A Volume of Memorial Essays from His Friends in England* (London: Nelson, 1957), 1–46 (5–6).

25 Fritz Saxl, *Verzeichnis astrologischer und mythologischer illustrierter Handschriften des lateinischen Mittelalters in römischen Bibliotheken* (Heidelberg: Carl Winter, 1915).

26 Aby Warburg, notes, 1911–14, WIA, Kasten 7.

27 Fritz Saxl to Adolph Goldschmidt, 6 February 1923, WIA, GC – Goldschmidt, on the talk that became Goldschmidt's essay 'Frühmittelalterliche illustrierte Enzyklopädien', *Vorträge der Bibliothek Warburg, 1923–24* (Leipzig: Teubner, 1926), 215–26.

28 Hamburgische Universität, *Verzeichnis der Vorlesungen* (Sommersemester 1933).

extant manuscript. This was an illustrated eleventh-century south Italian copy of a ninth-century encyclopaedia, *On the Nature of Things*, compiled in the Germanic north by Rabanus Maurus, monk of Fulda. Rabanus had based his encyclopaedia on Isidore's earlier work (rearranging and supplying Christian commentary on selected entries). Saxl posited that an illuminator of Rabanus' text had done much the same. That is, not only had the eleventh-century Italian illuminator copied the image cycle from a now-lost Rabanus manuscript, but the ninth-century illuminator had constructed a cycle by selecting from a now-lost illustrated Isidore. To prove his hypothesis (and thus help to chart the transmission of profane imagery from antiquity), Saxl worked systematically through the south Italian pictorial cycle, matching the medieval pictures with antique images, discovering all manner of authentic details, often misunderstood, not to be accounted for by the adjacent text. Thus, to give one example, only the existence of an illustrated Isidore would explain how a northern illuminator might know that Dionysus should hold a bowl. For Saxl, this was but a first step in a larger inquiry. In his second lecture he analysed two twelfth-century encyclopaedias of a 'new type': illustrated works by Lambert of St Omer and Herrad of Landsberg. These were created in an era 'when learning and the arts started afresh', with the retrieval of lost classical sources via Spain (including the texts of Aristotle) and southern Italy. On the basis of his research, Saxl drew inferences about the cultural function of the genre, which he saw as twofold: preserving the old and stimulating the new.

> As a rule encyclopaedias do not contain original research; they are intended for the use of a wide public. They are indicative of the fact that a period of learning is approaching its end, and that the desire is felt to see the achievements of the past recorded, in order that such records may be made accessible as a basis for new and different investigations. It is not so much the information which encyclopaedias contain which makes their history an interesting topic; rather, their significance lies in the fact that at a certain time there arises the need for a new encyclopaedia, in the

author's selection of material from the contributions of earlier scholars and in the system by which he welds them into unity.[29]

Wind was never much interested in tracking the *Wanderstrassen* of ideas and images, later declaring himself 'averse to the type of historical thinking which traces a motif *à travers les ages* and ends by becoming lost in the mazes of its own relativism'.[30] He had come to know Warburg at a time when the scholar was earnestly seeking to extract principles from his earlier historical research. Wind would find inspiration in Warburg's methodological demonstrations, notably in his decipherments of pictorial programs and his explorations of creative exchange among artists, patrons and thinkers in elite circles in quattrocento Italy (Medici, Este, Malatesta). In the 1930s Wind turned to cinquecento Italy as he embarked on the study of the theological and philosophical sources of Michelangelo's Sistine ceiling and Raphael's *Stanza della Segnatura*, programs that he investigated in the light of what was thought and thinkable in the circle around Pope Julius II.[31] The work would confirm him in his conviction that ideas spark the artistic imagination, that 'great artists have always been intellectually quick'.[32] In 1939 in London he set out to reveal 'The Renaissance Encyclopaedia in Raphael's Frescoes'.

Wind posited a fourfold program, extending from walls to pendentives to the ceiling vault,[33] hypothesizing that the ancient model of

29 Fritz Saxl, notes, 1939, WIA, Saxl papers, 'Encyclopaedia'. These include notes on Casanatense 1404, the basis of Saxl's wartime article 'A Spiritual Encyclopaedia of the Later Middle Ages', *Journal of the Warburg and Courtauld Institutes* 5 (1942), 82–142.

30 Wind, 'Report 1939–1945', Bodleian, EWP, MS. Wind 7, folder 2; Takaes de Oliveira, 'L'esprit', 163–7.

31 Wind treated both programs in his Chichele Lectures, delivered in 1954 at All Souls College, Oxford ('Art and Scholarship under Julius II'), which would lead to his being named the first professor of art history at the university, in 1955. See Bodleian, EWP, MS. Wind 12, folder 1.

32 Edgar Wind, *Art and Anarchy* (3rd edn, London: Duckworth, 1985), 52.

33 Edgar Wind published two brief notes: 'Platonic Justice, designed by Raphael', *Journal of the Warburg Institute* 1 (1937–8), 69–70; and 'The Four Elements in Raphael's "Stanza della Segnatura"', *Journal of the Warburg Institute* 2 (1938–9), 76–9. The drafts for the incomplete book have been made available in Bernardino

encyclopaedic learning governed the whole. In chapters drafted about 1950, he gave prominence to Raphael's friend Celio Calcagnini. This polymath suggested that the liberal arts 'are so linked together by mutual bonds that none of them can subsist without the aid of the other' and maintained: 'Nor is it possible that anyone should master one of these arts to perfection without becoming informed with some parts of the others.' Wind would find the encyclopaedic ideal enshrined in Calcagnini's statement: 'Hence it will be found to be a true saying that no discipline probes its own principles. For it seeks aid from the one next to it and nearest in kind, and demands to be enlightened by extraneous rays (*alienis radiis*).' In this draft he would restate ideas dating to the late 1930s: 'An encyclopaedic scheme emerges [...] which shows that Philosophy was regarded as "translatable" into Theology, Poetry, and Jurisprudence.'[34] The contemplation of the encyclopaedic ideal would inform Wind's interventions into curricular reform in Chicago in 1943, as would his longer history of participation in educational experiments.

Training the mind

When in August 1939 Wind departed for the United States, it was to teach for a semester at St John's College in Annapolis, Maryland. The invitation had come from his smart, quirky friend Scott Buchanan, who had been recruited away from the University of Virginia in 1937, along with

Branca, ed., *Edgar Wind's Raphael Papers: The School of Athens* (Wroclaw: Amazon KDP, 2020). See Pascal Griener, 'Edgar Wind und das Problem der *Schule von Athen*', in Horst Bredekamp, Bernhard Buschendorf, Freia Hartung and John Krois, eds, *Edgar Wind: Kunsthistoriker und Philosoph* (Berlin: Akademie, 1998), 77–103 (stressing the 'encyclopaedic' dimension); and Giovanna Targia, 'Détails et hypothèses: Edgar Wind, Aby Warburg et L'École d'Athènes de Raphaël', *Revue germanique internationale* 28 (2018), 69–86.

34 Edgar Wind, application for a Guggenheim Fellowship, 1950, Bodleian, EWP, MS. Wind 216, folder 1.

Stringfellow Barr, to save the small liberal arts college (Figure 11.6). The two reformers (who first met in Oxford as Rhodes scholars in 1919) had been appointed dean and president respectively. At Virginia they had discussed (unrealizable) curricular change. Arriving at St John's, they implemented reform with remarkable dispatch. Now they could experiment with alternatives to the American 'elective' system, in which, unguided, university students took any course in any order, behaving much like customers in a department store. The stakes were high: a liberal education, they felt, was desperately needed in a time that was witnessing the rise of totalitarian regimes in Europe.[35]

Wind had come to know Buchanan and Barr during his first American phase, as well as their colleagues in reform, Richard McKeon and Mortimer Adler, then on the faculty at Columbia University. In those years he had entered philosophical circles, speaking, writing, immersing himself in pragmatist philosophy, and learning to teach. At the University of North Carolina, Chapel Hill, as a postdoctoral fellow and instructor, he had developed a course array: Greek Philosophy, Modern Philosophy, Philosophy of Science, and Ethics and Philosophy of Fine Arts.[36] He gave some lectures at Columbia, where an undergraduate honours course in Great Books had been launched,[37] and this led to his participation in another sort of experiment: in 1925 he taught at a summer school for working women at Miller's Place, Long Island, there successfully instructing students in ways of looking at art.[38]

35 Charles A. Nelson, *Radical Visions: Stringfellow Barr, Scott Buchanan, and Their Efforts on Behalf of Education and Politics in the Twentieth Century* (Westport: Bergin & Garvey, 2001); on the 'New Program' at St John's College, see Introduction and Chapters 1 and 5.

36 Nora G. Esthimer (University of North Carolina) to Margaret Wind, 20 February 1979, Bodleian, EWP, Wind MS. 1, folder 7.

37 Nelson, *Radical Visions*, 39–42.

38 On the summer school, supported by the NLGC (National League of Girls' Clubs), its experimental structure (four discussion topics approached from different disciplinary perspectives: 'Women and Society', 'Group Life', 'Our Changing Moral Code', 'Social Progress'), and Wind's teaching there, see Nathaniel Peffer, *New Schools for Older Students* (New York: Macmillan, 1926), 93–8. Wind would return to Long Island to teach in the summer of 1928, after joining the staff of the Warburg Library.

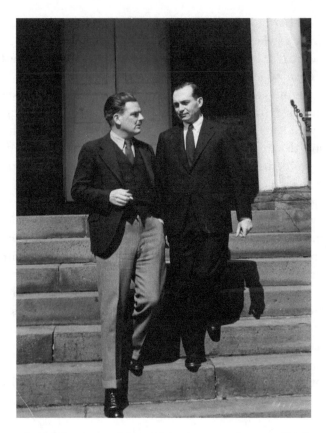

Figure 11.6: Stringfellow Barr and Scott M. Buchanan on the steps of McDowell Hall,
St John's College, Annapolis, Maryland, 1940. © St John's College Digital Archives,
SJC-P-0011.

Soon he was teaching at the People's Institute at the Cooper Union in
New York, invited by young Scott Buchanan, its assistant director. This was
a school committed to offering workers and immigrants access to higher
education. From a description of 1926: 'For over half a century the Cooper
Union has given, in order to advance Science and Art, education to over
200,000 men and women, regardless of race or creed, without money and

without price.'[39] In 1927–8, just before starting in Hamburg, Wind taught the 'Philosophy of Physics' to these non-traditional students.[40]

At the KBW Wind would endeavour to bring his American experience to bear. A first idea was to invite Buchanan, should he win a Guggenheim Fellowship, to spend time at the library coming to know Warburg.[41] This plan fell through (nor was the alternative, to invite Richard McKeon, pursued), but, locally, Wind promoted Buchanan's first book, *Possibility* (1927), making certain that both Warburg and Cassirer had it in their hands.[42] The study had originated as a Harvard dissertation, one that Alfred North Whitehead approved and John Dewey reviewed favourably ('a first-class piece of much needed intellectual work').[43] In its opening chapter Buchanan considered a theme that would begin to attract Wind forcibly, that of the 'intellectual imagination':

> One of the most puzzling affinities in human thought is the free play of the imagination in harmony with the concepts of understanding. It is a commonplace that scientists as well as poets happen upon the clues to their discoveries in their day dreams. It is also to be noted that one of the most significant differences between minds is in the uses made of such imaginings.[44]

In September 1929, Wind was able to show Warburg a copy of Buchanan's second book, *Poetry and Mathematics*, and Warburg 'had great hopes for it'.[45] This book was itself an offshoot of Buchanan's

39 *The Cooper Union, Sixty-Sixth and Sixty-Seventh Annual Reports* (1 July 1926), 17. The text continues: 'Its Founder, Peter Cooper, a mechanic of New York, wished to give others opportunity for self-improvement which he had been denied.' It was stressed that '*all* the various schools of science and art, the reading rooms and lectures, are *free* to those profiting by them.'

40 Edgar Wind, 'Lebenslauf', Bodleian, EWP, MS. Wind 2, folder 2.

41 Aby Warburg, 20 and 23 September 1928; *Tagebuch*, 343, 344.

42 Edgar Wind to Aby Warburg, 13 October 1928; 13 March and 30 April 1929, WIA, GC – Wind.

43 John Dewey, 'Things, Thought, Conversation', *The Nation* 126 (18 April 1928), 449–50, also treating Mortimer Adler's *Dialectic*.

44 Scott Buchanan, *Possibility* (New York: Harcourt Brace, 1927), 17.

45 Aby Warburg, 10 September 1929; *Tagebuch*, 523.

cross-disciplinary teaching at Cooper Union,[46] and thus, it might be said, a striking demonstration of encyclopaedic thinking. When the invitation came to teach for a semester at St John's College in 1939, Wind was unlikely to reject it.

Buchanan and Barr had together set up a bold four-year program of study, one based on tutorials, seminars, laboratory work and occasional lectures. Undergraduates, learning languages all along, moved through great ideas approached not through textbooks but through primary sources, seminal texts in the Western tradition across domains of knowledge. They moved logically, largely chronologically, from idea to idea: Euclid in the first year, Einstein in the fourth. Disciplinary divisions ceased to exist. All faculty members were expected to teach the entire curriculum (some would promptly resign).[47] Buchanan would have seen Wind as fitting right in.

The timing of the visit was less than propitious. Wind arrived in the United States at the end of August 1939; England and France declared war on Germany in the first days of September. He taught for the semester, charmed by Annapolis but unsettled by the 'American way of Life' in wartime, hoping for an early return to Europe.[48] At semester's end he remained in the United States, teaching at New York University, beginning to lecture around the country, and working on behalf of the Warburg Institute. His efforts bore fruit, not least his success in securing an invitation in 1940 (subsequently declined) for the Warburg Institute to transfer to Washington, DC, for the duration of the war.[49] His lectures brought him celebrity, and he came into his own as a public intellectual.[50] In 1939 McKeon, dean of humanities at the University of Chicago, invited him to lecture (Wind's topic: 'The Philosophy in Raphael's Frescoes').[51] By 1941 the idea of his

46 Nelson, *Radical Visions*, 35–6; McKeon and Adler attended Buchanan's lectures, which led to discussion of basing a curriculum on the rediscovered seven liberal arts.
47 Nelson, *Radical Visions*, 4–5.
48 Edgar Wind to Rudolf Wittkower, 5 October 1939; Edgar Wind to Fritz Saxl, 6 October 1939, WIA, GC – Wind. In the latter he wrote: 'Buchanan is as delightful as ever, but a little tired and at heart convinced of the futility of his enterprise.'
49 On Wind's activities, see *Warburg Institute Report, June 1940 – August 1941*, 3–4.
50 Jean Seznec to Fritz Saxl, 17 July 1942, WIA, GC – Seznec.
51 Richard McKeon to Edgar Wind, 1 November 1939, Bodleian, EWP, MS. Wind 8, folder 1.

joining the faculty had been raised. He would be appointed professor in the Department of Art at Chicago as of 1 October 1942, with the strong backing of Hutchins.[52] Once again he was teaching in an environment where curricular reform was at issue and departmentalism was under scrutiny.[53] The debates were ferocious and extended well beyond Chicago. A chance survival – a copy of an anti-Hutchins pamphlet with vehement annotation by a pro-Hutchins reader – graphically demonstrates the intensity of feelings aroused (Figure 11.7). The pamphlet was published by Harry D. Gideonse, associate professor of economics at Chicago.[54] In it he argued passionately against what he saw as Hutchins' desire to impose an outmoded Platonic-Aristotelian-Thomistic tradition of thought, to deny Cartesian thinking, to disallow scientific method. The anonymous reader attacked the text with underlines, asterisks, question marks and comments. The lengthiest diatribe, handwritten, falls in line with Wind's kind of thinking:

> This author has said nothing to refute Hutchins and has overwhelmingly misunderstood Hutchins' references. Hutchins refers to comprehension of thoughts and ideas rather than fact gathering chores and procedures; for Hutchins believes that a sound education into theory – disproven, proven and proposed – is best, and better than a 'vocational' training in how to run experiments. The assumption Hutchins makes is that a sound general education – theoretical education – will allow the student to develop his–her own experiment in order to test hypotheses. This author has missed the point. Rather he defends his position – the position Hutchins refutes – by failing to abstract the true hypothesis of Hutchins' writings.

52 Richard McKeon to Edgar Wind, 3 December 1941; Board of Trustees to Wind, 24 February 1942, Bodleian, EWP, MS. Wind 8, folder 1.

53 For Wind at Chicago, see Rebecca Zorach, 'Love, Truth, Orthodoxy, Reticence; or, What Edgar Wind Didn't See in Botticelli's *Primavera*', *Critical Inquiry* 34/1 (2007), 190–224, esp. 195–206 ('Pagan Mysteries at Chicago'); Ingo Herklotz, 'Chicago und das Abendland: Schritte zur Remigration', in Ingeborg Becker and Ingo Herklotz, eds, *Otto von Simson, 1912–1993: Zwischen Kunstwissenschaft und Kulturpolitik* (Vienna: Böhlau, 2019), 175–239.

54 Harry D. Gideonse, *The Higher Learning in a Democracy: A Reply to President Hutchins' Critique of the American University* (New York: Farrar & Rinehart, 1937), 10.

times and all places. Nor if these qualifications and repudiations are seriously meant can he oppose in substance the position which is taken in this essay.

The dominant emphasis, the detailed criticisms, and the educational suggestions which Mr. Hutchins' books present originate from and make sense only within the framework of the traditional metaphysics of rational absolutism. It may well be that their author is changing his emphasis and perhaps to some degree his philosophical position. But until this is explicitly stated and the implications for specific problems are drawn, discussion must center around the larger published presentations of his views. No one would be more delighted than its author if Mr. Hutchins, recognizing in this essay the substance of his views, allays the apprehensions which his own pages have raised. But the fact remains that the misapprehensions—if misapprehensions they be—are responsible for the idea that the higher education in America is to forsake the path of science and humanistic concern for a democratic society and to return to the Ivory Tower of absolutistic metaphysics. There are even rumors—incredible as it may appear—that the faculty of the University of Chicago, nourished by Scholasticism, is to take the lead in charting this new course for the higher learning. This essay is contributed to the discussion with the purpose of correcting these misapprehensions and rumors.

This author has said nothing to refute Hutchins and his overwhelmingly misunderstood Hutchins' references. Hutchins refers to comprehension of thoughts and ideas rather than fact gathering chores and procedures; for Hutchins believes that a sound education into inquiry—disproven, proven and proposed — is best, and better than a "vocational" training in how to run experiments. The assumption Hutchins makes is that a sound general education—theoretical education—will allow one student to develop his/her own experiment in order to test hypotheses. This author has missed the point, rather he defends his position — the position Hutchins refuses—by failing to extract the true hypotheses of Hutchins' writings.

Figure 11.7: Anonymous reader's handwritten response to Harry D. Gideonse's arguments in *The Higher Learning in a Democracy: A Reply to President Hutchins' Critique of the American University* (New York: Farrar & Rinehart, 1937), copy in Harlan Hatcher Library, University of Michigan, Ann Arbor.

At Chicago, Hutchins had gathered reformers around him, recruiting McKeon and Adler from Columbia and, briefly, Buchanan and Barr from Virginia. In 1936 all were members of a fractious Committee on the Liberal Arts, soon disbanded.[55] Wind, placed on the executive committee of the university's new Committee on Social Thought, enjoyed the sharp exchanges during meetings; it was in this context that he proposed his book series 'Encyclopaedic Studies'. Increasingly outspoken, he made his position felt.[56] Significant unpleasantness arose when, asked to be involved in teaching the undergraduate core course, he bridled at McKeon's imposition from on high of a standardized Great Books curriculum.[57] By 1943 he was eager to leave, and the idea of splitting his time between Chicago and London after the war, to ease the Warburg Institute budget, was abandoned.[58]

Saxl's encyclopaedia

In 1945 Saxl travelled to the United States to promote an idea that had come to him in the late 1930s, on the eve of war. His ambition was to launch a large-scale Anglo-American venture. This, he knew, would require the

55 On Hutchins' reforms, see Nelson, *Radical Visions*, 54–63.

56 For Wind's 'resolution' – a counter-proposal to the faculty Senate's 'Memorial to the Board of Trustees on the State of the University' – and events unfolding in the summer of 1944, see Bodleian, EWP, MS. Wind 8, folders 2–3, including the clipping 'Professors Will Confer on Dispute with Hutchins: U. of C. Senate to Vote May 10 on Asking Trustees to Withhold Power from Him', *Chicago Sun* (2 May 1944).

57 Zorach, 'Love', 205; Takaes de Oliveira, 'L'esprit', 117.

58 Edgar Wind to Fritz Saxl, 10 April 1943; and Gertrud Bing to Edgar Wind, 1 June 1943: 'The Committee on Social Thought sounds as if its aims were allied to Warburg methods; except for the fact that one has grown wary of attempts to integrate the results of researches which have not had a common denominator while they were being carried out.' Bodleian, EWP, MS. Wind 7, folder 2; Takaes de Oliveira, 'L'esprit', 134–6, 136–40.

backing of prominent scholars and scholarly organizations as well: the British Academy, the Medieval Academy of America, the Renaissance Committee of the American Council of Learned Societies. He offered the Warburg Institute as the home of the undertaking: an 'Encyclopaedia of the Middle Ages and the Renaissance, AD 600–1560', which would pithily summarize the results of relevant twentieth-century scholarly work to date. There would be fifteen 'stout' volumes, some 10,000 entries, extensive bibliographies and generous illustration. Saxl provided a sample entry ('Maps') and a tentative list of some 500 headings for the letter 'A' (e.g. Abreviatura, Abdication, Abecedarium, Abel): a Warburgian list that, following age-old precedent, proves to have been extracted in good part from earlier encyclopaedias: Brockhaus and Britannica. It was to be a twenty-year project, beginning with a three-year planning phase.[59]

Saxl had kept Wind abreast of matters. Shortly before his cross-Atlantic trip he had written not only about the incorporation of the Warburg Institute into the University of London but also about his idea to sponsor the creation of a 'Pauly–Wissowa for the Middle Ages and Renaissance'. Assuming Wind's compliance, he wrote: 'Of course I must first know what you think about it because the main work will be done when you are in power, not me. I am sure you will have many more ideas, and ideas which are probably more practical as far as the American side is concerned.'[60] Wind had by that time resigned from the University of Chicago in anticipation of returning to London with his second wife, Margaret Kellner Wind, and had relocated to Northampton, Massachusetts, to take up a short-term visiting professorship at Smith College.

59 Fritz Saxl, 'Project of an Encyclopaedia of the Middle Ages and the Renaissance', 1945, WIA, Saxl papers, 'Encyclopaedia'.
60 Fritz Saxl to Edgar Wind, 8 March 1944, Bodleian, EWP, MS. Wind 7, folder 2. On the rupture, see Franz Engel, 'Though This Be Madness: Edgar Wind and the Warburg Tradition', in Sabine Marienberg and Jürgen Trabant, eds, *Bildakt at the Warburg Institute* (Berlin: De Gruyter, 2014), 87–115; Takaes de Oliveira, 'L'esprit'; Monica Centanni, 'The Rift between Edgar Wind and the Warburg Institute, Seen Through the Correspondence between Edgar Wind and Gertrud Bing', *Edgar Wind Journal* 2 (2022), 75–106.

Wind and Saxl met twice: briefly in New York and for a longer time in Northampton. The upshot was that Wind resigned from the Warburg Institute. The reasons that he laid out, in letters to Bing and Wittkower, were several: his outrage over the initial offer (demotion to 'Reader' and a drastic cut in salary); his dismay over the hierarchical administrative structure resulting from incorporation into the university; and his weary sense that Saxl was retreating to the pre-war practice of making appointments based as much on charity as on the commitment to developing 'a particular scientific method'.[61] But the sticking point was Saxl's encyclopaedia, which he took to be emblematic of the Institute's current trajectory. Cynically assuming that the Medieval Academy of America, 'utterly dead', would go along with the plan, he offered blistering critique, calling it typical of Saxl's projects in being 'grand in plan but timid in invention'. Modern encyclopaedias, he felt, had the effect of supplanting rather than steering readers toward the sources; Pauly–Wissowa, 'a great funerary monument' to classical studies, should, in his view, stand as a 'warning rather than a model'.[62] What most disturbed him was that the scholarly energies of the young would be 'channelled into the unconstructive labour of compiling', precisely when they should be 'free for constructive research and produce new results'. Saxl, similarly working from conviction, had prioritized collaboration as a timely goal in itself. He, like Warburg, valued encyclopaedias as indispensable tools, to which he added his sense that they were especially needed at ends of periods of learning, serving to make accessible the achievements of the past and thus to furnish 'a basis for new and different investigations'.

61 Edgar Wind to Gertrud Bing, 15 and 30 June 1945; Edgar Wind to Rudolf Wittkower, 30 June 1945, Bodleian, EWP, MS. Wind 7, folder 2; Engel, 'Madness', 107–15; Takaes de Oliveira, 'L'esprit', 148–54, 155–8.
62 *Paulys Realencyclopädie der classischen Altertumswissenschaft*, 83 vols (1890–1978); the first recension undertaken by August Pauly in 1839, the second by Georg Wissowa in 1890.

Epilogue: A grave rupture

Saxl's project (like Wind's) soon faded from view. In 1946 the American Council of Learned Societies denied funding for the planning phase; moreover, the reaction of potential collaborators on both sides of the Atlantic had been mixed, some of the concerns echoing Wind's own. Too late: Wind had tendered his resignation from the Warburg Institute. In response to a gracious note from the committee of management, expressing appreciation for his efforts in Germany, England and America, Wind had replied: 'Very much against Mr. Saxl's and my own will, it became apparent [...] that our views concerning the function of the Institute could no longer be reconciled.' The issues Wind emphasized were two: 'whether or not the Warburg Institute should be primarily a charitable institution, and whether it should become an agency for the kind of cumulative research that results in encyclopaedias, manuals, etc.'[63] Over time, cross-Atlantic exchanges became more acrimonious, one of the charges being Frances Yates' appropriation, without acknowledgement, of ideas that Wind had delivered in his 1939 lectures 'The Renaissance Encyclopaedia in Raphael's Frescoes'.[64] When Saxl died of a heart attack in March 1948, Wind was no longer in the Institute's line of succession. He would remain at Smith College – there, too, promoting pedagogical experimentation[65] – until 1955 and his move to Oxford University as first holder of the chair in art history.

63 Edna Purdie to Edgar Wind, 5 November 1945, and response, 11 December, WIA, GC – Wind; Takaes de Oliveira, 'L'esprit', 161–2.

64 Wind included Frances Yates' 'The Academics of Henri III' in his proposed book series, read four of its chapters, then stopped communicating; thinking that Wind 'did not in any way wish to be associated with the book', she removed his name from *The French Academies of the Sixteenth Century*, published in 1947. Her failure to cite his work caused fury. For the correspondence, see Bodleian, EWP, MS. Wind 7, folder 3.

65 Edgar Wind, 'Two Types of Courses – Traditional, Experimental: Humanities 292a – Experimental', *Smith Alumnae Quarterly* (May 1953), 136.

The rupture was painful on both sides, perhaps especially to Bing, who saw the Warburg–Saxl–Wind succession as the only one that made sense; but even she, while aware that others, too, had suffered from Wind's brutal outbursts, could not pass over the manner of the break.[66] Differences in wartime experience, and sheer distance, had aggravated the misunderstandings, certainly causing Wind's memories of the pre-war past to be darkly filtered. Saxl and Wind alike saw themselves as Warburg's heirs; each believed Warburg regarded him as a 'son'.[67] Their experiences differed: Saxl's acquaintance with the founder of the 'encyclopaedic' library stretched over nineteen years (including the painful years of Warburg's mental illness); Wind's something more like nineteen months. Timing, training and temperament led them to seize and develop different aspects of Warburg's capacious project. Saxl had always recognized Wind's intellectual gifts, his support starting in 1922, when he recommended that Teubner publish Wind's doctoral dissertation.[68] The two had collaborated closely, daily, across a fraught decade, and Wind had participated in others of Saxl's projects. In 1933–4 he had provided some forty entries as well as introductions to the German and English editions of the first volume of the *Bibliography on the Survival of the Classics*.[69] In 1943 he would include Saxl's 'The Pictorial Illustrations of Mediaeval Encyclopaedias' in his series proposal. And in 1945 he expressed approval for another of Saxl's post-war initiatives, that of publishing a series of art-historical 'sources'.[70]

66 Gertrud Bing to Walter Solmitz, 9 December 1945, WIA, GC – Solmitz.
67 Fritz Saxl, 'Rede gehalten bei der Gedächtnis-Feier für Professor Warburg am 5. Dezember 1929', 1, Warburg Institute library, CIO 549; Edgar Wind to Jean Seznec, 25 August 1954, Bodleian, EWP, MS. Wind 7, folder 5. See Ianick Takaes de Oliveira, ' "Il y a un sort de revenant": A Letter-Draft from Edgar Wind to Jean Seznec (Summer 1954)', *La rivista di engramma* 171 (January–February 2020), 97–112 (103) (a passage crossed out before being sent).
68 Fritz Saxl to Teubner Verlag, 14 October 1922, WIA, GC – Teubner.
69 Wind recalled having reservations about this project as well ('inconducive to creative scholarship'). Margaret Wind, biographical notes, December 1927 – December 1933, Hamburg; recorded around 1970. Bodleian, EWP, MS. Wind 3, folder 2.
70 Jean Seznec to Fritz Saxl, 7 September 1945, WIA, GC – Seznec.

Wind's negative reaction to 'Saxl's encyclopaedia' was in line with deeply felt convictions about scholarly purpose. One volume in the series 'Encyclopaedic Studies', he hoped, would treat 'The Growth of Lexicography and the Decline of the Encyclopaedic Ideal'. Wind would have agreed with Saxl's statement of 1946: 'We are unlike any other London University institution in that we came in from outside. We have been given unusual opportunities, and our friends therefore have a right to expect unusual results.'[71] But Saxl's encyclopaedia was, in Wind's estimation, anything but 'unusual', representing a 'flight into conventionality'. Hence his anger, hence the wounding warning from the theorist of the 'encyclopaedic ideal' in the letter to Bing of 1945: 'the moment may come when the Warburg Institute is no longer the most suitable place for developing Warburg's methods and ideas.'[72]

71 Fritz Saxl to Howard L. Goodhart, 1 June 1946, Los Angeles, Getty Research
 Institute.
72 Wind to Bing, 15 and 30 June 1945.

BEN THOMAS

12 Circular Arguments: Edgar Wind at Chicago, 1942–1944

Although it began with great hopes and mutual admiration, Edgar Wind's brief time at the University of Chicago during the Second World War rapidly developed into a fraught situation for the philosopher and art historian. In addition to suffering a lengthy period of serious illness during the spring and summer of 1943, when he was treated for pneumonia, phlebitis and pleurisy at the Billings Hospital, Wind found that his academic position at the university was becoming increasingly embattled.[1] 'The newcomer found himself surrounded by an atmosphere of martial violence', he wrote in 1945 in a report to Fritz Saxl, director of the Warburg Institute in London, in which he also noted that he had been described by colleagues as a 'menace' and an 'obscurantist'.[2]

1 Wind referred to his illness in a letter of 25 May 1943 to Robert M. Hutchins, complaining that 'the various opiates which are mercifully administered in this hospital have so befuddled my mind that I was unable for a considerable time to produce any coherent sentences'. Bodleian Libraries, University of Oxford, Edgar Wind Papers (hereafter Bodleian, EWP), MS. Wind 8, folder 2.

2 Edgar Wind's report to Fritz Saxl on his American activities on behalf of the Warburg Institute, 1939–45, 1945, Bodleian, EWP, MS. Wind 7, folder 2. The charge of obscurantism can be found in a letter from Ronald Crane to John Nef, 18 February 1944 (Bodleian, EWP, MS. Wind 8, folder 2), objecting to the Committee on Social Thought's 'Memorandum Concerning Studies in the Field of Renaissance Civilization', which was drafted by Wind. Crane objected to the study of the interrelating traditional and novel aspects of cultural revivals being framed as the 'central *problem* of Renaissance studies' as a kind of '*a priori* history' which is the 'direct opposite of disinterested scholarly inquiry into the meaning and historical relations of these works and hence (when made the sole or dominant approach) essentially obscurantist'.

Wind had been relieved at first to be offered a full-time tenured post in the Art Department at Chicago in February 1942, which contrasted in its security with the peripatetic existence he had led since 1939. The outbreak of war, while he was on sabbatical leave at St John's College, Annapolis, had prevented him from returning to his position at the Warburg Institute. In fact, his Warburg colleagues had requested by telegram that he remain in the United States with a view to negotiating the library's transfer there. But Wind had also been attracted to Chicago by the possibility of participating in ground-breaking interdisciplinary developments and educational reforms.[3] He admired the progressive ambition of the university's president, Robert Maynard Hutchins, and participated in the work of John Ulric Nef's interdisciplinary Committee on Social Thought. However, he quickly found himself caught up in a turf war with the dean of humanities, Richard McKeon, who stressed to him the priority of departmental and divisional duties over interdisciplinary initiatives. Wind was also drawn into the larger political struggles that divided the Senate at Chicago over the constitutional revisions and educational experiments proposed by the president; and opponents of Hutchins, such as the literary critic Ronald Salmon Crane and the economist Jacob Viner, attacked a scholar they perceived as one of the president's strongest allies.[4]

While many of the clashes Wind endured at Chicago can be attributed to the usual sources of tension in academic life, such as conflicting personalities and the defense of vested interests, they also reveal fundamental

3 Secretary to the Board of Trustees of the University of Chicago to Edgar Wind, 24 February 1942, Bodleian, EWP, MS. Wind 8, folder 1. Wind was formally appointed to the tenured post of professor in the Art Department of the University of Chicago on 24 February 1942, with the position beginning on 1 October 1942 on a salary of $6,000 p.a. The same file contains correspondence with Robert M. Hutchins on the possibility of Wind's 'military service in the armed forces of the United States'.

4 A letter from Wind to Jacob Viner of 28 April 1944 (Bodleian, EWP, MS. Wind 8, folder 2) indicates an angry exchange with Wind, stating, 'I fail to understand how my proposal could possibly be construed to reflect on you personally […] If you have any doubts about my sincerity in this matter, I suggest that you enquire into the circumstances under which, last autumn, I offered my resignation from the University.'

methodological and philosophical differences. These disagreements take on a larger and more controversial dimension in the context of the searching historical enquiry into interpretive method carried out at Chicago across disciplines as part of the general wartime efforts to make the university fit to fulfil its purpose, however that might be defined. For example, in emotive remarks made in a speech given at the Trustees–Faculty Dinner on 12 January 1944, Hutchins suggested that the university's motto – *Crescat scientia vita excolatur* [Let knowledge grow that life may be enriched] – was inadequate, because it was overly materialistic and should be replaced by a line from Walt Whitman: 'Solitary, singing in the West, I strike up for a new world.'[5] In the same speech, Hutchins asserted that the purpose of the university was 'nothing less than to procure a moral, intellectual and spiritual revolution throughout the world', adding that 'the whole scale of values by which our society lives must be reversed if any society is to endure'.[6]

These remarks were taken by many in Hutchins' audience to imply his desire to impose a transformative social mission on the university, and as such to threaten established notions of academic freedom. Among those who opposed Hutchins at this point were humanities scholars who advocated a neo-Aristotelian form of methodological pluralism. Wind, on the other hand, had been defended by Hutchins against attempts to impose this form of pluralism on him in his teaching, and consequently supported the president as the better guarantor of academic freedom in practice. It is certainly suggestive to find Wind, the lone representative of the Warburg approach to cultural history at Chicago at the time, coming into dispute with two of the leading figures of the neo-Aristotelian 'Chicago School of Criticism' in Crane and McKeon (not to mention arguing with Viner, one of the founders of the Chicago School of Economics).[7]

5 Walt Whitman, 'Starting from Paumanok', 1, *Leaves of Grass*, in Walt Whitman, *The Complete Poems* (London: Penguin, 2004), 50.

6 Robert M. Hutchins' speech at the Trustees–Faculty dinner, 1944, Bodleian, EWP, MS. Wind 8, folder 2. On Hutchins, see Mary Ann Dzuback, *Robert M. Hutchins: Portrait of an Educator* (Chicago: University of Chicago Press, 1991) (p. 196 for this speech).

7 This is the context in which Wind produced a significant paper on the problem of 'Aesthetic Universals' for the Committee on Social Thought, for which see

While at Chicago, Wind also proposed a revival of encyclopaedic studies – understood to mean 'learning in a cycle (or circle)' – and his concept of connected disciplines unified through dialogue may well have informed President Hutchins' reformist views on the role of the university.[8] Therefore, Wind proposed a Renaissance conception of encyclopaedic learning across connected disciplines, in opposition to traditional views of the university curriculum as consisting of discrete and separate disciplines. If Hutchins characterized the mission of a reformed university as a revolution, then Wind's efforts to revive the principle of a common 'universe of knowledge' could be described as an attempted Renaissance.

Encyclopaedic studies

Wind's association with Chicago began in 1939 when he was on leave from the Warburg Institute, working at St John's College, Annapolis, in Maryland, at the invitation of Scott Buchanan and Stringfellow Barr. A letter from McKeon shows that Wind was initially invited to give a course of guest lectures, entitled 'The Philosophy in Raphael's Frescoes'.[9] Wind always gave his lectures from memory, so that usually the only documentary record of them is the slide list. However, he was a consistent thinker who tended to refine an argument over time rather than alter it. It is possible, therefore, to ascertain the argument of the lectures Wind gave at Chicago from the later draft of a book on Raphael dating from 1950, and from related documents such as an application for a Guggenheim grant and the transcript of a telephone conversation related

Ben Thomas, *Edgar Wind and Modern Art: In Defence of Marginal Anarchy* (London: Bloomsbury, 2020), 77–9.

8 For a more detailed analysis of this, see the essay by Elizabeth Sears in the present volume (Chapter 11).

9 Richard McKeon to Edgar Wind, 1 November 1939, Bodleian, EWP, MS. Wind 8, folder 1.

to this research proposal. Here he argued that Raphael's *School of Athens* conveyed an encyclopaedic conception of knowledge:

> To a truly 'liberal' scholar, there is thus no fixed order of precedence among the arts and sciences; and this distinguishes some of the Renaissance curricula from those of the Middle Ages. The arrangement of the disciplines in a 'circle' or an 'orb', so vividly suggested by the word *encyclopaedia*, was not sufficiently conveyed by the Latin term *artes liberales*, and was in fact incompatible with the ascending sequence of the old *trivium* and *quadrivium* which resembled a ladder rather than an orb.[10]

Wind's interpretation of the *School of Athens* can be only briefly summarized here. He began to develop it in 1938 when he realized that Alberto Pio and Gianfrancesco Pico della Mirandola, nephews of the philosopher Giovanni Pico della Mirandola, were present in Rome at the court of Pope Julius II, and could have advised Raphael on the iconography of a set of murals that, according to Wind, demonstrated Pico's theory that the philosophies of Plato and Aristotle could be reconciled. In *The School of Athens*, Plato appears pointing upwards, exemplifying poetic enthusiasm, while Aristotle points downwards, representing rational analysis. At the vanishing point of the perspective construction these two opposite if complementary gestures fall under the regimes of different divinities: Apollo, represented as a statue in a niche to the left of the composition, who in the scheme of the Stanza della Segnatura is closest to poetry as represented in the fresco of Parnassus, and Minerva who is nearest to jurisprudence in a corresponding niche to the right. Raphael achieved through his design a reconciliation of opposites [*discordia concors*], demonstrating Pico's claim that 'every proposition in Plato can be translated into a proposition in Aristotle if only you take into account that Plato speaks the language of poetical enthusiasm where Aristotle speaks the language of rational analysis'. He also showed, in the groups of philosophers surrounding the central pair of Plato and Aristotle, the continuous transition from one branch of knowledge to another involved in an encyclopaedic conception of the

10 Edgar Wind, 'The School of Athens', c. 1950, typescript, 110, Bodleian, EWP, MS. Wind 216, folder 4. See also Bernardino Branca, *Edgar Wind's Raphael Papers: The School of Athens* (Wroclaw: Amazon KDP, 2020).

unity of knowledge. Quoting another of Raphael's humanist friends, Celio Calcagnini, Wind argued that the fresco showed how 'no science probes its own principles, because it seeks aid from the one next to it and nearest in kind, and demands to be enlightened by extraneous rays (*alienis radiis*)'. There is, therefore, no hierarchy among disciplines, as each is situated on the circumference of a circle, equidistant from central truth, from where it supports its neighbours in their endeavours.[11]

Wind's reading of Raphael's frescoes extended ingeniously to the smallest details: for example, in the Parnassus, Raphael depicted Apollo playing a *lira da braccio* (which Wind referred to as a 'viola'). According to Wind this anachronism was deliberate, because the 'viola' was itself a reconciliation of opposites, combining the separate strings and distinct notes of the lyre with the continuous melodic phrasing of the flute. In this way, the chastity of the lyre and the passion of the flute – 'the flute is the instrument of passion, whereas the lyre is the instrument of restraint' – are combined, or rather harmonized, in a stringed instrument played with a bow.[12] Regardless of whether this iconographical reading of Raphael's works was persuasive to art historians, or could be sustained today in the light of subsequent research, it proved particularly attractive to American academics like Hutchins and Barr who were questioning the role of higher education in contemporary society and exploring new teaching methods to produce critically engaged citizens. Wind's interpretation of Raphael, drawing on Pico's conception of the 'dignity of man' and his tolerant acceptance that there are many paths to truth, seemed in the context of wartime debates almost like the blueprint for a revived liberalism grounded on an inclusive philosophy, and a curriculum for educating rounded progressives. Raphael had articulated in visual terms a philosophical perspective deriving from Pico that emphasized a holistic understanding of learning achieved through balance and tolerance: 'because as a complete human being you did not want only to serve Apollo, you did not want only to serve Minerva, you wanted to be reasonable and enthusiastic at the same time'.

11 Wind, 'The School of Athens'.
12 'Transcription of telephone recording, Wednesday 14 June 1950', Bodleian, EWP, MS. Wind 216, folder 1.

This conception of liberal learning had its roots in antiquity – for example, it is at the basis of the education of the architect outlined by Vitruvius – and was revived during the Renaissance by humanist scholars. It also informed the arrangement of Aby Warburg's library, according to the Warburg Institute Classification Scheme, as Wind argued in 1935: 'The library endeavours to be encyclopaedic, i.e. it interconnects such seemingly independent subjects as the history of art, of science, of superstition, of literature, of religion, etc.'[13] Interestingly, in his 1944 address 'The Organization & Purpose of the University', Hutchins compared the University of Chicago to an encyclopaedia:

> The modern university may be compared with an encyclopaedia. The encyclopaedia contains many truths. It may consist of nothing else. But its unity can be found only in its alphabetic arrangement. The university is in much the same case. It has departments running from art to zoology; but neither the students nor the professors know what is the relation of one departmental truth to another, or what the relation of departmental truths to those in the domain of another department may be.[14]

A unified purpose for Chicago could be achieved only through 'discussion and agreement' across disciplines[15]

Correspondence between Nef and William Benton, the university's vice-president, deals with Wind's proposal to publish a series of encyclopaedic studies to complement Chicago's partnership with the Encyclopaedia Britannica. Nef highlighted 'the importance of the interrelationships between all branches of knowledge' and 'the unity of learning and scholarship as a whole', as conceived by Wind, and the 'special significance which work of this kind would have coming from the University of Chicago'.[16]

13　Edgar Wind, 'The Warburg Institute Classification System', *Library Association Record* 2 (1935), 193–5. Cited by Branca, *Edgar Wind's Raphael Papers*, 74.

14　Robert M. Hutchins, 'The Organization & Purpose of the University', 20 July 1944, 8–9, Bodleian, EWP, MS. Wind 8, folder 2.

15　Hutchins, 'The Organization & Purpose of the University', 8–9.

16　John Nef to William Benton, 19 July 1943, Bodleian, EWP, MS. Wind 8, folder 1.

Interestingly, Wind advanced the claims of an encyclopaedic tradition that advocated the 'universe of knowledge' against the 'excessive growth of departmentalism in scholarship' and 'the deadening effect of this intellectual self-mutilation' regrettably felt in the present. The goal of the proposed series of monographs would be no less than to 'reawaken what might be called the encylopaedic imagination'.[17] Wind's reading of intellectual history here aligned with the institutional goals of Chicago's president. According to Hutchins, Chicago's structure permitted 'the student and the professor to think in terms wider than a departmental discipline and to gain support from those who are working in other departments on other aspects of their own problems'.[18] In particular, encouraged by the philosopher Mortimer Adler, Hutchins was a proponent of the so-called 'Great Books' approach to teaching in the humanities, which had been developed by a number of like-minded scholars whom Wind had known during his earlier sojourn in the United States from 1924 to 1927, such as Buchanan and Barr, with whom he had collaborated at the Cooper Union in New York.

The 'McKeon trouble'

At Chicago, Wind found himself pulled in different directions by the demands of department, division, college, and Nef's interdisciplinary Committee on Social Thought. In particular, he clashed consistently with McKeon, who having secured Wind's appointment resented the fact that Wind seemed more comfortable in Nef's orbit in the Division of Social Sciences. What makes these complex intrigues of more than merely biographical interest is the light they shed on methodological differences

17 Edgar Wind, 'Memorandum on Encyclopaedic Studies', Bodleian, EWP, MS. Wind 8, folder 1. Among the scholars proposed by Wind were Cornford, McKeon, Maritain, Adler, Saxl, Panofsky, Kristeller, Yates and Seznec.

18 Robert M. Hutchins' speech at the Trustees–Faculty dinner, 1944, Bodleian, EWP, MS. Wind 8, folder 2.

within the faculty at Chicago, in terms of both research and teaching. A summary of the events of Wind's brief tenure at the university will help to put these debates in context.

Wind clashed dramatically with McKeon just as he took up his post in October 1942, objecting to the instructions for tutors that he had been supplied with, which aimed to secure uniform delivery of the course 'Humanities 2'. 'I have never in my life taught anything which I do not believe', Wind wrote to McKeon, withdrawing from teaching on this course. This refusal to subordinate his strong personal convictions to institutional demands would define his problematic Chicago period.[19] Then, in March 1943, Wind wrote to McKeon, informing him of his intention of giving a course of five public lectures for the Committee on Social Thought, entitled 'Renaissance Philosophy and Art'. McKeon's initial response was that these lectures could go ahead, but without the support of the Humanities Division. The fact that the dean gave written permission for the lecture series on the understanding that it would be 'extra-curricular' (that is, in addition to Wind's workload for the Art Department and the Humanities Division) would later become a point of contention. In April 1943, McKeon then proposed that Wind should give a further series of ten public lectures for the Division of Humanities on Renaissance art and culture. Wind agreed, proposing the topic 'Pagan and Christian Mysticism in the Art of the Renaissance', which prompted McKeon to object to the inclusion of the word 'mysticism' in the title on the grounds that it would deter people from attending.[20]

19 Wind to McKeon, 12 October 1942, Bodleian, EWP, MS. Wind 8, folder 2.
20 The quarrel between Wind and McKeon on the appropriateness of the term 'mysticism' elicited an interesting statement from Wind on his research, in a 'Statement by Wind on the McKeon Trouble, Possibly to be Submitted to the Committee on Policy [of the Division of Humanities]' (Bodleian, EWP, MS. Wind 8, folder 2): 'I was using "mysticism" in the strict technical sense employed by Renaissance authors and artists when they contrast a "mystical" image with a "literal statement". My entire view on Renaissance art in its symbolic aspects, which I intended to develop in these lectures, centers in the theory that pagan as well as Christian subjects are treated figuratively, not literally; which makes it possible to harmonize them. Since this is, in my opinion, the common denominator between such varied expressions of Renaissance art as are to be found in the works

During the summer of 1943 Wind was seriously ill and his convalescence lasted into the autumn, causing delays to his planned lecture series and communication problems with the dean, and also with Ulrich Middeldorf, the chair of the Art Department. Wind later claimed that his inability to meet McKeon in his office personally – he was sedated in a hospital bed – was interpreted as 'a deliberate act of discourtesy'.[21] At this time, he was also offered the visiting Neilson Research Professorship at Smith College, an invitation that Hutchins pressured him to decline (although Wind continued to keep in touch with Smith and took up the post in 1944). Hutchins had recently made Wind an executive member of the Committee on Social Thought and wanted him to focus on that project, notably his proposal for a series of publications of 'Encyclopaedic Studies'.

Meanwhile, Wind was being pressured by the dean of humanities to devote more time to his departmental teaching. McKeon wrote to Nef complaining about the 'disposition of Professor Wind's time' given that he was 'already scheduled for a series of ten public lectures on Renaissance Art in the division of the Humanities' and demanding that one of the lecture series be cancelled. Nef replied, explaining that Wind's lectures on Renaissance art and philosophy had been postponed due to his illness, and that they were different in content from those intended for the Division of Humanities. Consequently, McKeon required Wind to provide an explanatory statement to the Divisional Committee on Policy on 6 September 1943, a move that Wind saw as an attempt to silence him. One reading of the documents, more favourable to McKeon, is that his concern was simply to ensure the success of lectures and classes offered in the Division of Humanities, and that he resented Nef's refusal to cancel the lecture series, on a similar topic, for the Committee on Social Thought ('you are trying in a very crude and inexpert manner to pull my leg') and was asserting the 'prior claim that I think the Division has on Mr. Wind's time'.[22] A less charitable interpretation is that McKeon was aiming to disrupt the

of Botticelli, Mantegna, Raphael, Michelangelo, Titian, Tintoretto and even El Greco, it seemed to me a suitable subject for a general course of public lectures.'

21 Edgar Wind, 'Statement by Wind on the McKeon Trouble'.
22 McKeon to Nef, 12 August 1943, Bodleian, EWP, MS. Wind 8, folder 2.

plans of Nef's interdisciplinary committee, which he saw as a threat to the autonomy of the Division of Humanities. (Nef's reply to McKeon protested, 'what are you trying to do, bully me? [...] Wind's lectures in the Social Sciences were scheduled with your written consent.')[23] In the end, McKeon cancelled Wind's lecture series for the Division of Humanities.

Distressed by these conflicts, Wind wrote to Nef offering to withdraw from the Committee on Social Thought, and then wrote to Hutchins on 2 October 1943 offering to resign from his post at Chicago after the Divisional Committee on Policy rejected his statement. Hutchins sent a telegram assuring Wind that a solution could be found, which prompted Wind to outline the terms under which he was prepared to stay at Chicago. ('I hope this does not sound too much like a "Bill of Rights for Professors".') These included the stipulation that the dean of the humanities and the chair of the Art Department would not 'infringe on my right to define the methods and formulate the themes of the courses and lectures for which I am responsible' and that they 'would not have the authority to make a commitment in my name without my consent.'[24] In spite of Hutchins' support for Wind, there were renewed efforts in December 1943 from McKeon and Middeldorf to persuade Wind to teach a follow-up course to Humanities 2, titled 'Introduction into the Literary and Philosophical Interpretation of Art', which had been advertised in the catalogue of courses under his name without his permission. The plan was that Middeldorf would simultaneously run a course on the formal analysis of artworks. Wind explained that 'the separability of form and content in the study of Art was asserted in the Instructions of Humanities 2 and was one of the points on which I had voiced my disagreement [...] The course as later announced in the catalogue actually suggests a method directly contrary to my own.'[25] Wind was again pressured by Chicago's managers to comply: 'If I understood them correctly, they meant to say that I was not obliged to give the course, but that I would be very uncooperative if I didn't.' In response, Wind asserted

23 Nef to McKeon, 16 August 1943, Bodleian, EWP, MS. Wind 8, folder 2.
24 Wind to Hutchins, 6 November 1943, Bodleian, EWP, MS. Wind 8, folder 2.
25 Edgar Wind, Supplementary Report to Bill of Particulars, Bodleian, EWP, MS. Wind 8, folder 2.

the faculty members' constitutional right to regular departmental meet-
ings, and then objected to McKeon attending the first Art Department
meeting to be held in twelve years.[26] Finally, Wind's version of his treatment
at Chicago – that having failed to co-opt him to a pluralist methodological
project his colleagues were trying to silence him altogether – was vividly
outlined in a 'bill of particulars', which Wind was obliged to draw up for
the University Committee on Policy after he had launched a counter-attack
against the critics of Hutchins in the Memorial Controversy that gripped
the university at the beginning of 1944. This dispute, which resulted in
Wind leaving Chicago, will be discussed in greater detail following an ana-
lysis of the first conflict with McKeon over Humanities 2.

Instructions for 'Humanities 2'

Shortly after Wind's arrival at Chicago, and three days before the start of
term, McKeon requested through Middeldorf that Wind participate in
the teaching of the general course 'Humanities 2' in the undergraduate
college by taking over a seminar of sixteen of the 600 enrolled students.
The seminar instructors were briefed on the overall approach to the course
in a document entitled 'Instructions concerning Lectures, Readings, and
Discussions for the General Course in the Humanities (Humanities 2),
September 1942', which in turn was to be handed out to the students
along with a chronology of significant dates to be learnt for the exam,
which took the form of a paper combining multiple-choice and summary
questions. Beginning with two weeks each on Herodotus and Thucydides,
the course then progressed to Gibbon, Michelet, Paine and Burke. The
list of instructors for the course included Crane, Olson and McKeon,
who would later publish together as the so-called 'Chicago School of
Literary Criticism' – perhaps the request that Wind teach with them on

26 McKeon to Wind, 8 February 1944, Bodleian, EWP, MS. Wind 8, folder 2: 'I shall
 not attend the meeting of the Department'.

Humanities 2 was an attempt to enlist him in their ranks?[27] If so it failed, as Wind found it impossible in good faith to deliver the course according to the 'Instructions', and withdrew from teaching it after a couple of weeks. The unsparingly critical letter he sent to McKeon explaining this decision set in train the conflictual course of events that would eventually lead to Wind leaving Chicago for Smith College in 1944. Wind wrote to Nef in 1943, identifying the 'serious clash' over Humanities 2 as the origin for the 'McKeon trouble' when 'I took the liberty, again without realizing the repercussions in McKeon's mind, of frankly criticizing him for his excessive interference with the teaching in the College'.

The function of the general course was to teach students how to read texts and interpret artworks by providing them with four 'basic disciplines' to follow: 'Humanities 2 is designed to train the student in a group of disciplines and skills [...] equal emphasis should be put on the disciplines without which the humanities are unintelligible, and on the books on which they are employed.' Through deploying the 'basic disciplines' on texts, students would learn the 'Arts of Interpretation and the Purpose of the Humanities'. The four fundamental approaches outlined in the Instructions were (1) to consider a work of art or a book 'in itself, independent of the accidents of the circumstances in which it was conceived', which is the mode of appreciation; (2) to take into consideration the work's subject matter, which is the mode of history; (3) to analyse the work with regard to its author's intentions, which is the mode of expression; and, finally, (4) to pay attention to the audience reaction to the work, which is the mode of communication. It follows that 'A given work may, then, be analysed successively for the appreciation of the work itself, for the consideration of various aspects of it as they bear on history, for the determination of its intellectual content, and for the estimation of its effects.' Although particular disciplines of analysis are best suited to different kinds of work, it is possible, for example, to interpret a poem in terms of its reception, so the student 'must therefore be prepared for the application of one technique

27 Richard McKeon, 'Criticism and the Liberal Arts: The Chicago School of Criticism', *Profession* (1982), 1–18: 'There was no such thing as [...] a Chicago School of Criticism.'

in a field which might seem primarily the subject of another'. McKeon's Instructions form the kernel of an important article he wrote entitled 'The Philosophic Bases of Art and Criticism', which was subsequently reprinted as a seminal statement of the Chicago approach to literary criticism, in Crane's *Critics and Criticism: Ancient and Modern* volume published in 1952.[28] While McKeon claimed that the 'basic disciplines' provided a rationally grounded approach to criticism, for Wind the idea that aesthetic value could be 'appreciated' separately from a consideration of content was anathema. Or as Wind put it in his report to Saxl, he was 'averse to the type of historical thinking which traces a motif *à travers les ages* and ends by becoming lost in the mazes of its own relativism'.[29]

Wind wrote to McKeon on 12 October 1942, 'with brutal frankness', withdrawing from the course – which he described as a regimented and inflexible approach to a 'none too fortunate selection of books' – and objecting to the Instructions as 'utterly unsuitable' and 'wrought with strange fallacies concerning the nature of the humanities, as some of us understand them'. Wind was amazed that the instructors did not revolt, and stated that handing out a list of dates to be learnt by rote was 'one of the most humiliating experiences I have ever had as a teacher'. That Wind's reservations about McKeon's Instructions were shared by other faculty members at Chicago is shown by a statement of 23 June 1944 by David Grene of the Greek Department, included as evidence in the later Bill of

28 Richard McKeon, 'The Philosophic Bases of Art and Criticism', *Modern Philology* 41/2 (1943), 65–87, and 41/3 (1944), 129–71. Ronald S. Crane, ed., *Critics and Criticism: Ancient and Modern* (Chicago: Chicago University Press, 1952). The literary critic W. K. Wimsatt noted of this book in 1954 that 'five of the essays in this volume (222 pages, surely far too great a proportion of the book) are contributed by Professor Richard McKeon, a specialist in the history of philosophic systems who looms massively and portentously behind the whole Chicago effort. Two things the Chicago literary critics apparently owe to him as mentor: a deep preoccupation with Aristotle's literary philosophy and a quasi-pluralistic theory regarding various historically recoverable critical systems.' W. K. Wimsatt, *The Verbal Icon: Studies in the Meaning of Poetry* (London: Methuen, 1970), 44–5.

29 Wind's report to Fritz Saxl, 1945.

Particulars submitted by Wind to the University Committee on Policy. Grene reported that:

> the failure to understand that the assumed objectivity of the 'disciplines' is no objectivity at all, has borne hardest on the non-conformists […] The mental attitude of such non-conformists has most consistently been treated with a sorrowful pity or disciplinary measures or most often by an apparent unwillingness to admit that such a disagreement is honestly possible by a fully conscious intellectual opponent.[30]

The approach that had come to be known among the staff as 'scientific criticism', and among students as 'formal analysis', was not to be viewed simply as a personal opinion 'but as an accepted method of literary procedure about which *qua* method there is no ground for dispute'. Words in themselves had an intrinsic logic and significance that were paramount in appreciating a text: 'I have listened in staff meetings', Grene reported, 'to a complicated analysis of the first nine chapters of Gibbon's history according to Aristotle's four causes, in which any reference either to the Roman Empire or to the eighteenth century was explicitly declared to be irrelevant.'

Wind had a similar experience to Grene when his initial letter criticizing the 'basic principles' promulgated in Humanities 2 'was received by the Dean with extreme displeasure and resulted in a session which resembled an inquisitional court procedure rather than an academic discussion'.[31] The complexities of McKeon's thought can hardly begin to be traced here. One of his students, the philosopher George Kimball Plochmann, described how McKeon 'sought a method that could treat other methods and other concepts in a virtually natural way, for otherwise distortions would creep in. His own concepts ground his method of taking in all methods, rather than grounding one more system.'[32] In his letter of 12 October 1942, Wind

30 David Grene, Statement for the Bill of Particulars, 23 June 1944, Bodleian EWP, MS Wind 8, folder 2.
31 Bill of Particulars, Wind's Report, Bodleian, EWP, MS. Wind 8, folder 2.
32 George Kimball Plochmann, *Richard McKeon: A Study* (Chicago: University of Chicago Press, 1990), 28.

perceptively pointed out the weaknesses of a pluralistic method from his own experience of studying symbols:

> Methods of attack which oppose one another are represented by you as peacefully supplementing one another, with the result that they lose their meaning and focus. I know that you cherish this device of reconciliation, but no one who thinks enough and seriously believes what you say on page 4 [of the Instructions] about 'communication' can accept your unqualified recommendation of *appreciation in the abstract* three paragraphs before. Nor can anyone who has dealt with symbols follow your argument when you separate 'expression' from 'communication'. Your assertion that these different disciplines 'may be used independently on any given book' is simply contrary to fact.

Earlier in 1942, Wind had delivered a thoroughly Warburgian account of modern art, in a lecture series given at the Museum of Modern Art in New York; in this letter can be sensed the frustration of an advocate of the *Pathosformel* encountering a completely alien methodology. The danger to Wind at Chicago, however, lay in the political consequences of 'pluralism' being advanced, somewhat ironically, as the sole critical method, resulting not in a 'circular' illumination of one discipline from the perspective of another, but in the dominance of neo-Aristotelian philosophy over other subjects. In the later Bill of Particulars drawn up by Wind, he said of McKeon:

> As there can be no doubt that the Dean is sincere in his belief that his discovery of 'basic techniques of inquiry or research' gives him mastery over so many divergent fields, the source of his harmful administrative method need not be sought in any malignant intention, but rather in a mis-guided philosophy.[33]

The Memorial Controversy and the Bill of Particulars

The Memorial Controversy was a particularly bruising episode in Hutchins' presidency at Chicago. Prompted into action by the series of

33 Bill of Particulars, Wind's Report, Bodleian, EWP, MS. Wind 8, folder 2.

idealistic proposals made in the president's speech at the Trustees–Faculty Dinner on 12 January 1944, opponents of Hutchins mobilized around a Memorial or 'Bill of Rights', which called for the trustees of the university to require the president to consult with faculty over appointments and structural or strategic changes. Signatories to the Memorial included 119 full professors; the Senate voted to recommend the document to the Board of Trustees, which then held a vote of confidence in Hutchins – which he survived. Wind reported to Saxl:

> The succeeding debates in the University Senate, in which Mr Hutchins was attacked as a 'revolutionary', have given me an idea of the extremes to which unbridled passion can drive the misuse of intelligence; and while in retrospect it strikes me as humorous that the debate had to be carried on under police protection, I am happy to say that this particular struggle ended with a victory, however narrow, on the side of academic freedom.[34]

In his speech at the Trustees–Faculty Dinner, Hutchins had reflected in a self-deprecatory tone, accompanied by caustic jokes, on his 15 years as president, during which time, he argued, nothing of consequence had been achieved. Hutchins stated bluntly that 'the University is not excellent enough' and that Chicago's 'reputation for pioneering on the frontiers of education and research' was largely undeserved and due only to the comparably terrible state of American education. In its current form, the university was 'a conspiracy to preserve the status quo'. To reverse this situation, Hutchins made a number of suggestions: the system of acquiring credits towards a degree should be abolished and methods of instruction reformed towards 'reading lists, a tutorial system, and general examinations' rather than a proliferation of courses; academics should all be full-time, salaries should be raised and determined by need, academic rank should be abolished, and outside earnings should all be paid back to the university; there should be a greater emphasis placed on interdisciplinary approaches, on educating teachers and on Chicago's extra-mural reach (including the Encyclopaedia Britannica) rather than on vocational training

34　Edgar Wind, Report to Fritz Saxl on his American activities on behalf of the Warburg Institute 1939–45, 1945, Bodleian, EWP, MS. Wind 7, folder 2.

for professions; and the university should be more democratic, with the president elected to serve shorter terms, and required to consult the faculty, supported by a smaller Senate elected directly by the whole faculty. All of these measures were prerequisites to enabling the university's true purpose, which was to shape American freedom following the war, in a manner similar to how the University of Paris had formed medieval civilization. Hutchins wanted to focus the 'total resources of the University [...] on the problem of raising the intellectual level of the society which it serves'. To those of an idealist or utopian disposition this was a stirring call-to-arms. For those concerned with maintaining acquired rank, external income, and the priority of research over teaching, or indeed for those altruistically worried about disciplinary integrity or student expectations of a degree program, this was alarmingly impractical talk.

Wind followed these events closely, as is evident from press cuttings he kept among his papers from *The New York Times*, *The Chicago Sun* and *The Chicago Daily News* – all of which reported the campus controversy.[35] Following Hutchins' speech, a self-appointed committee of six professors – Jacob Viner, Ronald S. Crane, Sewall Wright, Avery O. Craven, Ezra J. Kraus and Frank H. Knight – wrote to Hutchins on 28 February 1944 requesting clarifications and reassurances concerning the practical consequences of the ideas outlined in his speech. They were concerned that the implication of the call for 'a moral, intellectual and spiritual revolution' was the imposition of a 'philosophically unified program of academic studies and activities that would serve as a means to the ends you state'.[36] Hutchins' response was that he had no intention of imposing a single program or objective on the university, and that he would not be able to even if he did – because he was governing according to Chicago's constitution in which, he reminded the protestors, the Senate had no veto. In both of his suggested reforms, either increasing or decreasing the president's power, the role of the overall faculty, as opposed to the full professors who made up the Senate, would be enhanced.

35 Now in Bodleian, EWP, MS. Wind 8, folder 3. Subsequent quotations in this section are taken from these press clippings.
36 Bodleian, EWP, MS. Wind 8, folder 3.

Dissatisfied with what they saw as Hutchins' ambiguous response, the six opposition professors circulated their Memorial demanding that 'the university should not be committed to any particular philosophy or dogma' – notably a 'particular formula of revolutionary change' – and that the independence of departments and divisions from presidential control should be maintained. The extent of the opposition was picked up by the local press: *The Chicago Daily News*, for example, published a series of five reactions from leading academics to Hutchins' proposed administrative reforms, while *The Chicago Sun* reported that the president's opponents were seeking a promise from the trustees that Hutchins will 'not be given power to make major changes in the university's educational policies and appointments without the consent of the faculty'.

Harry M. Beardsley, a reporter at *The Chicago Daily News*, dramatized the conflict between president and faculty as one between totalitarianism and a democratic society of checks and balances, between the state and the individual. By contrast, the professor of political science, Jerome G. Kerwin, described it as the conflict between old and new ideas, with the Senate, which was dominated by older and more conservative academics, resisting necessary change. Interestingly, in his copy of the Memorial, Wind highlighted the sentence:

> The Senate is convinced, moreover, that if the University is to be safeguarded against the encroachment of dogma, as well as against a progressive lowering of its standards, there must be continued control by its members, organized according to subject matters in departments, divisions and schools, over the appointment and promotion of those who are to give instruction or conduct research in their respective fields.

Wind decided at this point to take a political stand against the Memorial, circulating a counter-resolution which stated that 'in attempting to defend academic freedom, the resolution is in danger, therefore, of defeating its own purpose' because it 'fails to protect the faculty against encroachments by those departmental and divisional officers who have attempted to interfere with the freedom of teaching in the past and are encouraged in those attempts by the very clauses of the resolution'. Wind's files contain several letters from colleagues supporting him in principle but refusing to sign his statement for strategic reasons – and presumably

because they did not want to take an open stance against their department heads. On 6 May 1944 Wind also signed, along with 143 other members of the faculty, a petition to the Senate Committee on University Policy, calling for an elected Senate as 'the University, as at present constituted, does not give the entire faculty an effective means of expression and action.'[37]

Wind's resolution against the Memorial drew an angry response from the economist Jacob Viner, who thought it was aimed at him; denying this, Wind referred Viner to the circumstances in 1943 when he had offered to resign. Subsequently, an unintended consequence of Wind's attempt to support Hutchins was that he was requested on 13 June 1944 to draw up a Bill of Particulars 'naming the persons against whom his more specific charges are directed' and substantiating his charges for the Committee on University Policy – a request that ultimately had to come from Hutchins as president. On 30 June 1944, E. A. Duddy (an expert on agricultural economics), the chair of the committee, acknowledged receipt of the Bill of Particulars and began his investigation. Wind's complaints against McKeon and Middeldorf are itemized in exhaustive detail in the 'Bill of Particulars in support of the Statement regarding the Memorial to the Board of Trustees' (with additional statements of support by John Nef and Ralph Tyler).

The complaints that Wind itemized in his report were that: (1) No departmental meetings had been held in the Art Department for a twelve-year period from 1932 to 1944; (2) Middeldorf and McKeon decided 'educational policy' and the 'faculty had no voice in the planning of the curriculum'. Wind had objected to McKeon attending the first meeting of the Art Department on 9 February 1944, and Middeldorf requested that he apologize to McKeon, which Wind saw as 'coercion and intimidation'; (3) Decisions concerning the Art Department had been made without consultation; (4) Middeldorf's method of 'over-ruling dissenting opinion' was exemplified by 'the announcement [in the catalogue of courses of 1943–4] of a course of his own phrasing ("Introduction into the Literary and Philosophical Interpretation of Art") in my name without my consent and regardless of my objections'; (5) Similar abuses of power have occurred in the Latin department; (6) The attempt made by McKeon

37 Bodleian, EWP, MS. Wind 8, folder 2.

to suppress a series of extra-curricular lectures in the Division of Social Sciences 'which had been scheduled with his written consent', and the fact that 'when this attempt failed, Mr McKeon suppressed, through his divisional Committee on Policy, a course of lectures which he had invited me to give in the Division of the Humanities'; and (7) The concentration of power in McKeon's hands and his tendency to reduce departmental chairs to 'positions of intellectual servitude'.[38] The 'basic techniques of inquiry or research' as understood in the Division of Humanities were discussed as an instrument of McKeon's 'abuse of power'. In conclusion, Wind (with the support of Nef and Tyler) stated that Hutchins was not a threat to the future of scholarship but that 'various elements in the faculty' had revealed themselves as 'the enemies of freedom of teaching and research'. Writing privately to Wind, Nef remarked: 'You know, I think, how grateful I am, and Hutchins is, to you for carrying on the fight here. I wish there were more tangible results.'[39]

While Chicago was torn apart by infighting, Wind heard the news that the Warburg Institute had been incorporated into the University of London. Anticipating his imminent return to the Institute which, as he had reassured Saxl in 1943, 'in my personal opinion, I have never left', Wind wrote to Hutchins that 'I have written to John [Nef] and expressed the hope that some form might be found by which I could remain on your Committee and serve as your "liaison" officer in London. You know how much I liked working with you and John, and it would be a pity if it were to stop.'[40] Wind negotiated with Hutchins that his salary at Chicago should be paid up until the end of the year, and he wrote to Middeldorf on 30 October 1944 resigning his post in the Art Department on those terms. Then on 10 November 1944 Wind heard that the Bill of Particulars had been dismissed by Duddy's committee because of 'insufficient evidence'. Wind felt humiliated and abandoned by Hutchins and wrote angrily to him,

38 Edgar Wind, 'Bill of Particulars in Support of the Statement Regarding the Memorial to the Board of Trustees', June 1944, report, Bodleian, EWP, MS. Wind 8, folder 2.
39 John Nef to Edgar Wind, 8 October 1944. Bodleian, EWP, MS. Wind 8, folder 2.
40 Edgar Wind to Robert Hutchins, 19 October 1944. Bodleian, EWP, MS. Wind 8, folder 2.

a move that Nef felt was unfair to the president. Nef also stated that 'the loss caused by your departure to what the University of Chicago ought to stand for is irreparable'.[41] Following the rejection of the Bill of Particulars, Wind moved to take up the offer of the Neilson Professorship at Smith College. Chicago then ceased paying his salary and a lawyer had to be engaged to secure full payment up to his agreed departure date. As a consequence, Wind severed all connections with Chicago, writing in his report to Saxl: 'I was not displeased to leave Chicago, though a limited number of my colleagues regretted it. Smith College, which appointed me to the William Allen Neilson Research Professorship in the Autumn of 1944, has proved refreshingly undramatic.'[42]

Conclusion

Writing to Saxl from his sickbed in the Billings Hospital in 1943, Wind contrasted Hutchins with McKeon. The president was 'a man of singular intelligence, imagination and daring, very young for his post (just 43), and for reasons which he declares he knows, one of the most loyal, enthusiastic and far-sighted supporters I have had in this country.' The dean, on the other hand, 'has been extremely ambiguous after my arrival here and our collaboration has not been too successful'. This development had been predicted by Barr and Buchanan, who 'now think it is a great joke'.[43] Wind had known McKeon since the summer of 1928, and had thought highly of him, even recommending him to Aby Warburg as a potential visiting fellow at the Warburg Institute.[44] At Chicago, however, the two

41 John Nef to Edgar Wind, 28 November 1944. Bodleian, EWP, MS. Wind 8, folder 2.
42 Wind, Report to Saxl.
43 Edgar Wind to Fritz Saxl, undated draft, 1943, Bodleian, EWP, MS. Wind 7, folder 2.
44 Edgar Wind to Aby Warburg, 30 April 1929, cited in Branca, *Edgar Wind's Raphael Papers*, 56.

scholars clashed. While Hutchins had embraced Wind's conception of encyclopaedic learning, seeing it as supporting his reforming mission for Chicago, McKeon had provoked Wind's opposition because of a methodology that he considered timid relativism and a management style that he saw as an 'abuse of power'. In his strongly worded rejection of McKeon's Instructions, Wind implicitly contrasted the dean's approach with that of William James in 'The Will to Believe':

> Yet one of the most essential lessons to be taught to young people in the humanities is that they cannot proceed without taking the risk of certain commitments, and the adventurous part of the study is to discover what these risks are. You, on the other hand, try to tell them that they can play safe on all sides and need not take any risks since all sides can be peacefully harmonized if only one does not commit oneself to any. 'Everything is so true that nothing is quite true' is a wonderful formula for levelling out all the differences of truth. I assure you that nothing will induce me to teach this lesson.[45]

At Smith College, Wind devised an 'experimental' sophomore course, Humanities 292a, which could be seen as the antidote to McKeon's Humanities 2: 'it is not an orientation course but a disorientation course, whose purpose is to break up prejudices. And when new ideas are bred, these in turn create new prejudices which I hastily try to break up again. It is a slightly explosive process.'[46] Beginning with Plato and ending with William James, the course had at its heart Pico's 'Oration on the Dignity of Man': a text arguably more significant in the context of wartime America than it ever had been in the fifteenth century.[47] Wind was urging his students to take the risk of freedom – and to be reasonable and enthusiastic about it at the same time!

45 Edgar Wind to Richard McKeon, 12 October 1942, Bodleian, EWP, MS. Wind 8, folder 2.

46 Edgar Wind, 'Humanities 292a: An Experimental Course', *Smith Alumnae Quarterly* (May 1953), 136.

47 Brian P. Copenhaver, *Magic and the Dignity of Man: Pico della Mirandola and His Oration in Modern Memory* (Ann Arbor: Belknap Press, 2019).

JAYNIE ANDERSON

13 Understanding Excessive Brevity: The Critical Reception of Edgar Wind's *Art and Anarchy*

Like most of Edgar Wind's books, *Art and Anarchy* began as a brilliant performance: the Reith Lectures on radio that entranced a British audience at prime time, first aired in the lead-up to Christmas, from 24 November to 22 December 1960. The lectures were then broadcast and re-broadcast internationally, in Australia, Canada, South Africa and the United States. Their initial publication in the BBC weekly, *The Listener*, sold out in New York within days, because every New Yorker just *had* to have a copy of the Reith Lectures. Individual essays were reprinted in popular magazines. The audio recordings of some of the lectures are now available online, and we can hear Wind's unique, compelling voice, the words clearly pronounced in English with a mesmerizing German accent: I 'Art and Anarchy'; II 'Aesthetic Participation'; III 'Critique of Connoisseurship'; IV 'The Fear of Knowledge'; V 'The Mechanization of Art'; VI 'Art and the Will'.[1] Initially broadcast and printed in *The Listener* without images – Wind's words alone conjuring ideas – the lectures were republished three years later as a book, to which he added extraordinary footnotes, often short essays of a few hundred words, as well as a small selection of black-and-white illustrations.[2] *Art and Anarchy* became Edgar Wind's most successful and most widely read book, which from its beginnings provoked a global discussion. As

1 The extant lectures are available at 'Edgar Wind – Art and Anarchy', BBC Reith Lectures, <https://www.bbc.co.uk/programmes/p00h9lbs>, accessed 9 July 2023.

2 All references are to the first edition in book format: Edgar Wind, *Art and Anarchy: The Reith Lectures 1960, Revised and Enlarged* (London: Faber & Faber, 1963).

recognized by Kenneth Clark, the art historian who made art popular on British television, Wind's broadcast words drew people beyond routine scholarship, to the excitement of theory.[3]

In his opening words Wind generates complexity and difficulty. He warns us that art is an uncomfortable business, that imagination has a capricious power, that Plato alerts us that art may be a disruptive force, and the artist must learn to rage correctly. Wind compares Plato's views on art in his account of 'sacred fear' (whereby the artist learns to regulate the imagination for the good of the state) with Hegel's philosophy that in the Romantic period art was displaced and marginalized by science. For Hegel, art has become superfluous, and Wind quotes at length from Hegel's *Lectures on Aesthetics*: 'We find no personal longing, obsession or desire, but only a pure pleasure in the phenomenon [...] an inward warmth and joy of sensibility [...] which raises the soul, through the serenity of form, above any painful involvement in the limitations of reality.'[4]

The subtle complexities of Wind's arguments in the opening chapter are exemplified by his unusual comparison of two works, by Mantegna and Manet (Figures 13.1 and 13.2), both described as *The Dead Christ with Angels*, representations of angels mourning Christ. They exemplify the contrasting Platonic and Hegelian views of the function of art. The first was painted in an age of faith, the Italian Renaissance, when patrons determined with care what they commissioned, and an altarpiece brought worshippers to their knees. The second was painted by Manet for pure pleasure, for a Salon audience. Wind's discussion is a philosophical comparison of the different functions of art in different periods, one that mirrors the famous stylistic comparative principles created by Heinrich Wölfflin, who was for Wind 'perhaps the greatest art-historian of the last generation,'[5] but used for a different purpose. Wind continues that for Hegel, art has moved into the margin, but it does not lose its quality, only becoming a 'splendid

3 Kenneth Clark to Edgar Wind, 30 December 1960 and 6 July 1963. Bodleian Libraries, University of Oxford, Edgar Wind Papers (hereafter Bodleian, EWP), MS. Wind 98, folder 1.
4 Hegel, quoted by Wind, *Art and Anarchy*, 15.
5 Wind, *Art and Anarchy*, 20.

Figure 13.1: Andrea Mantegna, *Christ Mourned by Angels* [museum title *Christ as the Suffering Redeemer*], 1495–1500, tempera on panel, 83 × 51 cm. From the collection of Cardinal Silvio Valenti Gonzaga, state secretary to Pope Benedict XIV. Statens Museum for Kunst, Copenhagen.

Figure 13.2: Eduard Manet, *Christ Mourned by Angels* [museum title *The Dead Christ with Angels*], 1864, oil on canvas, 179.4 × 149.9 cm. Metropolitan Museum of Art, New York. H. O. Havemeyer Collection, Bequest of Mrs H. O. Havemeyer, 1929.

superfluity', although he concedes that Hegel may have overshot the mark. Wind's elegant and fluent prose resembles a Platonic dialogue, with a web of interconnected conceptual intricacies.

The second lecture, 'Aesthetic Participation', develops the argument, in that the widespread diffusion of art has resulted in a facile response. It is a criticism of the doctrine of 'Pure Art', a theme that had always preoccupied Wind, even as a student; and he was particularly provoked to always criticize it in an English context, as in his anonymously published review

for the *Times Literary Supplement* of the second edition of Kenneth Clark's *The Gothic Revival* (1950), five years before Wind took up the chair of art history at Oxford (Figure 13.3).[6] Nor were art historians immune to aesthetic purism. The influence of writers like Heinrich Wölfflin, who 'reduced his artistic perception to an emotionally untainted sense of form', so that he could move easily from a work by Raphael to one by Rubens, from Holbein to Rembrandt, was central to Wind's reaction against the treatment of art as if it were pure, 'a useful and economical fiction'. Other writers – Roger Fry, Clive Bell and Bernard Berenson – similarly failed to grapple with the imaginative forces of art, concentrating rather on formal qualities.

Wind's third lecture, which he titled the 'Critique of Connoisseurship', made the nineteenth-century Swiss-Italian politician Giovanni Morelli, who invented connoisseurship for the modern world, a figure of fascination in twentieth-century art historiography. I read *Art and Anarchy* as an undergraduate in Melbourne in 1963. There I encountered Morelli (Figure 13.4), triggering a lifelong interest that culminated more than fifty years later in a biography.[7] Although Wind had always criticized formalism, he saw many virtues in connoisseurship as practised by Morelli. For Wind, Morelli was a connoisseur of genius, who 'detested the grandiloquent verbiage' of other connoisseurs. His method was a 'meticulous technique of visual dissociation', for he sought unimportant details that would reveal an artist's personality, small idiosyncrasies that seem unessential, and for this reason he represented an extreme case of the marginalization of art in the modern world. Wind perceived the aesthetic behind Morelli's thought as the Romantic cult of the fragment:

6 Edgar Wind, 'Pure Art' [review of Kenneth Clark's *The Gothic Revival: An Essay in the History of Taste*], *Times Literary Supplement* (13 October 1950), [645]. Newspaper cutting from Edgar Wind's papers on *Art and Anarchy*, Bodleian Libraries, University of Oxford, Edgar Wind Papers (hereafter Bodleian, EWP) MS. Wind 98, folder 3. Inscription by Margaret Wind, who then omitted it from Wind's publications.

7 Jaynie Anderson, *The Life of Giovanni Morelli in Risorgimento Italy* (Milan: Officina Libraria, 2019); and in Italian translation: *La vita di Giovanni Morelli nell'Italia del Risorgimento* (Milan: Officina Libraria, 2019). The biography contains a Bibliography of my publications on Morelli.

LITERARY SUPPLEMENT

LONDON, PRINTING HOUSE SQUARE

CENTRAL 2000

Friday October 13 1950

PURE ART

Sɪʀ Kᴇɴɴᴇᴛʜ Cʟᴀʀᴋ's book on the Gothic revival was first published in 1928, and he has now issued a new edition with a preface in the form of a letter to the publisher, in which he explains the difference between the opinions he holds now, on this and other subjects, and those which he held when he had just ceased to be an undergraduate; there are also some footnotes in which his earlier judgments are corrected. The writer tells us that he was brought up on theories of pure art, " the pure form of Roger Fry and the pure architectural values of Geoffrey Scott," and how far he has moved in this position comes out most clearly in a footnote on Fra Angelico. He quoted in 1928 a remark of the younger Street that his father felt so strongly the exalted nature of Fra Angelico's work that he " made a proper appreciation of it a test of his own moral state "; in 1949 Sɪʀ Kᴇɴɴᴇᴛʜ writes: " I suppose I thought this absurd but I now think it is true."

It is amusing to wonder what Roger Fry would have made of this observation, coming as it does from a writer whose aesthetic judgment he would respect now as he respected it in the past. It implies, of course, a final rejection of the whole immensely influential aesthetic of which Fry was no doubt the most persuasive advocate but which also found expression in many other ways. It provided the theoretical basis and often the stimulus for the production of abstract art and, indeed, of most modern styles of painting. It did as much as anything to make possible the modern [illegible] the connoisseur to move easily from the work of Raphael to that of a native carver without trying to understand the mentality of either. And in many other ways it proved far more inspiring than, on the face of it, so strict and colourless a doctrine had any right to be. But the difficulty was that there were too many points on which it seemed to conflict with experience. Pɪᴄᴀssᴏ's most unrealistic compositions had a way of arousing such extremely impure emotions as pity and terror. Fry himself had to strain his argument when attempting to dissociate the two aspects of art which he called the psychological and plastic elements, to both of which elements he himself was unusually and equally sensitive. And Sɪʀ Kᴇɴɴᴇᴛʜ Cʟᴀʀᴋ amusingly observes that at the end of his book on the Gothic revival he attributed the failure of this movement to ethical and social causes without noticing that he had implicitly abandoned his " pure Scottist position."

Evidently this was not the place in which to make more than the briefest reference to whatever new aesthetic theory has supplanted that held by Sɪʀ Kᴇɴɴᴇᴛʜ Cʟᴀʀᴋ in 1928. But, even so, the necessarily abrupt and often negative statements of his present position are curiously characteristic of critical opinion at the present time. Every one feels that the doctrine of pure form is unsatisfactory, but no one seems to have found any equally comprehensive aesthetic to put in its place; certainly nothing equally stimulating has as yet appeared.

There is certainly great difficulty in enlarging the basis of aesthetic appreciation so as to include and to put into their right place those psychological elements which Fry rejected. Thus there is obviously much to commend the idea that one must understand goodness to have a proper appreciation of Fra Angelico, but it is hazardous to go from this to the extreme position, that it is even necessary to be in a good moral state, which is apparently held by Sɪʀ Kᴇɴɴᴇᴛʜ Cʟᴀʀᴋ. Is it then, necessary to be full of superstitious fears in order to be moved by Mexican sculpture, or eager for meat in order to understand the caveman's art? Even as between the artist of the Renaissance and the modern observer, there is a wide gulf to separate the motives of the one from the sympathetic understanding of the other and—what seems very much to the point—it is a gulf the mere existence of which has only lately been revealed; the subjects of some Renaissance paintings, it has lately been discovered, are altogether different from what they were once believed to be, and played a much larger part in the conception of the picture than had been suspected, yet ignorance of this did not seem to impair a genuine appreciation of such works. No doubt the truth lies somewhere between the extreme position, that all the artist's emotions and interests must be shared by the observer, and the inhuman or superhuman detachment at which those who held theories of " pure " art once aimed. But exactly where it lies is the essence of the problem.

The Times Literary Supplement,

13 October 1950, p. 645

Catholicity of Taste by encouraging

Figure 13.3: Edgar Wind, 'Pure Art' [review of Kenneth Clark's *The Gothic Revival: An Essay in the History of Taste*], *Times Literary Supplement* (13 October 1950), [645]. Newspaper cutting from Edgar Wind's papers on *Art and Anarchy*, Bodleian Libraries, University of Oxford, Edgar Wind Papers, MS. Wind 98, folder 3. Inscription by Margaret Wind.

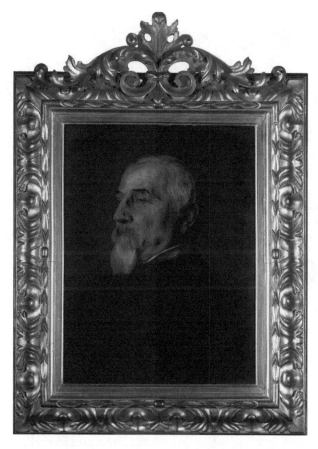

Figure 13.4: Franz Seraph von Lehnbach, *Portrait of Giovanni Morelli*, 1887, oil on paper, 60 × 48 cm. Galleria d'Arte Moderna, Milan, gift of Gustavo Frizzoni, 1916.

At first glance, Morelli's concentrated study of the lobe of an ear might seem like Wölfflin's curious concern for a nostril, but the resemblance is deceptive. Whereas Wölfflin uses the small detail as a module for building up the larger structure, Morelli cherishes the authentic fragment as the trace of a lost original.[8]

8 Wind, *Art and Anarchy*, 42.

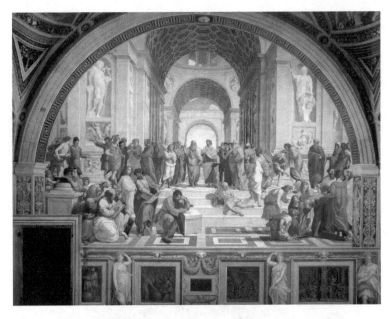

Figure 13.5: Raphael, *The School of Athens*, 1509–11, fresco. Stanza della Segnatura,
Apostolic Palace, Vatican Museums, Rome.

Wind's fourth Reith Lecture, 'The Fear of Knowledge', begins with
the argument that Plato's sacred fear of art has been supplanted in the
twentieth century by the modern fear that knowledge might harm the
imagination. For Wind this was the most important lecture in the series.
At its heart is an interpretation of Raphael's *School of Athens* (Figure 13.5)
as a superb combination of 'intellectual precision and pictorial fantasy'.
Raphael succeeded in painting 'what a less intelligent and less sensitive
artist might have found to be an utterly unpaintable subject: an abstract
philosophical speculation of weird intricacy but rigorous logic'. The pages
that follow, as Wind wrestles with Raphael, are some of the most quoted
from *Art and Anarchy*, often provoking reviewers to ask for more about
Raphael. For Wind, Raphael's *School of Athens* was the most important
painting in the world, the most subtle depiction of philosophy possible.
Wind argues that the rediscovery of an exact subject matter of a painting
does influence our aesthetic judgement, and gives several examples from

his 1948 book *Bellini's 'Feast of the Gods'*, in which he proudly continues to recognize that artwork as a 'facetious' painting, despite adverse criticism.[9] He also cites his 1940 paper on Botticelli's panel mistakenly called *La Derelitta*, 'which does not represent a weeping woman shut out from her house, but the grave biblical figure of Mordecai (from the Book of Esther), dressed in sackcloth and mourning before the King's gate' (Figure 13.6).[10] The principal figure has long hair; the deciding factor for Wind was the previously unnoticed beard. Wind fails to mention his interpretation of Botticelli's *Primavera*, in which he identified the rape of Chloris, her lips breathing spring roses as she becomes Flora – often considered his most perceptive identification.[11]

The fifth lecture, 'The Mechanization of Art', begins with the assertion that although it might be thought that art and mechanization are exclusive, they have become increasingly interrelated. There are many historical examples of reactions against mechanization, such as when the Duke of Urbino forbade from his library any printed books, preferring manuscripts, words written by a scribe seeming more personal than printed type. Wind is not against mechanization, but he objects to the unimaginative use of it, as in the parodies of mass-produced chairs after Mies van der Rohe. Or – significantly, in relation to architectural conservation – there are those who believe that replacement is possible, whereas to Wind's mind architectural innovation as with Viollet le Duc is preferable. Similarly in the conservation of paintings: no intervention is neutral, and those that attempt to take a picture back to its 'original' state will be easily datable with time. Of particular interest are Wind's comments about the effects

9 Edgar Wind, *Bellini's 'Feast of the Gods': A Study in Venetian Humanism* (Cambridge, MA: Harvard University Press, 1948).

10 First published as Edgar Wind, 'The Subject of Botticelli's "Derelitta"', *Journal of the Warburg and Courtauld Institutes* 4/1–2 (October 1940–January 1941), 114–17, reprinted in Edgar Wind, *The Eloquence of Symbols: Studies in Humanist Art*, ed. Jaynie Anderson, with a biographical memoir by Hugh Lloyd-Jones (Oxford: Clarendon Press, 1983), 39–41.

11 As recognized by Charles Dempsey, *The Portrayal of Love: Botticelli's Primavera and Humanist Culture at the Time of Lorenzo il Magnifico* (Princeton: Princeton University Press, 1992).

Figure 13.6: Sandro Botticelli, *Mordecai Weeping at the King's Gate* [formerly known as *La Derelitta*], 1480, cassone panel, tempera on wood, 47 × 45 cm. Galleria Pallavicini di Palazzo Pallavicini Rospigliosi, Rome.

of photography on the imagination of artists, who develop works of art that are suited to reproduction, their aspiration being to belong to André Malraux's 'Museum Without Walls' (*Le musée imaginaire*, 1947). Wind suggests that Picasso may have adapted and simplified his palette so that it could be reproduced in a colour print.[12] Wind then draws a parallel with recorded music, whereby gramophone recordings are polished and edited

12 Wind, *Art and Anarchy*, 76–7.

together piece by piece, in a way that no performer could play with such mechanical proficiency. The last example is a speech given by President Roosevelt for the opening of the National Gallery of Art in Washington in 1941, when he was expected to address the audience directly, but instead was broadcast, leaving the audience feeling like eavesdroppers.[13]

Finally, in 'Art and the Will', Wind reflected on ways in which artists in different periods exercised their will – or failed to do so. He quoted his most admired Renaissance philosopher, Pico della Mirandola, in his protest against the papal inquisitors who attempted to control men's beliefs. In the Renaissance, patrons such as Isabella d'Este tried to dictate as closely as possible the subjects that Giovanni Bellini, Perugino and others depicted, with more or less success, whereas in more recent times artists worked increasingly alone, as when sculptors worked on the UNESCO building in Paris; they were ignored by the architects who were creating the building. Thus, by the twentieth century even the state had become a passive or timid patron. Abstract expressionism was a case where artists were left too much alone, and here it was clear that Wind had little respect for the abstract expressionists, comparing their mark-making to doodling. 'These artists have carried introspection to an extreme, and nevertheless try to break out from the seclusion it imposes upon them.' His conclusion was that artists could not be held responsible for their isolation in the twentieth century, that there was an affinity between 'pure art' and mechanization. The only challenge to the artist is: ' "Will it record well"?, "Will it reproduce well?", "Will it distribute well?" '[14] Wind concluded, surprisingly, by quoting the American philosopher William James on the chief difference between brutes and men: 'Prune down his extravagance, sober him, and you undo him.'[15] Clearly inadvisable.

It is hard to summarize or to easily understand the content of this successful short book.[16] To an Oxford friend, Bruce McFarlane, Wind

13 Wind, *Art and Anarchy*, 79.

14 Wind, *Art and Anarchy*, 99.

15 Wind, *Art and Anarchy*, 102.

16 As shown in Hugh Lloyd-Jones' summary in 'A Biographical Memoir', in Wind, *The Eloquence of Symbols*, xiii–xxxvi, and in the attempt by Ben Thomas, *Edgar*

admitted that he had 'studied brevity to excess' as he explained the
rich and concise references to earlier scholarship in *Art and Anarchy*
(Figure 13.7).[17]

Art historians have tried to understand the success of Wind's lectures,
grudgingly using terms like 'magical'. The best attempt was by Wind's good
friend and most ardent supporter in Oxford, Isaiah Berlin, himself an
equally compelling lecturer, who delightfully explained the conflicting
emotions experienced by Wind's audiences, including himself, when they
heard him lecture:

> I do not know what word I would use – something like 'implacable quality' seems
> to me nearer it. If you are to account for the negative emotions felt towards him,
> perhaps the marvellous flights of imagination, the ingenuity built upon ingenuity –
> those marvellous constructions in his lectures, not always supported by conclusive
> factual evidence but beyond refutation by mere facts – irritated the 'solid and sound'
> who felt uncomfortable and even shocked to be transported into such rich realms
> outside their sober disciplines ('to put it mildly').[18]

Nor was Berlin alone in his view, as he proudly reported in a letter
he dictated on 9 May 1958 to Philip Hofer, librarian of the Fogg Museum
of Art at Harvard and publisher of Wind's monograph on *The Feast of
the Gods*: 'Edgar Wind goes from triumph to triumph – the gangways
of the Playhouse in Oxford are crammed with bodies one on top of the
other unable even to squeeze into the empty standing room behind the
seats and not even the antics of Douglas Cooper outdid the magical hold

Wind and Modern Art: In Defence of Marginal Anarchy (London: Bloomsbury, 2020), 19–25.

17 Edgar Wind to K. B. (Bruce) McFarlane, 1 November 1963, Bodleian, EWP, MS. Wind 98, folder 1.

18 Isaiah Berlin to Colin Hardie, 5 April 1973, Bodleian Libraries, University of Oxford, MS. Berlin 202, folder 16. References to Wind are also in Berlin's published correspondence: Isaiah Berlin, *Enlightening: Letters 1946–1960*, ed. Henry Hardy and Jennifer Holmes (London: Phaidon, 2011), esp. 599, 600. I am grateful to Henry Hardy for his advice and guidance about the papers of Isaiah Berlin, and for permission from the Trustees of the Isaiah Berlin Literary Trust to reproduce quotations from them here.

1st November 1963

Dear Bruce,

Thank you again (my influenza having been mastered) for your delightful and nourishing letter. Your remarks leave no doubt in my mind that I have 'studied brevity to excess'. I should have made clear that the features I stressed were not the only features at any given time, and however significant they may have seemed to me, there were also contrary forces at work. This I clearly failed to convey. However, since you challenge me to name any writer of significance or influence, apart from Mallarmé /and Joyce/, who would fit my description, - well, here is a small collection: the Goncourts, Théophile Gautier, Baudelaire, Verlaine, Rimbaud, Valéry, Poe Walt Whitman, Swinburne, Rilke, Hofmannsthal, Verhaeren, Proust, Virginia Woolf. Unless you had forbidden it, I would have included also the late Henry James. The self-sufficient artistry of his stylistic elaborations seems to me, as in Proust, a perfect example of 'dissociation of sensibility'. Incidentally, I must decline both the glory and the shame of being the first to have made these observations. I tried to show in the notes how many others had made them before me. In fact, I expected the book to be dismissed as vieux jeu. I am amazed, but not elated, that it should seem paradoxical and perverse.

Tennyson, whom you justly name as representing the contrary forces, seems to me to prove how weak

Figure 13.7: Edgar Wind, letter to K. B. (Bruce) McFarlane, 1 November 1963. Bodleian Libraries, University of Oxford, Edgar Wind Papers, MS. Wind 48, folder 2.

which Edgar has over his audiences.'[19] Journalists in Oxford recorded the crowds, as the audience was exceptional. Other professors who failed to

19 Isaiah Berlin to Philip Hofer, 9 May 1958, transcript of dictabelt recording, University of Oxford, Wolfson College, Berlin Archive.

attract such an audience could be ungenerous. Berlin's own lectures on the definition of Romanticism, at the National Gallery of Art in Washington (also now available online),[20] convey something of his own unconventional approach to lecturing. Berlin relished the provocative wit of Edgar Wind, which had similarities to his own.

Wind was encouraged to deliver the Reith Lectures by a Russian woman of great intelligence and charm, whom he had known for many years: Anna Kallin, who successfully persuaded many other distinguished art historians, including Anthony Blunt and Kenneth Clark, to present on the BBC Third Programme.[21] Wind realized that these lectures were for an audience who had to imagine the pictures. 'Though I speak without notes, I read a few notes to think,' he wrote to Kallin.[22] In fact, Kallin managed to extract texts from Wind before the lectures, and she helped refine their content before they were broadcast, sometimes irritating Wind in the process.[23]

The reaction to the broadcasts and publications of *Art and Anarchy* are documented in hundreds of letters in the Wind archive. He received numerous invitations to lecture at some very prestigious institutions in England and the United States. He refused them all. There was a wide-ranging response from a varied audience: artists, musicians, museum directors, art historians, restorers, theologians, and Oxford dons and friends – those involved in the contemporary art world and those in more traditional scholarship. Wind replied courteously and wittily, as on 3 April 1961 in a letter to the director of the London Furniture Development Council,

20 Isaiah Berlin, 'Some Sources of Romanticism', The A. W. Mellon Lectures in the Fine Arts, 1965, six lectures, available on University of Oxford Podcasts: Isaiah Berlin, <https://podcasts.ox.ac.uk/series/isaiah-berlin>, accessed 10 July 2023.

21 The BBC Third Programme broadcast nationally between 1946 and 1967. It specialized in classical music, and arts and culture programming. It was replaced by Radio 3.

22 Edgar Wind to Anna Kallin, 14 January 1950, Bodleian, EWP, MS. Wind 46, folder 2.

23 As revealed in the correspondence between Wind and Kallin in Bodleian, EWP, MS. Wind 46, folder 2, and in Margaret Wind's commentary in MS. Wind 95, folder 2.

J. C. Pritchard, concerning the discussion of the reproduction of chairs in the lecture 'The Mechanization of Art':

> When I spoke about Mies van der Rohe's 'beautiful and comfortable chairs', I had a variety of them in mind, – the Barcelona chair, the MR, 'Tugendhat' and 'Brno' chairs, and also those 'conchoidal' chairs, of which Philip Johnson reproduced some drawings in his book. I was under the impression that, at one time or another, I had encountered hackneyed versions of all of them, but the most obvious instances are, of course, the tubular chairs (mimicking Mies MR chairs) of which some singularly offensive specimens greet me every morning in the university corridors. I was much amused that you found the Barcelona chair uncomfortable. I enjoyed sitting on it in Philip Johnson's house and found myself very reluctant to rise from it. But I must try again when I get a chance. Is it often found in England? I am glad you agree that it is handsome.[24]

This letter documents a seemingly trivial part of Wind's argument, to reveal how carefully he had thought about every detail in every line, even down to a tacky chair that irritated him daily when he saw it in an Oxford corridor.

One aspect of Wind's success as a lecturer was that his meticulousness in determining the quality of his lantern slides, personally supervising their creation. He insisted that they be made from original photographs or works of art to create large (3¼-inch square) slides. He showed only one image at a time, often illuminating a great work of art with a detail from a contemporary print or something from popular culture. He refused to show coloured images, which he described as 'les belles infidèles' and which, he believed, 'contaminated a recollection', whereas a black-and-white illustration was an 'unambiguous abstraction'. Wind's attitude was characteristic of his generation, but what was the consequence for art history of lecturing in black and white over many decades? Digitization has now made colour reproduction much more accurate, so it would be hard to be quite as sceptical as Wind, though digitization has raised other issues that complicate things, for example the ability to control scale in a way that is wonderful for the scientist – and connoisseur – but totally improbable for real and

24 Edgar Wind to J. C. Pritchard (director of the London Furniture Development Council), 3 April 1961, Bodleian, EWP, MS. Wind 98, folder 2.

ordinary viewing. In the present essay most of the reproductions are in
colour, so that the reader may judge the difference in emotional effect.

Although *Art and Anarchy* was always dismissed by Wind's literary
executor, Margaret Wind, as 'a tract of the times', it was a light-hearted yet
complex statement of his method as it had developed by 1960, a decade
before he died. References to Renaissance art abound, and one way of
reading the book is to see it as a commentary on his Renaissance research.
It was never purely about modern art, as many have misunderstood it to
be. Whereas in *Pagan Mysteries in the Renaissance* Wind revealed himself
to be Warburg's true heir,[25] and much more besides, in *Art and Anarchy* he
conveyed his own beliefs as an art historian, making reference to many of
his previous writings. Each sentence is densely referential to his own ideas
and those of others. It became Wind's most popular book, reprinted many
times in English as well as being translated into German, French, Italian,
Spanish, Japanese, Hungarian and Rumanian.[26]

Even so, in the Wind archive Margaret Wind left a note to future
scholars, expressing her opinion that the lectures should never have been
published. On other occasions she succeeded in blocking editions in Italian,
Spanish and French of her late husband's *Feast of the Gods*, a book she often
dismissed with the comment: 'No one believes in that anymore.'[27] What
provoked such certainty that she could control her late husband's publica-
tions and his reputation? By creating that very successful archive of her
husband's life, she thwarted her own intentions. Because once the archive
was opened in 2009, and catalogued by 2015, the interpretation of Edgar
Wind's contribution to art history was changed forever. In frank letters in

25 In a previously unpublished review of Gombrich's biography of Warburg, Wind
 makes his claim to be Warburg's heir, even at the expense of Panofsky, who
 Wind claimed was intimidated by Warburg. See Jaynie Anderson, ' "Posthumous
 Reputations": Edgar Wind's Rejected Review of Ernst Gombrich's Biography of
 Warburg', *The Edgar Wind Journal* 3 (2022), 14–35.
26 Jaynie Anderson, 'Edgar Wind and Giovanni Bellini's "Feast of the Gods": An
 Iconographic "Enfant Terrible" ', *The Edgar Wind Journal* 2 (2022), 9–37.
27 Margaret Wind, cited in Anderson, 'Edgar Wind and Giovanni Bellini's "Feast
 of the Gods" ', esp. 11 n. 4. There is precise evidence in the archive to show that
 Margaret Wind blocked translations in French, Italian and Spanish.

the archive, Wind explains his views more clearly than in the concise form of writing he favoured in his books.[28]

Art and Anarchy had a long gestation period, beginning with a 1953 article in the periodical *Preuves* (1951–75), a trendy, left-wing publication financed by the Congress for Cultural Freedom and the Central Intelligence Agency. First given at a conference in Paris, the article of one-and-a-half pages succinctly defines major themes: the discussion of contemporary art is far too serious, especially when it is all about caprice; Mondrian may be a capricious charmer – until he takes mathematics as a didactic discipline; artists present themselves as researchers, but fail to understand contemporary science; as when Picasso chose to illustrate Buffon's outmoded eighteenth-century *Histoire naturelle*, which he published in 1942; art has become marginal and is no longer at the centre of life.[29]

The British public's first reaction to *Art and Anarchy* was to misunderstand it as a Renaissance historian's confused attempt to confront modern art. The book was criticized anonymously on the front page of the *Times Literary Supplement* in a review, 'Art in the Margin?', now known to have been written by Alan Bowness, the first lecturer in modern art at the Courtauld Institute.[30] Bowness took exception to Wind's acceptance of the Hegelian view that art has become marginalized in our lives, and found the comparison between Mantegna and Manet unfair, as Bowness thought that Manet was influenced by Ernst Renan's conception of Christ as the perfect man (not the Son of God), and thus produced an image of suffering humanity. Bowness concluded: 'can the comparison prove anything more than that Mantegna's is the better picture, and this for evident aesthetic reasons, unconnected in their place in time?'

28 An example is Wind's letter to Frances Yates of 4 September 1938, Bodleian, EWP, MS. Wind 154, folder 1. For the full transcript, see Bernardino Branca, 'The Giordano Bruno Problem: Wind's 1938 Letter to Frances Yates', *The Edgar Wind Journal* 1 (2021), 35–8.

29 Edgar Wind, 'Un art de caprice, de recherches, un art marginal', in *Problèmes de l'art contemporaine: Supplément de la revue 'Preuves'* (July 1953), preserved in Bodleian, EWP, MS. Wind 78, folder 1.

30 Alan Bowness, 'Art in the Margin?', *Times Literary Supplement* (12 March 1964), 205.

Wind relished the controversy and, in a lengthy reply, quoted a contemporary source that *did* relate Manet and Renan: a critic in the *Vie Parisienne* who in May 1864 had written a nasty review of the Salon where the painting was first exhibited, comparing Manet's rendering of the sepulchre to a coal-pit: 'Do not fail to see Monsieur Manet's Christ or rather *The poor Miner dragged out from the Coal-pit* executed for Monsieur Renan.'[31] Manet's acknowledged text was John 20:5–12, which as Wind notes was omitted by Renan from his *Vie de Jésus* (1863), as it was about the Resurrection. Wind concluded:

> What fascinated Manet about this subject was the combination of white linen, a wax-coloured nude and angels with azure-coloured wings, all set against sepulchral darkness. He thus produced for the exhibition of 1864 a religious still-life in the Spanish style, by which he hoped to compete with the Old Masters. [...] He was a practising Catholic and bound by an enduring friendship to the abbé Hurel, who officiated at the Madeleine.[32]

Bowness backed down, expressing the hope that both interpretations could be seen as two honest attempts to understand Manet.[33] Wind refused this suggestion and replied again at length. Wind enjoyed polemics, while his British colleagues avoided them. He pointed out that all the four religious paintings that Manet executed were for the abbé Hurel, whose portrait Manet painted at least twice. When Zola reviewed Manet's career in 1867, he compared the *Dead Christ* to the *Dead Matador*, preferring the religious painting for combining realistic audacity with elegance. 'It was in gratitude for this appreciation that Manet gave Zola a sketch of the admired painting. Your reviewer is mistaken in his belief that this gift (now in the Louvre) was a preparatory study for the picture, exhibited in 1864.'[34] Bowness was silent. Wind was not only a master of ideas, but remarkable in his connoisseurial knowledge about the detail of the relationship of a sketch to a painting. In later editions of *Art and Anarchy*, Wind added lengthy

31 Edgar Wind, quoting *Vie Parisienne* (1 May 1864), in a letter to the editor, *Times Literary Supplement* (2 April 1964), 277.
32 Wind, letter to the editor, 2 April 1964.
33 Alan Bowness, letter to the editor, *Times Literary Supplement* (2 April 1964), 277.
34 Edgar Wind, letter to the editor, *Times Literary Supplement* (9 April 1964), 296.

footnotes about Manet's Christ, a revised and even lengthier version of the correspondence in the *Times Literary Supplement*.[35] No historical details were ever given about Mantegna's altarpiece, not even a reference to the distinguished Mantuan provenance: the collection of Cardinal Silvio Valenti Gonzaga, state secretary to Pope Benedict XIV.

Wind's English contemporaries pigeonholed him as an Italophile, but he had an early acquaintance with British and French culture which contributed to his rare art-historical understanding. As Austin Gill, with whom he taught joint courses on Stéphane Mallarmé, remembered: Wind 'moved in French culture with the discrimination of a connoisseur, a searching curiosity, and a kind of intimacy. He spoke French not simply well and fluently, but as one who learned the language as a child and never ceased to like using it.'[36] The same could be said of his knowledge of the English language, which he spoke well, having travelled in England with his father as a child.

It is sometimes said that it is unnecessary to know about the life of an artist or writer to understand their works. Can we separate art history from its maker? With many, such as Giorgio Vasari, such knowledge can only enrich our experience. In the case of Edgar Wind, the publication of Hugh Lloyd-Jones memoir in 1983[37] and the opening of the Wind archive helped us understand the genesis and development of his complex research, beginning with Rebecca Zorach's 2007 article 'Love, Truth, Orthodoxy, Reticence; or, What Edgar Wind didn't see in Botticelli's *Primavera*'.[38] Two later publications were important: Bernardino Branca's biography, *Edgar Wind, filosofo delle immagini* (2019), and the monograph by Ben Thomas, *Edgar Wind and Modern Art: In Defence of Marginal Anarchy* (2020). Both scholars made extensive use of the archive, and their books

35 Edgar Wind, *Art and Anarchy* (2nd edn, New York: Vintage Books, 1969), 199–202.

36 Austin Gill, comments on Wind in a letter to Margaret Wind, Bodleian, MS. Wind 12, folder 2.

37 Lloyd-Jones, 'A Biographical Memoir'.

38 Rebecca Zorach, 'Love, Truth, Orthodoxy, Reticence; or, What Edgar Wind Didn't See in Botticelli's *Primavera*', *Critical Inquiry* 34/1 (Autumn 2007), 190–224. Zorach consulted the archive before it went to the Bodleian.

reveal that Wind was more interested in contemporary art than had been previously realized, throughout his life, and in different parts of the world.

Thomas discusses at length how Wind enjoyed friendships with significant artists: Pavel Tchelitchew and Ben Shahn in America, and later the American artist in Oxford Ron Kitaj, who as a student at the Ruskin School of Drawing, Oxford, had attended Wind's legendary lectures, and was inspired to paint images of Warburg. None of these artists was discussed in Wind's publications, though Tchelitchew and Shahn contributed to and were present at Wind's lectures at Smith College, surely a negative judgment as to what Wind ultimately thought of their quality as artists. The constancy of Wind's interests, whether in Renaissance or contemporary art, emerges from the book by Thomas. He charts Wind's ideas as they developed in the 1920s and 1930s in Berlin with his thesis *Das Experiment und die Metaphysik* (1934), and argues that:

> Wind's approach to modern art reveals significant aspects of his particular understanding of a method of historical analysis of symbols deriving from Warburg, although inflected in his case by a philosophical position where German idealism has been revised in the light of American pragmatism.[39]

Throughout his peripatetic career, Wind had always been an attentive observer of contemporary art, whether in Berlin, Boston, Chicago, London or New York. He had lectured on modern art, notably in America in June 1941: 'The Literary Background of Modern Art' at the Museum of Modern Art in New York. In April of the following year, Wind gave a series of five lectures, entitled 'The Tradition of Symbols in Modern Art', comprising 'The Heritage of Baudelaire', 'History of the Monster', 'Picasso and the Atavism of the Mask', 'The Survival of Wit' and 'Scientific and Religious Fallacies: Our Present Discontents'. Contemporary artists whom Wind discussed reappeared in *Art and Anarchy*, all European surrealists: Marcel Duchamp, Paul Klee, José Clemente Orozco, Pablo Picasso, Man Ray and Georges Rouault. In his book, Ben Thomas painstakingly reconstructed these lectures from slide lists, fragments of letters and critical accounts that reveal the depth of Wind's relationship with modern art and artists.

39 Thomas, *Edgar Wind and Modern Art*, 1.

Even from his earliest years Wind had been a gifted pianist; as the section in *Art and Anarchy* on the twelve-tone music of Schoenberg reveals, he understood contemporary music. His brief but intense romantic friendship with the dancer Agnes de Mille suggests an early understanding of contemporary embodiment performance.[40]

In the 1940s Wind was one of the most popular lecturers on art in the United States. At the National Gallery of Art in Washington he was invited to lecture on that collection's 'iconographic enfant terrible', Giovanni Bellini's *Feast of the Gods*, then a relatively unknown picture, acquired in 1942 from an English collection, at Alnwick Castle. Wind identified the subject as Priapus attempting to rape Lotis or Vesta, as described by Ovid in *Fasti*.[41] He argued that Bellini had represented the gods as inebriated, boorish and decidedly un-Olympian. His interpretation was met with criticism and considered too sensual for a painting of that period.[42]

Like many art historians of his generation – Kenneth Clark and Ernst Gombrich, for example – Wind preferred figurative art, and seems never to have been at ease with abstract expressionism, a movement whose artists he considered to have carried introspection to extremes, doodling monumentally. For him, action paintings by Soulages derive a certain authority from their size, rather than their content. The one work of art that is illustrated in *Art and Anarchy* that is contemporary with the book is the sculpture *Two Piece Reclining Figure No. 2* (1960) in the Tate Gallery (Figure 13.8), by Henry Moore, with whom he had a passing acquaintance. Moore's sculpture, Wind remarks, reveals a fascination with geology. It is known that Moore had studied completely on his own in 'the celebrated jungle of the British Museum's ethnographic collection'. That leads to the speculation: would a museum allow a 'great sculptor' to curate an exhibition drawn from its ethnographic collection? Wind's idea was surprising in 1963, but not in the twenty-first century. He also wrote that Picasso, whom he disliked, breaks up each style so quickly as to rush into a new

40 Agnes De Mille, *Speak to Me. Dance with Me* (Boston: Little, Brown, 1973), 65–6, 312–15.
41 Ovid, *Fasti*, I, 391–440; VI, 319–48.
42 As discussed in Anderson, 'Edgar Wind and Giovanni Bellini's "Feast of the Gods"'.

Figure 13.8: Henry Moore, *Two Piece Reclining Figure No. 2*, 1960, cast 1961–2, bronze, 125.0 × 290.0 × 137.5 cm. Tate Gallery, London. © The Henry Moore Foundation. All Rights Reserved. Photo: Tate.

discord with haste, unlike artists who found their idiom and stayed with it: Matisse, Braque, Klee, Bonnard, and the 'great' Moore.[43]

There are major themes in *Art and Anarchy* that reverberate throughout Wind's writings. A central concern is his search to understand the iconography of works of art, allied with a continuing dissatisfaction with the inadequacies of formalism. Wind's disquiet with formalism first manifested itself while he was studying for his dissertation with Erwin Panofsky in 1922, when he questioned how works of art were studied without sufficient interest in their content – whether emotional or historical. Both men had developed as art historians when formalism was the dominant mode of thought, as demonstrated by Panofsky's *Perspective as Symbolic Form* (1927). Both changed dramatically when they overthrew the formalist traditions of Alois Riegl and Heinrich Wölfflin that had initially nurtured them.

Strangely, Edgar Wind's review of the second edition of Kenneth Clark's book *The Gothic Revival*, published in the *Times Literary Supplement* on 13 October 1950, has until now escaped notice in the bibliographies

43 Wind, *Art and Anarchy*, 61.

of Wind's writings, but is acknowledged in the archive (Figure 13.3). The review, entitled 'Pure Art', essentially mocked Clark's aesthetic:

> there is obviously much to commend the idea that one must understand goodness to have a proper appreciation of Fra Angelico, but it is hazardous to go from this to the extreme position, that it is even necessary to be in a good moral state, which is apparently held by Sir Kenneth Clark. Is it then, necessary to be full of superstitious fears in order to be moved by Mexican sculpture, or eager for meat in order to understand the caveman's art?[44]

Wind concluded:

> No doubt the truth lies somewhere between the extreme position, that all the artist's emotions and interests must be shared by the observer, and the inhuman or superhuman detachment at which those who held theories of 'pure' art once aimed. But exactly where it lies is the essence of the problem.

Clark recognized the author and replied in his moving lecture *Apologia of an Art Historian*, given at the University of Edinburgh on 15 November 1950.[45] In response to the question of whether you must believe in human sacrifice to understand Mexican carving, Clark answers, 'Yes':

> During the moment at which we are appreciating the Mexican carving we are participating imaginatively in that fierce deep emotional intensity of man which, at some point in almost every religion, has demanded human sacrifice. And our participation is made possible (or rather inevitable) not by the subject, but by the form. The philosophy or *ethos* of a work of art is always expressed through the form, not through the content.[46]

There was a continuing debate between Kenneth Clark and Edgar Wind from the time Wind was in England with the Warburg Institute. As Margot Wittkower recalled, Wind had subjected the text of an article by Clark for an early volume of the *Journal of the Warburg Institute* to

44 Wind, 'Pure Art'.
45 Kenneth Clark, 'Apologia of an Art Historian', *University of Edinburgh Journal* (Summer 1951), 232–8. Offprint – a gift from Clark to Wind – at Bodleian, EWP, MS. Wind 98, folder 3.
46 Clark, 'Apologia of an Art Historian'.

daunting criticism, and Clark withdrew the article, finding the experience of peer review with Wind uncongenial:

> After eliciting an article from Clark for the *Warburg Journal*, Wind responded: 'Well, it has good ideas, but now the real work has to begin. We have to know where you got that from, and who said this', and so forth, and Ken said, 'No, that's too boring for me. I'll give it to a more popular magazine.' Wind was very strict.[47]

The conflictual nature of their relationship may explain Clark's negativity when asked for his opinion on Wind's suitability for prestigious fellowships at King's College at Cambridge and All Soul's at Oxford.[48]

Wind's concerns were to remain remarkably consistent, as he explained in *Art and Anarchy*:

> Wölfflin insisted that the eye must be trained on forms that are emotionally less distracting. Thus, he was never satisfied in tracing a master's style in the design of a human figure or head. 'In the drawing of a mere nostril', he wrote defiantly, 'the essentials of the style should be recognised'. His ideal was an art history of the smallest particles which would trace developments of form by comparing 'hand with hand, cloud with cloud, twig with twig down to the lines on the grain of wood.'[49]

The converse was true of Erwin Panofsky, when, towards the end of his life, he returned in *Gothic Architecture and Scholasticism* (1951) to present a fascinating formalist analysis of how systems of scholastic and *theological* thought were mirrored in patterns, ground plans, systems of vaults, and other formulae in medieval architecture. When I visited Panofsky in 1967, at Princeton when I was a postgraduate student studying Giorgione and he was working on his last book, on Titian, Panofsky told me that of all his works, he was most proud to have written *Gothic Architecture and Scholasticism*.

47 Margot Wittkower, *Partnership and Discovery: Margot and Rudolph Wittkower*, interviewed by Teresa Barnett, Art History Oral Documentation Project, compiled under the auspices of the Getty Centre for the History of Art and the Humanities (Los Angeles: J. Paul Getty Trust, 1994), 208.

48 See Anderson, 'Edgar Wind and Giovanni Bellini's "Feast of the Gods"'.

49 Wind, *Art and Anarchy*, 22.

In art history there were many formalisms, which are concerned with constructing an aesthetic history of art in which one takes certain formal characteristics and isolates them as style. In all instances these formal characteristics were the bearers of cultural meanings, which varied according to different periods and thought patterns. In the 1950s and 1960s abstract expressionist art was accompanied by formalist analysis that Wind found uncongenial. When Wind returned to England in the 1950s he encountered another kind of anodyne formalism, a cautious British variation, exemplified by the writings of Roger Fry. So important did he consider the refutation of the prevailing British view that he addressed the subject directly in 'The Fallacy of Pure Art', where he defined his conception of art history as a discipline. This was his inaugural lecture as the first professor of the history of art at the University of Oxford, delivered on 29 October 1957.[50] Wind's argument in his inaugural lecture is still as relevant today.

Wind argued that the art historian can show how things that lie outside art can illuminate the perception of art in a way far more satisfying than any use of analogues; the use of analogues, he thought, opened the door to the very verbiage that art theory had been developed to reduce. Wind illustrated his lecture with his own interpretations of Piero di Cosimo's *Portrait of Simonetta Vespucci* (Figure 13.9) and Raphael's *Transfiguration* (Figure 13.10), which he illuminated in relation to Renaissance poetry and literature. In both instances he chose to interpret a masterpiece by explaining a particular iconographic detail. Simonetta is depicted wearing as a necklace a living serpent, a symbol of eternity, whose mouth is about to close on its tail. Wind interprets this motif as a reference to the poetry of Lorenzo il Magnifico, who believed that Simonetta's beauty became perfect only at death. We thus see an apotheosis of beauty about to happen when the serpent's mouth will close the ring of eternity.[51]

In the case of the *Transfiguration*, Wind saw the inscription on an engraving by Giulio Bonasone that reproduced the upper part of Raphael's painting as a key to the way in which Raphael's altarpiece was interpreted

50 The content of the lecture is given in part in Lloyd-Jones, 'A Biographical Memoir', xxviii–xxix.

51 Lloyd-Jones, 'A Biographical Memoir', xxix.

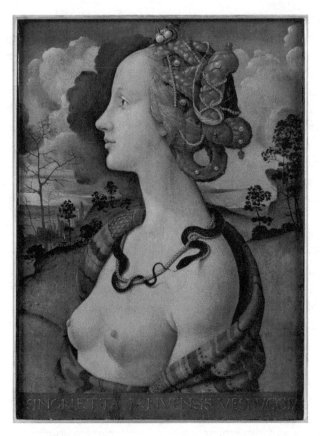

Figure 13.9: Piero di Cosimo, Portrait of a woman, said to be Simonetta Vespucci,
c. 1490, tempera on panel, 57 × 42 cm. Musée Condé, Chantilly.

in his own time (Figure 13.11). Raphael depicts two images of madness: one
the lunatic boy, the other the miraculous apparition on the mountain.
Wind interprets these two images as a reflection of Plato's distinction
between two forms of madness – mortal infirmity, and divine release – as
in Plato's *Phaedrus* (265A). For many, this leads to a higher appreciation
of the painting.

Wind did not live to see how a negative attitude towards iconography,
which had been especially prevalent in the field of Venetian art history, was

Figure 13.10: Raphael, *The Transfiguration*, 1516–20, oil on panel, 410 × 279 cm.
Vatican Museums, Rome.

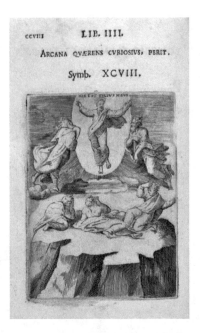

Figure 13.11: Giulio Bonasone, engraving after Raphael's *Transfiguration*, from Achille
Bocchi, *Symbolicae quaestiones* (Bologna: Giulio Bonasone, 1555). Warburg Institute,
University of London.

revived and practised by his successors Francis Haskell, the second professor
of art history at Oxford from 1967, and Haskell's pupil Charles Hope, dir-
ector of the Warburg Institute from 2001 to 2010. At a major conference
at Venice in 1976, titled 'Tiziano e Venezia', Haskell and Hope proposed
a new approach to the interpretation of Titian's secular imagery, an alter-
native to neo-Platonic interpretations by Panofsky and Wind. They stated
at a roundtable discussion that the study of Venetian art was not complex
at all, but 'simple' and 'straightforward', that Titian was just painting sexy
pictures for patrons who were uninterested in culture. Nothing much to
talk about really, since sex was a simple business. Or, as Haskell put it:

However different his subjects, however 'progressive' his technique, however remarkable his spiritual development (and however moving the impact on us), in that respect at least the old painter of the *poesie* for Philip II had not fundamentally changed from the provider of naked girls to a dissolute patriciate.[52]

Charles Hope considered that collectors outside Venice – major aristocratic patrons such as Alfonso d'Este, François I of France and Philip II of Spain – commissioned a different kind of picture from those commissioned by patricians in Venice, where 'there was a distinctive local tradition of erotic paintings which did not masquerade as anything else.'[53] No evidence was given for dismissing the entire Venetian patriciate in this way, nor for why someone who was dissolute was incapable of philosophical thought. Pietro Aretino, a self-confessed dissolute, would be at least one exception. There is some evidence that sixteenth-century Venetians enjoyed proposing different interpretations of works of art, as most recently discussed by Salvatore Settis,[54] but also analysed by earlier Italian scholars. Wind's own use of visual interpretations, such as Achille Bocchi's *Symbolic Questions*, was another exception, which shows a visual interpretation of Raphael (Figure 13.11).

What is especially interesting is how the understanding of nudity and sexuality in Venetian painting changed over the twentieth century, in just four decades. When, at the National Gallery of Art in Washington in the 1940s, Wind suggested that Giovanni Bellini had represented a rape with Priapus as the central protagonist, he was accused by Erica Tietze-Contrat

52 Francis Haskell, 'Titian: A New Approach?', in *Tiziano e Venezia: Convegno internazionale di studi, Venezia, 1976*, ed. Università Ca' Foscari Venezia (Venice: Neri Pozzo, 1980), 44.

53 Charles Hope, 'Problems of Interpretation in Titian's Erotic Paintings', in *Tiziano e Venezia*, 123.

54 Salvatore Settis, *Deeper Thoughts: Beyond the Allegory of Bellini, Giorgione, Titian*, Linbury Lecture (London: National Gallery, 2020), 20–1.

of pornography,[55] consistent perhaps with the standards of decorum then prevailing. But by the 1970s it was considered acceptable for Francis Haskell to describe Titian's portraits of women as naked girls for a dissolute patrician class, who were incapable of perceiving them as anything more than sexy pictures.

In the 1970s Horst Bredekamp initiated the rediscovery of the Germanophone historiography of art that had been lost through the emigration of scholars in the 1930s; he was concerned with the legacy of Aby Warburg as represented by Edgar Wind and Ernst Cassirer. Bredekamp convened the first conference about Edgar Wind (at Berlin in February 1996),[56] and argued that Wind, together with Panofsky and Gombrich, practised iconology in defiance of Nazism, and that their neo-Platonic explanations of paintings were seen as a defence of freedom.[57] Whether or not Wind's iconological analyses were 'right' or 'wrong', they have continued to give intellectual pleasure, and – as the huge popular reception to *Art and Anarchy* shows – most art lovers revel in their complexity.[58]

Criticism of formalism is apparent throughout *Art and Anarchy*. In his inaugural Oxford lecture Wind outlined, also for the first time, his criticism of connoisseurship, a subject to which he returned again and

55 Erica Tietze-Conrat's unpleasant review of Wind's interpretation of the 'Feast of the Gods' (Erica Tietze-Conrat, 'Mantegna's Parnassus: A Discussion of a Recent Interpretation', *The Art Bulletin* 31 [1949], 126–30) was libellous in her first draft, preserved in the Wind archive. Wind received that draft from *The Art Bulletin*'s editor and was invited to reply; he managed to have the accusations of pornography removed. Tietze-Conrat also criticized Wind's interpretation of Mantegna's *Parnassus*, especially Cupid's rude gesture at Vulcan. Bruno Mottin from the Louvre conservation laboratory recently revealed that Mantegna painted the thread of gold in gold dust, from Cupid's trumpet to Vulcan's genitalia, thus confirming Wind's interpretation. For the full documentation, see Anderson, 'Edgar Wind and Giovanni Bellini's "Feast of the Gods"', esp. 22–5.

56 Horst Bredekamp, Bernhard Buschendorf, Freia Hartung and John Krois, eds, *Edgar Wind: Kunsthistoriker und Philosoph* (Berlin: Akademie, 1998).

57 Horst Bredekamp, 'Götterdämmerung des Neuplatonismus', *Kritische Berichte* 14/ 4 (1986), 39–48.

58 As argued by Robert Gaston in his review of Elizabeth Sears' edition of Wind's *The Religious Symbolism of Michelangelo*, in *The Burlington Magazine* 145 (2003), 797–8.

again. Wind saw some virtues in studying connoisseurship, mainly that it was a fresh way of studying art, but it was also a way of discarding the accretions imposed on the visual by irrelevant associations, a heightening of the optical sensibility as such by exercising the eye without distraction. Wind objected to the vocabulary of connoisseurship, particularly that of Bernard Berenson and his philosophically pretentious theory of 'tactile values'. In his lecture Wind wrote:

> Such seemingly neutral terms as 'surface' or 'volume' do not take on their proper art-critical meaning until they are pronounced with the gustative purring that relates the connoisseur to the gourmet. Mr Berenson's 'tactile values' are in the same predicament: their tactility can be shown, their value not. If a person perceives the 'solid' features of a painting without feeling that this is a 'life-enhancing' experience, then the demonstration is at an end, and with it the whole of Mr Berenson's aesthetics.[59]

In *Art and Anarchy* Wind reveals a fascination with the historical figure of Giovanni Morelli, who was a very different proposition from Berenson. At the time of the Reith Lectures, Wind knew little about Morelli, except for Gustavo Frizzoni's memoir.[60] When Wind revived Morelli as a subject of topical interest in the 1960s he claimed that Morelli was predictive of modern psychology, concluding that 'modern psychology would certainly support Morelli: our inadvertent little gestures reveal our character far more authentically than any formal posture that we may carefully prepare'.[61] In Wind's analysis he chose, like Sigmund Freud, to focus on only a tiny aspect of Morelli's method. Yet strangely there is no mention of Freud in *Art and Anarchy*. Could Wind have been ignorant of Freud's essay on Michelangelo's Moses, published in 1914, one of the two essays that Freud wrote about artists? It seems unlikely that Wind would have forgotten Freud's claim, especially since Freud argued that he was more preoccupied with the subject matter of works of art than with their style:

59 Edgar Wind, 'The Fallacy of Pure Art', unpublished inaugural lecture at Oxford, 29 October 1957, Bodleian, EWP, MS. Wind 152.

60 Gustavo Frizzoni, 'Ein Lebensbild', in *Kunstkritische Studien über italienische Malerei: Die Galerie zu Berlin* (Leipzig: Brockhaus, 1993), xi–lxiii.

61 Wind, *Art and Anarchy*, 39–40.

Long before I had any opportunity of hearing about psychoanalysis, I learnt that a Russian art-connoisseur, Ivan Lermolieff, had caused a revolution in the art galleries of Europe by questioning the authorship of many pictures showing how to distinguish copies from originals with certainty, and constructing hypothetical artists for those works whose former supposed authorship had been discredited. He achieved this by insisting that attention should be diverted from the general impression and main features of a picture, and by laying stress on the significance of minor details, of things like the drawing of the fingernails, of the lobe of an ear, of halos and such unconsidered trifles which the copyist neglects to imitate and yet which every artist executes in his own characteristic way. I was then greatly interested to learn that the Russian pseudonym concealed the identity of an Italian physician called Morelli, who died in 1891, with the rank of Senator of Kingdom of Italy. It seems to me that his method of inquiry is closely related to the techniques of psychoanalysis. It, too, is accustomed to divine secret and concealed things from despised or unnoticed features, from the rubbish-heap, as it were, or our observations.[62]

The year 2023 is the sixtieth anniversary of the publication of *Art and Anarchy*. The critical reception of this book is extraordinary, without comparison for its range and success. Edgar Wind knew how to use the medium of radio to inspire so many different people and to make everyone think about theory – theories that went across the arts of all time and in all countries.

62 Sigmund Freud, *The Moses of Michelangelo*, in *The Standard Edition of the Complete Psychological Works of Sigmund Freud*, ed. and trans. James Strachey, in collaboration with Anna Freud, assisted by Alix Strachey and Alan Tyson (London: Hogarth Press, 1913–14), 222.

Notes on Contributors

JAYNIE ANDERSON AM, OSI, FAHA is Professor Emeritus at the University of Melbourne. She graduated with a first-class degree in history and fine arts from the University of Melbourne in 1966, receiving the Dwight Final Examination Prize in art history. She was then invited to undertake a doctorate at Bryn Mawr College, Pennsylvania, on Giorgione with Charles Mitchell, which she finished at the University of Oxford as the first woman Rhodes Fellow. She was examined by Edgar Wind for her research fellowship in Oxford, and later edited two volumes of his collected works: *The Eloquence of Symbols* (1983) and *Hume and the Heroic Portrait* (1986). Her most recent book is *The Architecture of Devotion* (2021).

BERNARDINO BRANCA is a PhD student at the University of Kent in Canterbury, UK. The title of his doctoral thesis is 'Edgar Wind and the Italian Renaissance: Art, Embodiment, and the Afterlife of Antiquity'. His research interests include the works of Aby Warburg and Edgar Wind, and the relationship between ideas and art during the Italian Renaissance. With Ben Thomas, Branca was the organizer of the conference 'Edgar Wind: Art and Embodiment', held at the Italian Cultural Institute, London, on 28–29 October 2021, and is co-editor-in-chief, with Fabio Tononi, of *The Edgar Wind Journal*, an online open-access twice-yearly publication. Branca's publications include *Edgar Wind, filosofo delle immagini: La biografia intellettuale di un discepolo di Aby Warburg* (Mimesis, 2019) and of a number of articles in *The Edgar Wind Journal*.

BERNHARD BUSCHENDORF taught German literature at various German universities. From early on, he pursued a transdisciplinary approach by applying *Kulturwissenschaft* in the Warburg tradition to literature; for example, when in his book on Goethe's *Elective Affinities* (Suhrkamp, 1986) he revealed the mythological and iconographical allusions inscribed into the novel's narrative. He has published widely on Edgar

Wind, for example, on major motives of his thinking, in the afterword to the German translation of *Pagan Mysteries in the Renaissance* (1981); on the collaboration between Warburg and Wind (1985); on Wind's concepts of enthusiasm and memory (1991); on Wind's role in the emigration of the Warburg Library (1993); and on the concept of the symbol in Vischer, Warburg and Wind (1998). He also published a revised German edition of *Experiment and Metaphysics*, with a methodological afterword (2001); and together with Franz Engel he edited and annotated Wind's unpublished Rede Lecture 'On Classicism' (2018).

FRANZ ENGEL studied philosophy, art history and musicology in Berlin and Rome. He completed a dissertation on the iconography and iconology of chaos and primordial formlessness. He has published various articles on Edgar Wind. Together with Bernhard Buschendorf he edited Wind's Cambridge Rede Lecture from 1960 entitled 'On Classicism'. Currently, he is the coordinator of the Census of Antique Works of Art and Architecture Known in the Renaissance, based at the Humboldt University Berlin.

OSWYN MURRAY was a pupil of Arnaldo Momigliano; he was a Senior Research Fellow of the Warburg Institute in 1967–8. From 1968 to 2004 he was a Fellow of Balliol College, teaching Greek and Roman History. He was the author of *Early Greece* (1980, 1983; translated into six languages; new edition forthcoming); history editor of *The Oxford History of the Classical World* (1986; translated into five languages); editor of a commentary on Herodotus, and the founder of sympotic studies (see *The Symposion: Drinking Greek Style*, Oxford, 2018). He has been a visiting Fellow at the Ecole des Hautes Etudes en Sciences Sociales in Paris and at the Massachusetts Institute of Technology, is an honorary member of the Scuola Normale di Pisa and the Royal Danish Academy, and held a Leverhulme Emeritus Fellowship in 2021–2. Currently an Emeritus Fellow of Balliol College, Oxford, his next book is: *The Muse of History: The Ancient Greeks from the Enlightenment to the Twentieth Century* (Penguin, 2024).

C. OLIVER O'DONNELL is a historian of modern art and intellectual history, with a particular focus on the transatlantic Anglo-American traditions of modernity. He is currently based at the Warburg Institute, University of London, where he is a Research Associate and member of the Bilderfahrzeuge Project. O'Donnell's research on Edgar Wind grew out of his interest in the philosophical tradition of Pragmatism, especially as it has influenced the interpretation of visual art. This topic is central to some of his other publications, including his first monograph, *Meyer Schapiro's Critical Debates: Art Through a Modern American Mind* (2019), and his recent article in the *Art Bulletin*: 'Peirce, Bierstadt, and the Topographic Imagination in Nineteenth-Century North America', among others.

PABLO SCHNEIDER is the Programme Manager for Art and Science at the Deutscher Kunstverlag and a Lecturer in art history at TU Dortmund University. He has published many works on Edgar Wind, Fritz Saxl, Aby Warburg and the circle of scholars linked to the Kulturwissenschaftliche Bibliothek Warburg.

ELIZABETH SEARS is George H. Forsyth Jr Collegiate Professor of History of Art at the University of Michigan. Trained in the Warburgian tradition, she specializes in Western medieval art and disciplinary historiography. In a series of studies focused on questions of method and the operation of academic networks, she has investigated the life and work of scholars including Warburg, Goldschmidt, Steinmann, Panofsky, Saxl, Bing, Klibansky, Heckscher, Janson, Seznec and Hinks; in 2000 she published an edition of Wind's writings in English on Michelangelo. She is now completing a book, *Warburg Circles*, set in the years 1929–64, treating the intellectual movement that traced its origins to the Kulturwissenschaftliche Bibliothek Warburg in Hamburg. Her work has been supported by a Guggenheim Fellowship and residential fellowships in Rome (British School), Hamburg (Warburg Haus), Berlin (American

Academy), Washington (CASVA), and at the Cullman Center for Scholars and Writers, New York Public Library.

IANICK TAKAES DE OLIVEIRA holds a BA in visual arts and an MA in art history from Universidade Estadual de Campinas, and is currently a PhD candidate in art history at Columbia University. Takaes specializes in Italian Renaissance art and twentieth-century art historiography, focusing on the Warburgian tradition and theories of empathy. For his MA thesis, he discussed and translated into Portuguese Edgar Wind's *Art and Anarchy* (1963). His recent articles have focused on Wind's later period (1955–71) and fraught relationship with the Warburg Institute. Takaes has also written about cases of acute psychosomatic reaction to artistic experiences (chiefly the Stendhal syndrome). His current research addresses the depiction of celestial paradise in fifteenth- and sixteenth-century Italy and the transatlantic transmission of Italianate heavenly imagery.

GIOVANNA TARGIA is currently working on the editorial project of Heinrich Wölfflin's collected works at the University of Zurich, and collaborating on the research project Languages of Art History at the Kunsthistorisches Institut in Florenz – Max-Planck-Institut. She studied philosophy at the Scuola Normale Superiore in Pisa, where she obtained her PhD in history of art in 2009 with a dissertation on Aby Warburg. She held postdoctoral fellowships from the Bibliotheca Hertziana – Max-Planck-Institut für Kunstgeschichte in Rome and from the Alexander von Humboldt Foundation at the Ludwig-Maximilians-Universität in Munich. In 2013 she was awarded the DAAD Ladislao-Mittner-Preis for the history of art.

BEN THOMAS is Reader in Art History at the University of Kent. From 1996 to 1999 he worked as a research assistant to Margaret Wind, the widow of Edgar Wind, helping her prepare the Wind archive for deposit in the Bodleian Libraries. He learnt more about scholarship and its importance from this experience than he did from the more formal aspects of his education. Thomas is the author of *Edgar Wind and Modern Art: In Defence of Marginal Anarchy* (Bloomsbury, 2020). He was also

co-curator of the award-winning exhibition *Raphael: The Drawings* held at the Ashmolean Museum in 2017.

FABIO TONONI is a Postdoctoral Research Fellow at the Centre for the Humanities (CHAM) in the Faculty of Social and Human Sciences of NOVA University of Lisbon, and teaches philosophy at the Centro Luís Krus – Formação ao Longo da Vida in the Faculty of Social and Human Sciences. He is Principal Investigator of an exploratory project titled IMCS – Imagination and Memory at the Intersection of Culture and Science, funded by CHAM, and editor-in-chief of *The Edgar Wind Journal*. His research interests include the essence and tasks of philosophy and science, the writings of Aby Warburg and Edgar Wind, the relationship between art and cognitive neuroscience, the interconnection between art and ideology, and postmodernism. In 2020 Tononi was convenor of the Aby Warburg Reading Group and Seminar at the Italian Cultural Institute of London. In 2021 he received a PhD from the Warburg Institute at the School of Advanced Study of the University of London. He held an internship at Villa I Tatti, the Harvard University Center for Italian Renaissance Studies in Florence.

TULLIO VIOLA is Assistant Professor in philosophy of art and culture at Maastricht University. He holds a PhD in philosophy (2015) from Humboldt University in Berlin and subsequently worked as a Postdoctoral Fellow at both Humboldt University and the Max-Weber-Kolleg in Erfurt. His research focuses on the dialogue between philosophy and the socio-cultural sciences in the nineteenth and twentieth centuries. He has written in particular on American pragmatism, German *Kulturwissenschaften*, and French philosophy. His first book, *Peirce on the Uses of History*, came out with De Gruyter in 2020. In addition, he published articles in *The British Journal of the History of Philosophy*; *History & Theory*; *European Journal of Pragmatism and American Philosophy*; and other journals. He is currently working on a project on the philosophy of culture in classical American pragmatism and its implications for today's dialogue between philosophy and anthropology.

Index

Page references in **bold** are to illustrations.

CULTURAL MEMORIES

SERIES EDITOR

Dr Katia Pizzi

Institute of Languages, Cultures and Societies,
School of Advanced Study, University of London

Cultural Memories is the publishing project of the Centre for the Study of Cultural Memory at the Institute of Languages, Cultures and Societies, University of London. The Centre is international in scope and promotes innovative research with a focus on interdisciplinary approaches to memory.

This series supports the Centre by furthering original research in the global field of cultural memory studies. In particular, it seeks to challenge a monumentalizing model of memory in favour of a more fluid and heterogeneous one, where history, culture and memory are seen as complementary and intersecting. The series embraces new methodological approaches, encompassing a wide range of technologies of memory in cognate fields, including comparative studies, cultural studies, history, literature, media and communication, and cognitive science. The aim of *Cultural Memories* is to encourage and enhance research in the broad field of memory studies while, at the same time, pointing in new directions, providing a unique platform for creative and and forward-looking scholarship in the discipline.

Printed by
CPI books GmbH, Leck